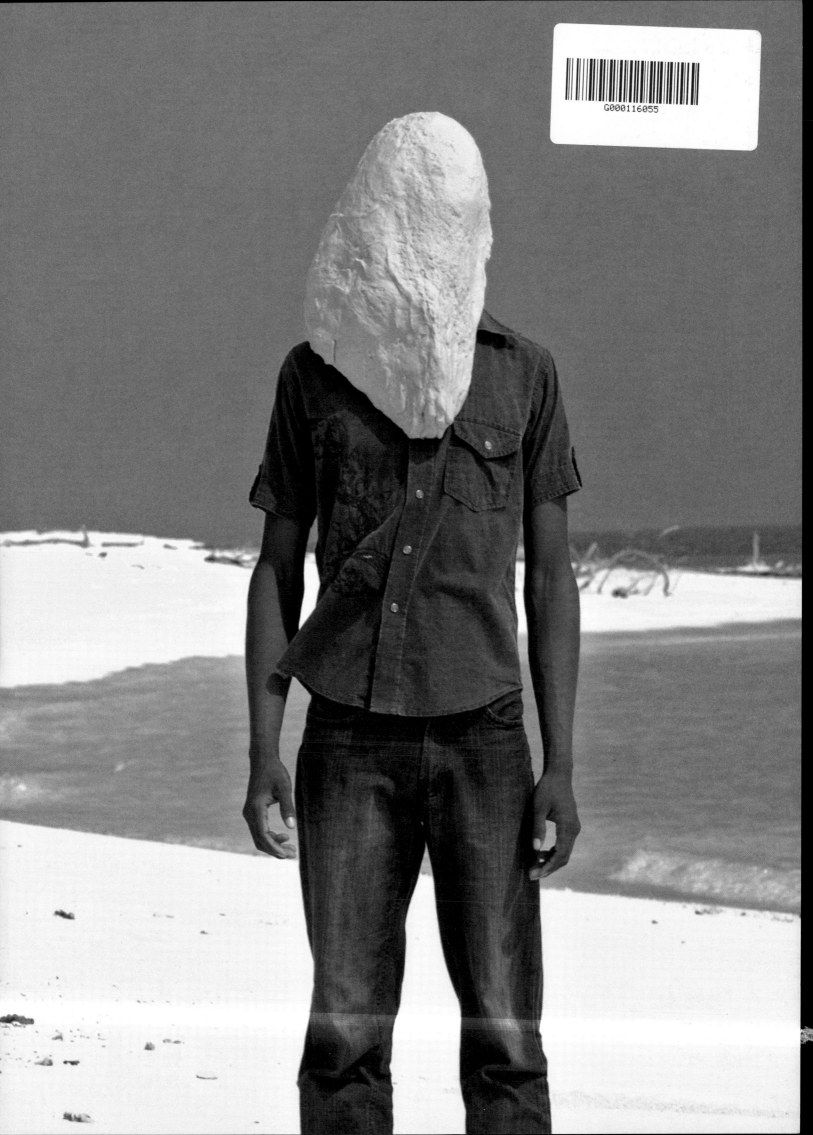

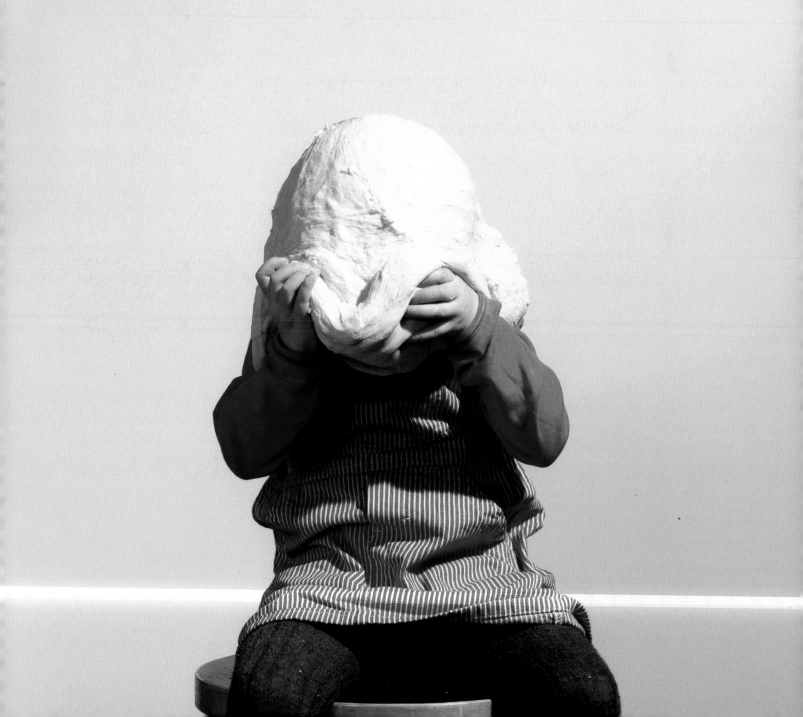

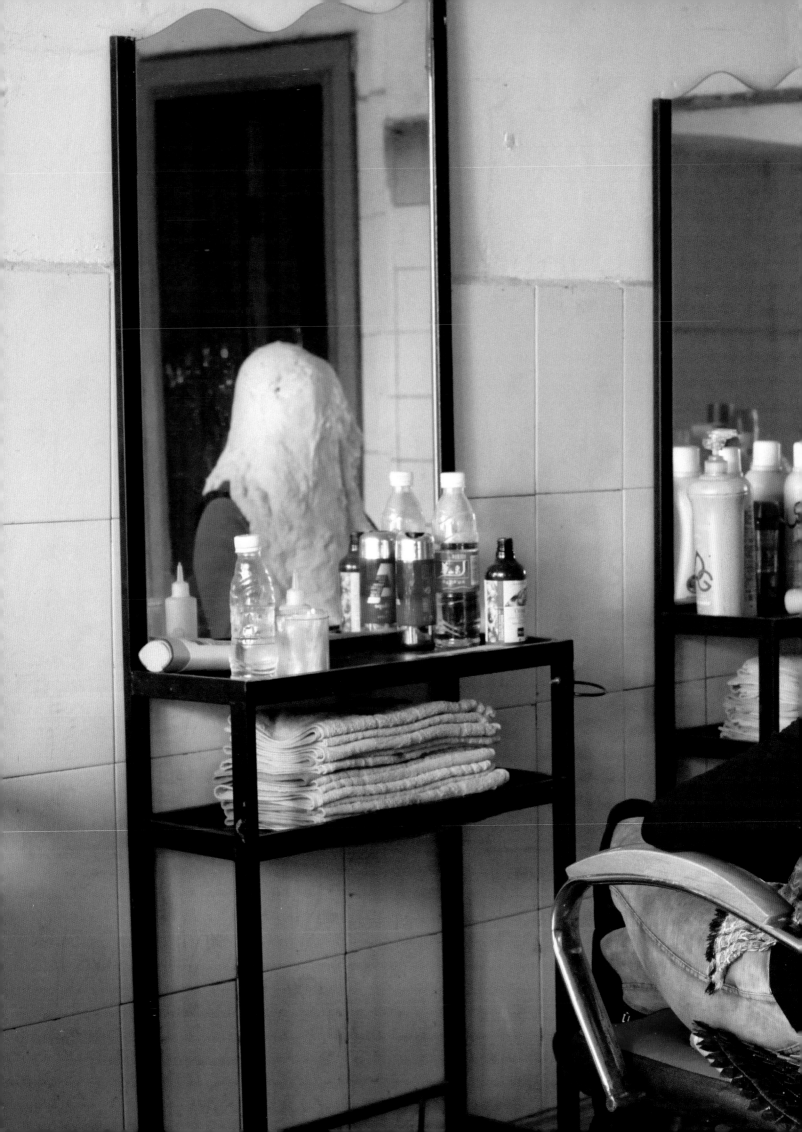

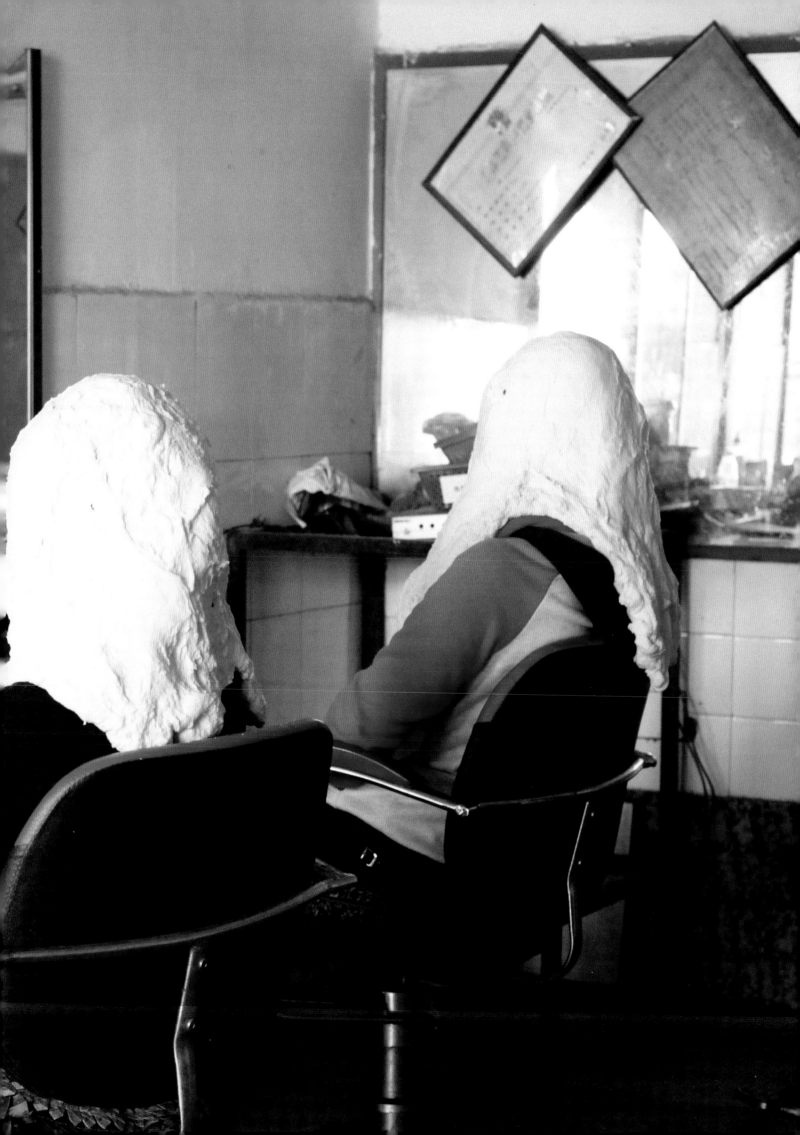

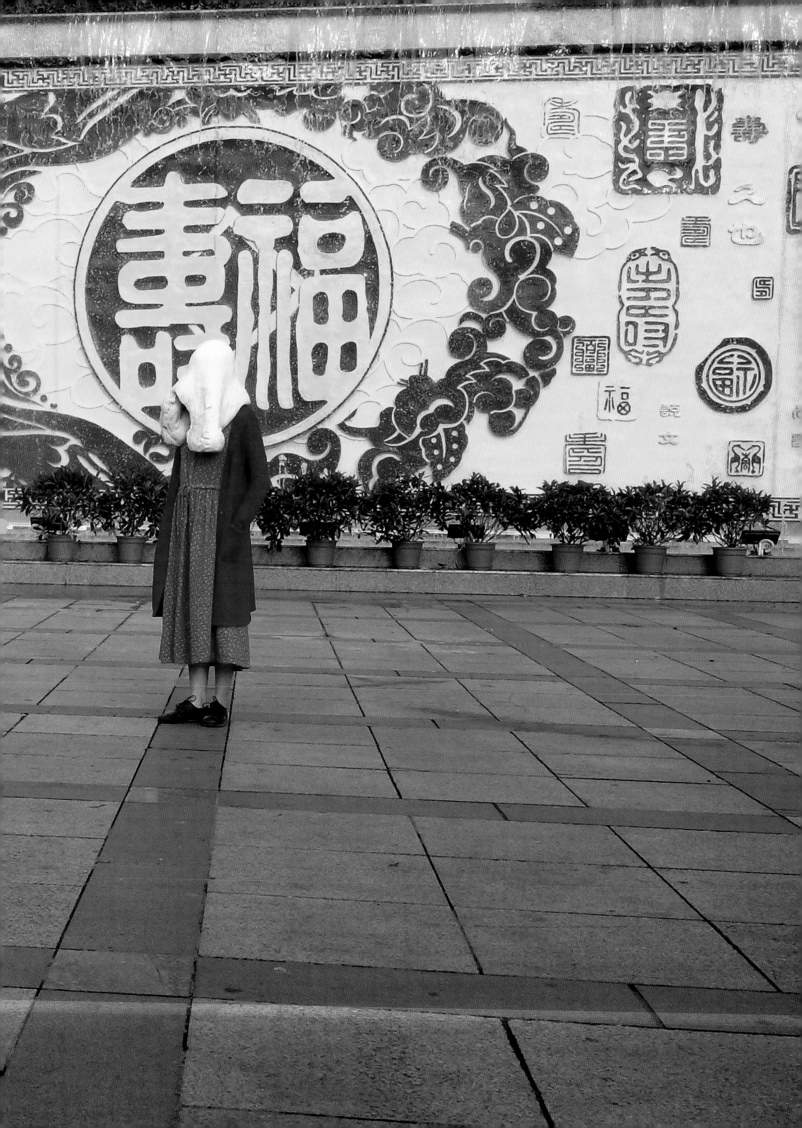

DOUGH PORTRAITS

SØREN DAHLGAARD

ART / BOOKS

With contributions by

Valentina Borsato	Ran Kasmý-Ilan	Barrie Mowatt
Fabio Cavallucci	Natalie King	Djon Mundine
Duan Yuting	Barbara Læssøe Stephensen	Amani Naseem
Rune Gade	Judi Lund Finderup	Karla Osorío Netto
Gim Gwang-cheol	Karen McQuaid	Pirkko Siitari
Rafet Jonuzi	Augustine Mok	Raimar Stange

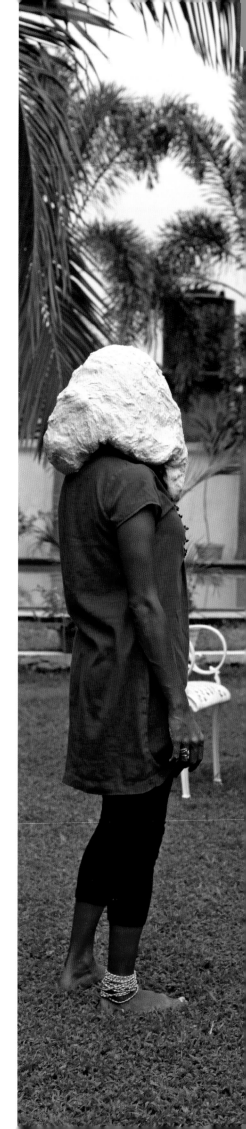

First published in the United Kingdom in 2015 by Art Books Publishing Ltd

Dough Portraits copyright © 2015 Art Books Publishing Ltd
Artworks copyright © 2015 Søren Dahlgaard
Texts copyright © 2015 the contributors

Art Books Publishing Ltd
77 Oriel Road
London E9 5SG
Tel: +44 (0)20 8533 5835
info@artbookspublishing.co.uk
www.artbookspublishing.co.uk

British Library Cataloguing-in-Publication Data
A catalogue record for this book is available from the British Library

ISBN 978-1-908970-22-0

Designed by Mette Flink (flink-art.dk) and Art / Books
Printed and bound in Latvia by Livonia

Distributed outside North America by
Thames & Hudson
181a High Holborn
London WC1V 7QX
United Kingdom
Tel: +44 (0)20 7845 5000
Fax: +44 (0)20 7845 5055
sales@thameshudson.co.uk

Available in North America through
ARTBOOK | D.A.P.
155 Sixth Avenue, 2nd Floor,
New York, N.Y. 10013
www.artbook.com

CONTENTS

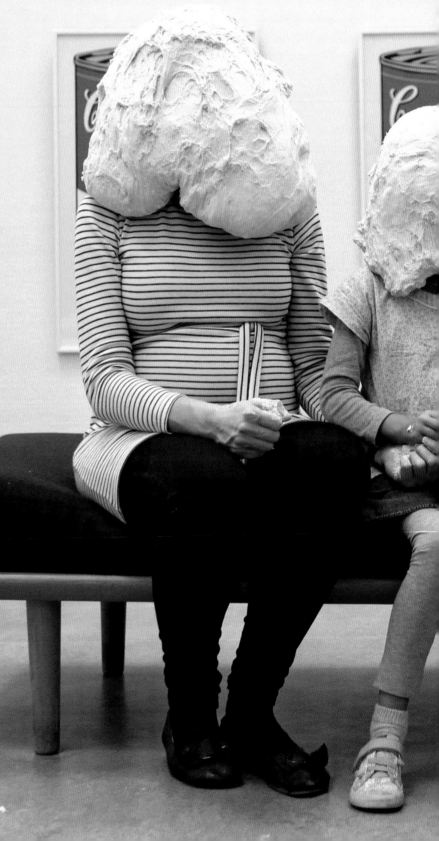

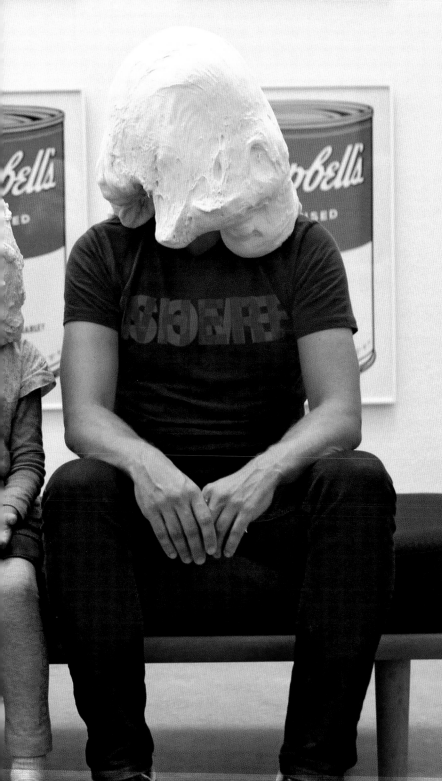

BY THY MASK I SHALL KNOW THEE

'By thy mask I shall know thee', says one of the characters from Danish author Karen Blixen's 1934 gothic tale 'The Deluge at Norderney'. It is a statement with so much force that it has become a saying in itself. A contradiction in terms. For the mask is indeed a tool for concealing the 'true face', and yet we all know that it is precisely the mask – the thing we choose to cover ourselves with, dress up in, decorate ourselves with – as well as the way we pose, that we use to orchestrate ourselves. And it is by these things – the masks – that we judge each other.

BARBARA LÆSSØE STEPHENSEN
RHETORICIAN AND WRITER, COPENHAGEN

Historically, a portrait was often the first work of art a poor family would invest in. And being portrayed is still one of the highest honours that can be given to great men and women. Contrary to the ordinary snapshot, the person represented renounces his or her control over the image, and in return gets an authenticity that the artist has contributed. By ceding sovereignty to the painter, photographer or sculptor, the person being portrayed exchanges pretence for a purer, more objective representation that has greater truth and value. The statesman, desiring an image of status, can never obtain this by posing before a camera alone. It is awarded to him by the artist.

Yet art history demonstrates again and again that portraits have been used to show off, impress and manipulate. From this perspective, the *Dough Portraits* are the purest portraits I have ever seen, because pretence is almost impossible. In this case, it is not just the subject of the portrait who has ceded sovereignty, but also the artist, who has had to give up controlling power to the lively and uncontrollable dough.

And that is when we begin to see. First and foremost, we register how we usually see. And then we realize what science has long claimed:

that facial gestures mean more to us than we might recognize, and that the expressions of the face generated by such feelings as fear, anger, disgust, sorrow and joy are similar everywhere and the easiest way to communicate.

Standing before these bizarre faceless figures covered in dough, we are confronted with the immediate difficulty of lacking the facial gestures we normally look for when we try to read another person. At once, we notice ourselves searching for other features that will tell us who we are facing. We look at the clothes – but discover that these say only so much. Then we turn to the body, and find it loaded with information. Once our attention is drawn to the sitter's form, we instinctively know how to read its language and use it to make judgments about the person. Does she resemble me? Is she brave or cautious? Is he funny? Is she tidy or more relaxed? Would I go to bed with him? Is she lazy? The position of the body becomes the important bearer of information: the sit-up-straight posture, the open palms of the hand, the laid-back attitude, men with their legs wide open, and girls with theirs crossed demurely. We can see these poses, and read them as expressions of individuality, but we are still on uncertain ground – without the faces.

The shapeless dough-lumps are both repulsive and horrifying as deformed heads. They remind us of The Elephant Man or ET. But like each of these icons of popular culture, they call for tenderness in their sorry shapelessness. Because even though it is not visible, we inevitably look for the face … and see it. Suddenly the dripping blurred, swollen blobs of dough appear as expressions of – or impressions of – the person within. Although we know that the real image of the person is to be found on the inside of the lump, and we are looking only at the outside of a mould, one cannot help but discover facial features in the material and be moved by them. Isn't the one with the heavy hanging dough-cheeks looking mournful? And does the guy in the suit not seem coarse with that bulldog-head? Don't you feel an urge to gently wave away the dough that has loosened itself and fallen down the side of that young woman's face, covering her cheek, like a bold unruly lock of hair? And isn't that little girl laughing at us?

A few years ago, an image went around the globe of an American soldier who had recently returned from Iraq and a collision with a bomb, with a face patched together, which was in truth barely a

face. It was a wedding picture of the soldier and his new wife, who had known him from before the war and the accident, and who continued to love him despite his disfigurement. And the whole world looked on in wonder. Because we are so dependent on faces, we cannot imagine how one can love a person with no face. What then is the person, and what is the mask?

In front of the *Dough Portraits*, we are no longer able to tell which is the truest image: the inside with its pretence, or the faceless outside with no pretence? And thus we are reminded of the difficulty of seeing anyone for what they are – love them for who they are 'inside'. Without form, there is no content. We can get rid of layers of self-staging and posing, renounce control over how we look ourselves, but not escape the power of form. Form will always govern and dominate, manipulate and assist our perceptions of each other. But by thy dough portrait I shall know thee.

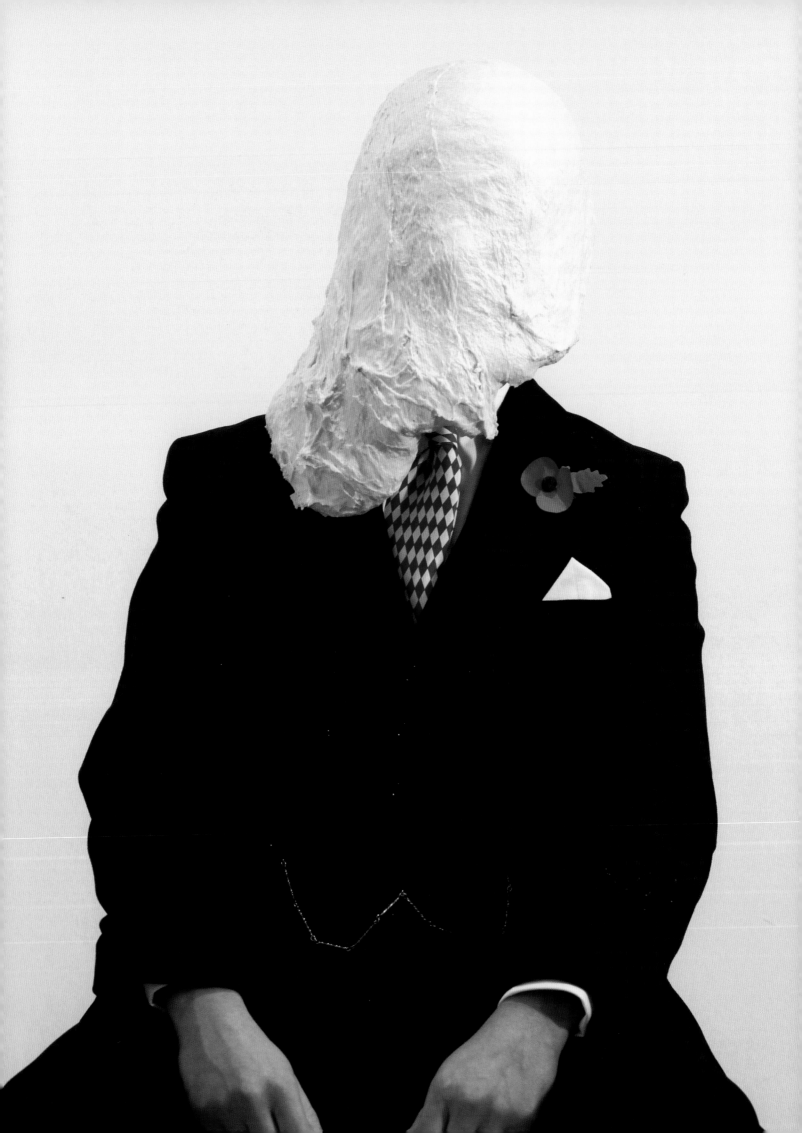

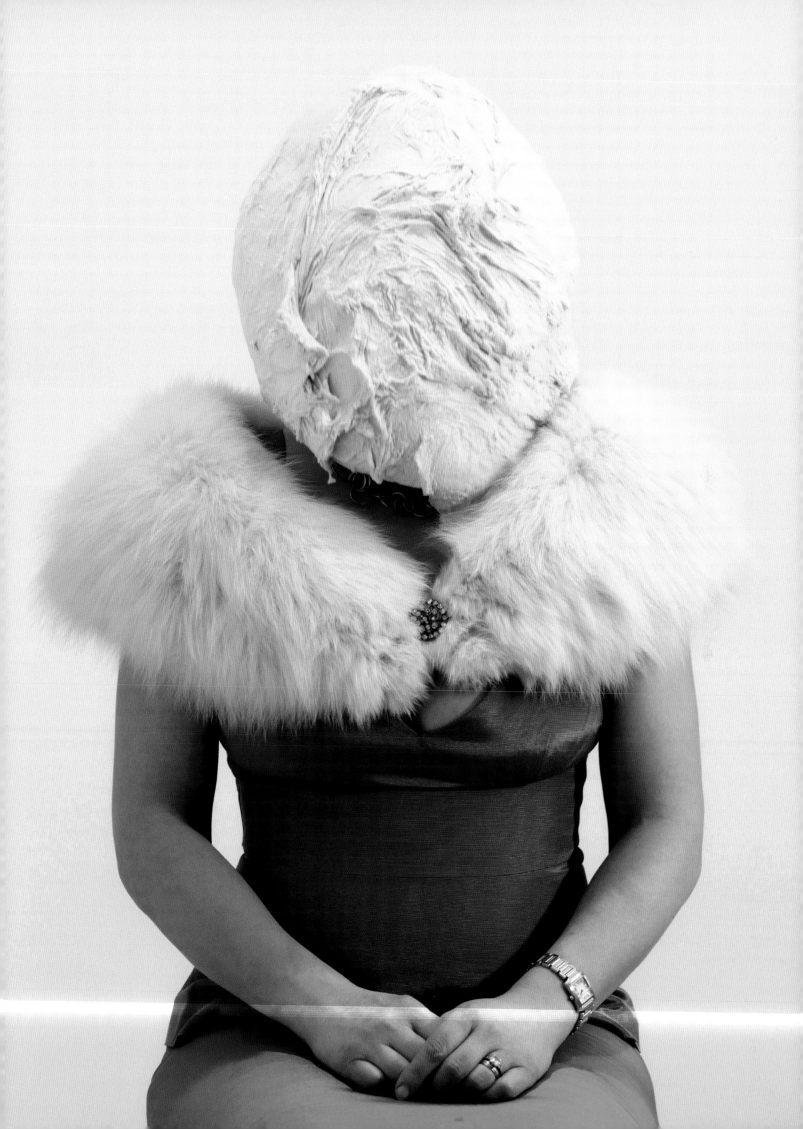

SCULPTURE AS PLAY

Søren Dahlgaard has said that we should think of his *Dough Portraits* as sculptural studies first and as photographs or videos second. Given the time-based actions involved, perhaps we should view them also as performative works. But while we might consider them as part of a long history and tradition of monumentalizing portraiture, they are portraits only in a negative sense – which is to say, they are negations of the representative portrait, with all its weighty connotations and heritage, a visual form that is unequivocally connected to power (the king's likeness) on the one hand and to control (the citizen's passport photograph) on the other.

RUNE GADE
ASSOCIATE PROFESSOR IN ART HISTORY,
UNIVERSITY OF COPENHAGEN

In Dahlgaard's *Dough Portraits*, every trace of recognizability is eliminated and the individual is buried in the liberating anonymity of the dough. The burden of representation is thus lifted from the shoulders of the subject, who no longer needs to worry about whether the portrait is successful or not. The sitter is *not seen*, and their invisibility is the whole point. The dough is a smooth mask that effectively hides the figure. This irony – the portrait's non-portrayal – elevates the dough works into a different dimension where this paradox is not central. Instead, it is the course of action that is paramount: the transformation from individual to type, from 'me' to 'dough', from recognizable to unrecognizable. Identity is no longer associated with the face but is confined to gesture, posture and attire. It is indeed an extended sculptural practice, one in which the subject is highly involved and active in the monumental erasure of their own identity.

The participants clearly find the whole process entertaining – and the humorous aspect of Dahlgaard's project cannot be overemphasized. But the comedy of the moment disguises a set of anxieties. The ten kilos of dough represent a concrete weight approximately twice that of a human head. In other words, the substance

bears down on the person beneath. The dough is heavy, but it is also sticky and alive, a tough, resilient mass sliding from the top of the head, pulled slowly but noticeably towards the ground by the force of gravity. The movement of the material – its gentle, unbroken fall – can be observed from outside, but it is *felt* from inside. From without, the migration of the dough is merely part of the sculptural action that Dahlgaard has intentionally set into motion; from within, inside the claustrophobic and suffocating darkness, its progress engenders both relief and panic. As the weight displaces itself from the head and neck, one begins to worry about where it is heading. Will it fall onto my skirt or trousers?

As a sculptural material, dough is characterized not only by its physical properties: another important dimension is its status as food. Because it can be baked and transformed into bread and other products, it is one of the world's most common foodstuffs, and in its different variants it is a staple food for billions of people all over the globe. When one uses dough as an artistic material, therefore, one invites reflections on the connection between food and art. For Dahlgaard, it is the light-hearted ludic qualities of both that dominate. He plays, so to speak, with his food, and gets his collaborators to play with theirs too. By doing so, he activates some of the first human impulses: the joy of handling food, not only feeling it with the lips and tongue, the cavity of the mouth and the taste buds, but also with the hands, with the fingers. Stir food, throw food, let it run down your mouth after you have chewed it thoroughly. If anything, the dough invites this excessive and childish game, the physical joy of burying fingers deep in the soft mass, kneading it, shaping it, becoming one with it. To allow oneself to be depicted as a dough head is part of a game that is precisely 'headless', and that thereby shifts the focus from the reflective to the prereflective, the body primate.

To enter into this lustful pact – an alliance between the portrayer and the portrayed – involves not only a surrender of identity, which

is erased momentarily, but also of sight, of which one is also temporarily deprived. As the subject sits there, overwhelmed by the slowly dribbling dough, she is for a brief moment *nobody* and *sees nothing*. To judge by people's reactions, this gives rise to mixed feelings: euphoria, enthusiasm, laughter, panic, embarrassment and unease. The portrayed individual is not the primary object of the evaluating and scrutinizing gaze of outside eyes, as those subjects in previous eras who sat in hours-long poses for painters must have felt. To the extent that one can talk about it being a portrayal at all, it is *the experience of being transformed* that lies at the heart of the dough portrait. But the transformation is more of an inner character than of an outer one. One accepts the blocking of vision, one accepts the elimination of physiognomy. In return, one gets an intense experience of a loss of self, an extra-thick skin that settles like an impenetrable casing around one's head, embraces one, as if one were being buried alive. A little death – perhaps precisely as orgasmic and wild as a sexual climax, which the French have, with their usual precision and subtlety, called *la petite mort*. But also a casing, a flexible sarcophagus, that one can embrace and try to shape, as so many of Dahlgaard's subjects do.

This is thus a new form of sculptural practice, one that converts the passive subject into an active participant: not only the protagonist who is portrayed, but also a collaborator in the portrayal. As Dahlgaard remarks, the contributors are the actual artists; he is just a producer of ideas and contexts. He makes it possible for everyone to realize his or her inner artist. At the same time, the dough is also active in the process. It is always the case that a material either creates a rebellious resistance or, with a particular cooperativeness, surrenders to the will and purpose of the artist. But the dough accentuates and dramatizes this facet of the artistic material in that it literally has its own life. It contains yeast and is thus a living material that changes shape, consistency and size, even if it is not manipulated or processed. The changeable form of the dough, its stretchability and elasticity,

its bulk and airiness, weight and flexibility, all combine to give it the character of an accelerated sculptural material – something that can barely be contained or fixed, but is destined to transform itself constantly into shapes over which there is little control or means of predicting.

This aspect of dough is something that Dahlgaard has investigated in other works related to these portraits, namely his time-based sculptural pieces with dough, such as *3 Hour Sculpture* and *12 Second Sculpture* (both 2006). The constant changeability of the material is a good reason to capture the process in photographic form and preserve it for posterity. In these works, one sees the element of temporality, which the dough itself determines. The artist has to act quickly, for the weight of the dough, its pull towards the floor, means that there is a limited window in which to operate. As sculptures, these works are thus delimited by time, having a beginning and a conclusion, like a short play. It may be wrong to call these pieces 'works' because in reality they are closer to 'play'. It is less a collaboration than a 'mutual game': artist and subject *play together*. The playful and experimental nature of the *Dough Portraits* is central to their potential as sculpture and as art.

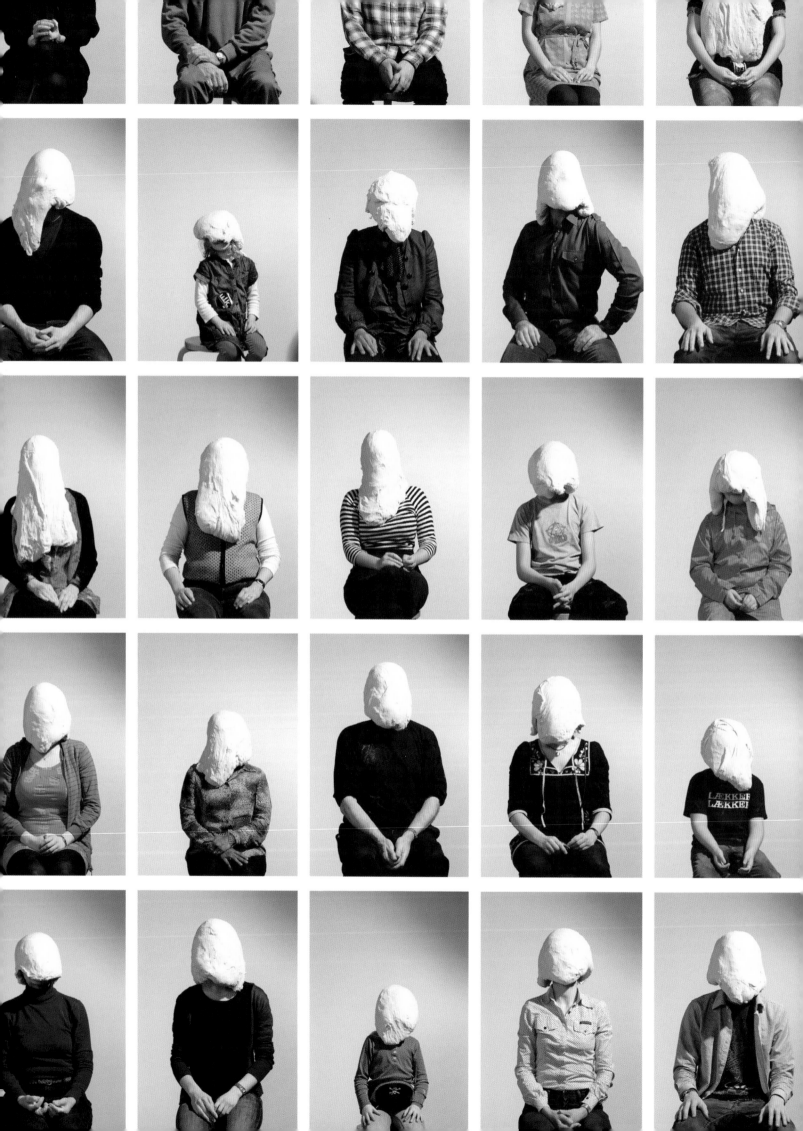

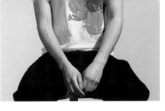
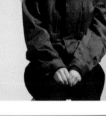
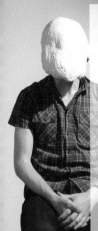
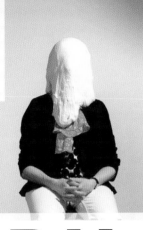
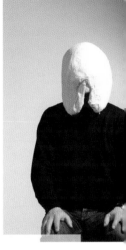

NATIONAL
GALLERY
OF DENMARK

YEAR **2008**
IMAGES **145**

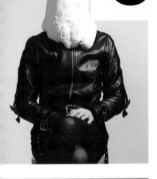
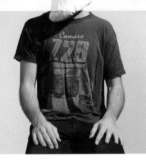
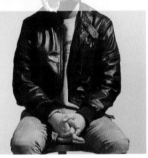
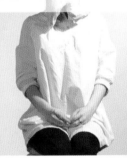
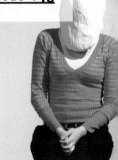
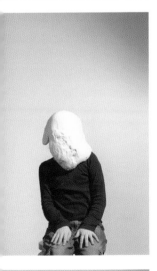
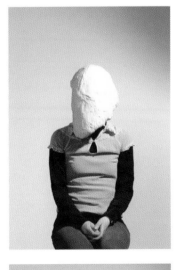
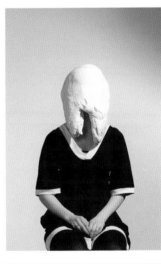
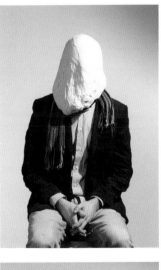
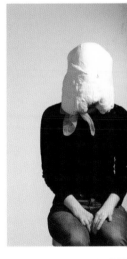
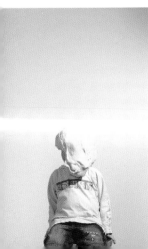
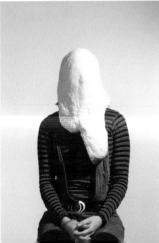
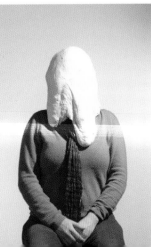
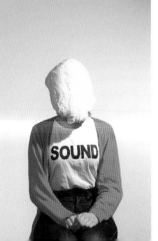
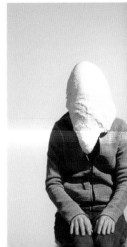

THE CURIOUS MATTER OF DOUGH

Søren Dahlgaard
Billedkunstner

Ten kilos of dough on my head. It really is a bit odd. And crazy. Will it get stuck in my hair and clothes? Will I be able to breathe? I'm not really very happy about the situation, but the dough isn't sticky. It is dry, soft and heavy. I shape it into a flat mass and sit down. The light from the photo lamps hurts my eyes, and it is difficult to get comfortable. It is now or never. 'Am I doing it right?', I wonder, as I sit down on the chair and lay the dough over my hair and face. It weighs heavily, and I sit up straight to maintain some sort of dignity. I am in a room full of people, all of whom are looking at me. Søren Dahlgaard is sitting behind the camera, ready to capture the moment in a portrait. The mood is light, but with an undercurrent of anxiety. What have I said yes to? I have never done anything like this before. When the dough surrounds my face, something unexpected happens: I feel calm. There is laughter in the distance, but it has got nothing to do with me, even though I know that they are laughing at me. I am protected. At this moment, there is only me. I have disappeared, but I am intensely present at the same time.

JUDI LUND FINDERUP
ART EDUCATOR AND EDITOR,
NATIONAL GALLERY OF DENMARK

It is Saturday 8 March 2008, and *Dough Portraits* at the National Gallery of Denmark is under way. There is a good atmosphere in the museum, which is buzzing with life. People of all ages stand in a queue and wait their turn. A lot of them want to have a look before they sign up. Most just have to go over and touch the dough. One can follow what is happening in front of the camera on some large screens. I am fascinated to watch people just before they have their portraits taken, sitting there with a name tag and transparent plastic hats on their heads. You suddenly understand why Dahlgaard talks about the collaboration and process in the work. There can be no doubt that you are part of it when you are there in the room. You are creating the work together with everyone else who is present.

Where is the work? Who is the artist?

The finished portraits do not constitute the work alone. The collaborative actions are also very much part of it. Dahlgaard may have started the project long before he met his first subjects, but it developed with their input, which the artist positively welcomes: 'The process from initial concept to final result is what I think is most interesting. I like to discuss my ideas with other people, and alter them if something is better. I am not fixed in my views. All for the sake of the project ...', he says. He has also got a very clear attitude about who the artist is: 'Every portrait is a tiny work of art created in collaboration between the model and me. I have got the idea, the dogma, and am the director, but what happens thereafter is created by the individual participant. Nineteen-year-old Nils or sixty-one-year-old Karen have shaped the dough themselves, chosen what clothes they wear and how they sit on the chair. They are co-creators. That is also the reason why they must sign the prints they can buy.'

 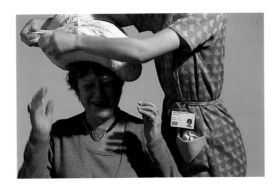 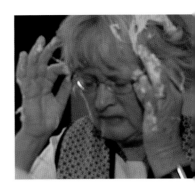

Why dough?

In his artworks, Dahlgaard transforms everyday objects because he believes that an unusual encounter with familiar things makes us see them in a new way. In the *Dough Portraits*, an absurd meeting arises between two well-known components: portrait photographs and dough. Most people have had their portrait taken in some shape or other: a snapshot, a strip in a photo booth, or a class picture at school, where you do not know whether to smile or not. You pose a little bit. Most people also know about dough. 'Dough and bread are universal', Dahlgaard explains. 'They are things we can all relate to. We know how it is made, how it feels to touch it, but when it appears in art, it can be difficult to place. It wakes people's curiosity.'

Where did identity go?

For Henrik Holm, senior research curator at the National Gallery of Denmark, this curiosity opens up a field of tension in the *Dough Portraits* that is about identity. Researchers in the field of neuroscience study how people read each other, and the most important way we do so is by interpreting the face. One of the first things we recognize when we are born are faces. The many facial muscles can reveal whether what someone is saying accords with what they really mean. The decoding of faces is thus vital for our survival: is this person acting in good faith? am I in danger? can I trust him or her? But what do we do when confronted with the *Dough Portraits*, where the face has gone and we can see only the body, first name and, sometimes, the age? Our decoding apparatus is disabled, which is both disturbing and stimulating. Perhaps that is where the portraits become interesting? They tease both us and our social nature. We try to decode the person in the picture and create an entity from the scant information that we have.

When there is dough in front of the face, then we begin to look at the shape and texture of the material, the traces of fingers, and we are more observant of other parts of the person – the hands and the body language. Are the shoulders tense? Are they relaxed? What do the clothes tell us about the person? The position of the hands? The angle of the head?

During the session at the National Gallery, art student Martin Frederik Kragh and I looked at an earlier portrait he had sat for, while he picked the dough off his fingers from a second one he had just come from. In the photo, he was wearing a white shirt, claret-coloured tie and dark trousers with braces. He thinks the image says a lot about who he is, but at the same time it contains a new identity: 'I am an evil 1930s villain – an evil printer with a shady sideline: that's cool! But I am also very much present myself, because of the clothes, which are what I normally have on.' But there is also something else which betrays him. His attention was drawn to it by his grandfather. The portrait was printed in the daily newspaper *Politiken*, and he asked his grandmother to save that day's issue for him. She told him he must have been mistaken, because he was not in the paper. 'Oh yes he is!' said his grandfather loudly in the background. 'He is on page 2. Anybody can see that by his hands. He is picking at them – it is a family weakness!' Martin Frederik is pleased with the portrait because it shows him as he is: 'Many times when pictures are taken, you are red in the face and look weird. When my face is hidden, I am the master of how I look.'

TV Avisen, the flagship news programme of Danish state broadcaster DR1, reports live from the *Dough Portraits* project at the National Gallery of Denmark, March 2008.

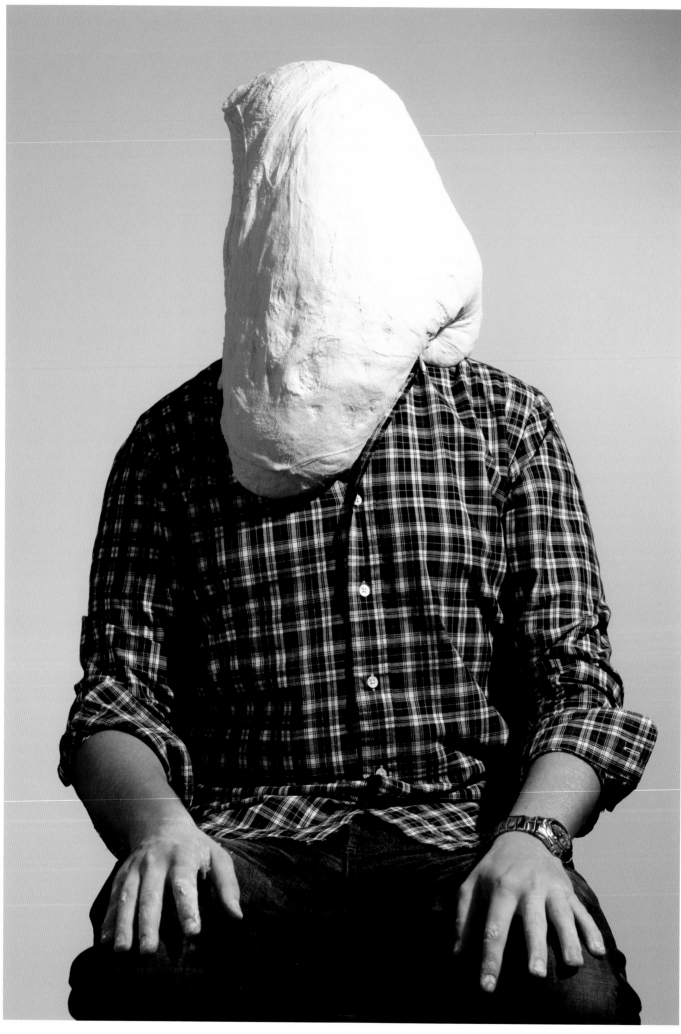

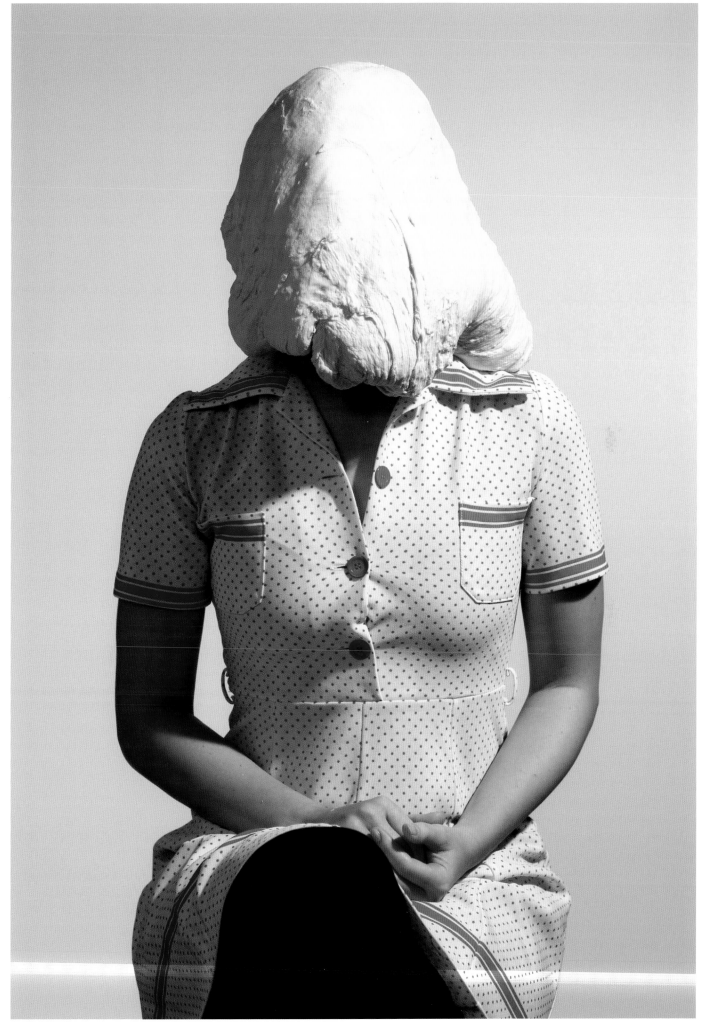

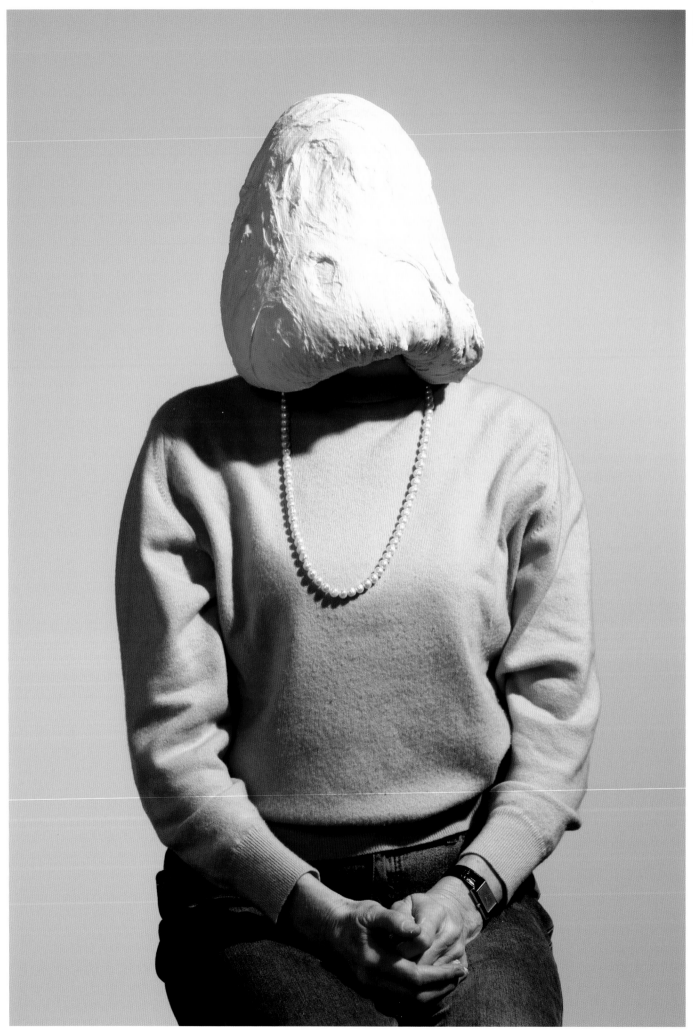

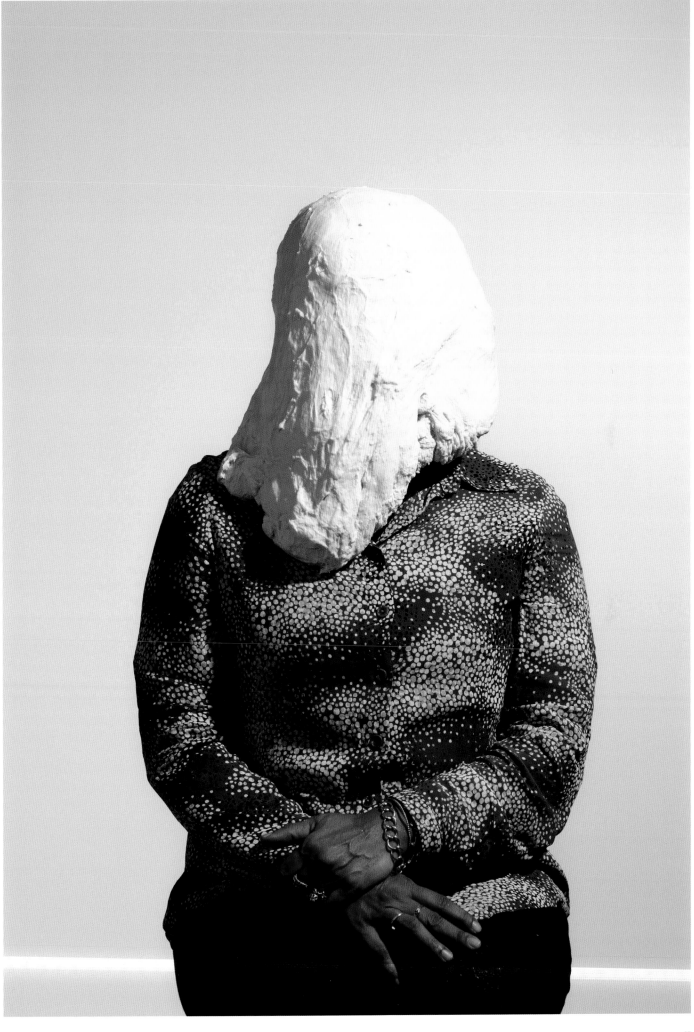

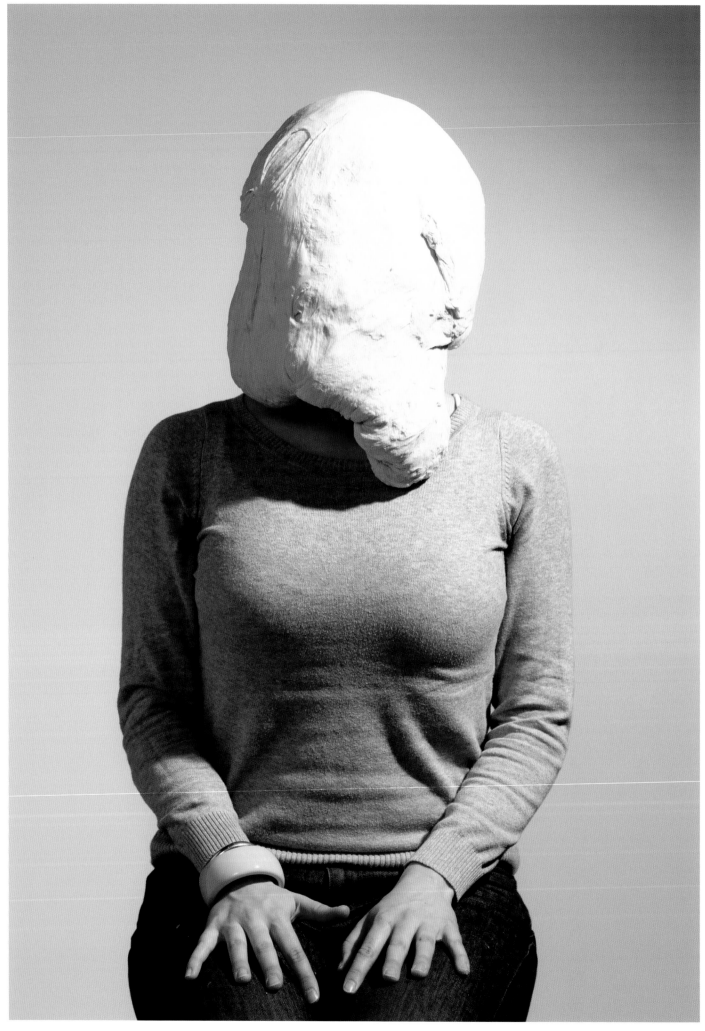

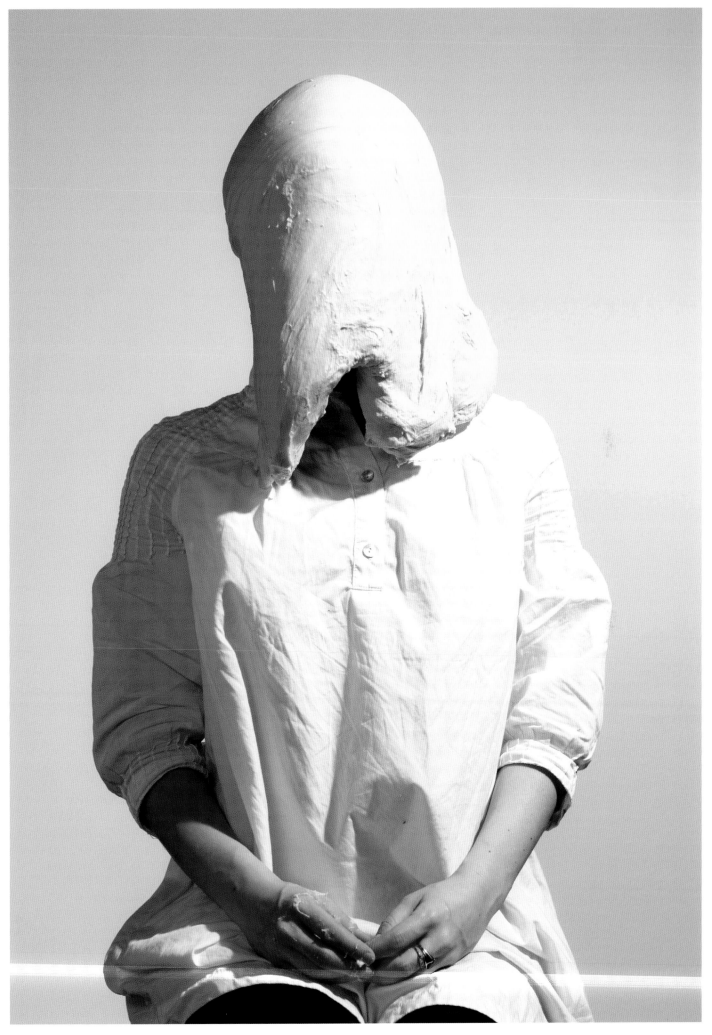

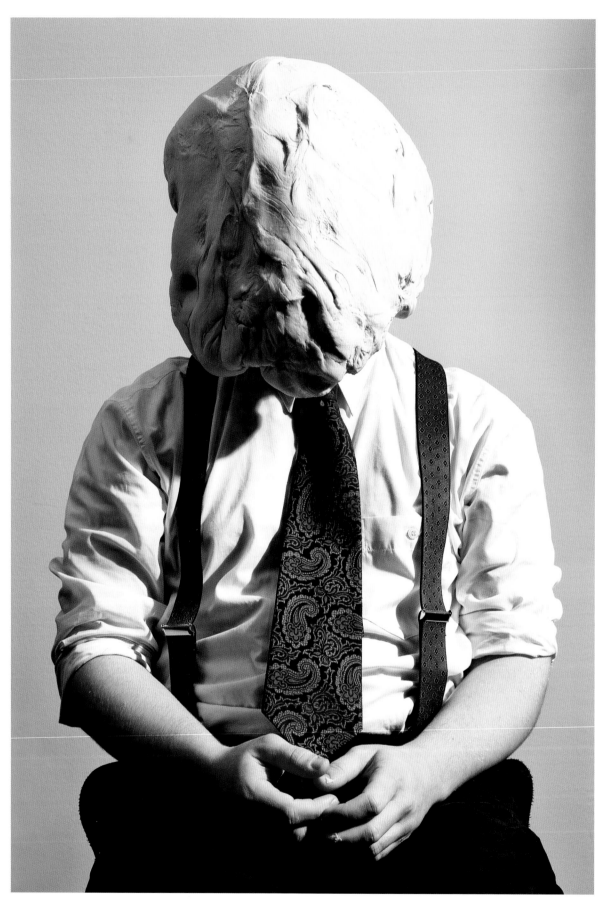

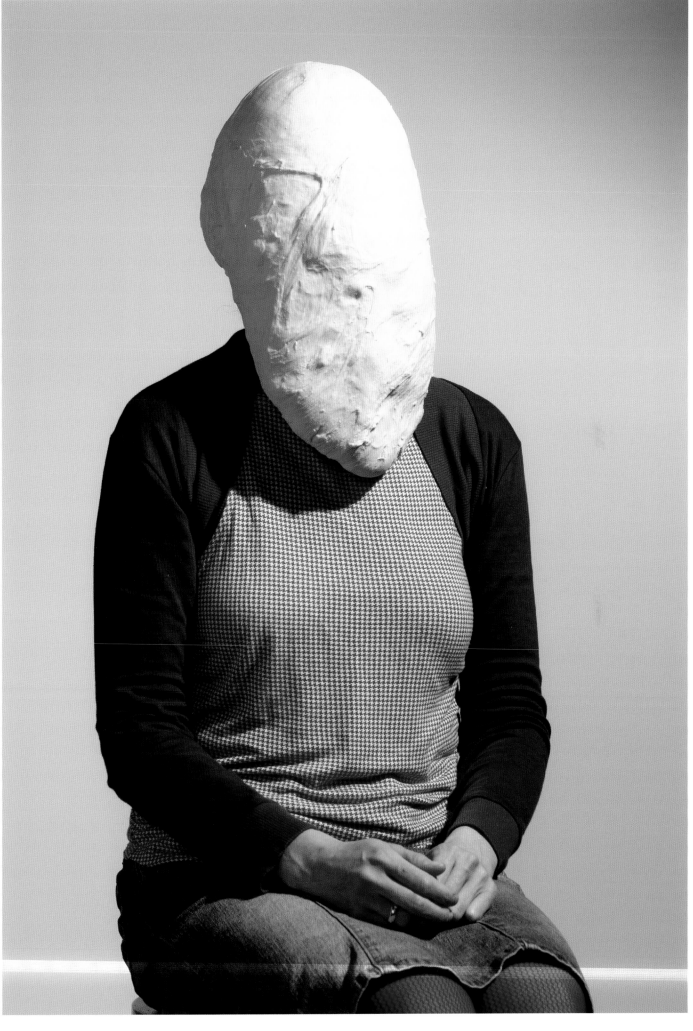

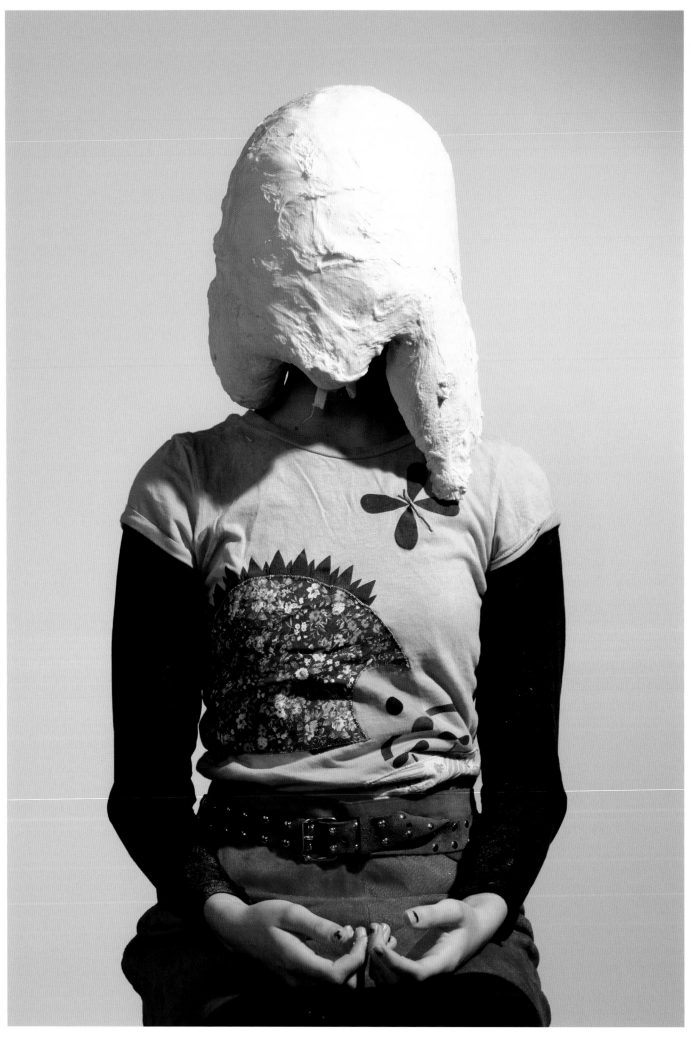

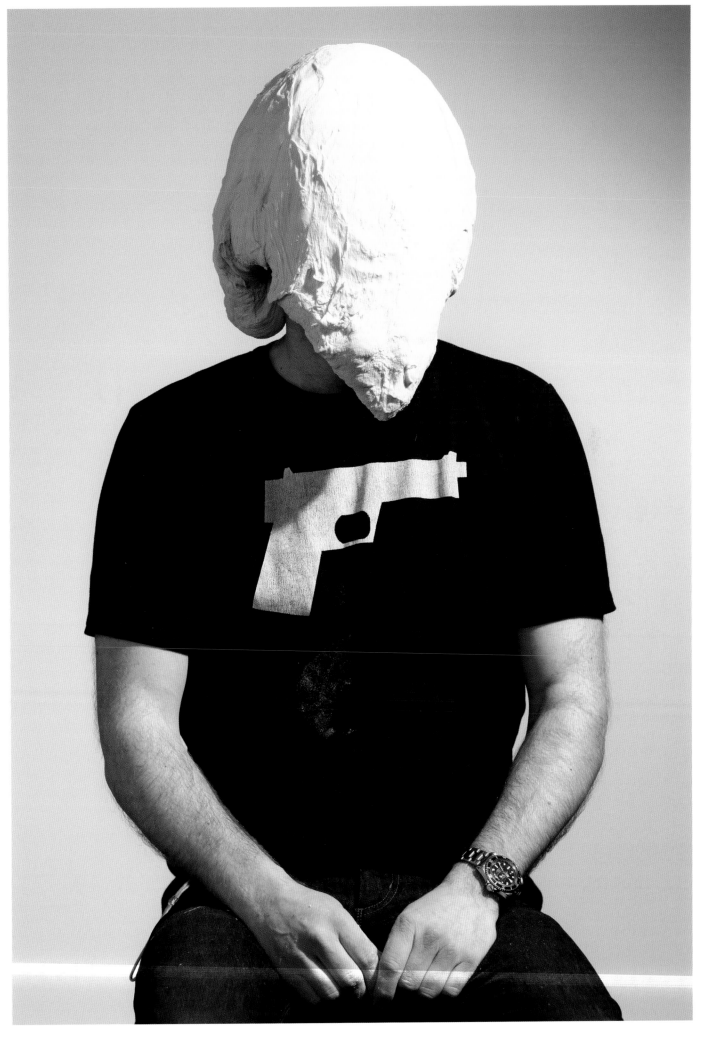

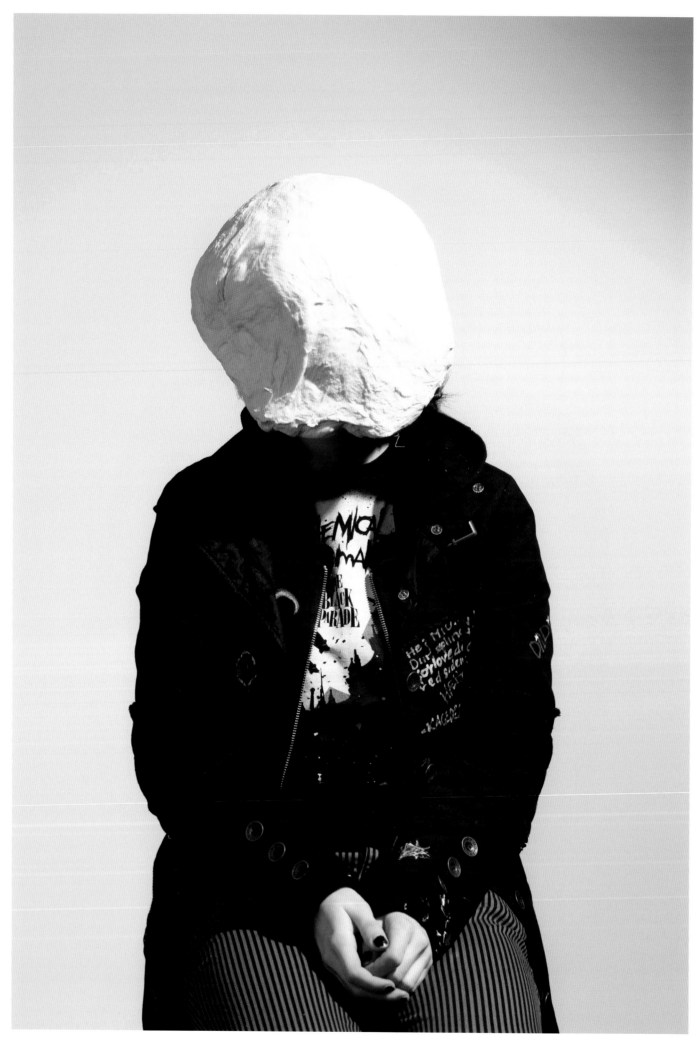

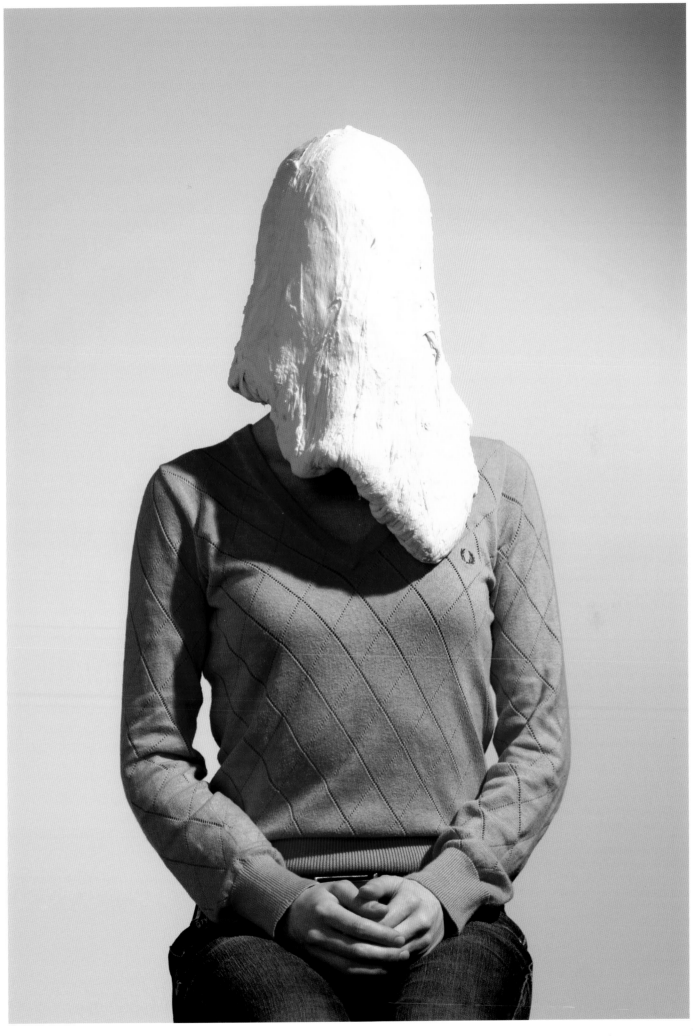

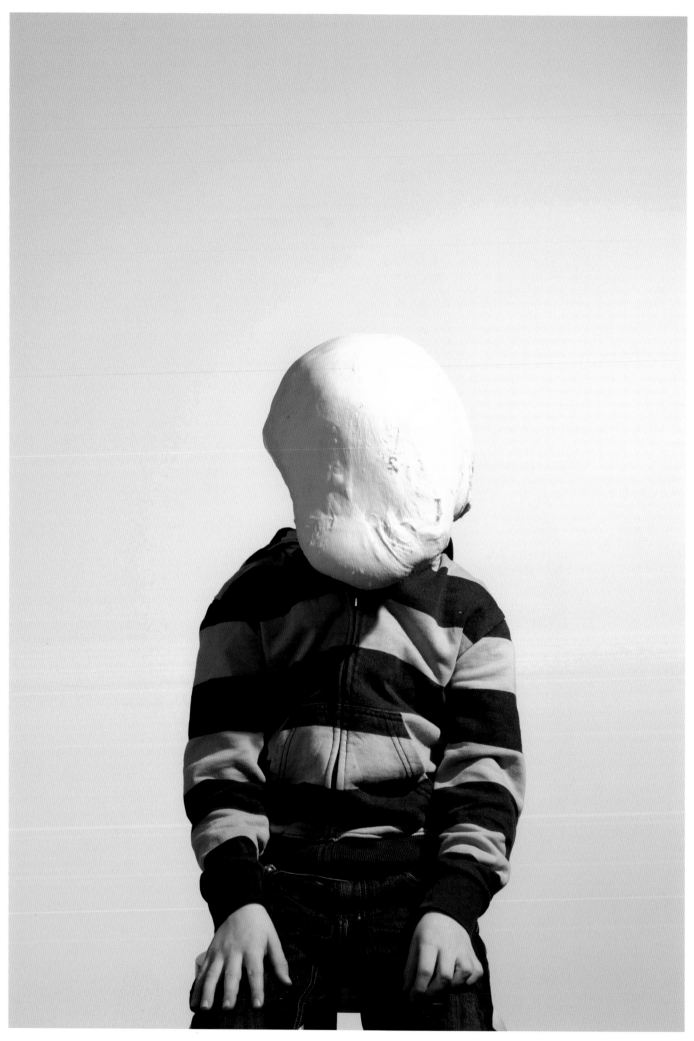

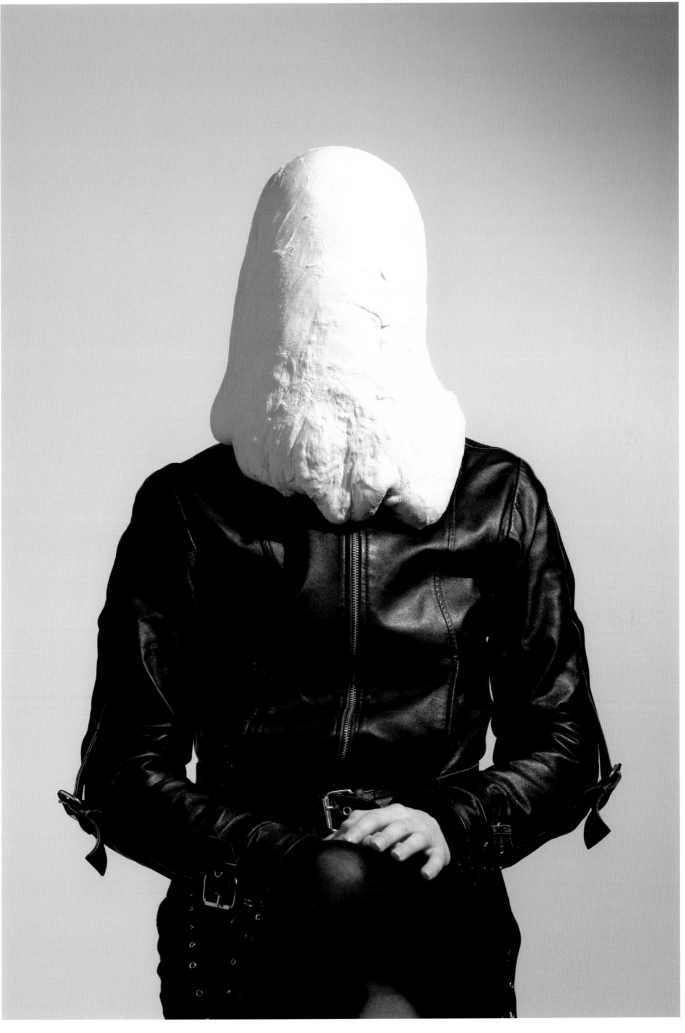

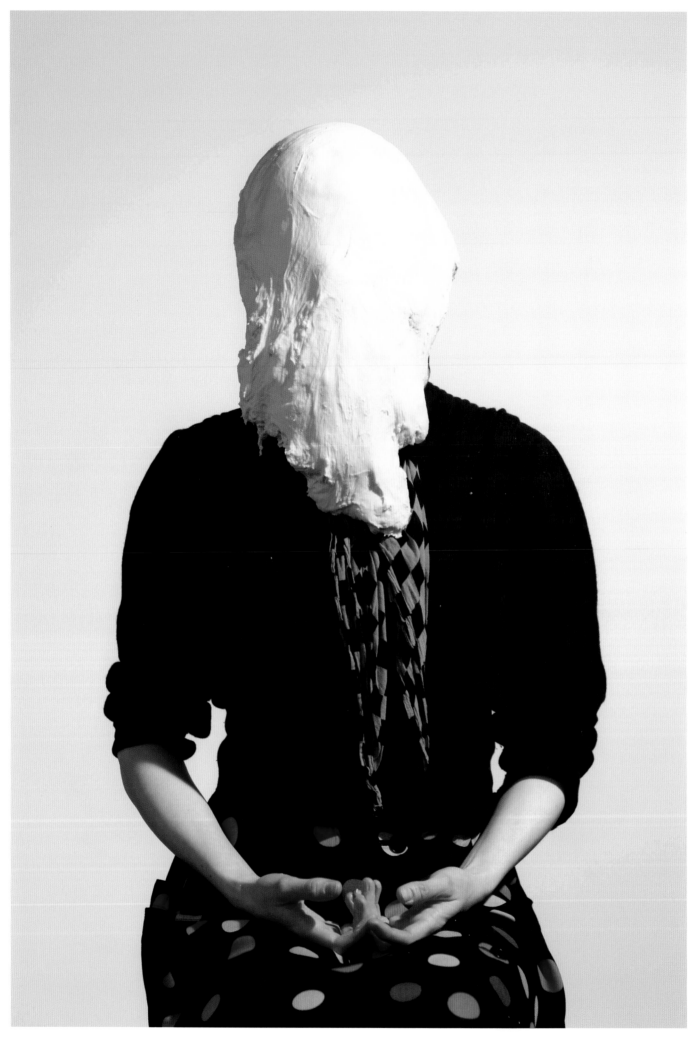

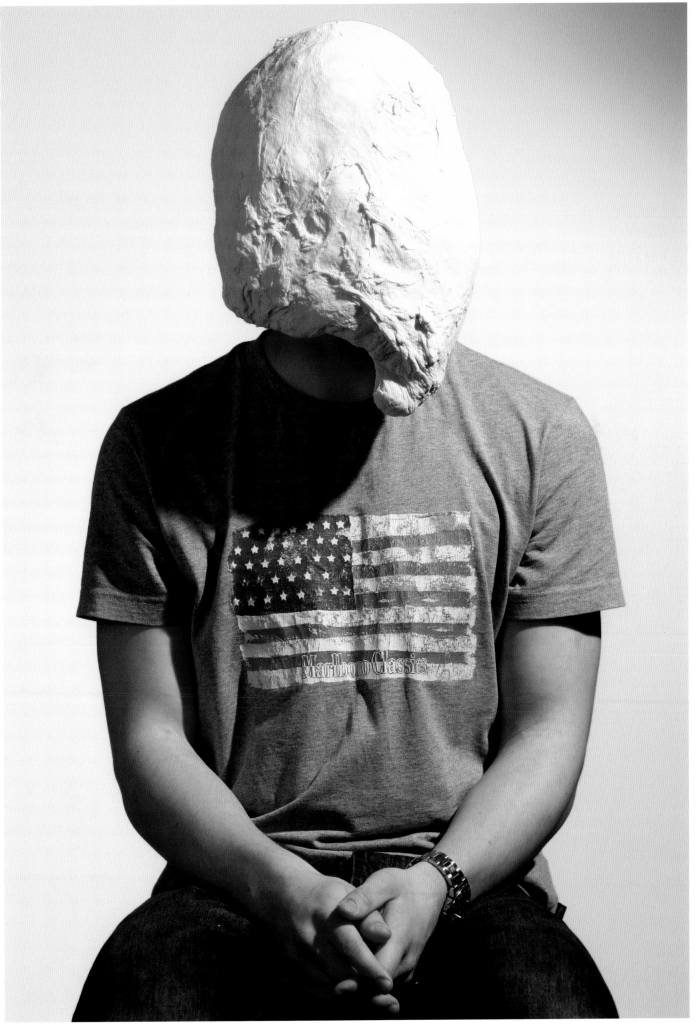

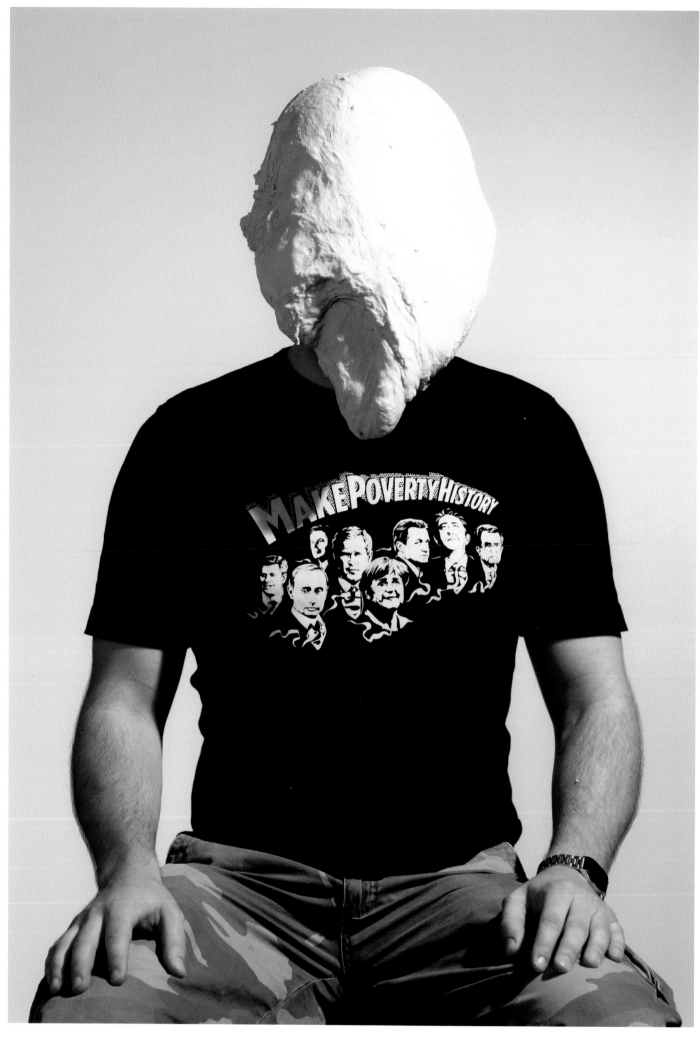

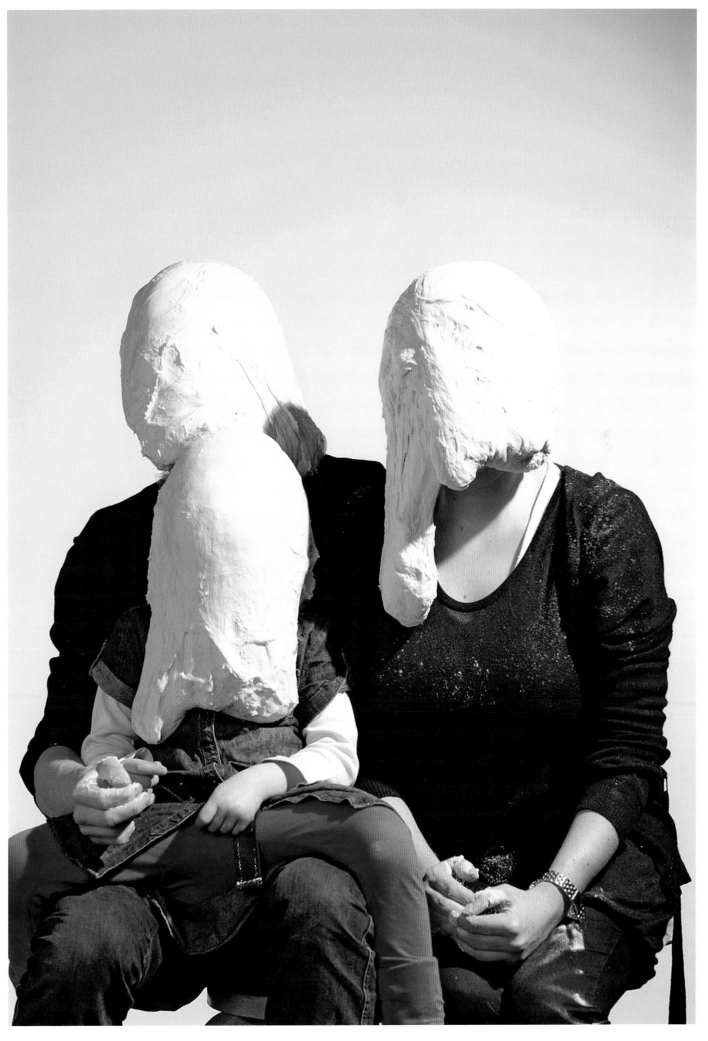

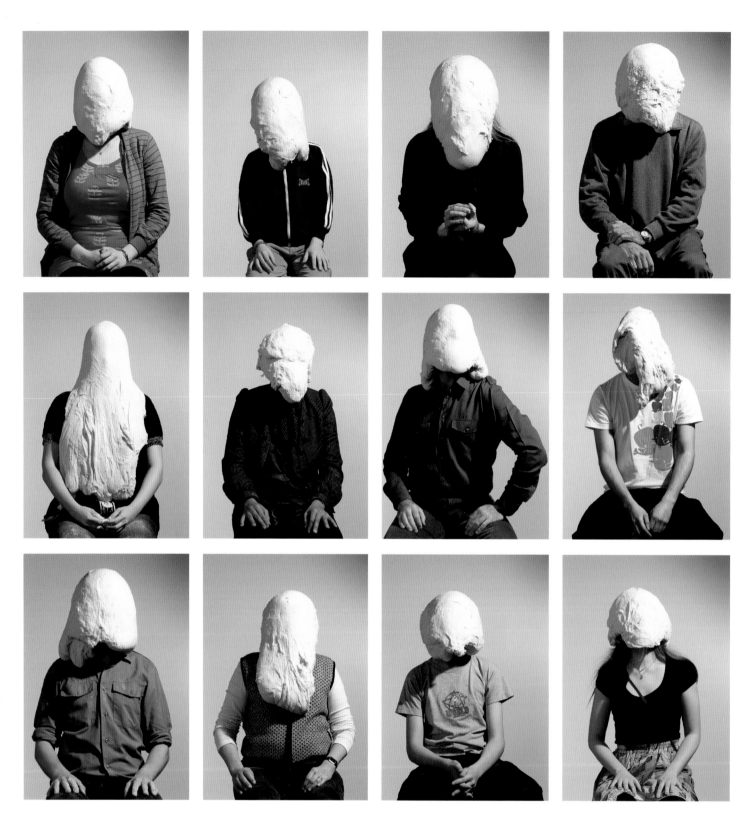

MARIE, 25; AUGUST, 9; ANETTE, 38; FRANK, 61
NANA, 34; JOSEPHINE, 36; ADRIAN, 43; ANTON, 23
PETER, 23; KIRSTEN, 61; SVEND, 15; MILLE, 20

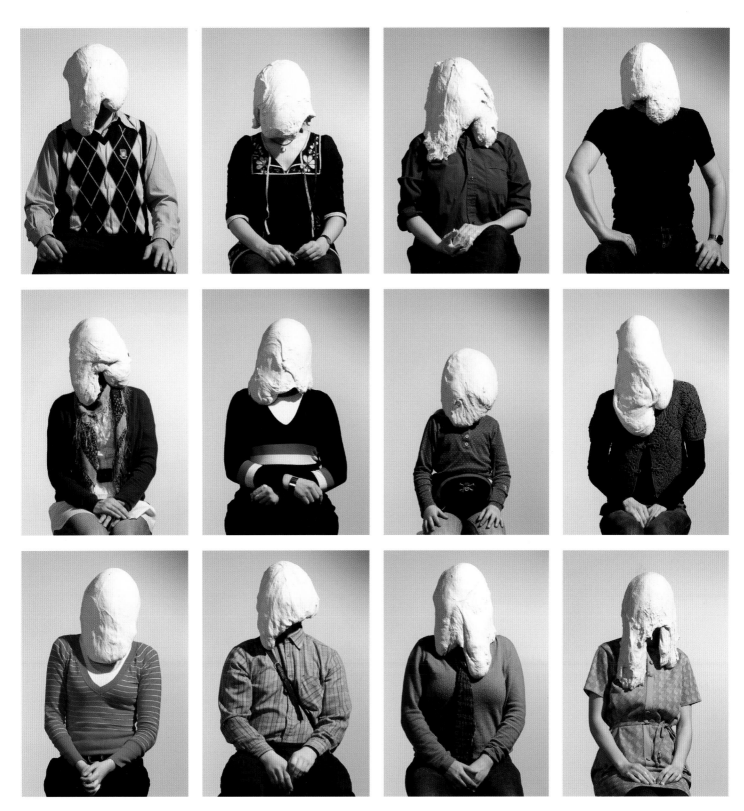

FASSI, 33; NETE, 39; MALENE, 28; FRID, 34
EVA, 32; MARIANNE, 47; ELLEN, 7; METTE, 34
PANDITA, 22; MARTIN FREDERIK, 18; JULIE, 43; IDA, 17

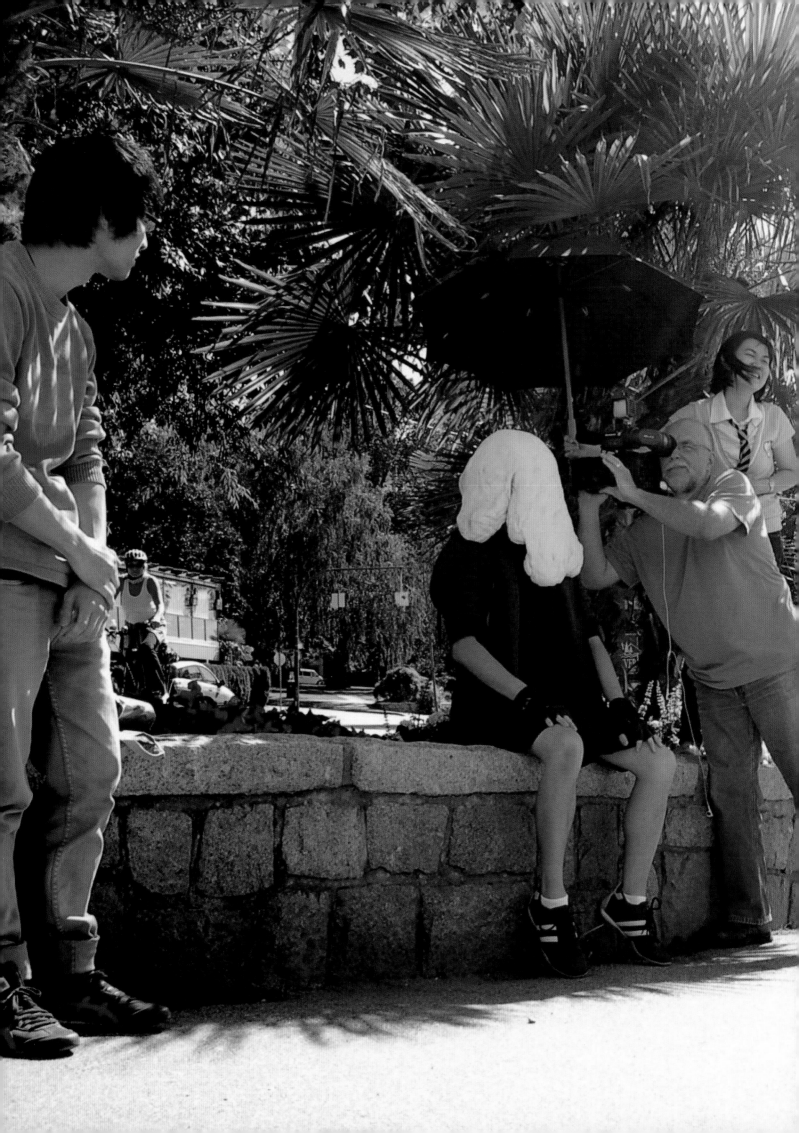

VANCOUVER BIENNALE

YEAR **2010**
IMAGES **75**

ART IN PUBLIC SPACE

The mandate of the Vancouver Biennale is to transform the urban landscape into an 'open air museum', creating fully accessible and globally inspired cultural experiences in places where people live, work, play and travel. Vancouver is known as a beautiful city with an outdoor recreational lifestyle, and it is consistently rated as one of the top three most liveable cities in the world. Additionally, it is a very multicultural place. With each exhibition, the Biennale's focus is to bring international, museum-quality art to public spaces in metropolitan Vancouver as a means to generate dialogue and discussion within the community. Søren Dahlgaard's *Dough Portraits* was one of sixty interactive urban interventions by several of the world's most celebrated senior artists and rising stars that embraced this spirit of the Biennale and the very idea of a museum of art in the open air.

BARRIE MOWATT
PRESIDENT AND ARTISTIC DIRECTOR,
VANCOUVER BIENNALE

Dough Portraits was selected for the 2009–11 Vancouver Biennale because it provided a unique opportunity for breaking down barriers between the artwork and the audience that normally exist in a fine-art setting. This was the first time that Søren had created the portraits outdoors, and he chose the English Bay Beach setting as the quintessential Vancouver backdrop. Only one hundred years earlier, English Bay had been the home of a towering first-growth forest and summer settlement for several First Nation tribes that was several centuries old. The wilderness, solitude and majesty of this bay has long been replaced by urbanization. Today, English Bay Beach is not only the southernmost boundary of the highest-density population in Canada, it is also the edge of a city of high-rise towers – a city within a city. Where once there was a pristine beach easily accessible by all, now there is a five-kilometre stretch of seawall with bicycle and walking paths that extend around downtown Vancouver, giving access only at certain intervals to the sandy beach and the ocean beyond. It was at one of these access points that Søren intervened in the neighbourhood to create his dough portraits.

Over the course of five days in September 2010, the artist and several volunteers coaxed, nudged, enticed and invited more than sixty people along the beach to take part in making the work. Although the portraits are 'faceless', they represent a diversity of individuals from different age groups, ethnicities and cultural and professional backgrounds who took time out from their work, walk, cycling, skateboarding, jogging, volleyball game, photography, people-watching, lunch or fitness routine to participate. Because

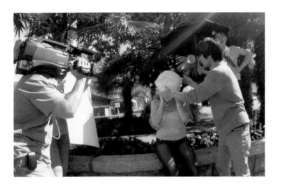
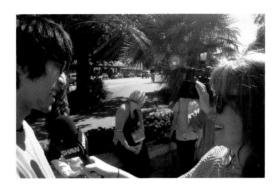
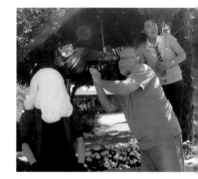

of his choice of location, Søren was able to capture the essence of Vancouver and its citizens' preoccupation with the outdoors and exercise. His interaction with each participant through the kneading of the dough and the framing of the image stimulated many conversations about identity on an individual basis. It also initiated a dialogue about society and a city going through much transition as a result of its geographical proximity to Asia and the United States, and its prominence as an open and receptive 'lifestyle city' in which tourism and immigration have become its most visible images. In this way, the *Dough Portraits* project not only engaged the community and neighbourhood in an art intervention, but also generated a debate that inspired the creation of a curricular unit for the Biennale's Big Ideas education programme. As a result, ninety-seven classrooms in nine Vancouver school districts implemented the Biennale's enquiry-based learning approach, with the *Dough Portraits* being the catalyst for discussion and dialogue on topics such as racism, immigration, beauty and gender. The dough head represents an identity in transition. People from all cultures can relate to identity. Dahlgaard asks his audience to question their own perceptions. What judgments would you form about someone if you were not given the opportunity to see his or her face or ethnicity?

In May 2011, the Biennale covered advertising hoardings and bus shelters across downtown Vancouver with one thousand commercially printed posters of the *Dough Portraits*. It was part of a guerrilla street campaign to bring the project back into public consciousness and to encourage, if only subliminally, further discussion. The

exhibition of the portraits in this context contrasts with that of other venues that have showcased the images as fine-art prints within enclosed and controlled spaces. This public campaign was a statement not only about the Biennale's role in making art accessible in public spaces – literally taking art to the streets – but also about the artist's commitment to engaging individuals and the community in a dialogue about our shared humanity, while reflecting on the existing dichotomy of high and low art. From my perspective, *Dough Portraits* is a public-art intervention that does what art is meant to do: it stimulates the senses and tickles the brain, generating thought and insight beyond the moment of viewing and engagement.

With thanks to Ammar Mahimwalla for his contributions to this text.

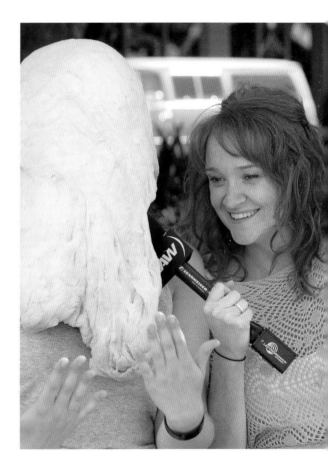

Popular Vancouver TV presenter Erin Shaw interviews volunteer Jay about the process of creating a dough portrait (top), but she is also keen to hear what it feels like direct from a participant at English Bay Beach.

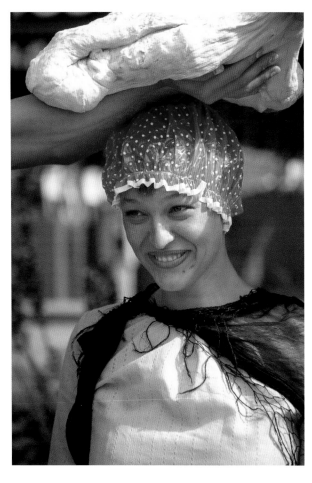

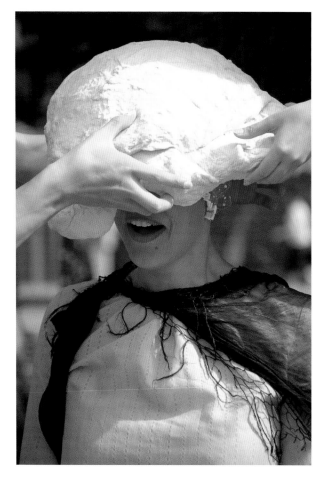

Some of the earlier Vancouver portraits, like this one of Cherie, were made at a spot on Beach Avenue looking onto English Bay Beach and out across the bay, but the team soon moved onto the beach itself.

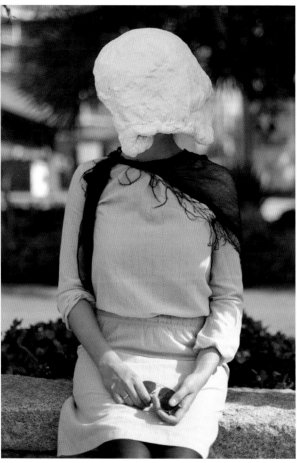

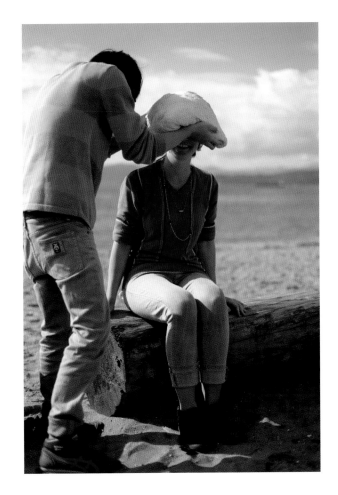

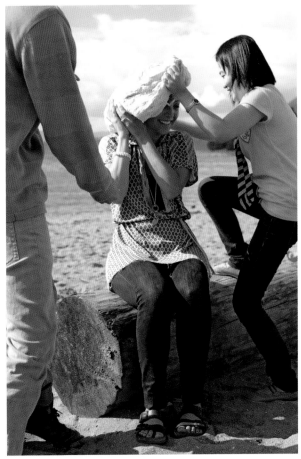

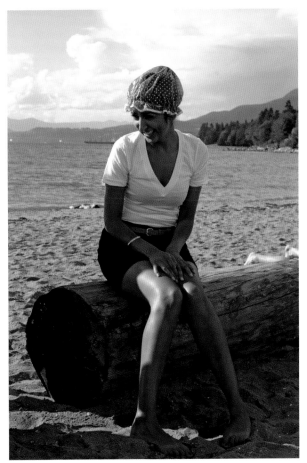

With the help of volunteers Jay and Peggy, Ellie (top left), Erica (top right) and Prit (right) get ready for their big moment on the beach with English Bay as the backdrop.

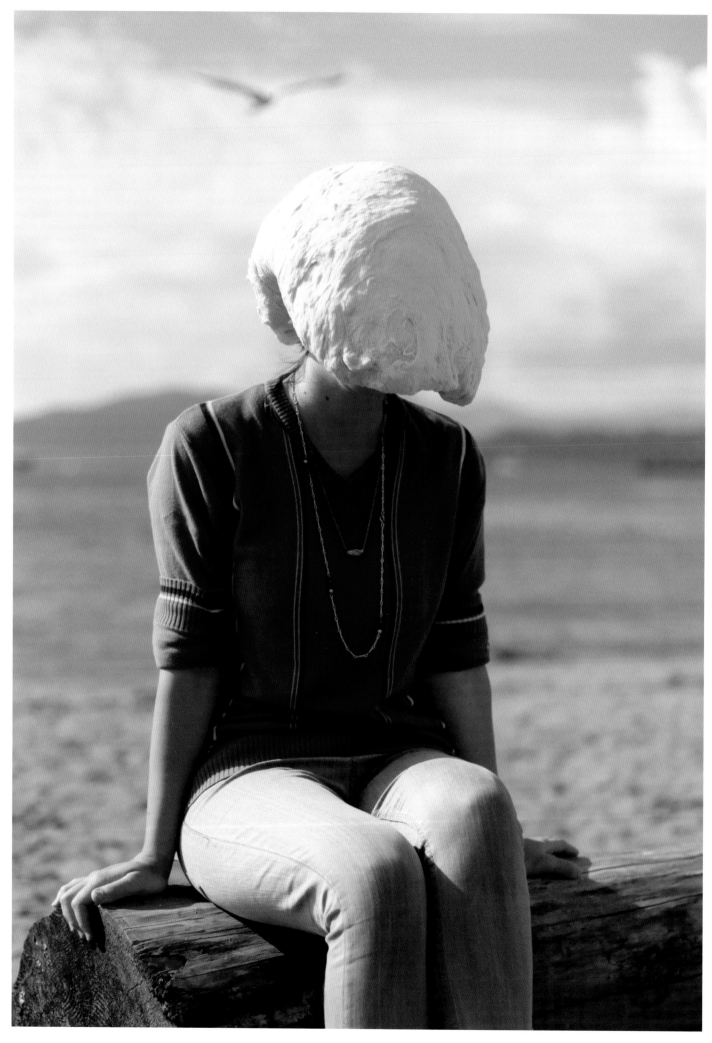

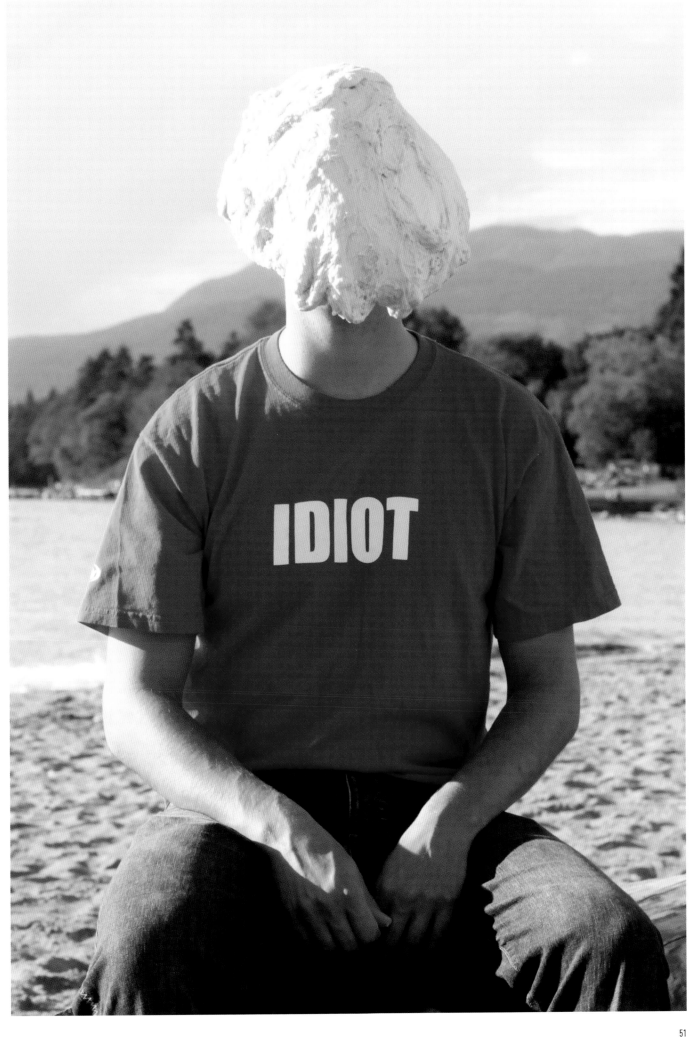

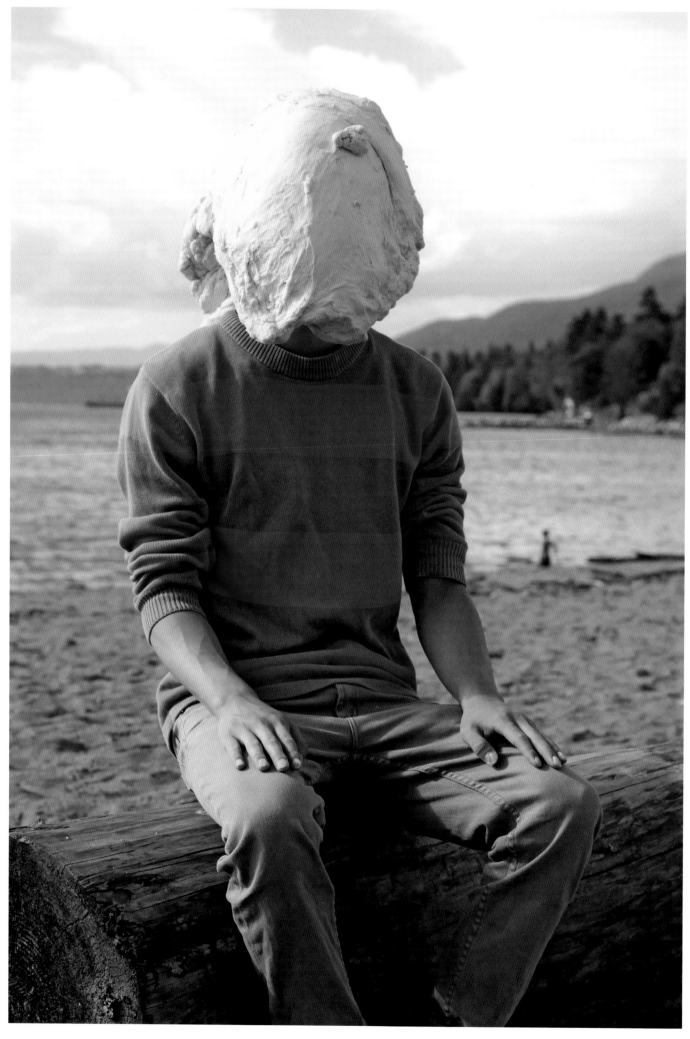

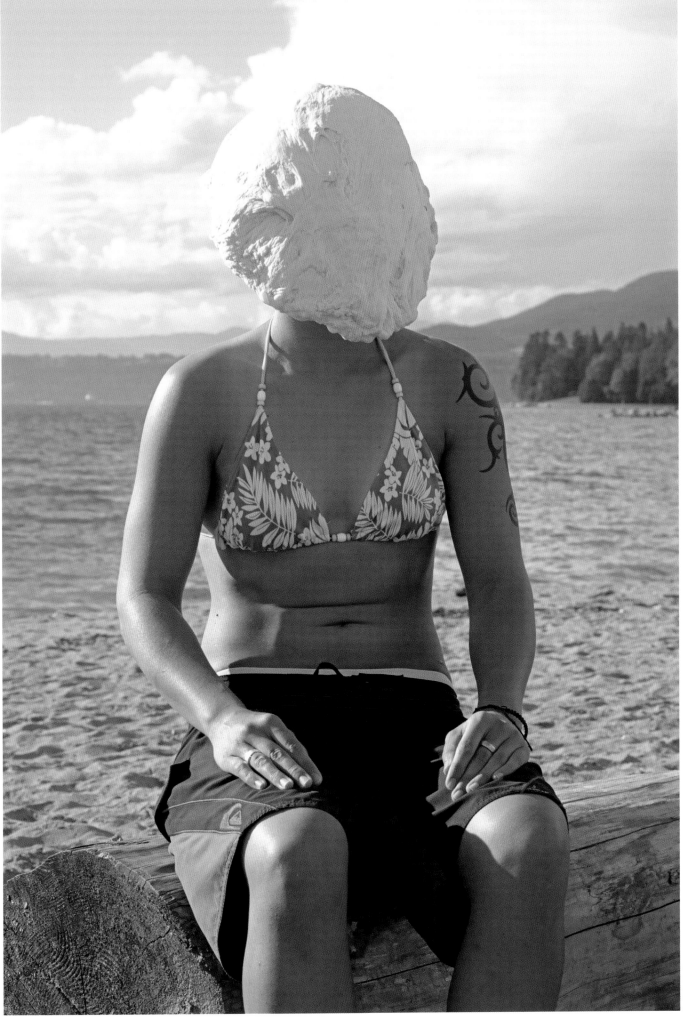

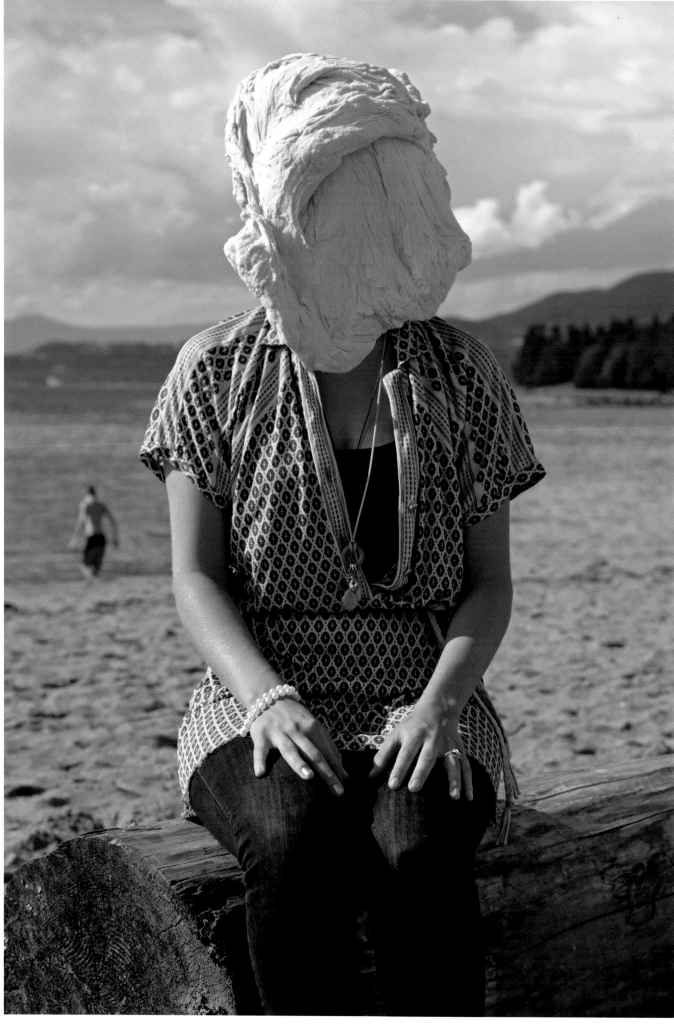

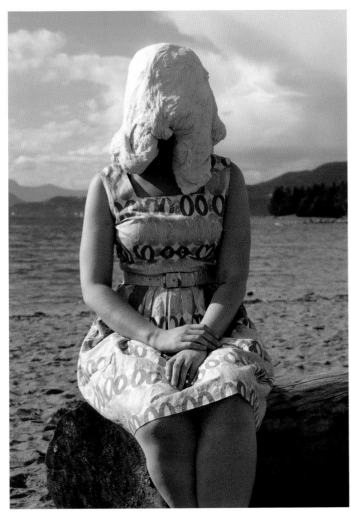
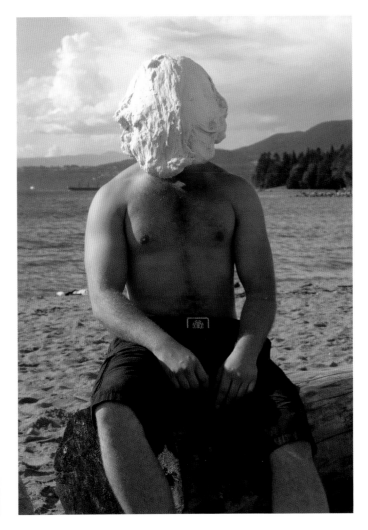

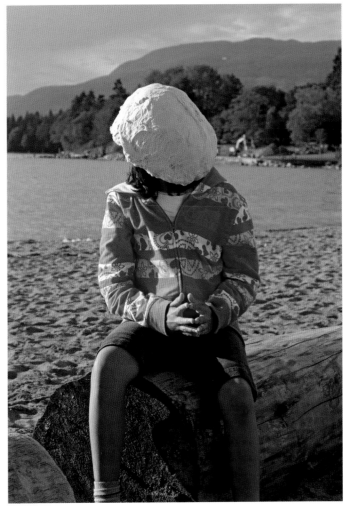

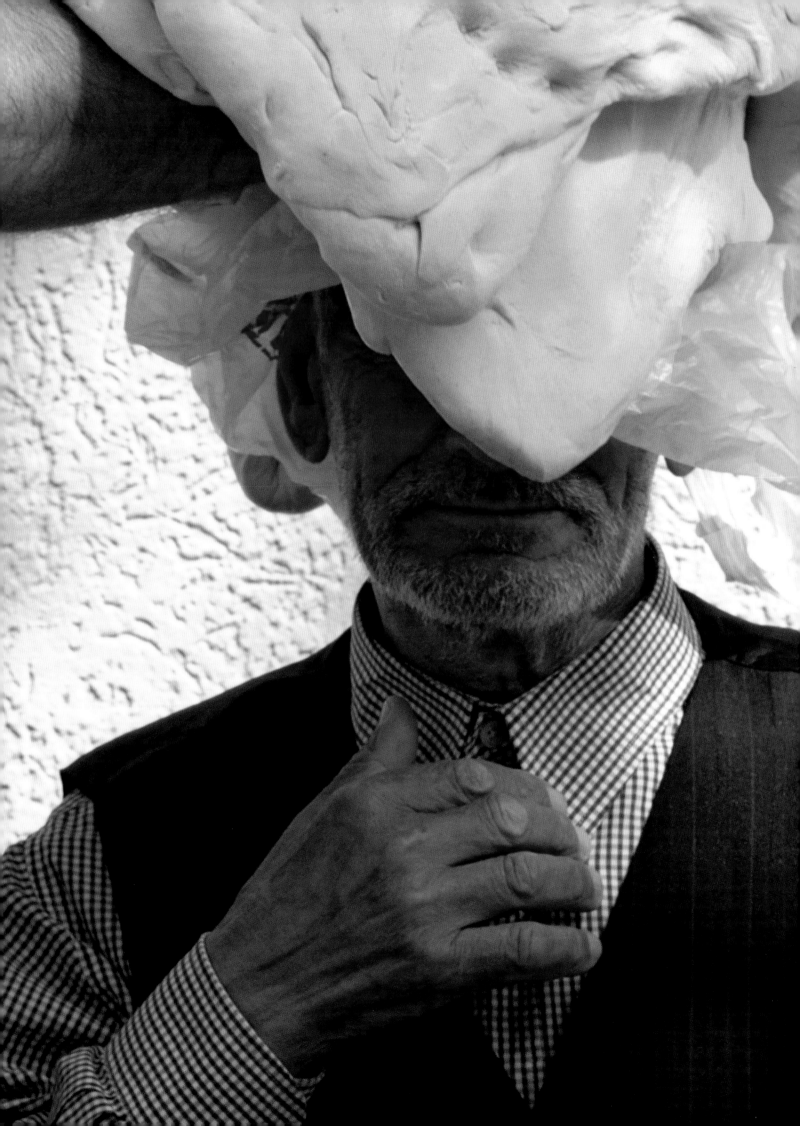

NATIONAL ART GALLERY OF KOSOVO

YEAR **2010**
IMAGES **42**

AN IDEA IS A FORCE OF NATURE, IF IT ARISES IN ITS ORIGINAL SHAPE

Søren Dahlgaard's *Dough Portraits* are special and idiosyncratic artworks. The excitement that the images generate when they are exhibited, the reactions people have to them, and even the visitors who come to see them are different everywhere. They are accepted, interpreted and commented upon in a variety of ways, and they provoke a wide range of emotions. All of these diverse responses come about for myriad reasons. But essentially, they can be split into two groups or sets of opinion, which occasionally, and again for a number of reasons, get in each other's way.

RAFET JONUZI
HEAD CURATOR, KU(RZ)NSTHALLE,
GRAZ, AUSTRIA

Both of these groups of people tend to be very surprised and, at the same time, fascinated by such a simple idea. But beyond that reactions diverge – one might say that what occurs is a schism. One group sticks with the simplicity of the idea and views it as a great-thought-turned-into-a-work-of-art, the physical and spiritual transformation of one identity into another or into several others. The other group has a problem with the material used in the technical realization of this idea – to wit, the dough. These people say that, for a good many reasons, dough should not be used as a plaything. People in the English-speaking world – where Play-Doh can be encountered in just about every kindergarten – may marvel at such European qualms. Then again, all of Europe has managed to shed the barbaric practice of capital punishment, which is still routinely applied in the United States. So who is to judge what is backwardness?

For those of us who prepared the *Dough Portraits* project in three separate locations in Pristina – in my family's private garden, in a school, and in front of the Galeria e Arteve e Kosovës (National Art Gallery of Kosovo) – these two sets of opinion were very clearly discernible. The adults had several reasons for their reactions, based on religion, television and everyday life. In contrast, the schoolchildren could be seen to have a lot of fun – and they were evidently fascinated. They were excited and restless, keenly expecting the moment when they could put the dough on their heads and experience the most peculiar and weirdest feeling that they had ever had. The kids' fascination increased even more once they took off the dough. Their astonished gazes reflected the same amazement as if they had just completed a round-the-world trip, and they talked to one another about a feeling that none of them had known previously.

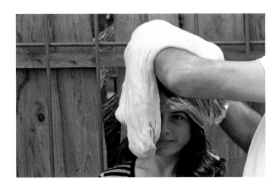 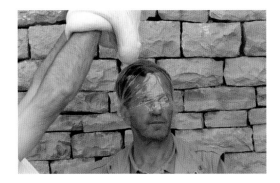 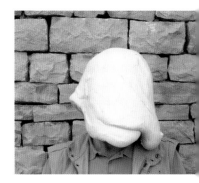

All of them spoke at the same time, as if they were going to relate something about another 'self' they had encountered. There were also other people present, both in my family garden and at the Gallery, who did not want to try the dough treatment, but nonetheless one could see in their eyes the curiosity burning, and it made the gleam in their faces shine even more intensely!

From that moment on, the world is a changed place. If all the people were speaking one and the same language, if they all had the same skin colour, the same education, what would they be speaking about? Would they know the word 'race'? Would the word 'negro' even exist? Would classifications such as 'Albanian', 'Korean' or 'English' be viewed as absurd? We could write out a list of questions regarding all these things as long as the Gospel according to Matthew.

So here are the people with the dough stuck on their heads, standing or sitting opposite one or a hundred other people, but from now on all the thousand-and-one conceptions they hold about the others are no longer true. And just as untrue are the ideas the other people have about them. Here that list comes into play again.

The notion that this person or that person is dark-skinned or light-skinned, or British, German, Albanian, French, Spanish, Japanese, Moroccan or Peruvian, is no longer relevant. What does count are the conversations about whether the person in question is intelligent or just a narrow-gauged fathead, whether he or she is human or just a consumerist bimbo. The *Dough Portraits* project is a literary and philosophical rumination on identity itself. Am I the person I think I am? That is a question that Luigi Pirandello posed to the audience of his 1921 comedy *Six Characters in Search of an Author*. Dostoevsky put it to his

character Ivan in *The Brothers Karamazov*, and Nietzsche put it to Zarathustra. Heidegger, too, writes out a long list regarding the question of identity. The journey of the *Dough Portraits* thus raises a big issue, which we will continue to confront for ever, and will talk about for an eternity to come.

I remember the warmth that the dough imparted to us at the instant it was put on our heads, the pressure it exerted on our heads and our faces, giving us the feeling that it was becoming part of our own skins, changing its shape from one second to another. The feeling was not unpleasant; it was good and comfortable, in a way that is hard to describe. There is nothing that quite compares with it. It feels like a second 'self': 'I' equals 'I'.

The *Dough Portraits* touched my now eighty-year-old father deeply. He could not say what was so special about them, but he did say that 'the boy' (by which he meant the artist) was a special young man. To please Søren, he took the dough, placed it on his own head, and so set out on an uncertain journey. But an uncertain journey is something we are all embarked on, after all.

Translated by Tom Appleton

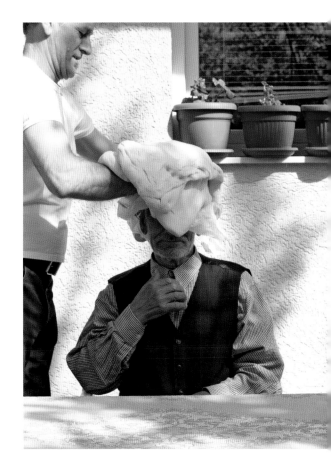

Pristina schoolchildren line up excitedly for their turn under the dough (opposite and top left), while a participant at the National Art Gallery of Kosovo assumes a silent and steady pose (top right). Meanwhile, the curator's father takes the whole strange business in his stride (above).

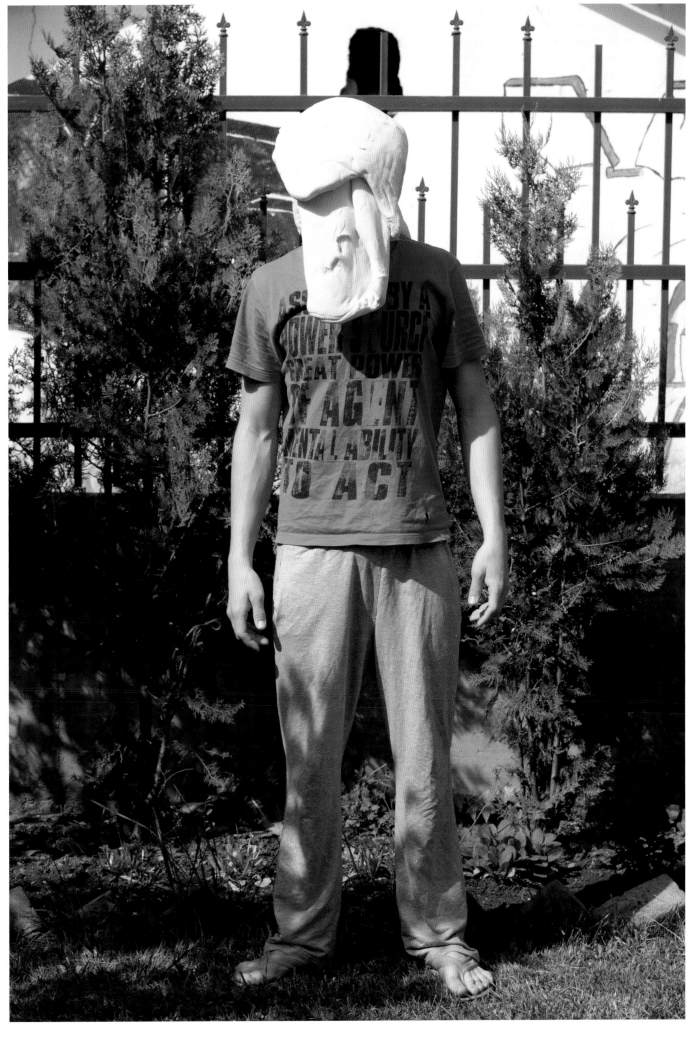

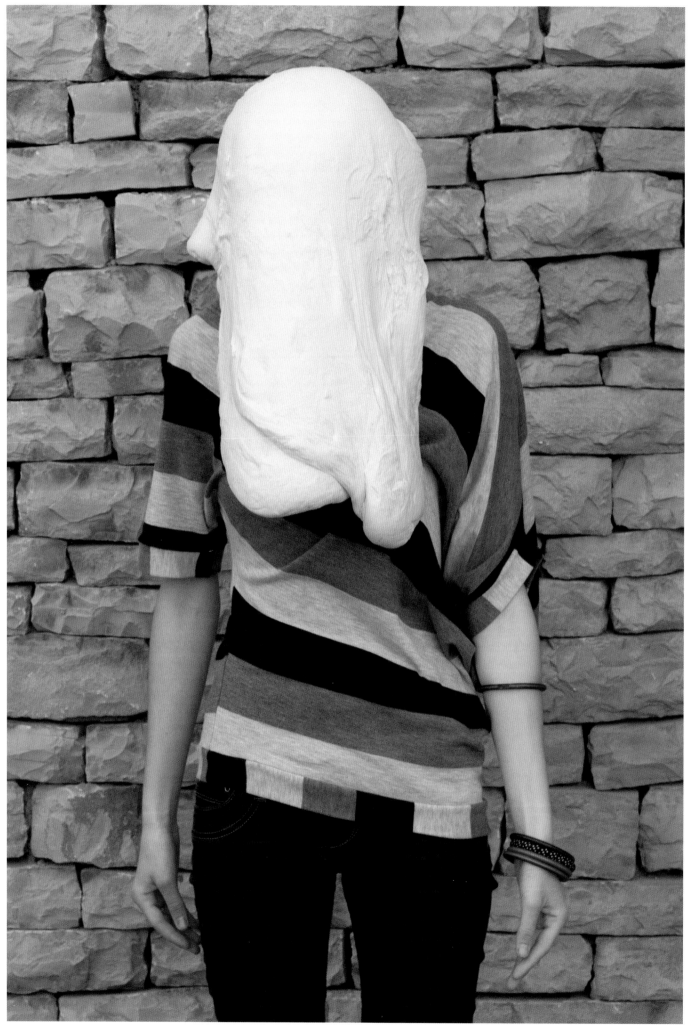

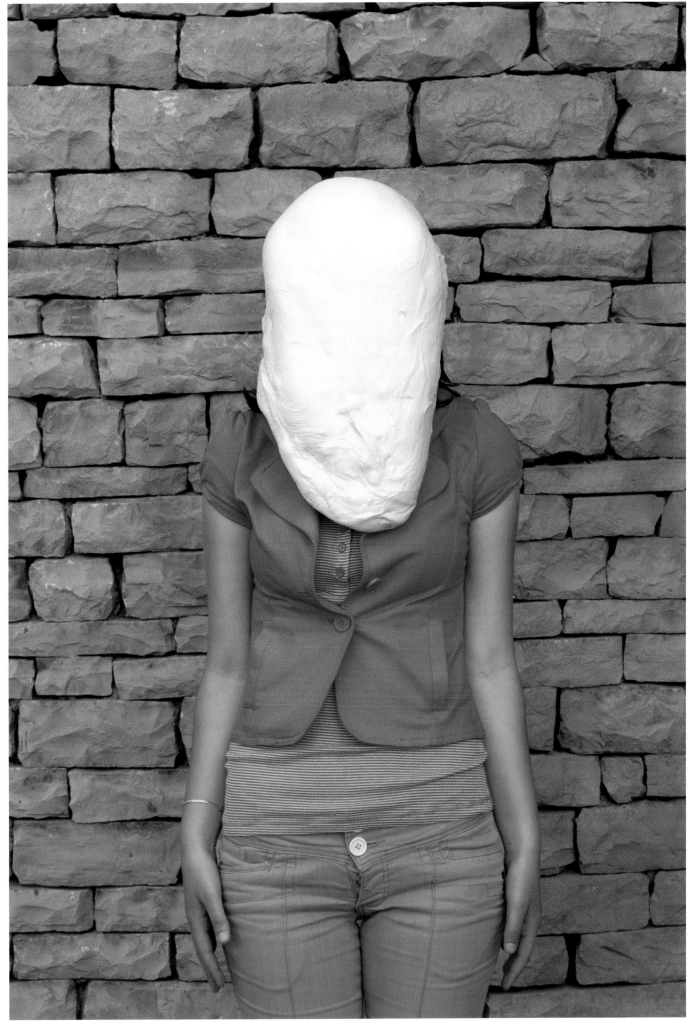

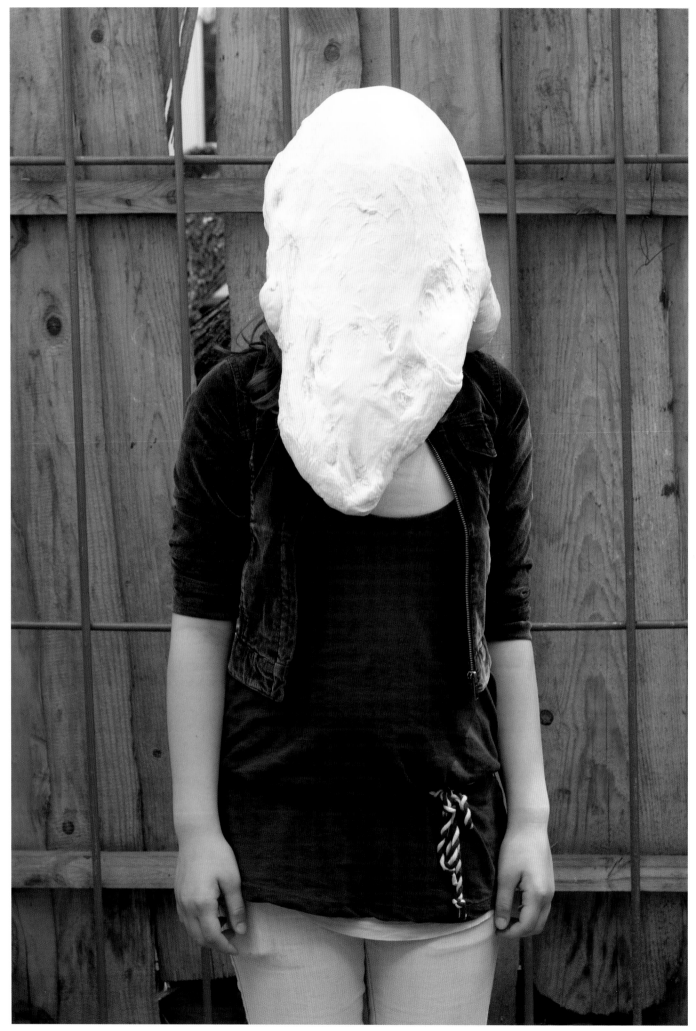

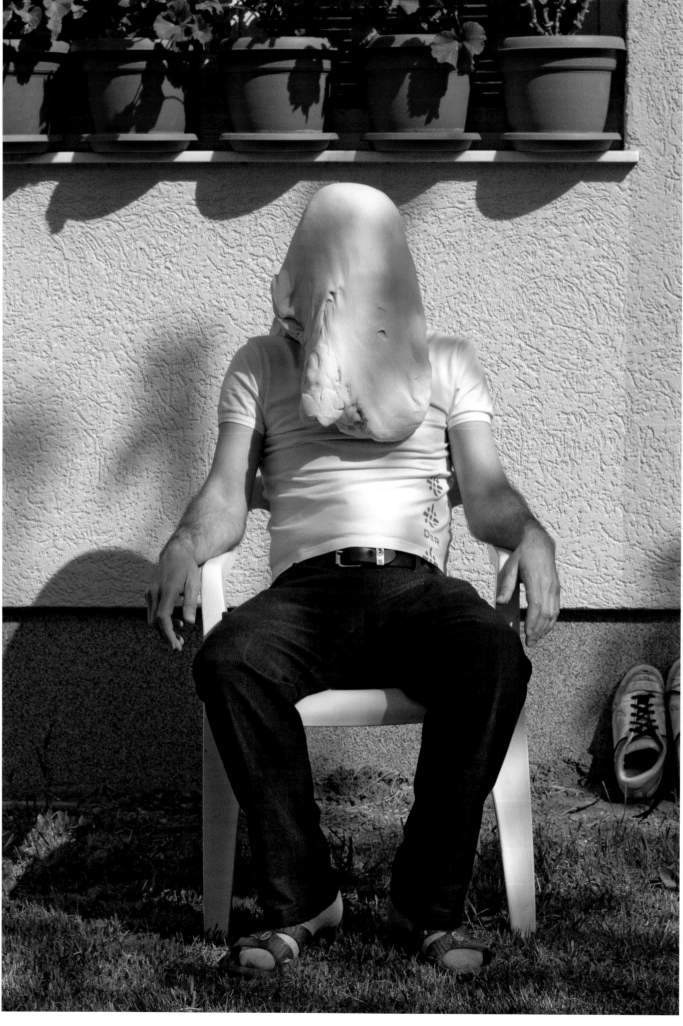

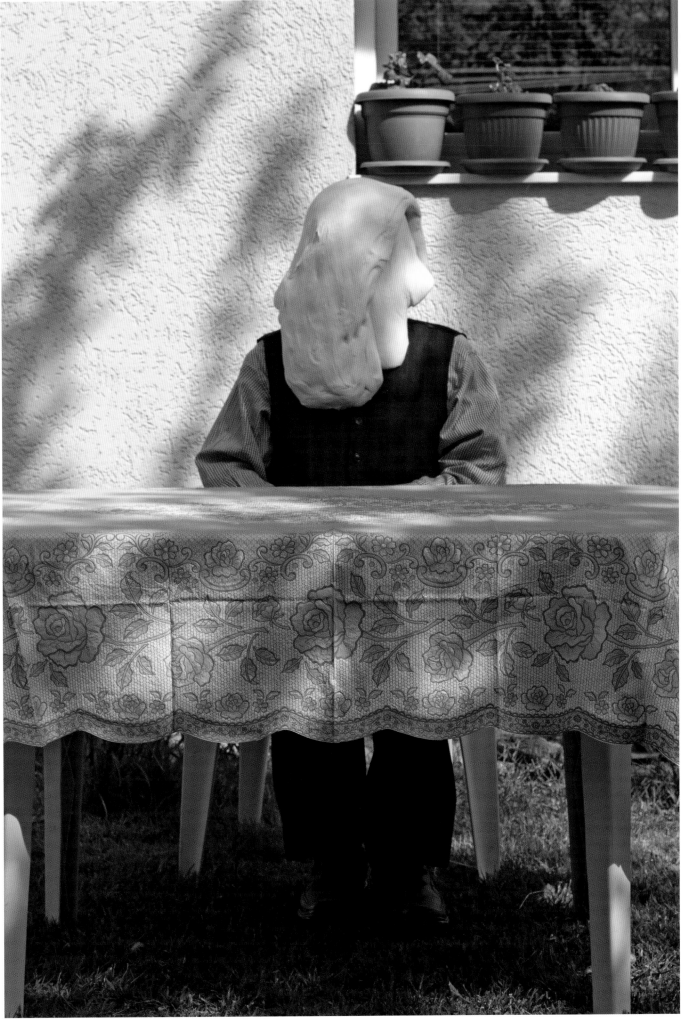

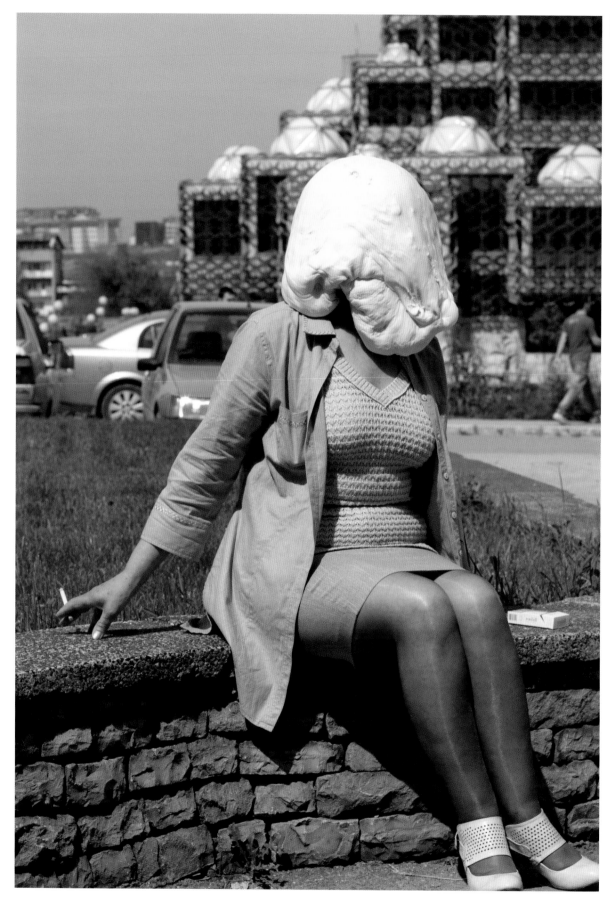

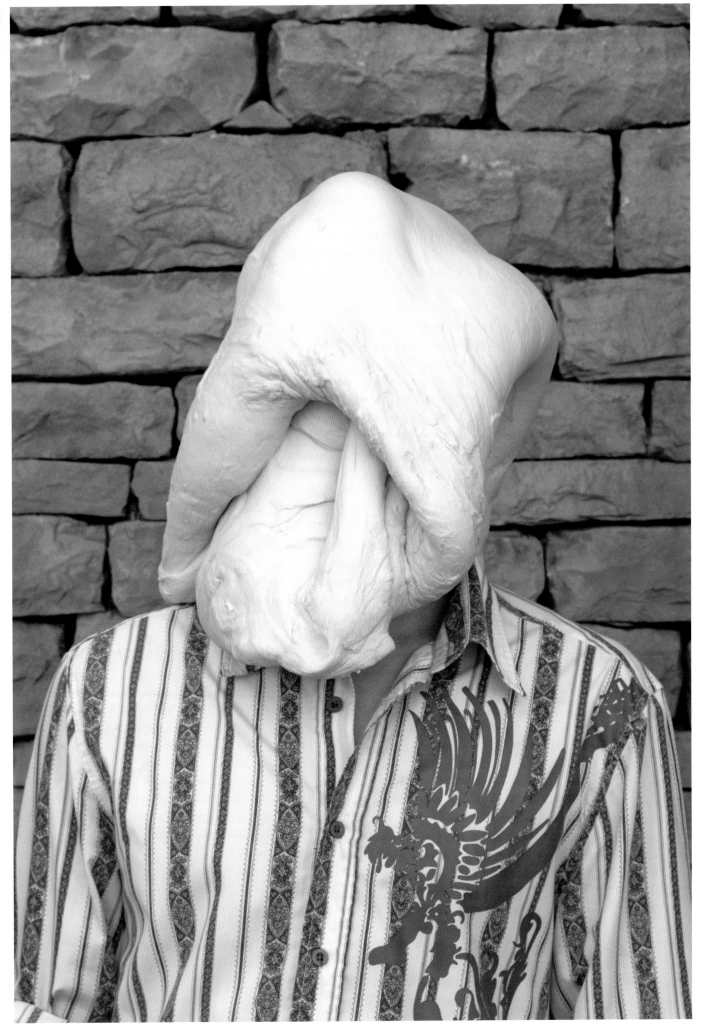

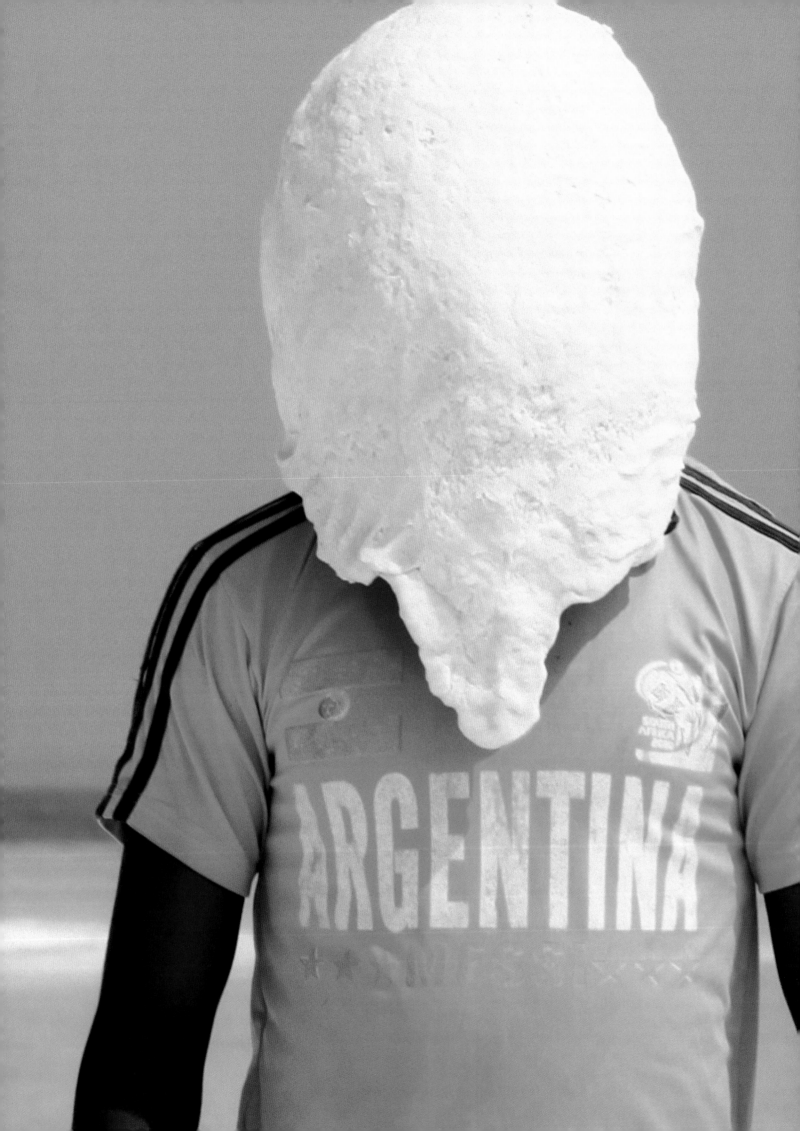

NATIONAL ART GALLERY OF MALDIVES

YEAR **2011**
IMAGES **18**

PLAYING WITH DOUGH

Putting dough on our heads is a playful act. It is a funny thing to do and it makes us laugh, maybe a little nervously. The absurdity of our purpose distances our actions from the mundane and places them in what the Dutch historian Johan Huizinga called the 'magic circle' of play. For Huizinga, play is at once part of and removed from everyday life. When we frame our actions within this magic circle, they mean something different. They take on meanings determined by our play, and we are distanced from everyday consequences and motivations. The results depend on the rules of the game, and those can develop during the course of our play. At the same time, playing can be a serious activity, and all acts can become playful. Play is a subtle sense that we have as humans, an integral part of our social selves.

AMANI NASEEM
ARTIST AND RESEARCHER,
MALDIVES

Just as play is universal, dough, too, is something that everyone is familiar with. It is an 'everyday material'. We have all used it in some way. But as Søren Dahlgaard says, it has no history of having been used in art. As such, as a material, it does not call up any references to or associations with a particular sculptural or other artistic tradition. It is therefore an 'everyday material' in this sense as well.

But when we play with the dough and shape it to put it on our heads, we are taken away from the everyday and are drawn into the artist's game, with its own set of rules. These rules are simple enough and the acts familiar enough that we can easily join in and take an active role in the process in creating the portraits. While this process may depart from more traditional forms of art, the resulting images can be placed squarely within classic portraiture: the dough, the posing and the careful cropping all serve to create iconic images with striking beauty.

Dahlgaard has often stated that he is not trying to make a point about identity with this work. Instead, it is the event and the image that are all important to him. He sees each dough portrait as a collaboration between the artist and the sitter. In this way, he questions not only the boundaries of the artwork, but also the traditional idea of the lone artist-creator. We participate in the artwork by bringing our own rules, our own sense of play, shaping both our personal image and the collective event.

It is a profoundly social game. We watch and comment as other people shape the dough and sit for their portrait. We anticipate the strangeness of being in their place and feeling the dough on our heads and faces. We listen to the reactions and descriptions of others as we wait our turn.

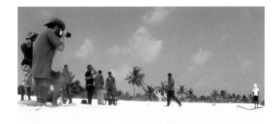
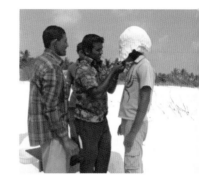

We laugh. When our time comes, we have our own way of kneading and shaping the dough. We naturally draw on our experiences and make our own associations; the action is thus absurdly yet effortlessly framed in relation to our personal lives, as well as being a constituent part of this very social event.

The *Dough Portraits* in the Maldives

When Dahlgaard photographed migrant Bangladeshi construction workers on a Maldives beach in late 2011, it was the second of two such events in the island nation. Two years earlier, he had conducted an indoor version in the capital Malé that was similar to the first in Denmark, this time involving ninety-nine sitters. 'It was heavy; my neck felt shorter!' said a sixteen-year-old schoolgirl who sat for the picture in her uniform with her school bag on her back. For her, the occasion was something she could do with her brother, who gave her a lift on his scooter. They helped each other knead the dough and they joked together as they sat for their portraits. 'My nose was squashed!' she laughed. The resulting portraits meant more to the siblings because they got to play and have fun. It was not traumatic for the girl, but she could remember the visceral experience long afterwards. It may be that the memorability of the event was due in part to its being on the border between playfulness and transgression.

The playful and the uncanny

Writing about the first *Dough Portraits* event at the National Gallery in Copenhagen, Danish art historian Henrik Holm argues that the portraits open up a field of tension about identity, despite what the artist might claim in this respect. 'There is a liberating banality about it', he claims. 'Come on, it's just dough. We play: let us get something going and see what happens.'

Yet at the same time, Holm also considers it 'an infringement on the person's self-image. The person sits there suddenly with a different relation to his or her surroundings, and new implications are brought up, which would not have been without such an infringement. It becomes serious, because there is an infringement at deeper levels.'

Holm sees something uncanny in the situation, and draws on the field of psychology to explain it as the sort of event that creates trauma: 'And then you cross over to the scary part of it. The persons are placed in a situation they are not in control of; they do not know how others will react, and I can't help thinking that they have voluntarily made themselves available for an experiment which deprives them of their identity.' He goes on to describe the moment the portrait is taken: 'The portraits make me think of the word "execution", which means "putting to death" – but it also means "carrying something out". They sit with a hood over their heads waiting for their sentence, waiting to be shot. They get dough on their heads while there are other people present. They get shot at with reactions, which they are not in control of. They have to sit there hearing everything people say, and they can do nothing. Their nice faces become a mere blob that collapses. It is as if the whole identity, which is built up so much around the face collapses. And they are helpless.' Play can be serious, and sometimes a game is more than 'just a game'.

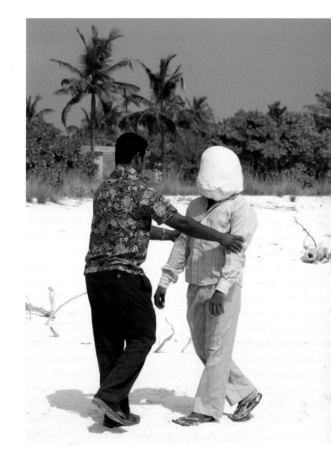

The eerily isolating effect of the dough was here heightened when each participant, deprived of all sense of anything around them, was led to an empty spot on the beach and left standing like a condemned man, waiting to be shot by the artist and their portrait to be executed.

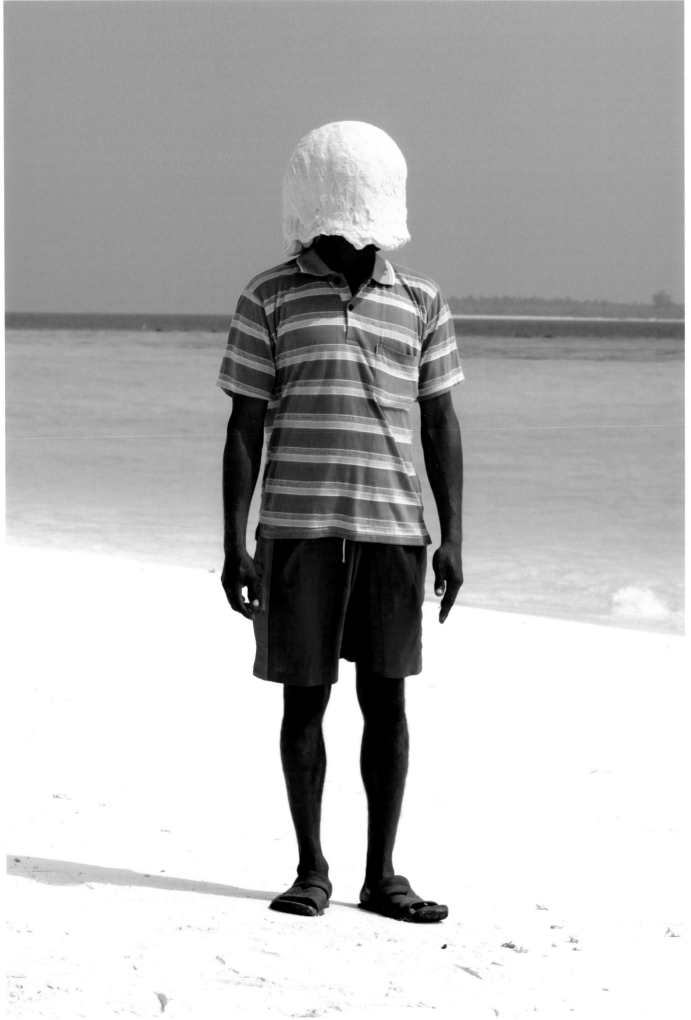

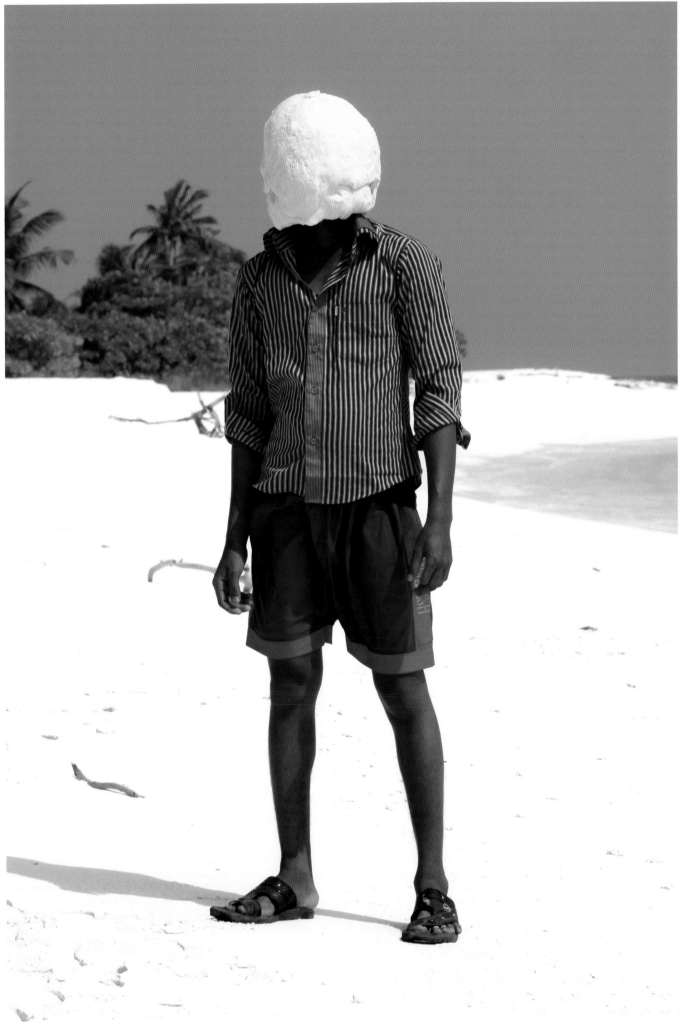

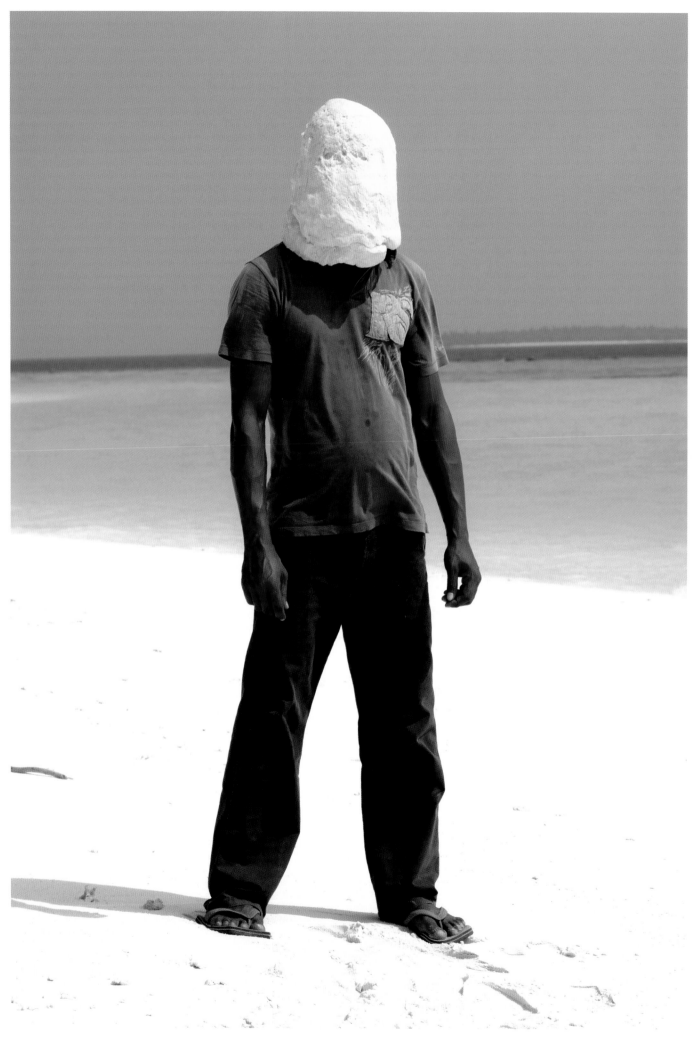

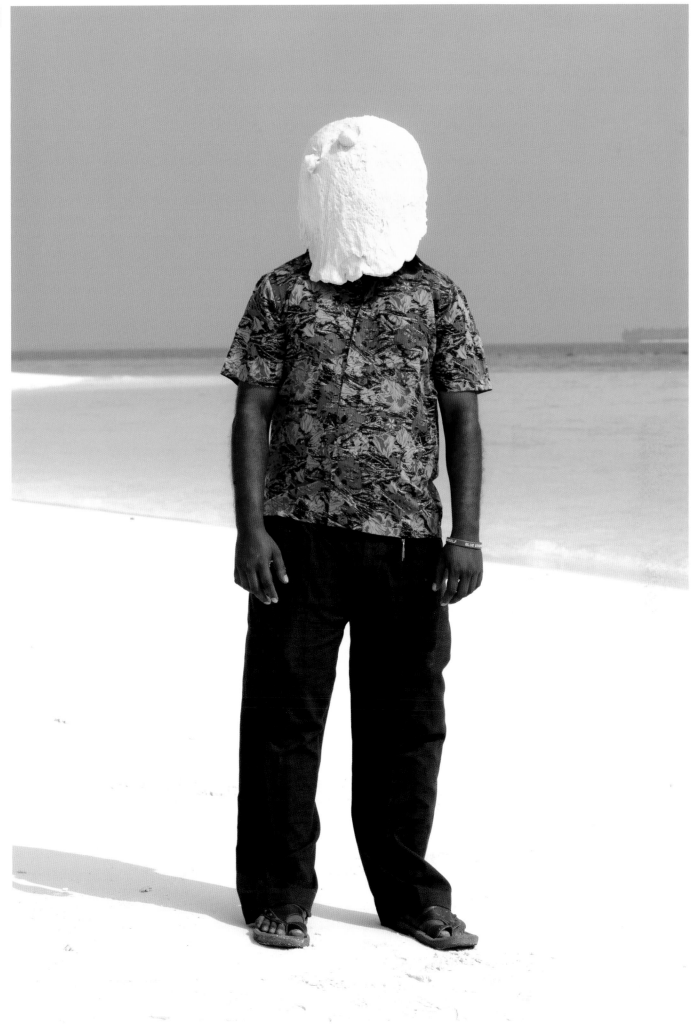

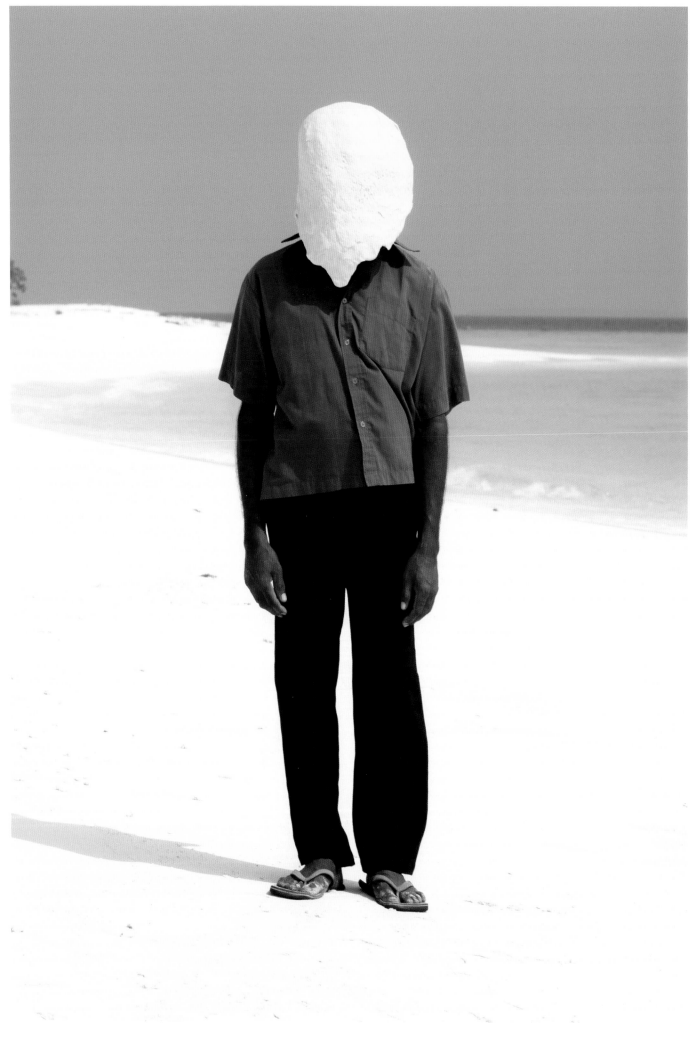

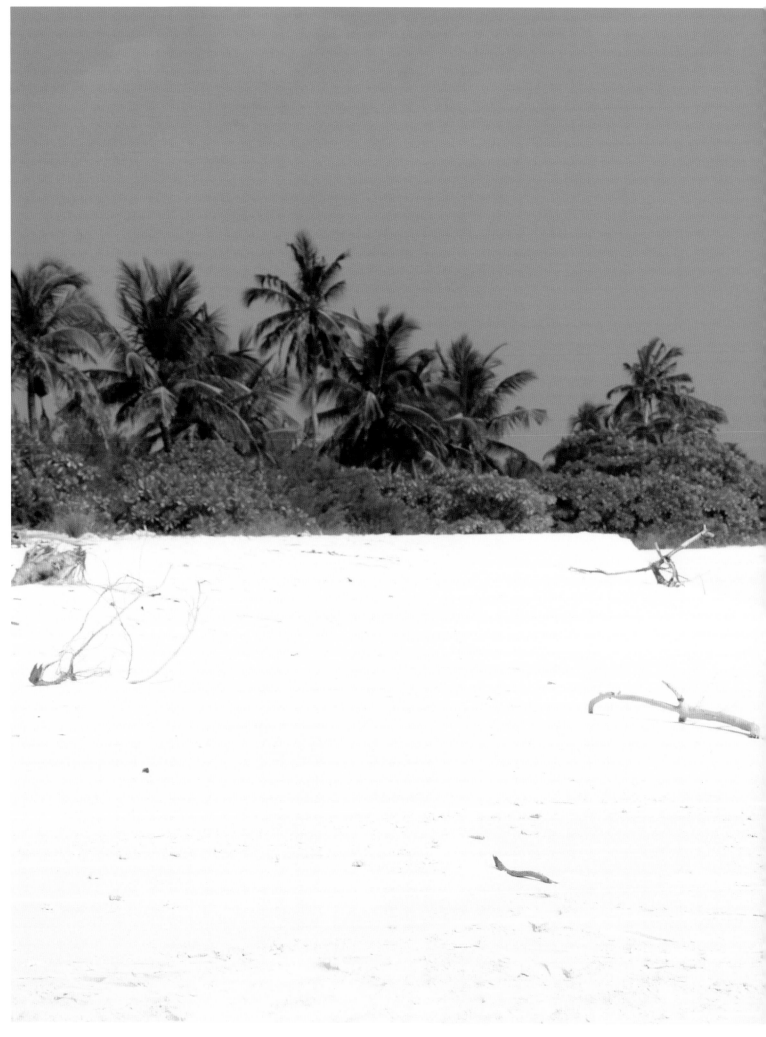

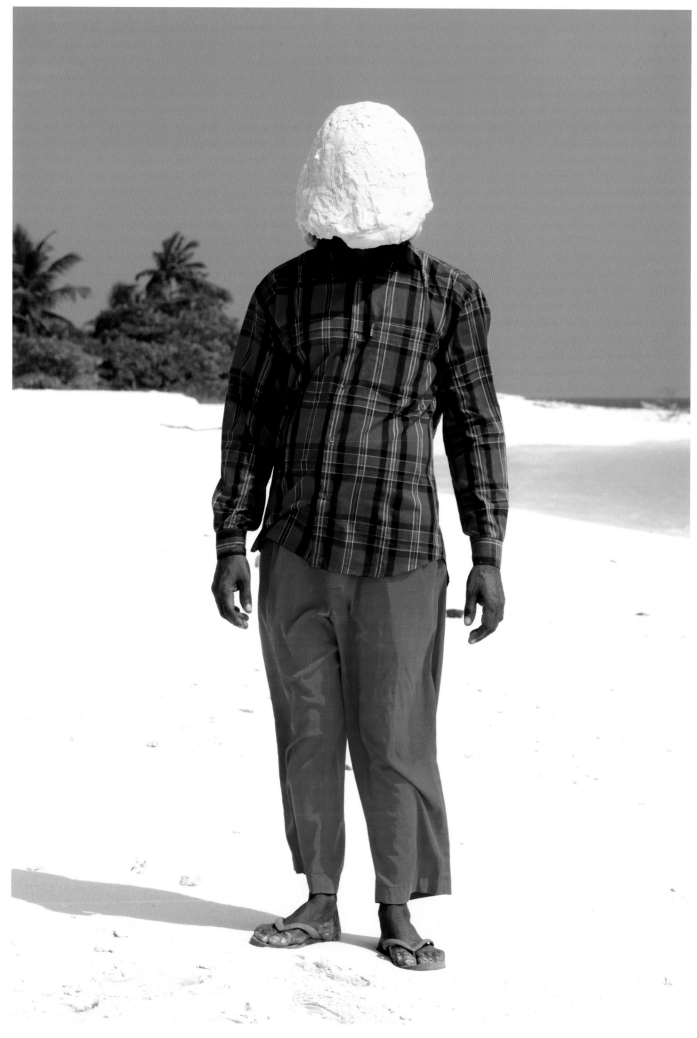

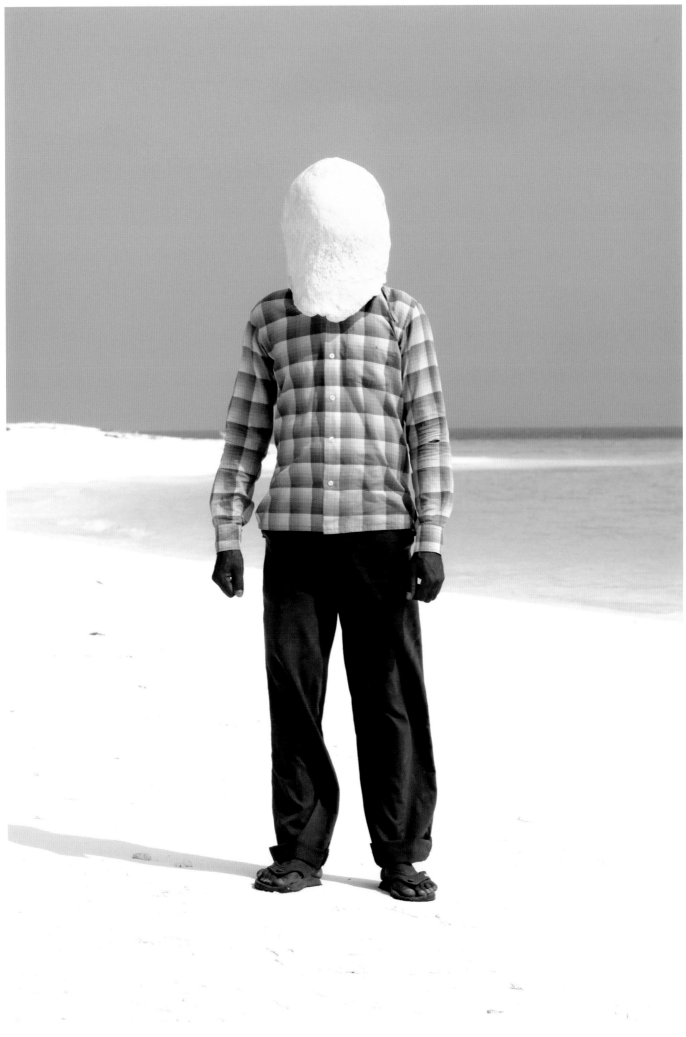

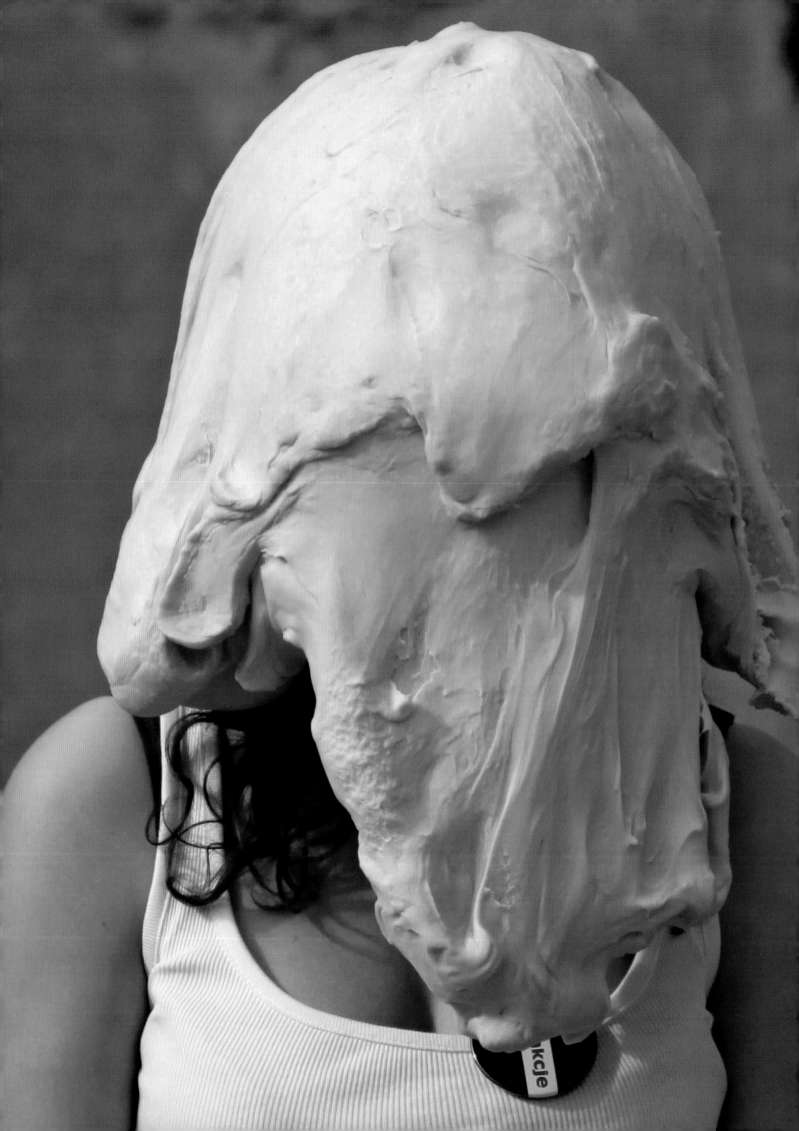

CENTRE FOR CONTEMPORARY ART

YEAR **2011**
IMAGES **45**

UJAZDOWSKI CASTLE, WARSAW

A MULTITUDE OF FACELESS PEOPLE

I first met Søren Dahlgaard in 2007, when he participated in the International Prize for Performance in Trento, Italy. The award had been organized by the Galleria Civica di Trento, of which I was then the director. I still remember the works that convinced the committee to select the young Danish artist for the exhibition: they were mostly made of dough, either in the form of baked baguettes or of soft raw dough. Wearing a costume similar to that of a medieval knight's armour (but made entirely from bread), the artist worked on his chosen canvas, usually a garden hedge or similar shrub, which he doused and splashed with biodegradable paint. It was, quite literally, a landscape painting.

FABIO CAVALLUCCI
DIRECTOR, CENTRE FOR CONTEMPORARY ART
LUIGIL PECCI DI PRATO AND FORMER DIRECTOR,
CENTRE FOR CONTEMPORARY ART
UJAZDOWSKI CASTLE, WARSAW

We were curious about this artist-baker, with his surreal paradoxical obsession. Indeed, the performance that he presented for the exhibition in Trento was a dough-based world, the main visual anchor of which was a huge hut-shaped construction on the stage. Inside this igloo-like structure made from five hundred baguettes, a cracking sound grew until there was an eruption. From there emerged the Dough Warrior, a cross between the fictional superhero The Thing and the Japanese manga super robot Mazinger Z. It was Dahlgaard, animatedly playing on some drums with baguette sticks from the 'Bread Hut'. His pace was furious as the bread broke and crumbs splintered to all sides in a sculptural collapse of the hut during his drum solo.

This primitive energy represented by dough speaks of our shared values, as I discovered once again some years later when I invited Dahlgaard to take part in a show/no show entitled 'Laboratory of the Future', a cycle of exhibitions, performances and events at the Centre for Contemporary Art Ujazdowski Castle in Warsaw. The project, the first act of which had the subtitle 'Regress / Progress', was born out of a desire to question and problematize how art had been traditionally exhibited. The theme itself alluded

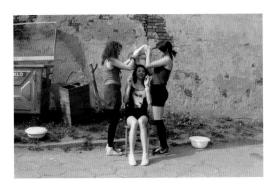 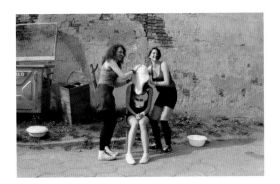 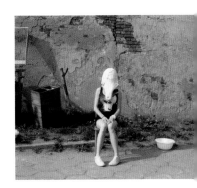

to innovation, posing the question of a possible future that embraced the notion of happy regress, instead of the worn-out principle of progress.

The programme was developed through sections organized by different curators and ran for several months. I curated the section entitled 'The Landscape of the Future'. Landscape in this context was used in the broadest sense and meant not only the Earth (with its natural or artificial aspects), but also the landscape of the human being – or more specifically the landscape of the mind, of imagination. In short, I tried to investigate the phenomenon of faces, the faces of this future of the imagination. Between Superflex's *Flooded McDonald's* video and a three-dimensional humanoid building by François Roche, I positioned Dahlgaard's photos of faces covered with dough. A hundred or so of the portraits, taken from previous events, were arranged next to each other to form a panorama. Later, during the course of the show, Dahlgaard created another set of dough portraits by photographing locals and visitors to the centre.

The series ended up acquiring a special significance for the exhibition. While all of the portraits were similar, they were at the same time so different. As shapeless masses, those lumps of dough transform humans into deformed cartoon characters. But like all cartoons, they are a parody that highlights real human behaviour in spite of that cartoon-ness. They recall faces, but yet have a different look, perhaps giving the same impression that human faces would do if they looked somewhat extraterrestrial. We may see the outline differences between these portraits but are unable to identify the details that make others unique in our eyes. It could be likened to being in front of a forest where the trees become a crowd. Even though we recognize the different heights, widths and textures of the trunks, we find it hard to distinguish or to give a name to each individual tree. Similarly, standing before the *Dough Portraits*, we realize how important clothes are and how our various poses and body language have an impact on our perception of a person. Ultimately, it is the outer layer that characterizes the individual, differentiating each of us from the other. This multitude of faceless people symbolizes not an anonymous crowd but rather of being one with nature so that, like nondescript trees in a forest, these individuals form a landscape.

Translated by Elena Camera

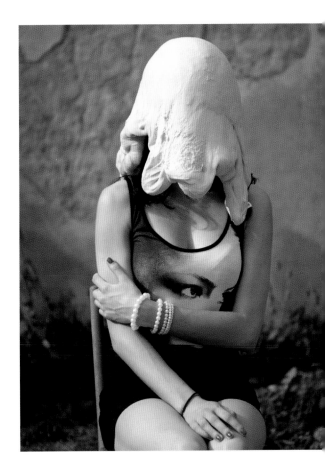

Patrycja is photographed during the event in May 2011 (top row), with her finished portrait (above).

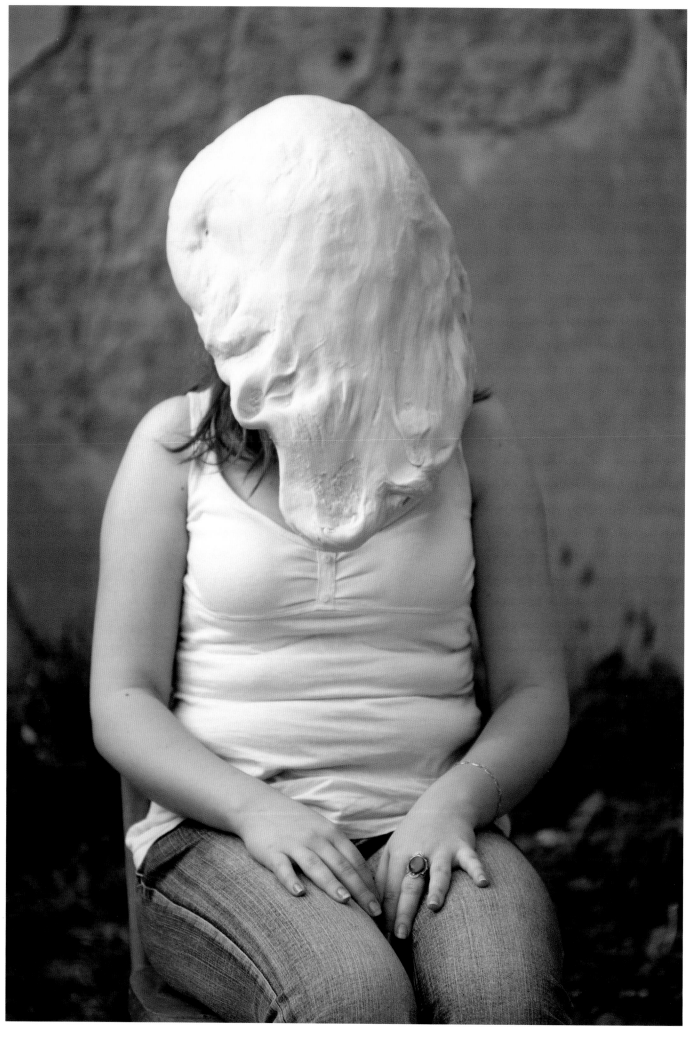

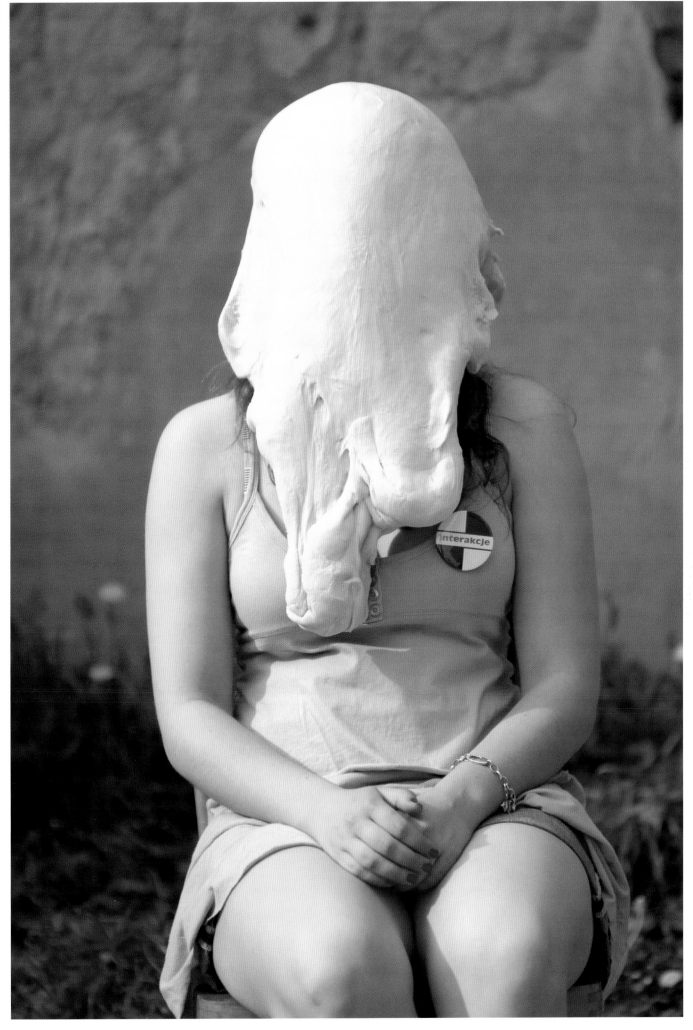

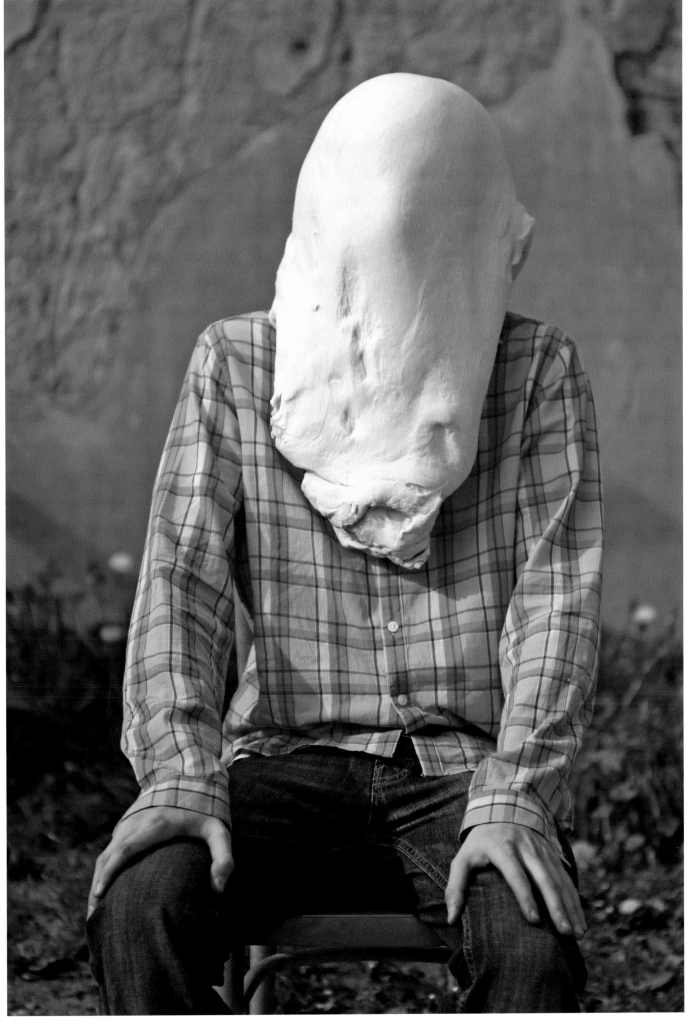

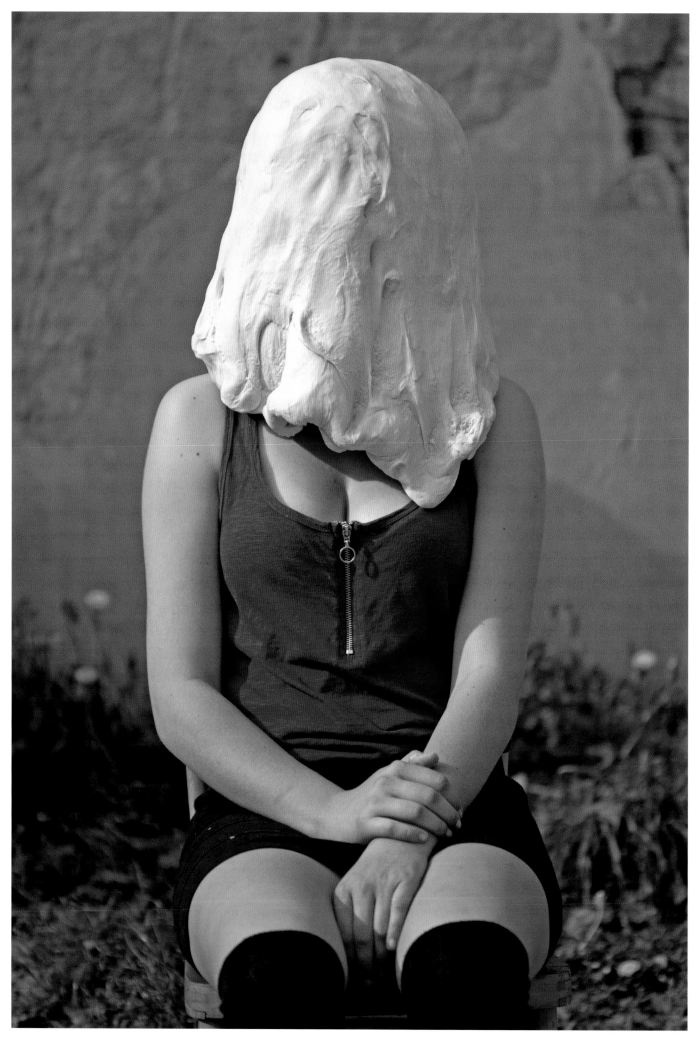

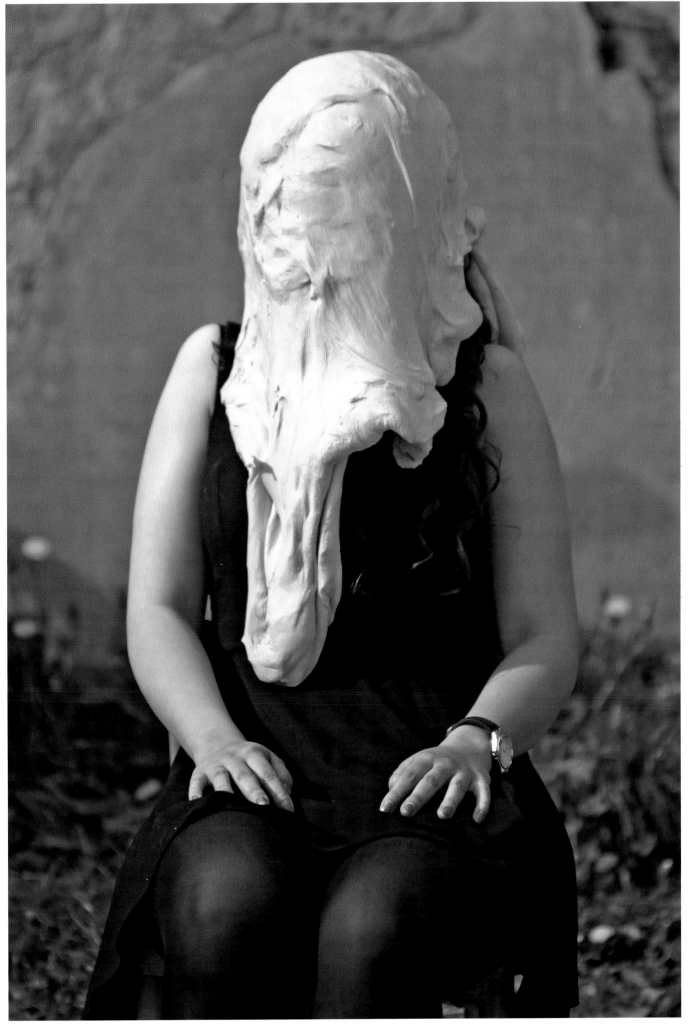

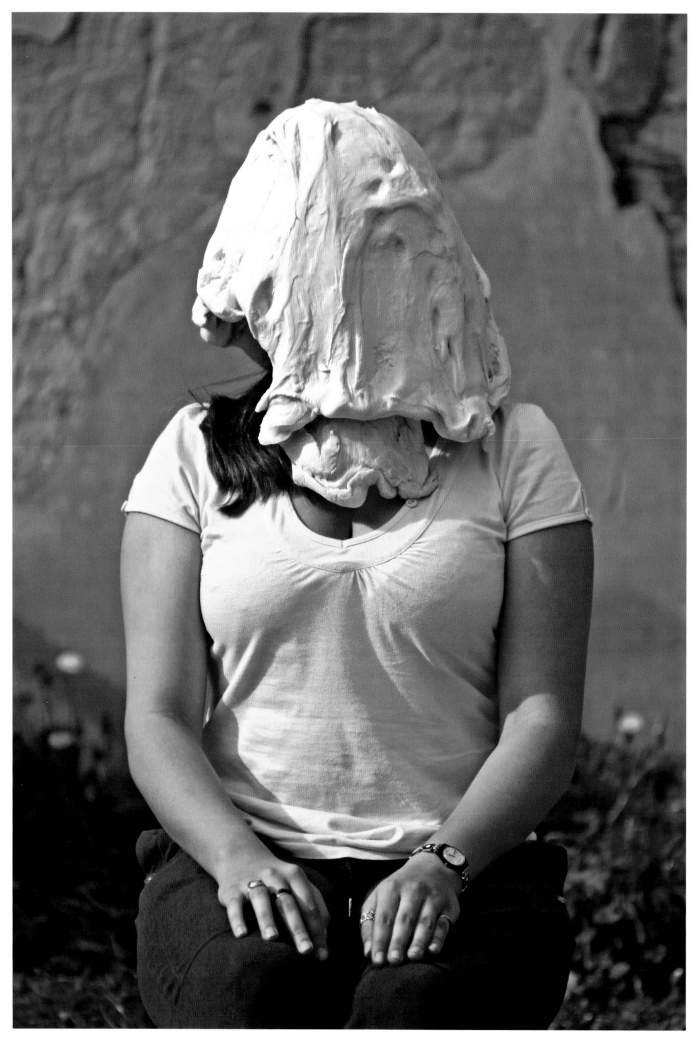

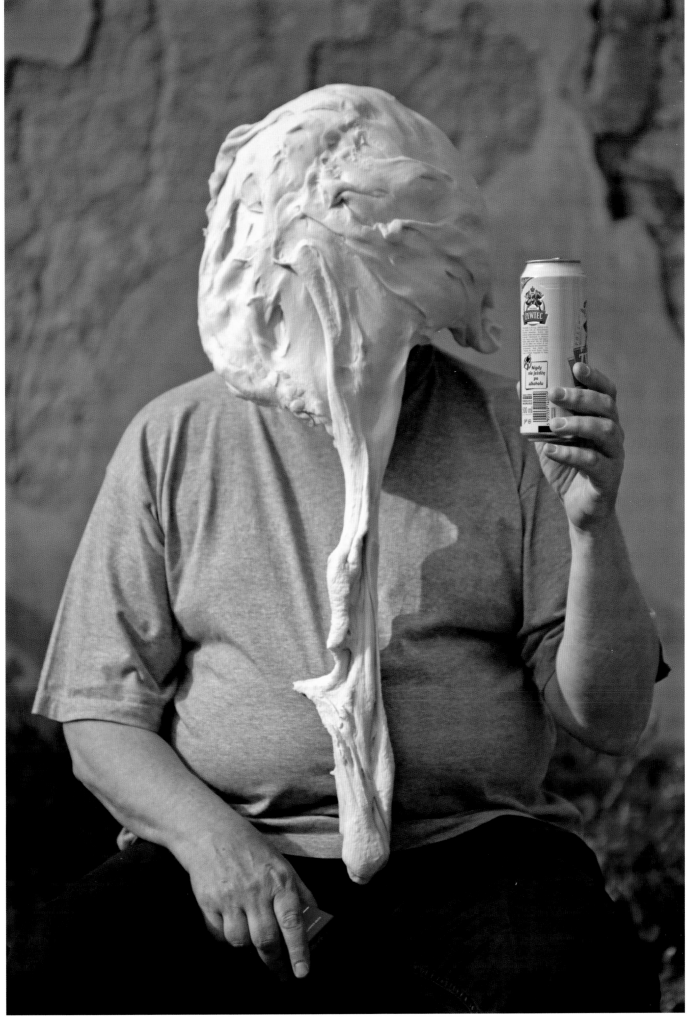

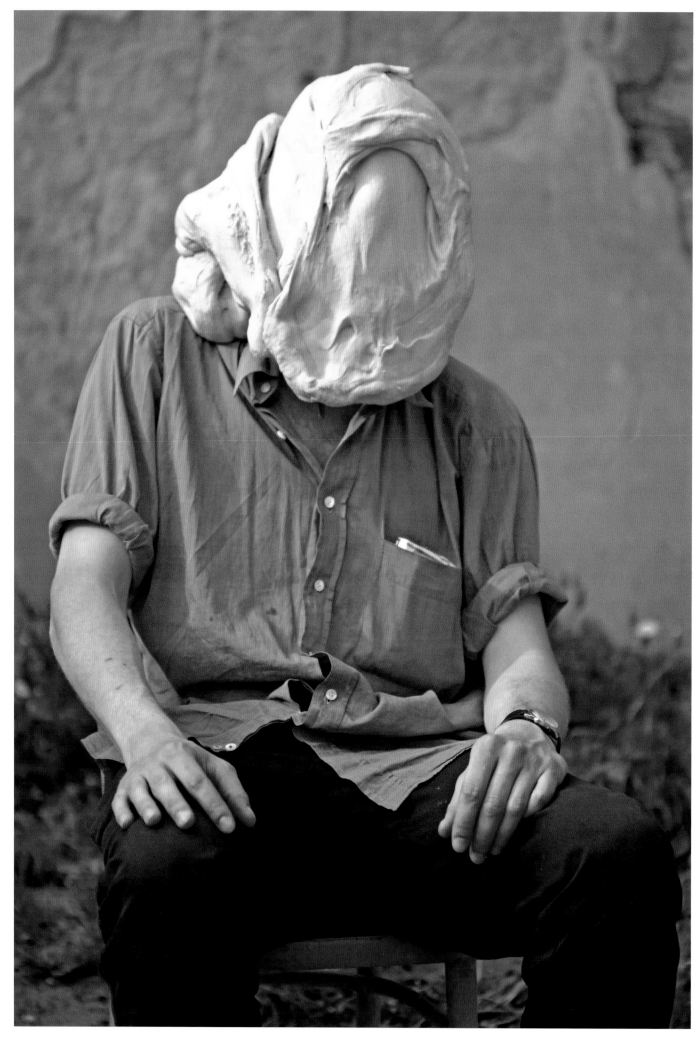

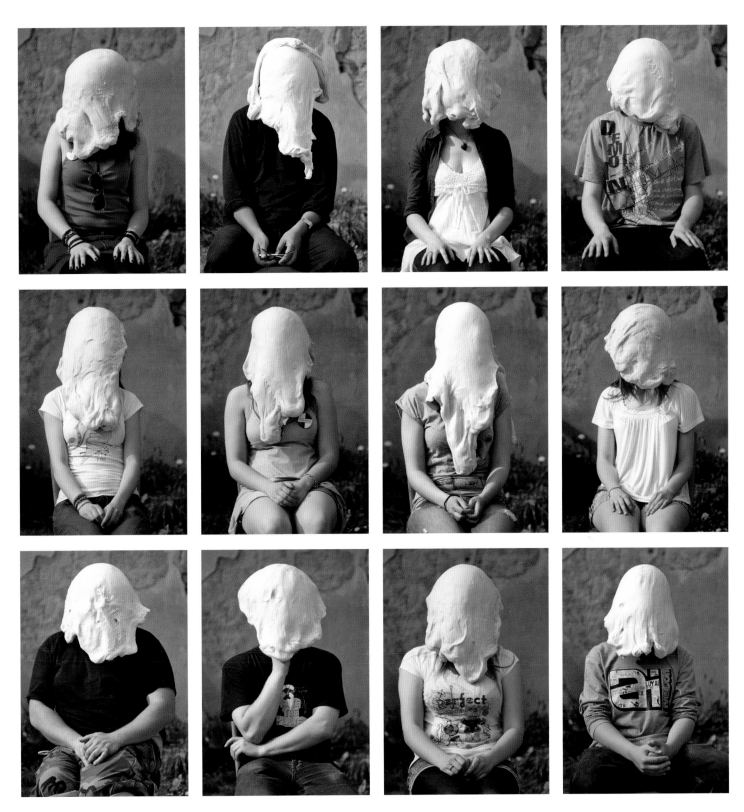

JULITA; KO; PAULINA; JAKUB
KAJA; OLGA; JULIA; NINA
SZYMON; MARIUSZ; ENA; KAMIL

97

ISRAELI CENTER FOR DIGITAL ART

YEAR **2011**
IMAGES **45**

NEIGHBOURHOOD DOUGH

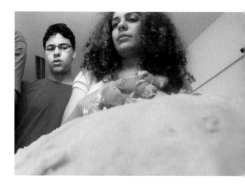

Dough is basic and universal. We know how it feels and remember from childhood how it is made and worked, how it becomes bread. We know well the comfort to be found in the smell of raw dough and that of baking bread, which is able to flash us back in an instant to the neighbourhood of our youth.

RAN KASMY-ILAN
CURATOR AND DIRECTOR OF EDUCATION PROGRAM,
ISRAELI CENTER FOR DIGITAL ART

When one looks at the portrait series by Søren Dahlgaard, the scent of dough is ever present, arising from the indelible link between memory and smell. That is the nature of our sense of smell, quite distinct from all other senses. Scent memories are the ones that remain intact the longest, long after visual memory has faded, a result of the olfactory bulb's proximity to the brain's limbic system, the place where our memories and feelings are stored. We even have the ability to smell something not present just because the expectation of its presence exists. Scent memory is a powerful tool that enables us to re-experience things, something tangible and utterly different from the memories we garner from other senses. For this reason, the smell of dough spontaneously evokes forgotten events and experiences, bringing us back to precisely the point we were when we first sensed it. This is what marks the divide between a cerebral act and true re-experience, the difference between knowing something and creating it.

On the afternoon of 31 May 2011, the residents of Jesse Cohen neighbourhood in Holon were invited to pose for a portrait with a ten-kilogram lump of dough on their heads. Jesse Cohen is a tiny neighbourhood on the margins of the city of Holon, itself a suburb of Tel Aviv. Sixty years after its establishment, the neighbourhood still remains a place of new immigrants, with a constant turnover of residents due to waves of migration, and it holds many different communities and cultures living side by side. The neighbourhood faces the various problems that are the result of its diverse population and history: severe poverty, racism, immigrant absorption, at-risk teens with nothing to do after school hours, single parents and families with many children, language difficulties, a sense of alienation when dealing with the municipality and

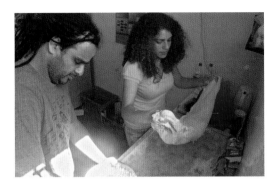 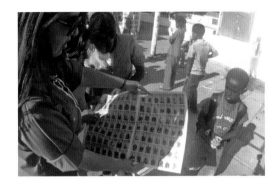 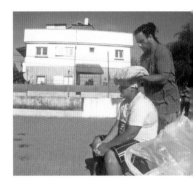

other local communities, ethnic tensions and generation gaps.

In 2010 a new model of action began to be implemented in Jesse Cohen: an art programme based on a communal sense of responsibility and partnership in the community. Led by the Israeli Center for Digital Art, it set up various projects addressing the specific needs of the local people, successfully involving a growing number of artists and residents, encouraging collective rather than individual initiative, and establishing the foundations for long-term change and sustainability. This model stands as testimony to the fact that, despite its difficulties, the neighbourhood is still the landscape of childhood memories, of pseudo-familial ties, a small but warm community, a people and place that should be celebrated.

The photographing of the dough-enshrouded portrait subjects was one of the first public acts to take place, and was an excellent way to demonstrate the success of the model. Each participant's intimate knowledge of dough came from their own personal memories, and also because they had themselves worked and kneaded the lump that now covered them. But detaching the dough from its usual context and using it as a sculptural material, as well as disrupting accepted 'rules' regarding traditional portrait photographs, created both a community event with a decidedly neighbourhood atmosphere and a public identity game that mixed the old with the new.

The lump of dough was placed on each head for a short time, long enough to allow each subject to disengage momentarily from the world, whose voices had been dulled. The world was blocked off, the head engulfed by that

primal and powerful scent, the weight of the mass bearing down – although the surprised subjects discovered that the sun's rays could still penetrate that shell. Outwardly, the dough oozed slowly down, captured on video in a kind of continuous still photography documentation. It made for a serene and static figure that within moments revealed the rising and lowing rib cage, breathing in and out, and the stretching of dough filaments as they continued to seep.

A portrait of a hidden face is an uncomfortable image, providing none of the features and expressions that are usually the portrait's main elements. But when covered by dough, with the associations that it entails, it seems a playful act of mischief. The *Dough Portraits* refer to the tradition of photographed portraits and to individual-collective history, as all of us have sat for class photographs and for ID or passport photos. These images are an important component of consolidating our identity to face the world, but the addition of dough as a sculptural material helps to create a new identity entirely. Viewing such portraits, you are forced to be more alert to body language, skin colour, clothing and posture – extracting new identifying signals from these outward signs. The lumps of dough are also individual, forming and stretching differently on each subject. Dahlgaard directed this neighbourhood project, with each participant choosing and then executing their assigned role, determining how to sit, what to wear and how to work the dough. After being printed as stills from the video, the portraits were exhibited in the Israeli Center for Digital Art, and copies were given to each participant. The scene created by Dahlgaard was both new and familiar, something that relied on the sense of community within the neighbourhood, and also enabled celebration of the place and the people who live there.

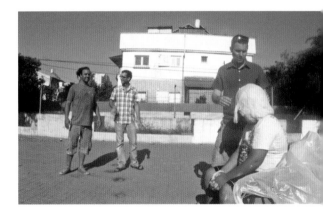

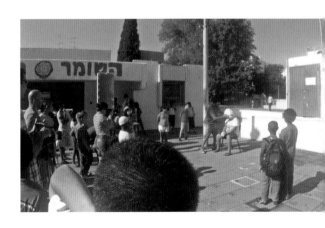

The dough is mixed (opposite and top left) while one of the organizers attempts to explain the project to the kids of the neighbourhood (top centre). When everything is ready, local artist Meir Tati prepares teenager Arial to sit for video portraits in two locations in the Jesse Cohen area of Holon.

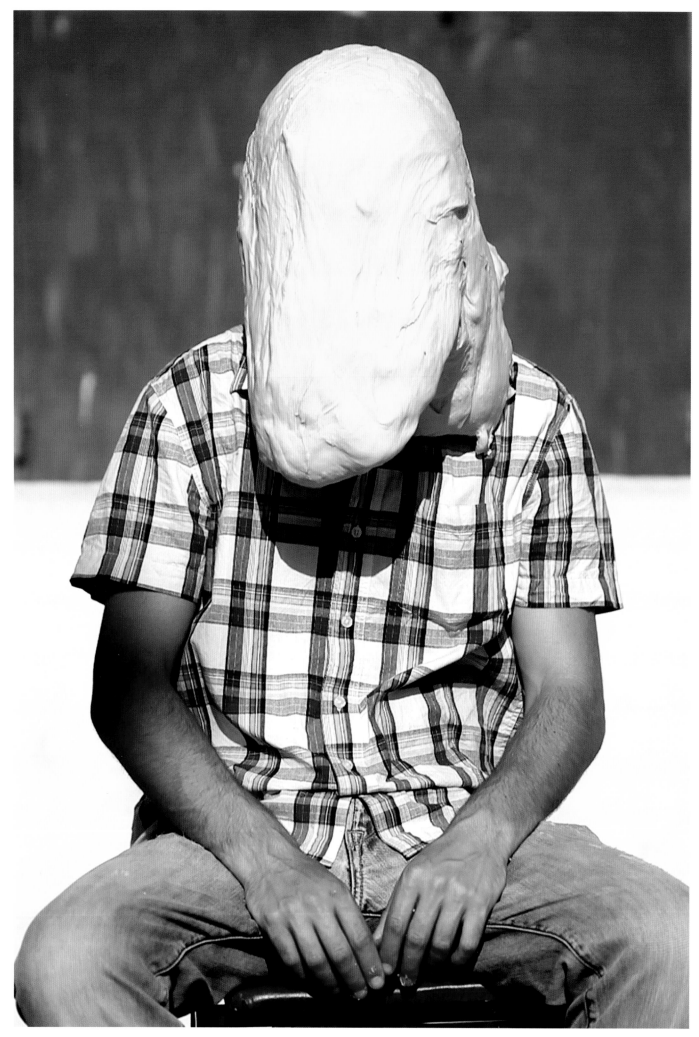

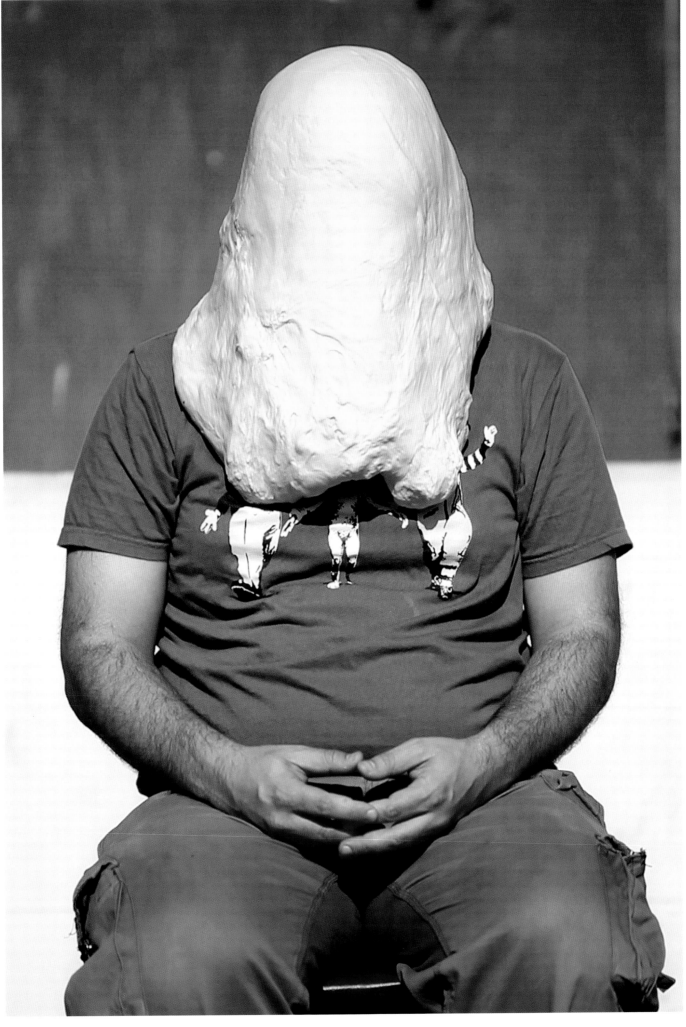

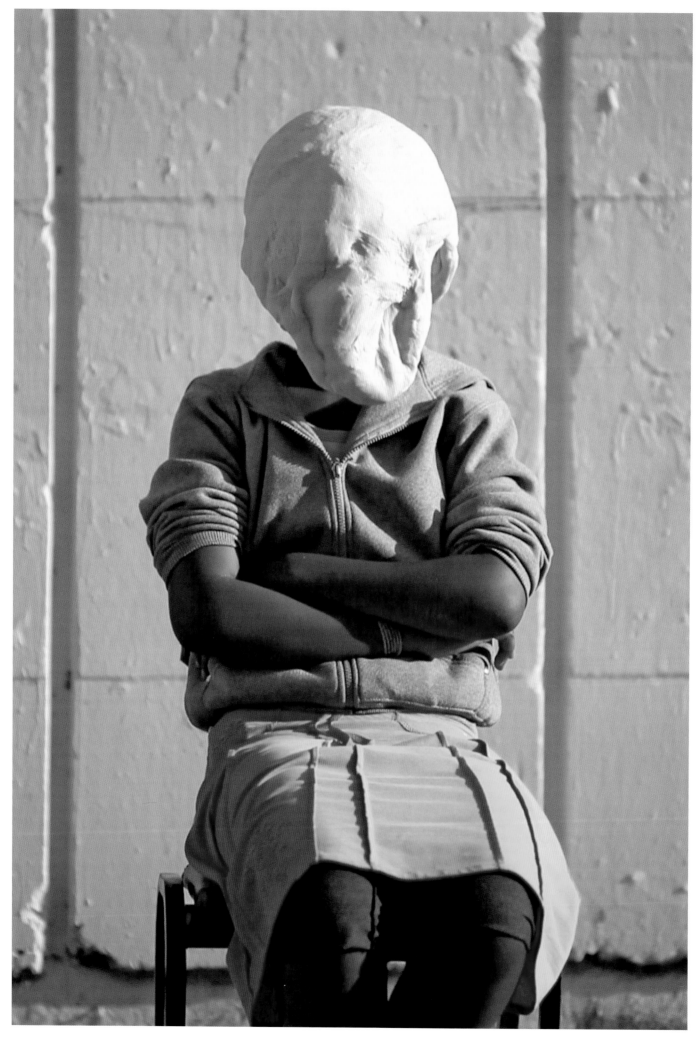

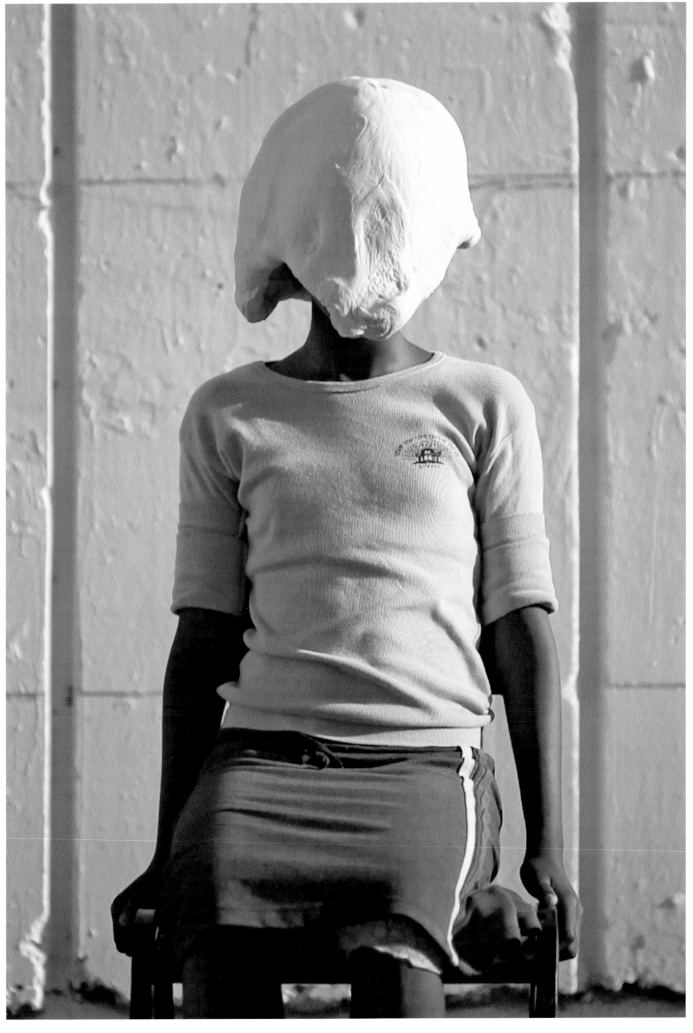

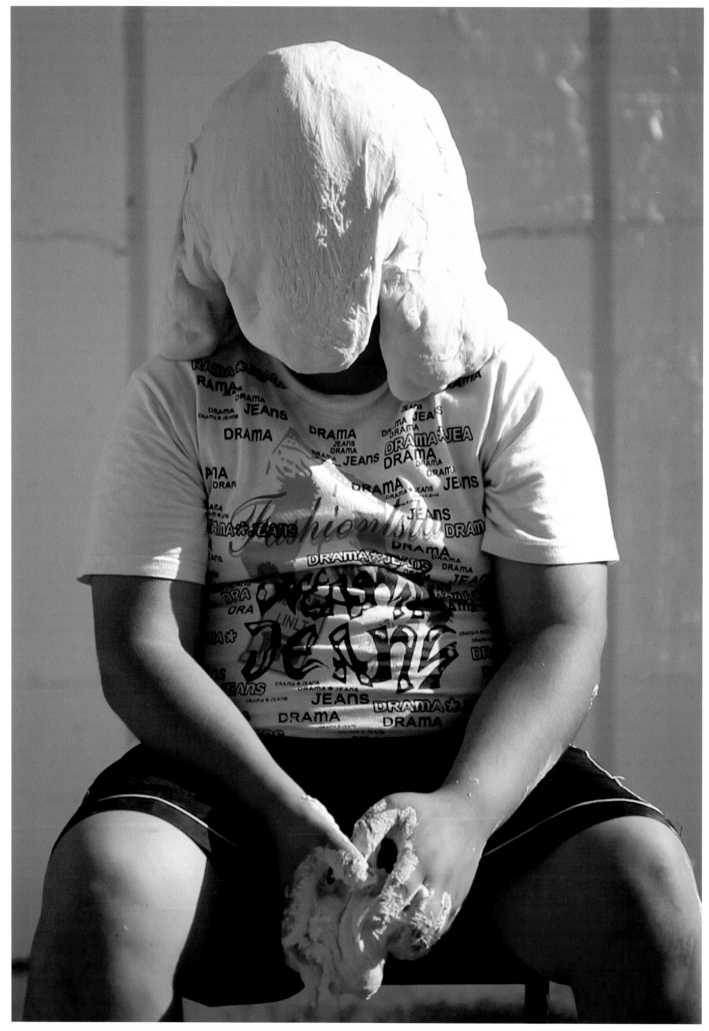

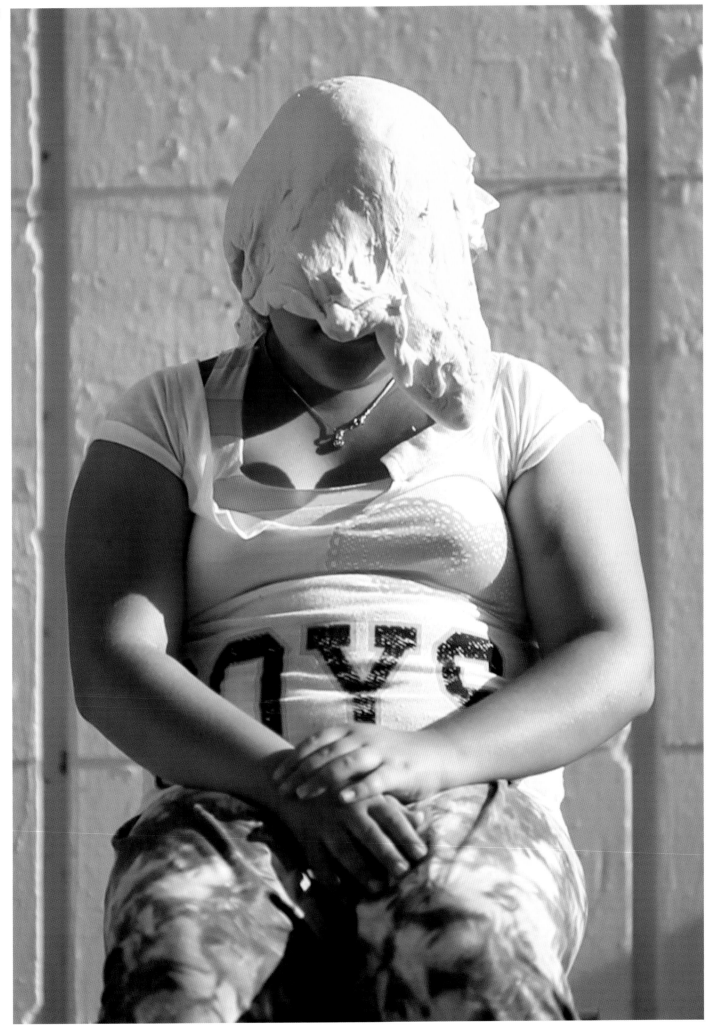

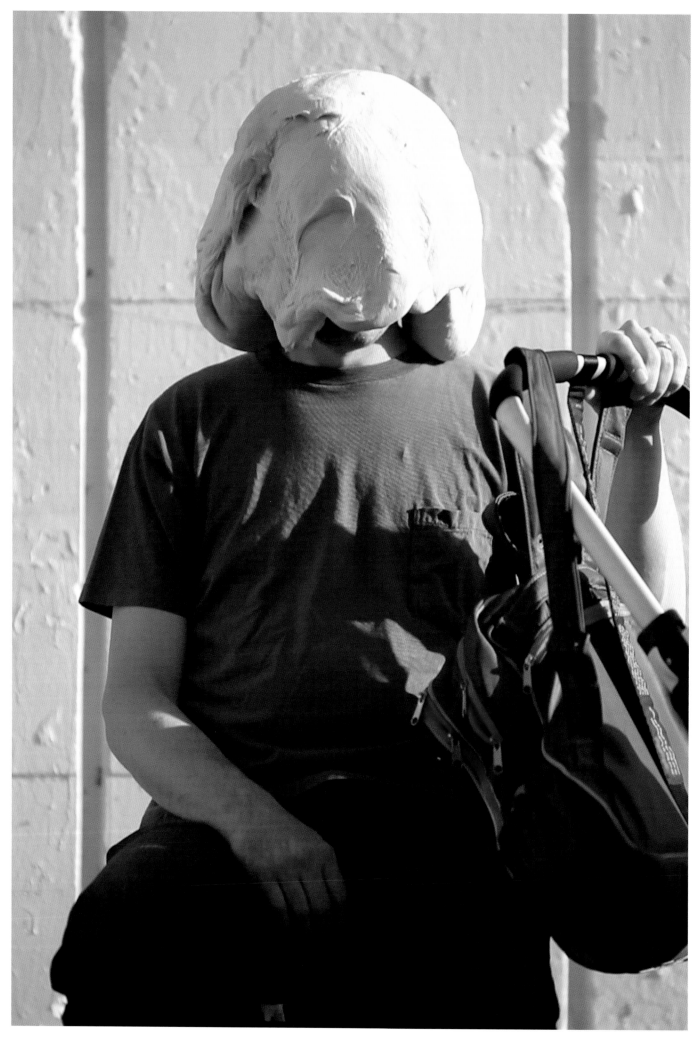

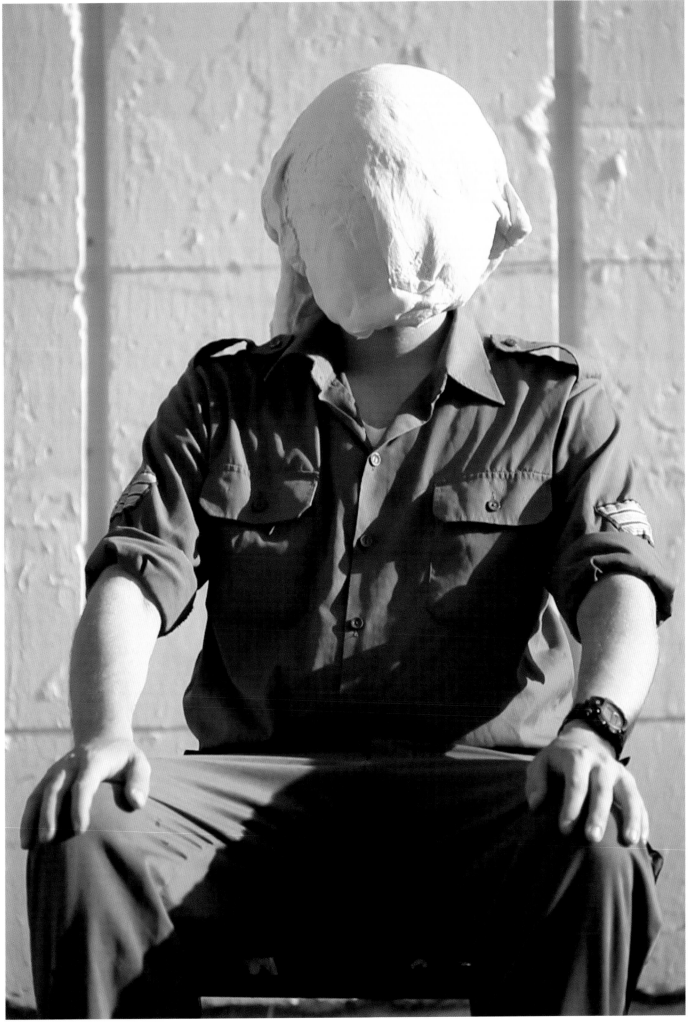

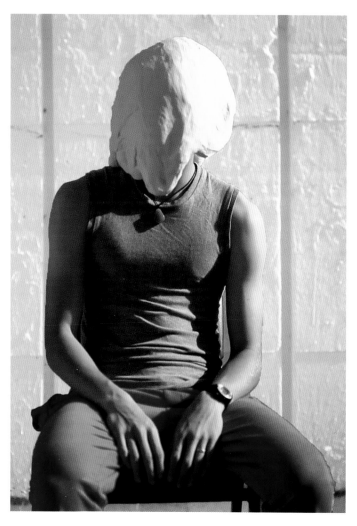
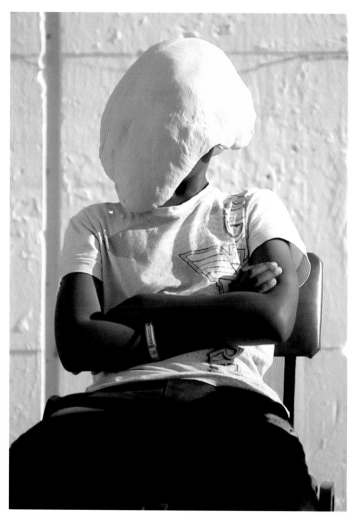
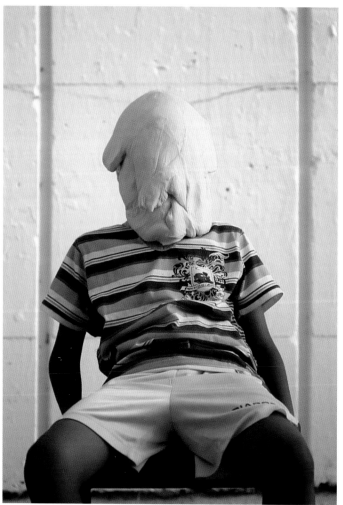
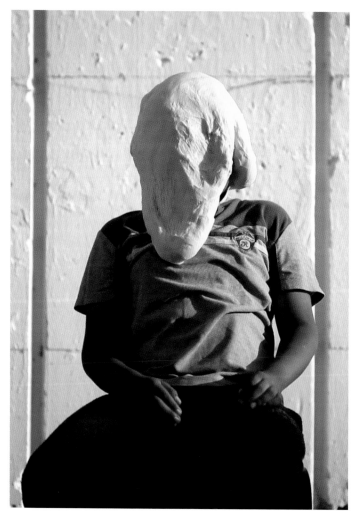

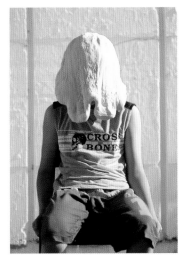 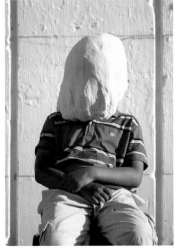 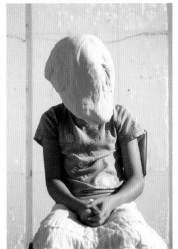 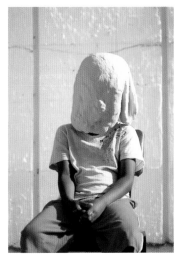

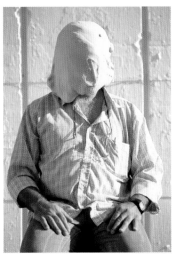 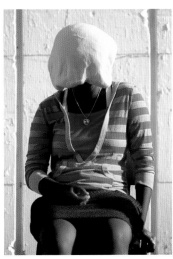 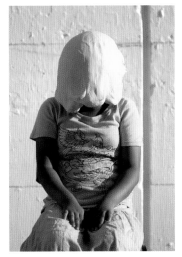 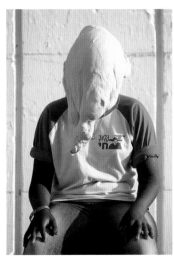

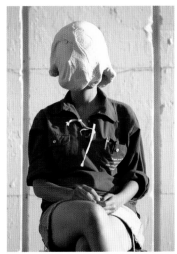 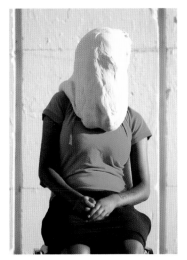 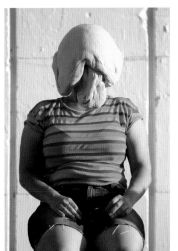 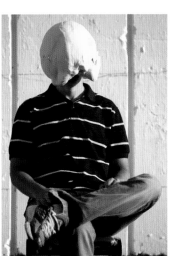

LIOR; ADANO; MORIEA; MOSES
YOSI; NAGATWA; YISHI; TALI
YAEL; REVKA; AVIGIEL; IDAN

OPPOSITE
MOR; SAMIAN
EYOV; YASHEMBEL

JOCKEY CLUB CREATIVE ARTS CENTRE, HONG KONG

YEAR **2011**
IMAGES **30**

THE FACELESS MASSES

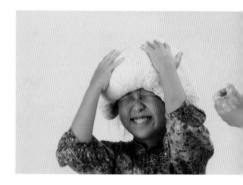

We invited Søren Dahlgaard to bring the *Dough Portraits* to the Jockey Club Creative Arts Centre (JCCAC) in Kowloon, Hong Kong, in October 2011. The project was to be part of a small festival of international performance art to commemorate the centenary of the Chinese Revolution in 1911. This series of revolts and uprisings had brought about the overthrow of China's last imperial dynasty, the Qing, and had established the Republic of China. Dahlgaard's project, while creating much bemusement and amusement among its participants and onlookers, also gave us much food for thought about these and more recent events in our lands.

AUGUSTINE MOK
CHIEF EXECUTIVE, CENTRE FOR COMMUNITY
CULTURAL DEVELOPMENT, JCCAC

The revolutionaries of 1911 were driven by the principles of freedom, democracy and equality. One hundred years on, the centenary gave us in Hong Kong an opportunity to reflect on these ideals. We wondered how free, democratic and equal the citizens of Hong Kong and the people of China had become after a century without kings and emperors? The reality is that the Revolution of 1911 may have brought republicanism but no genuine democracy. The officials of the new government were corrupt; there was exploitation of peasants by landlords, and of workers by capitalists; and the country as a whole was confronting the increasing aggression of the imperialists. In the face of these grave challenges, the Communist Party of China was formed in 1921, appealing to the masses that as leaders of the people they would resolve such problems. After a protracted struggle between various political factions, the Communist Party seized power in 1949. But, alas, the Party was set to become the dictator. This outcome is perhaps not surprising since the Communists saw themselves as the most conscious of the working class and its vanguard, believing that as such they were always correct in their ways and therefore had the right to control the fate of the country and the people. They turned themselves into dictatorial bureaucrats, and remain so to this day.

How did Dahlgaard's *Dough Portraits* help us to reflect on the events of 1911, 1949 and since? Well, putting dough on one's head was like the people of China in 1911 cutting off their pigtails, which symbolized the old society, in that it challenged the norm. It was an act of self-determination, if not defiance against convention. And while one's clothes were still identifiable with the lump on the head, the act made each sitter faceless – and that is the nature of history. When the masses took part in the revolutionary movement, the historical record would hardly document them clearly or vividly. Even if we may sometimes see individuals' faces, they remain anonymous, nameless. Only the leading revolutionaries, their faces and names, would be seen and known in the history books, even if the masses played a more important role than those so-called leaders. Without the support of the masses, there could have been no revolution.

The *Dough Portraits* revealed another important lesson for us. While we the people may be faceless, we are all individuals and all different. Not only were the sitters each different because they wore very varied and individualized clothes, but also every person's dough took on unique shapes and forms – each had a life of its own. Everyone in a revolution has a place and story, and each is different from the next.

Today, 104 years after 1911, the people of Hong Kong are still fighting for freedom, democracy and equality. Now, though, we use yellow umbrellas to protect ourselves from the tear gas of the authorities, our faces hidden and unseen. I look at the photographs of the Umbrella Revolution of 2014 and try to imagine dough covering the heads of the protestors instead of the umbrellas.

But when I look at the *Dough Portraits*, above all I remember the creative process – a process that was interactive and collaborative. First there was the willingness on the part of the sitter to submit: to have dough put on his or her head and then allow him- or herself to be photographed. Then there was the active role that each individual assumed. While the artist may have been the director, leading the process, it was the person beneath the dough who shaped the material the moment they applied it to their head. Perhaps this is a lesson for us, the faceless masses, for setting up the new society?

Much hilarity ensued for both young and old during the *Dough Portraits* session at the JCCAC, although for some the project raised serious questions about the issues facing Hong Kong and Chinese society.

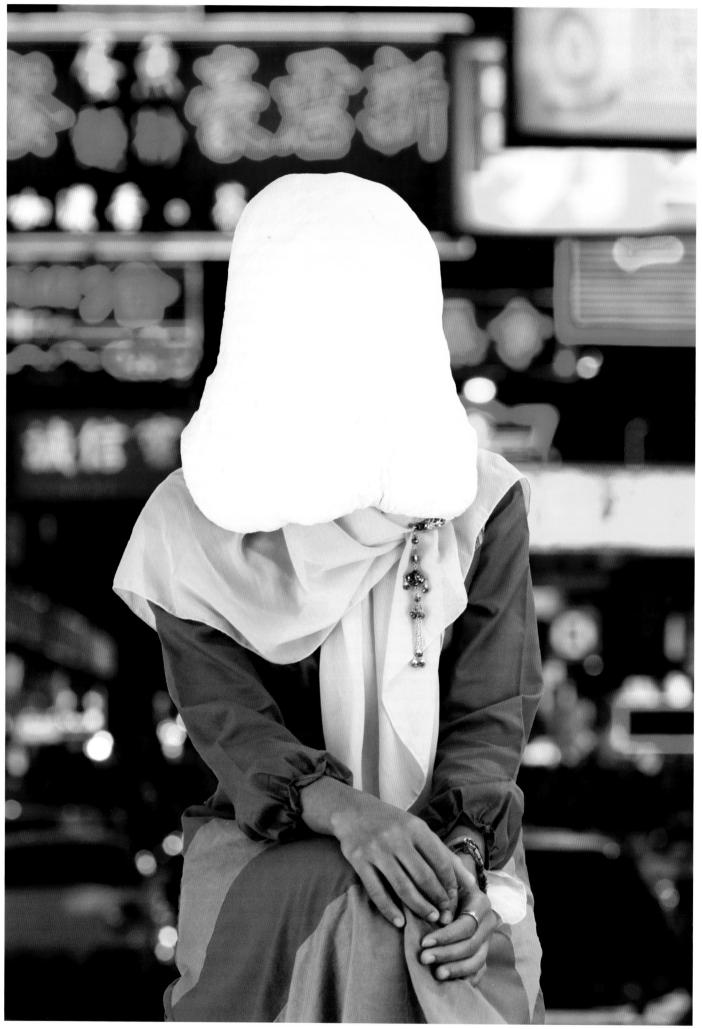

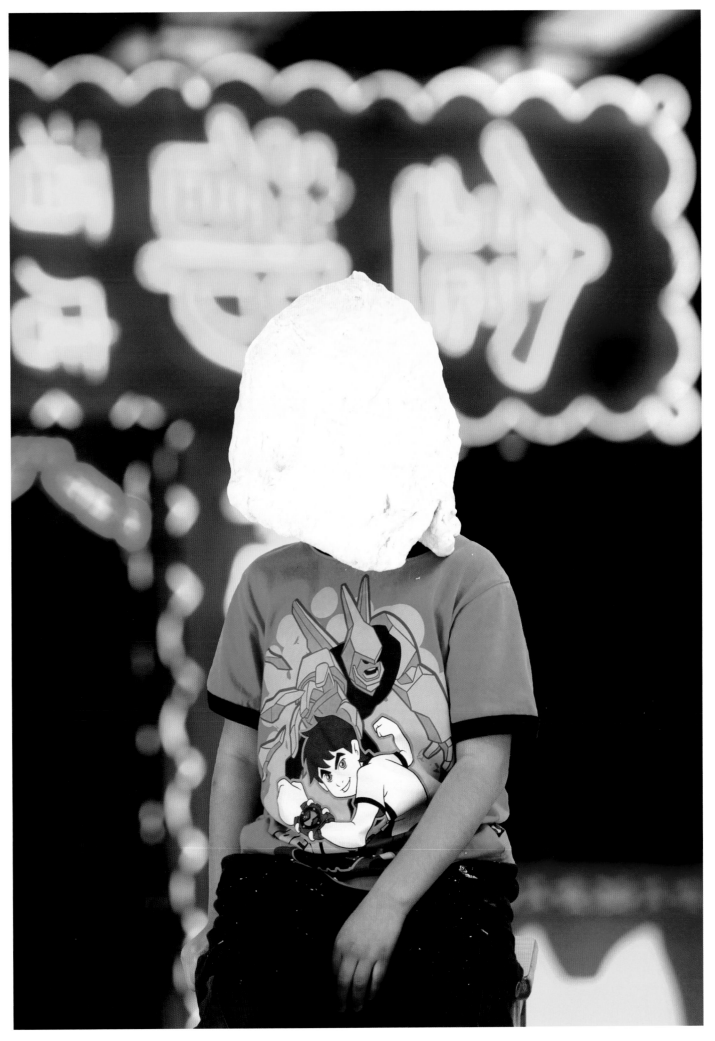

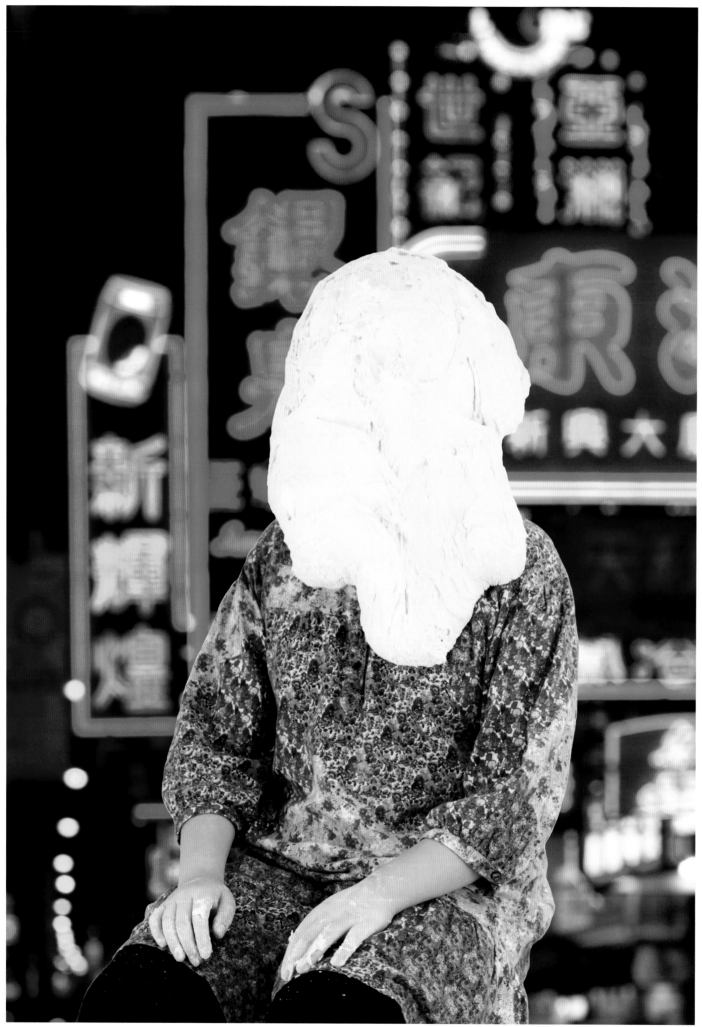

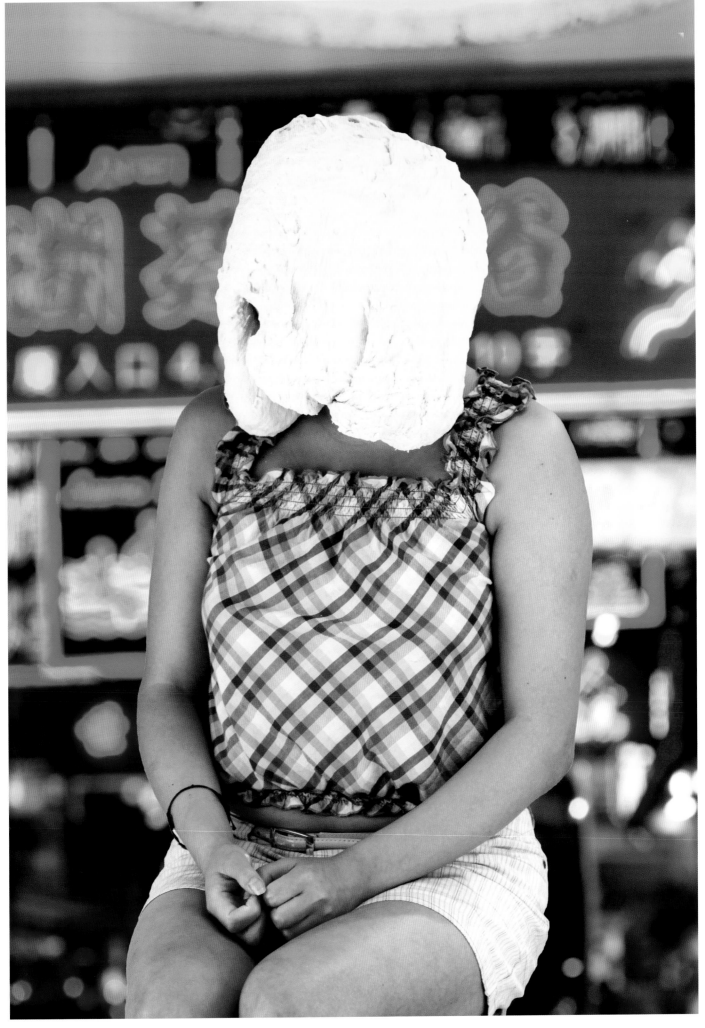

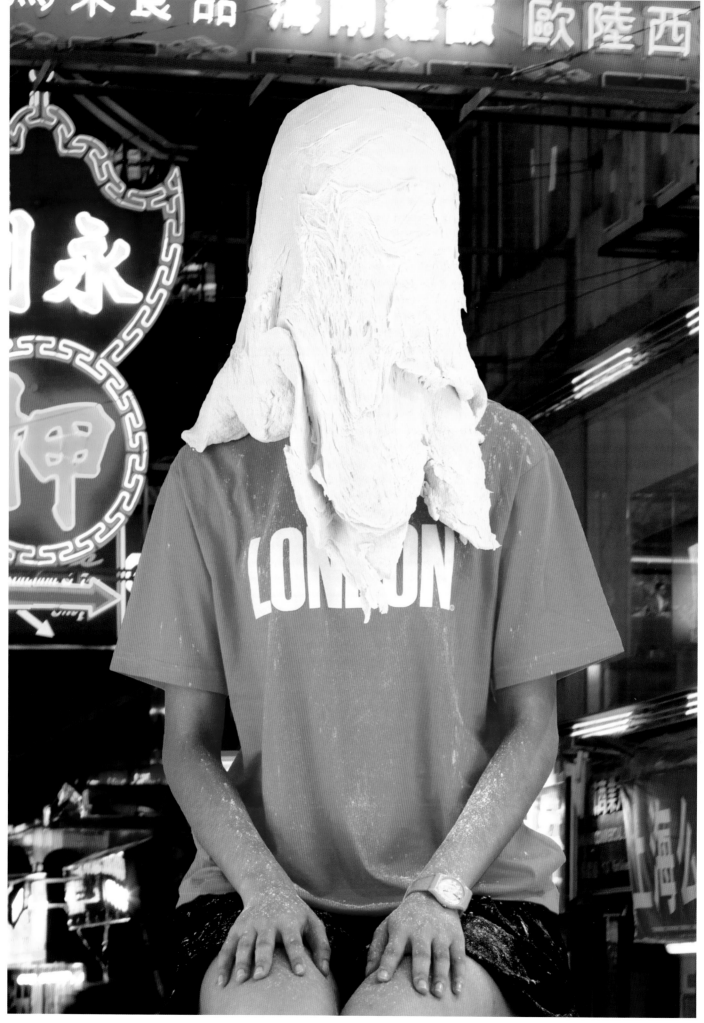

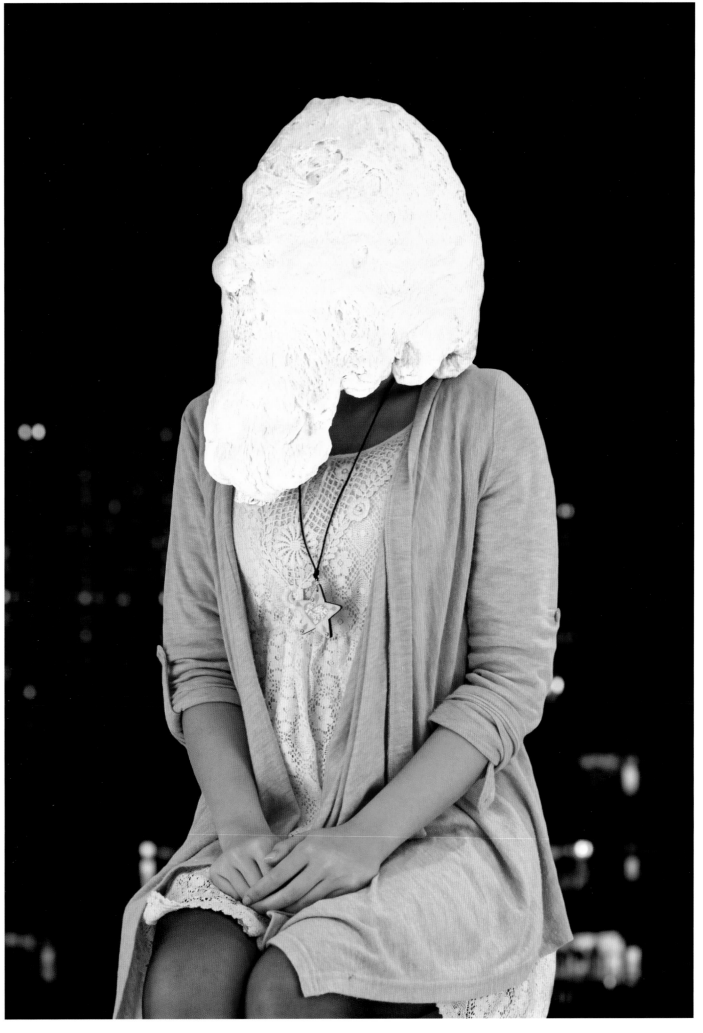

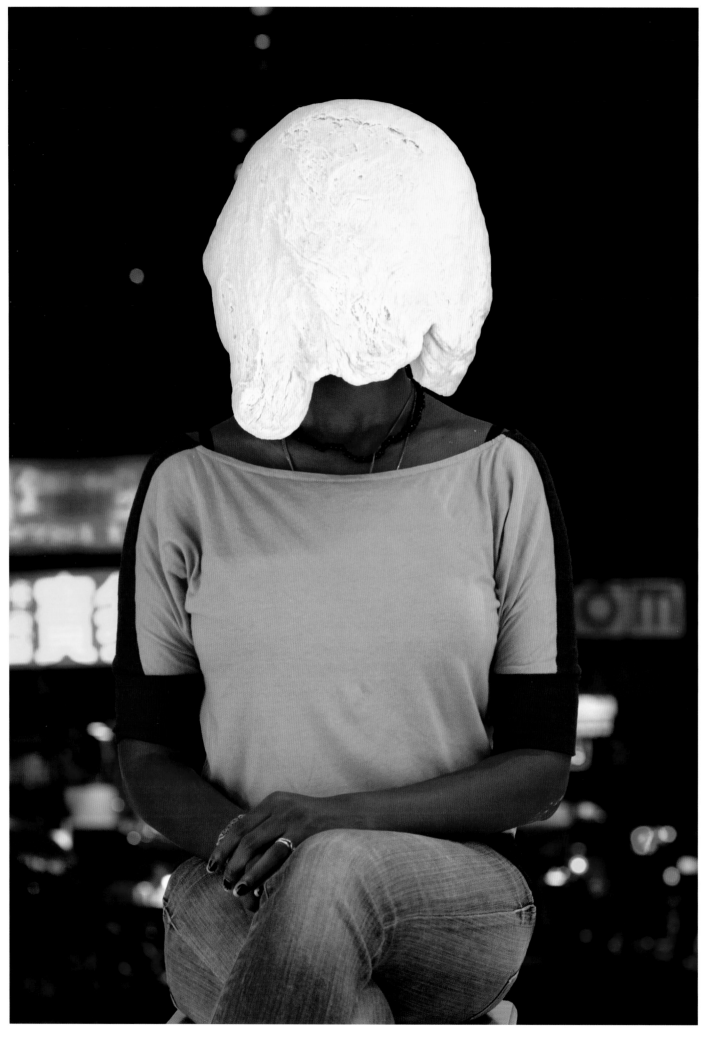

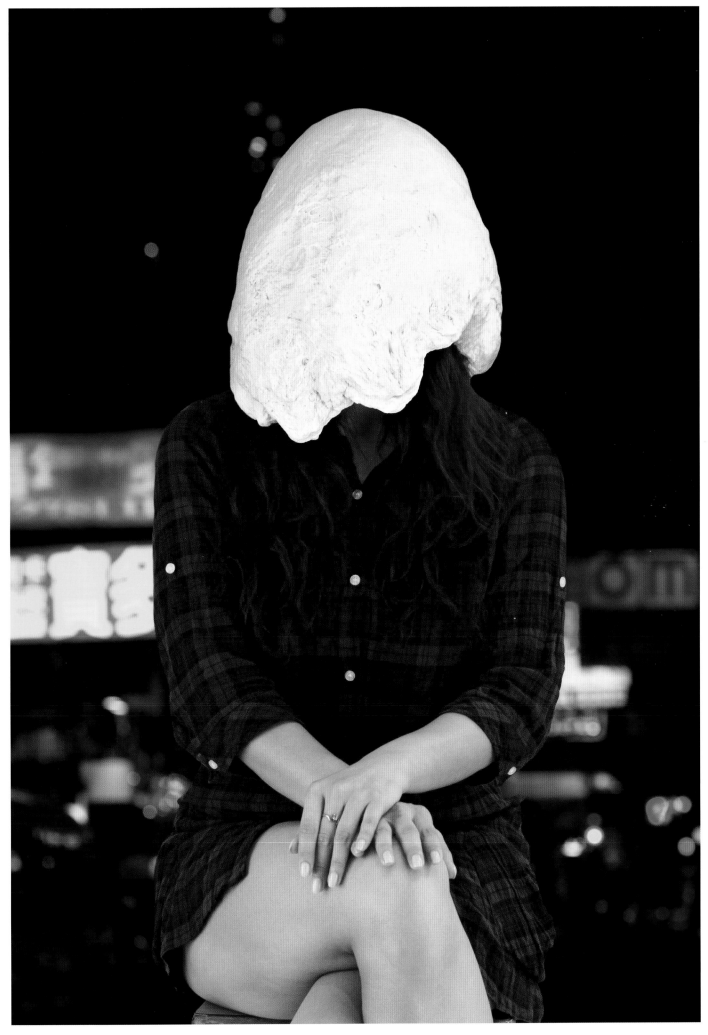

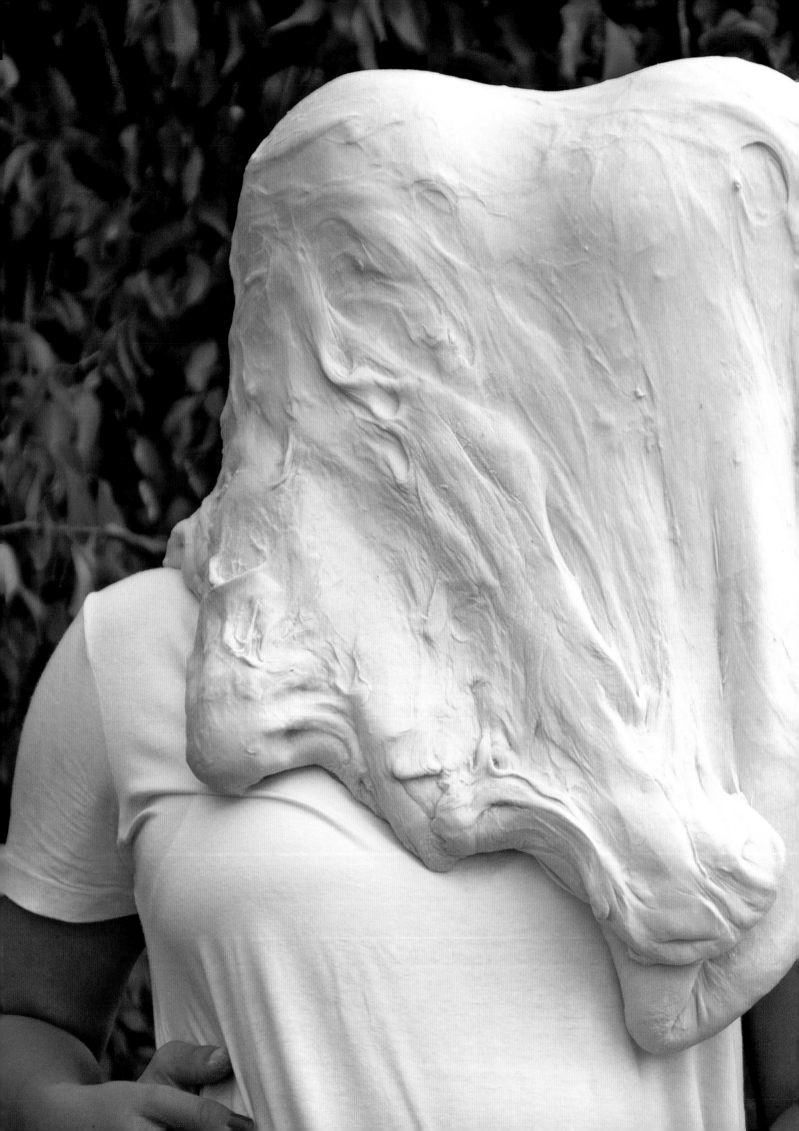

ECCO CONTEMPORARY CULTURE CENTER, BRASILÍA

YEAR **2011**
IMAGES **204**

THE BEAUTY OF CHAOS

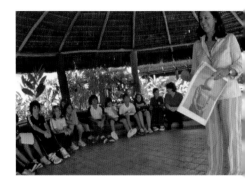

The first time I encountered Søren Dahlgaard was at the Foto Triennale in Odense, Denmark, in 2009, where he was presenting images of his Dough Warrior persona as it painted 'landscapes' on hedges. I was immediately impressed by the strength and viscerality of the work, which challenged the traditional pictorial narrative and brought fresh and renewed vigour to contemporary painting. I thought his spontaneous and intelligent way of creating art and the utopian ideas revealed in his various projects were not only innovative, but also coherent as a whole. I have been following his progress ever since, always enchanted by his highly individual approach to thinking about and making art.

KARLA OSORIO NETTO
DIRECTOR, GABINETE DE ARTE K2O, BRASILIA

One could say that Dahlgaard's work is strongly linked conceptually with postwar Japanese performance, New York's vanguard movements of the 1960s, and even 1970s land art. But he brings new elements to these artistic precedents, especially humour and irony, which are particularly evident in his live art and staged photographic series. His works incorporate performance, gestural production and random process, frequently enacted in front of an audience and often with the use of his own body. In several series, such as the *Dough Portraits*, another person becomes central to the work, resulting in a dynamic and intriguing process that subverts traditional methods of creating art. In some situations, the gallery is at once the artist's studio and the exhibition space, the place of both creation and display, whose traces remain in the final result.

In 'The Beauty of Chaos: Expanded Painting', a solo exhibition that I organized at ECCO – Contemporary Culture Center in Brasília in 2011, we had evidence of that. The show gathered, in one large and seemingly chaotic – but, in fact, highly organized and precisely curated – space, several bodies of work by the artist. These included his *Dough Portraits* and *Painting Portraits* series, both of which have an interactive element where the public plays an essential role in a performative act that is at once collective, curious and unique. In each case, there is an initial impact as we see faceless figures and wonder what is going on. Is this some comment on censorship, perhaps? But then one sees that actually these series are about identity. How much of an individual's identity is found in their face? How much is expressed by their body language? But these works also raise the question of the subject's place in the creation of the work, for here the role played by the portrayed

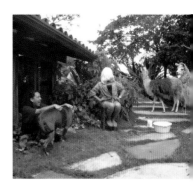

person is brought to the fore. These series reveal that every portrait, even the traditional painted version, is more than just a depiction generated by an artist contemplating a sitter from a distance, but the result of a close interaction with an active subject who has influence over the representation.

Nature, organic materials and everyday items are the staples of Dahlgaard's creative process. Plants, vegetables, bread, utensils and decorative objects are used as tools, but also become artworks in their own right. In each case, the artist seeks to break down existing technical and conceptual paradigms to find new meaning. As a material, dough, which is made from wheat flour, is rich with philosophical, spiritual and symbolic allusions, many connected with the origins of human existence. Wheat is the source of life, its transformation and processing into bread providing us with sustenance of the most basic but also the most essential kind. Dahlgaard draws on these allusions not only in the *Dough Portraits* and in his sculptural pieces fashioned from the material, but also when he transmutes himself into the Dough Warrior. This character, with a mixture of comic and mechanic traits, embodies pure creation as it explores the origins and essence of painting in the most spontaneous, crude and almost violent of ways. He is not the first artist to find inspiration in wheat's symbolism and spiritual significance, however. Vincent van Gogh considered wheat to be a metaphor for the cycle of human life – 'We, who live by bread, are we not ourselves very much like wheat ... to be reaped when we are ripe?', he wrote in a letter to his sister – but also thought that it stood as a celebration of growth, regeneration and the power of natural forces. At the same time, the Dutch artist saw the processes of ploughing, sowing

and harvesting as symbolic of humankind's efforts to overcome these very forces. Dahlgaard, too, explores these and related ideas with his dough-based work, which revisits traditional forms such as still life, portraiture and landscape of the kind practised by van Gogh, reinterpreting them in bold and innovative ways and injecting them with challenging, contemporary thoughts and references.

The 'chaos' that Dahlgaard presents to us has great aesthetic beauty, besides presenting new perspectives on the possibilities of painting and performance. The displacement of universal elements such as bread and the body to new uses, and the audience's essential participation in the work's production, lead us to reassess our understanding of the commonplace in the making of art. The French philosopher and art historian Georges Didi-Huberman once wrote that 'seeing is losing': that is to say, we become aware of what we are seeing only in the moment that it disappears from view. Perhaps by shrouding our heads with lumps of dough, we can widen our vision of what art is and can do.

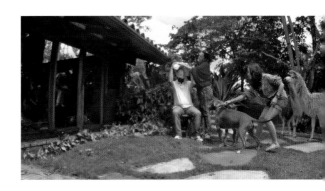

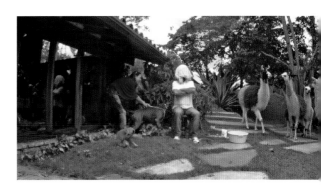

Karla Osório Netto enjoys explaining the process to students at the Escola das Nações, the School of the Nations (opposite), before leading a private and near chaotic session in her own garden – assisted by her energetic dog and a friendly family of llamas (top and above).

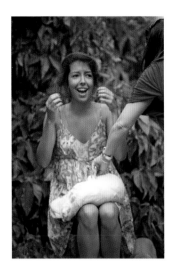
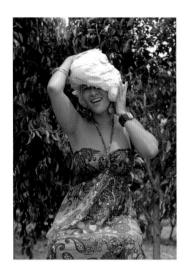
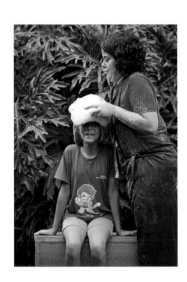

More than two hundred participants sat for portraits at three sites in Brasília – ECCO, Ação Social do Planalto and Escola das Nações. Among them were Rafaela, Abigail, Natália, Valdir and Glênio (left to right), Josefa (opposite, bottom left) and Milene (opposite, bottom right). Even Karla got doughed in the end (below).

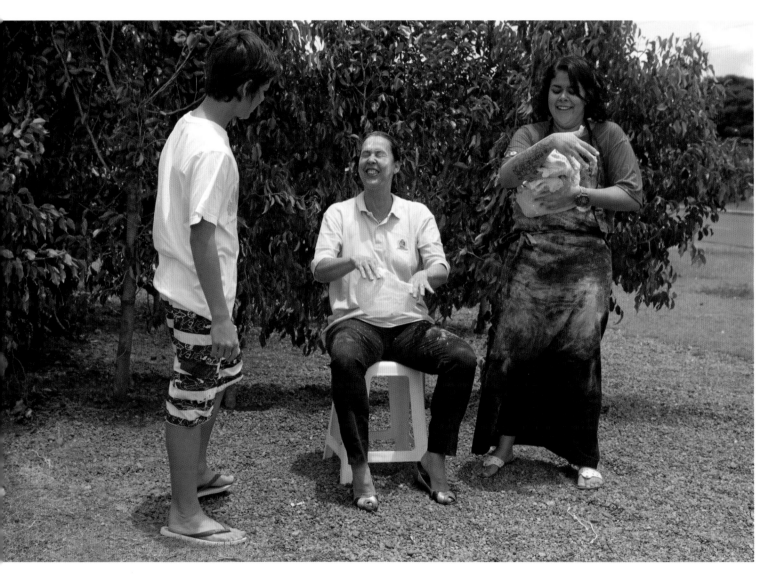

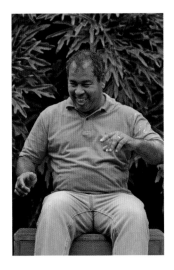
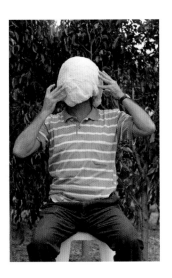
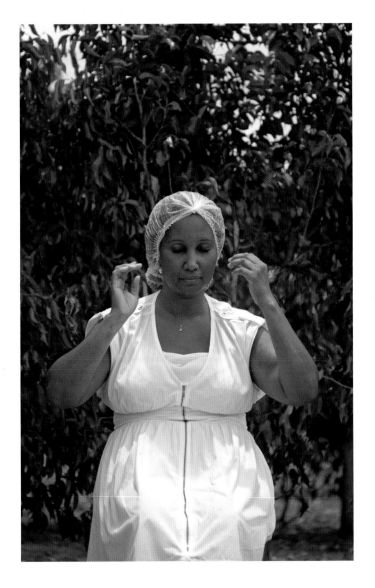
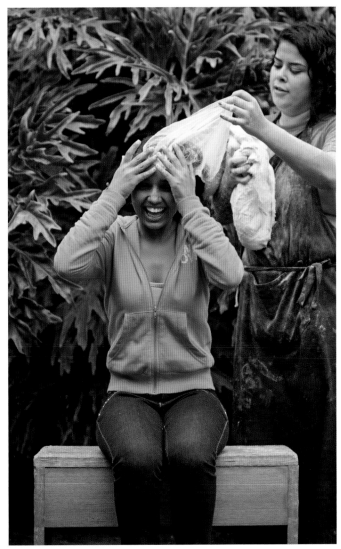

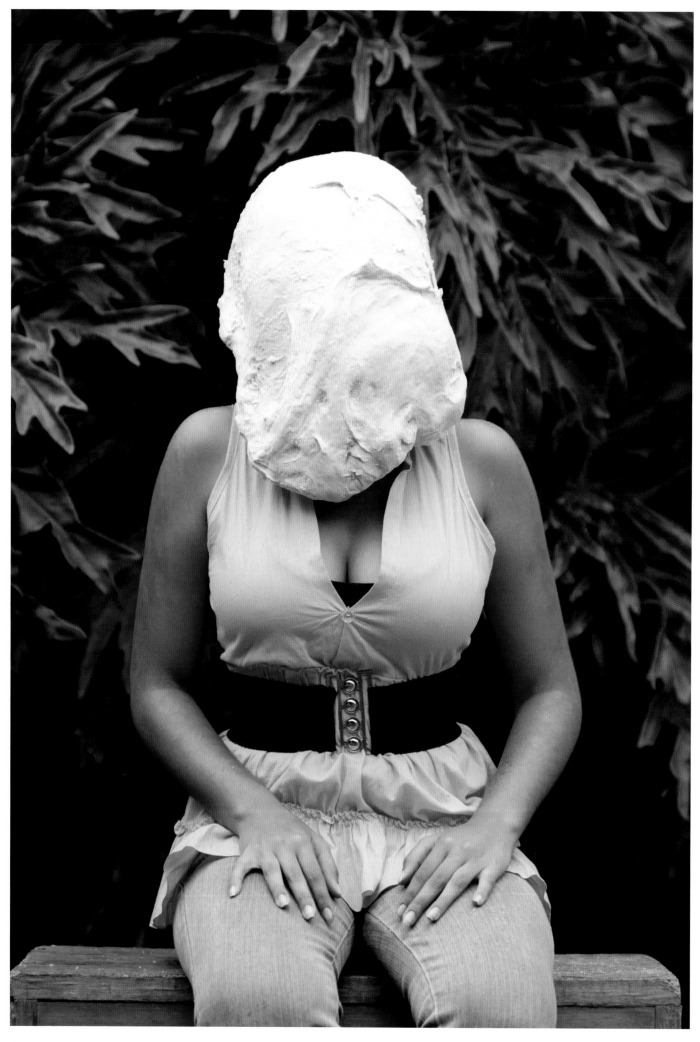

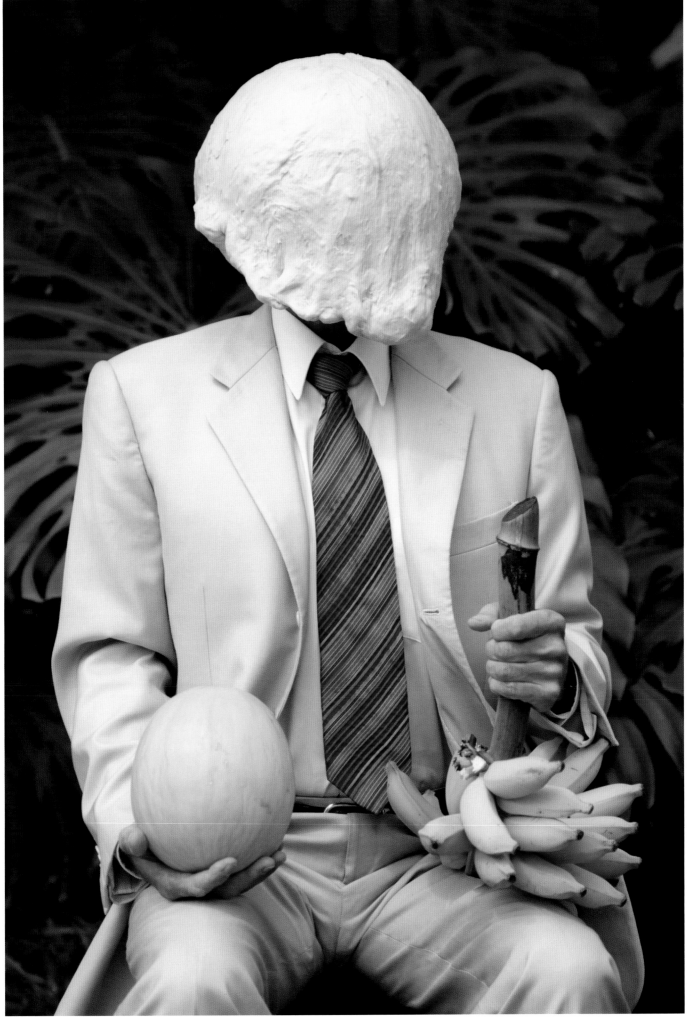

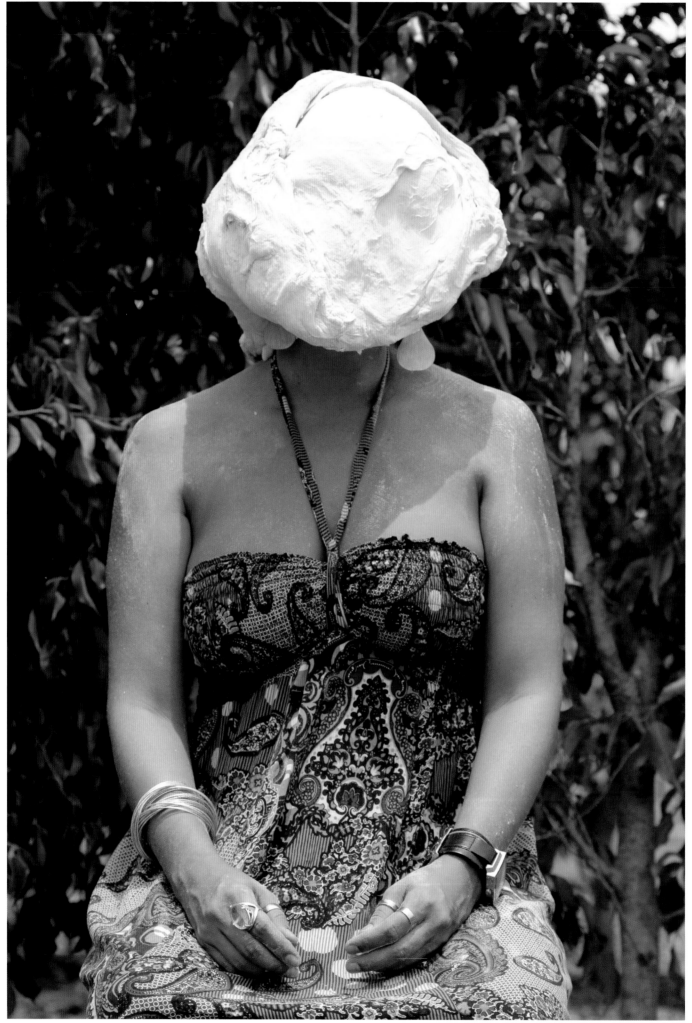

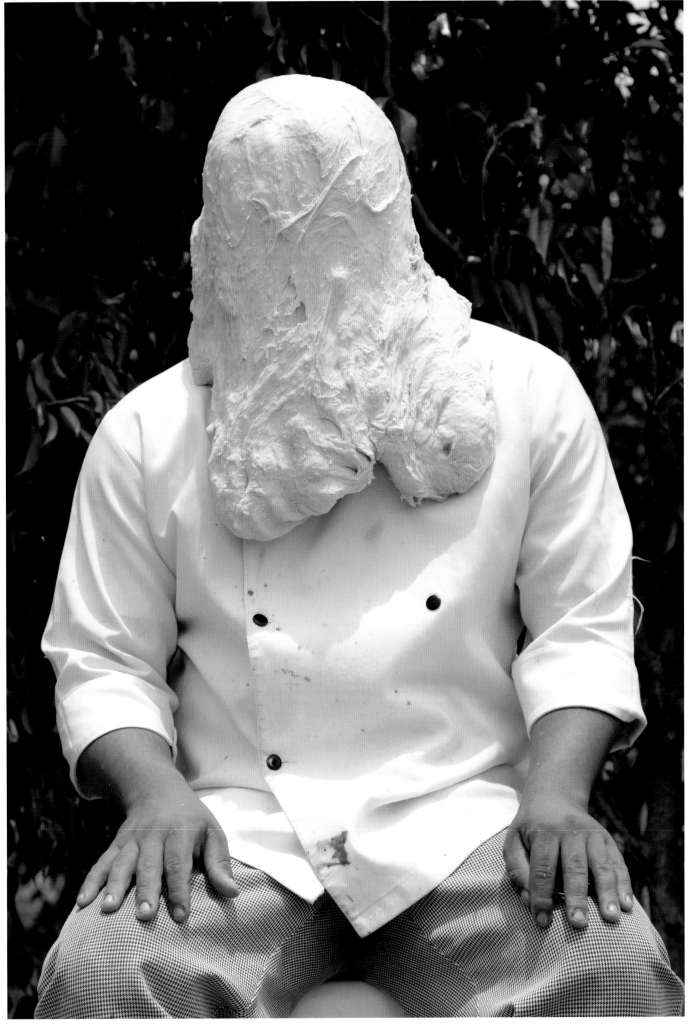

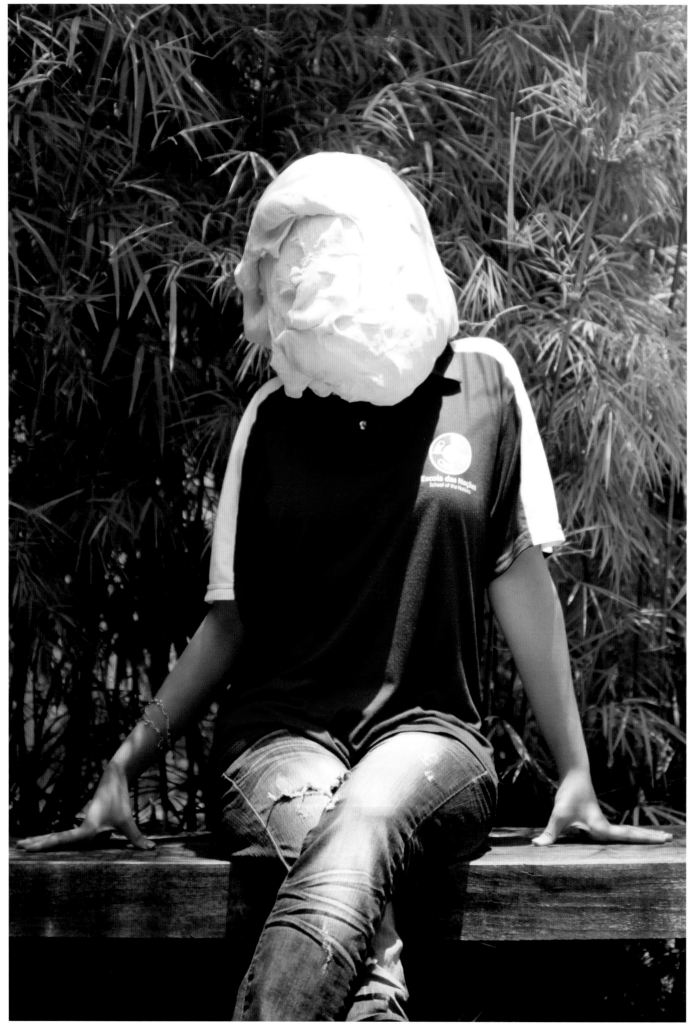

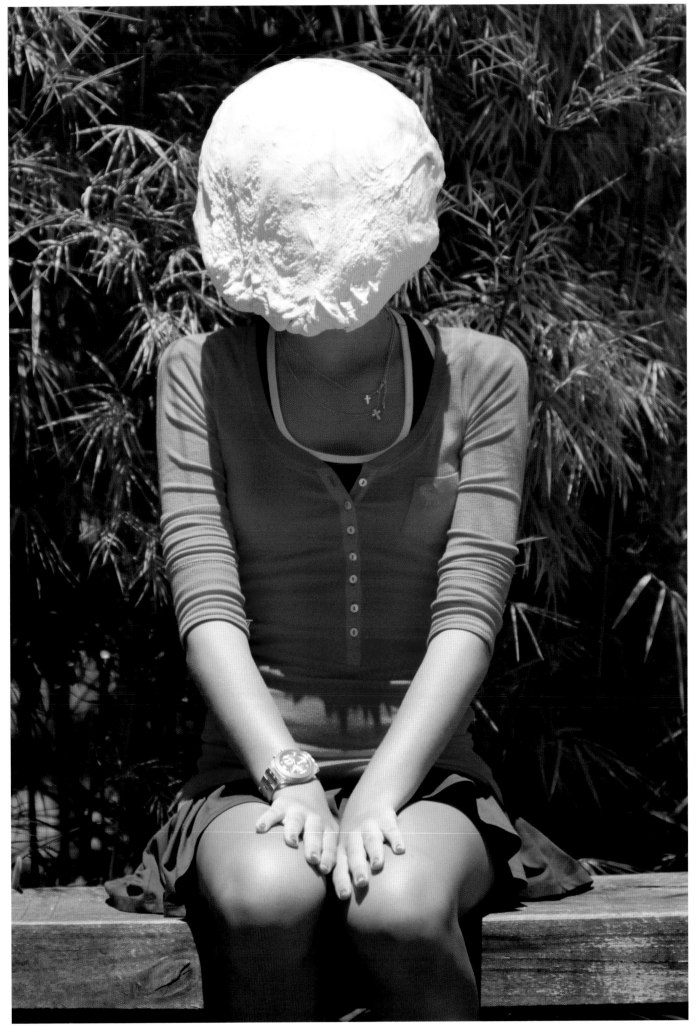

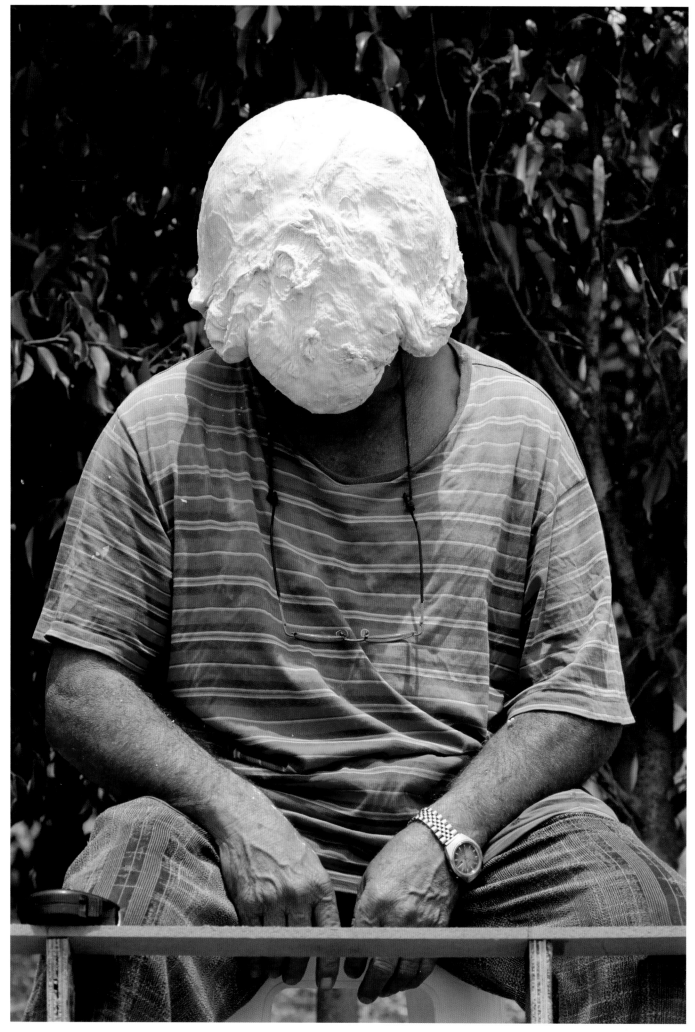

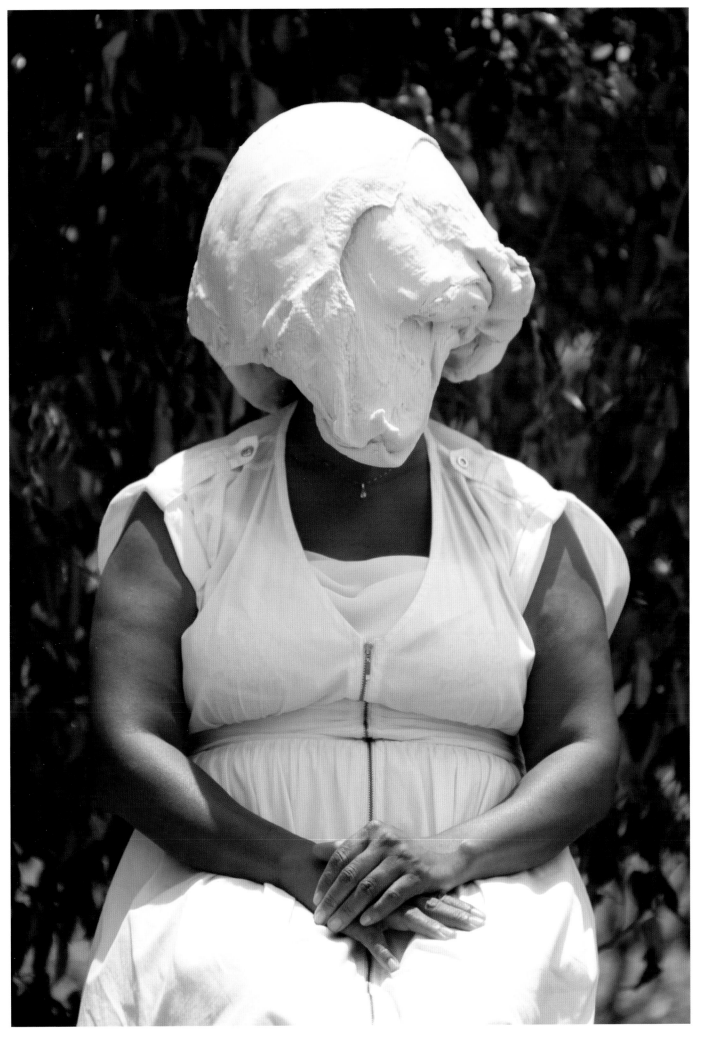

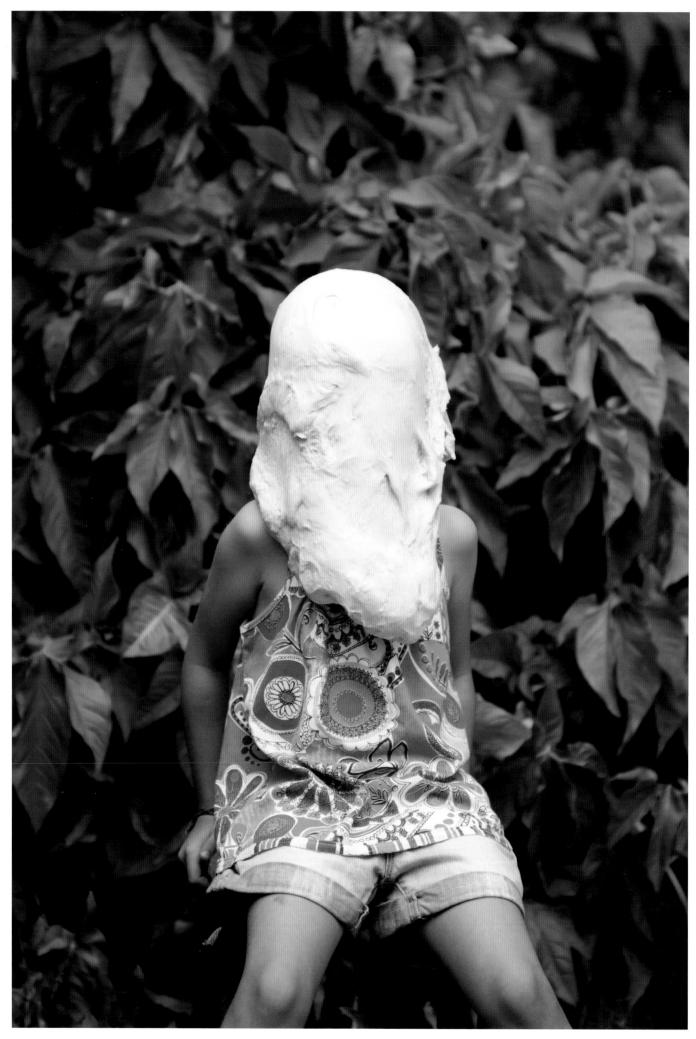

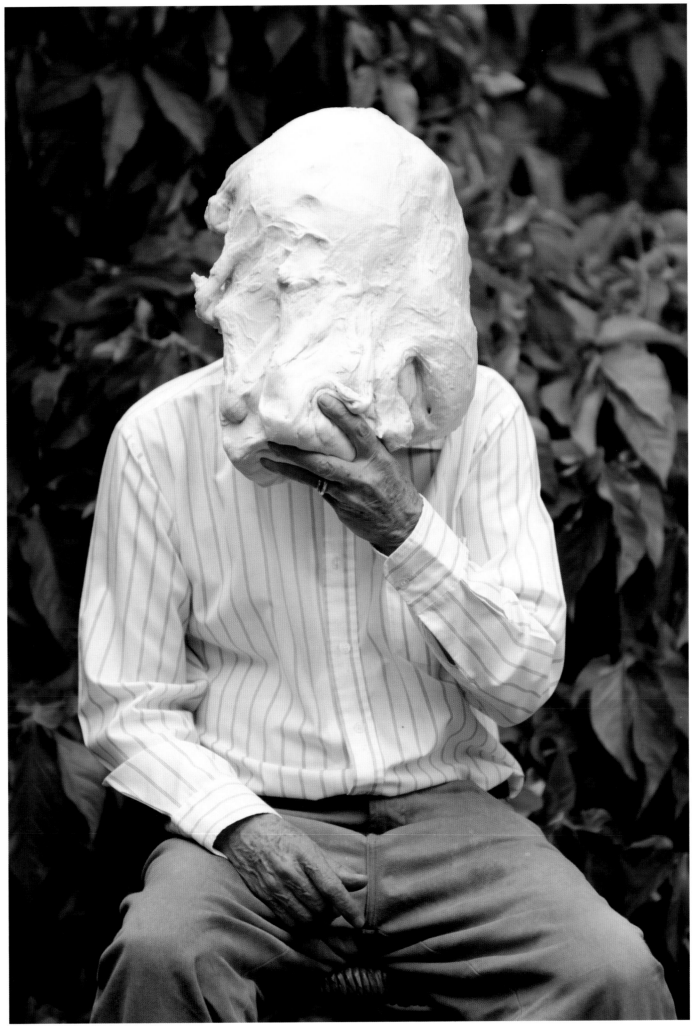

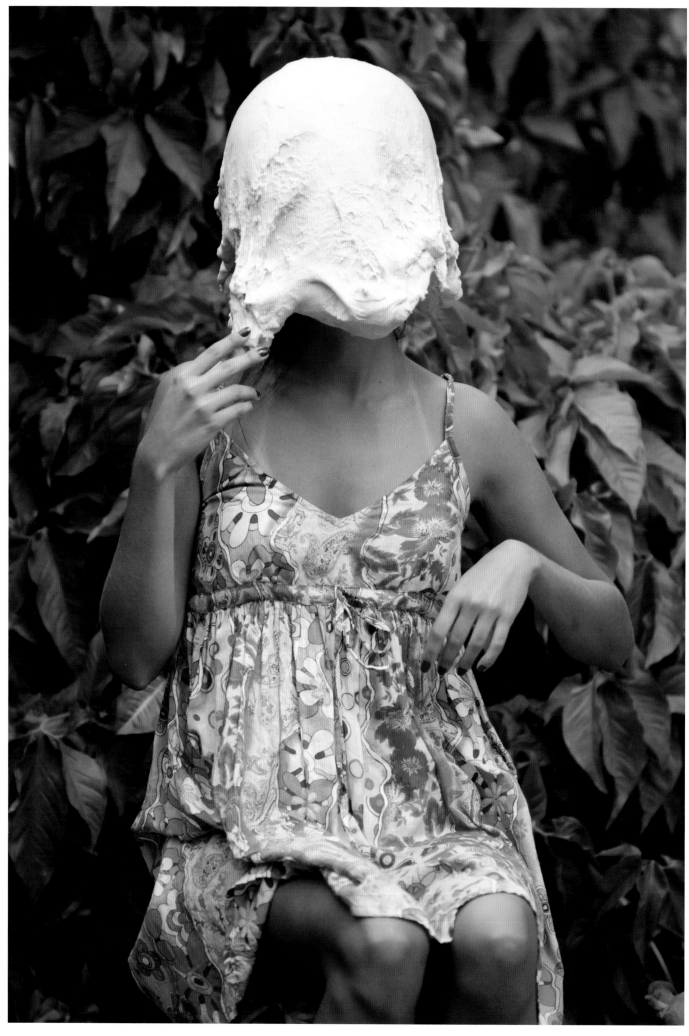

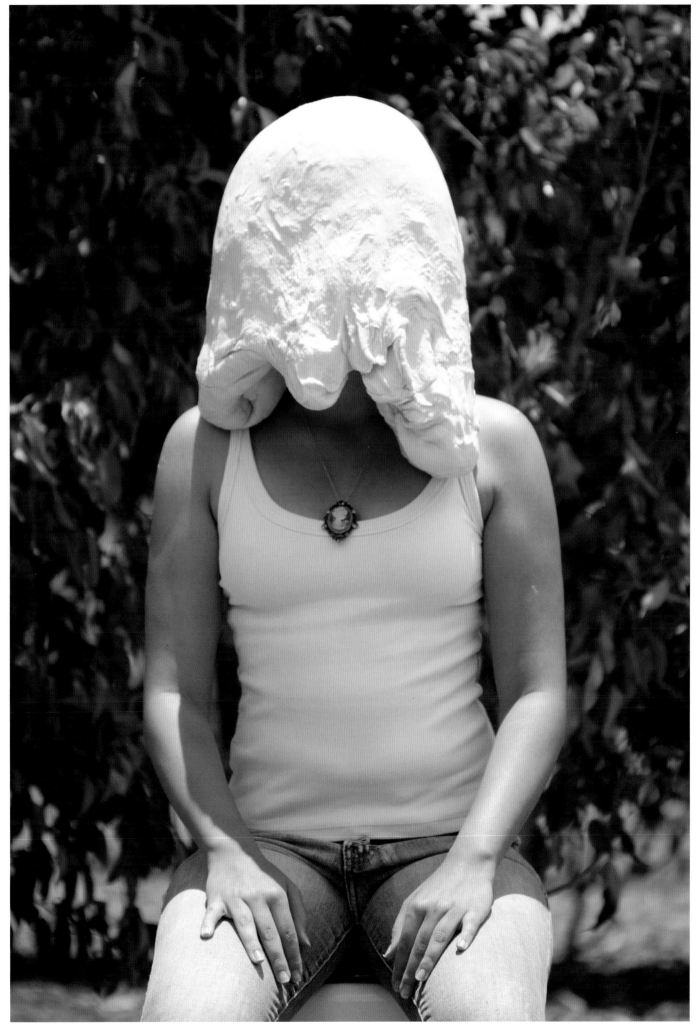

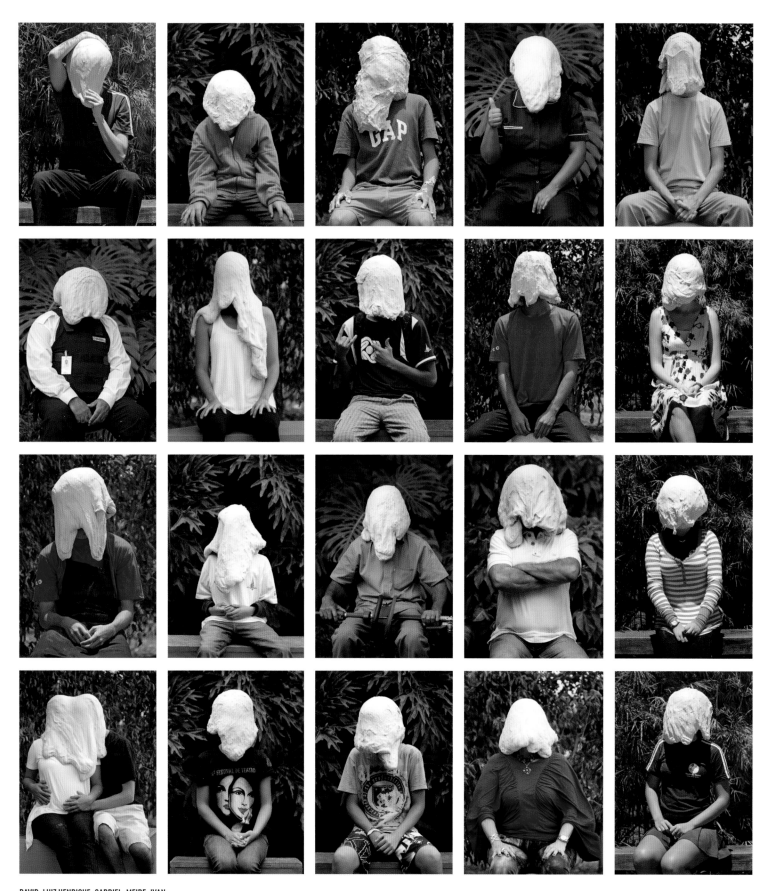

DAVID; LUIZ HENRIQUE; GABRIEL; MEIRE; IVAN
RAIMUNDO; DANIELLE; ALLEPHE; JEREMIAS; CARA
DANIEL; LUCAS; VALMES; ANTONIO; ALINE
MARCELA AND IVAN; DANIELA; MICHAEL; KARLA; MARIA

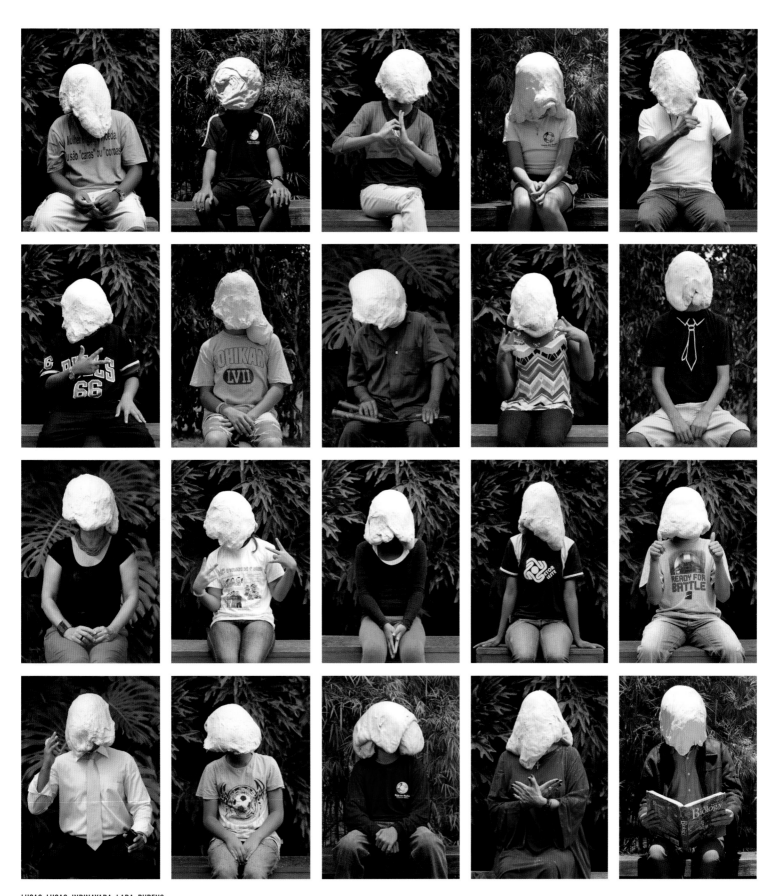

LUCAS; LUCAS; INDINAYARA; LARA; RUBENS
LORRAN; ANDRE; MANOEL; ESTER; IVAN
ANNE MARIE; VANESSA; ANA CATARINA; ADRIADNY; LUCAS
MARCELO; GUILHERME; HENRIQUE; NATANRY; GETÚLIO

GWANGJU BIENNALE

YEAR **2012**
IMAGES **80**

THE VANITY OF
HUMAN GREATNESS

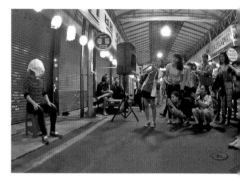

Søren Dahlgaard and I met in Beijing, China, in September 2009.
We were both there as participants in the 10th Open International
Performance Art Festival, the world's largest showcase of performance
and live art. Between four and six hundred international artists were
invited to take part in the festival, which was held over two months
at the Beijing 798 Art Zone, a vast decommissioned military factory
complex that is now a thriving art and culture area.

GIM GWANG-CHEOL
ARTIST, GWANGJU, SOUTH KOREA

Each week of the festival had a different curator
and set of artists. Søren and I were both taking
part in the sixth week, curated by Jane Jin Kaisen
from Denmark. We were two of more than forty
participants that week. Jane suggested that I put
on a solo exhibition of my previous performance
pieces rather than a single work. With great joy
and confidence, the process was going well.

During this week in Beijing, Søren introduced
himself to me and invited me for a coffee.
We walked around a bit, at last found a cafe,
and sat across the table from one another.
We talked for a while. 'Are you a part-time
artist or full?' he asked. 'Full-time', I replied.
'So am I', he said, smiling. Then he showed me
his catalogue, and like many artists we were able
to build a bond of sympathy through works.

A few days later, he said to me, 'Gwang-cheol,
I have my show in few days' time. As you've seen
from my works, I'm choosy when picking a model,
but I like your images. Can you be a model for
my performance?' Now, I do not normally act
as an assistant for other artists. Yet because of
his earnestness, which was apparent to me even
within a short time of our meeting, I knew that
he was a serious artist. So I thought about his
request for a while, but gladly accepted the offer.

On the day of his show, he prepared my costume,
which would soon become wet. A woman chosen
by him and I were sat down on chairs, facing
forward. Without any sound, Søren came out, as if
a skilled *Meister* in a factory, with long baguettes

all over his body. He then dripped and smeared coloured paints across my face from the sticks of bread and poured more colours from the top of my head down my body, solemnly. It felt special. The cold pigment dribbled down my face and onto my neck, down my chest and stomach and onto my legs. It finally covered my entire head, and I closed my eyes. Soon, the only sense left was the touch of the bread and the flow of the paint.

The show finished. I cleaned up and looked at the pictures. They were strange but humorous and interesting. We were like 'colour people'. Søren was satisfied and smiled, which I like very much. His nice big smile. We exchanged email addresses and became firm friends.

Three years later, in the autumn of 2012, I was director of the Gwangju International Media Arts Festival, which was held as a collateral event of that year's Gwangju Biennale. The festival went on for a week, for which I prepared for nearly a year. In all, fifty-one artists from fifteen countries participated. Søren willingly accepted my invitation. At first, I wanted to present the work that he had made in China, but the harmless paints that were required were way too expensive in South Korea. So we decided to organize a *Dough Portraits* project instead.

The event took place in two locations in Gwangju: the Gwangju Biennale itself and the Daein Market. Each place had a different audience and set of participants: at the Biennale, the sitters included

grandmothers, young girls, middle-aged men and women; at the market, the majority were traders selling their wares, surrounded by all the colourful sights, sounds and smells of a bustling marketplace.

But regardless of their ages, jobs, backgrounds or views of the world, with a lump of dough on their anonymous heads, there was only the vanity of human greatness. And that is what Søren's neat and minimal works give us: an illusion of human existence. There is an acute awareness of life and death in his bright and earnest smile. Quiet, yet sharp and strong-willed: that is Søren.

The night-time session at the Daein Market in Gwangju attracted a great deal of attention from both bewildered passers-by and neighbouring market traders.

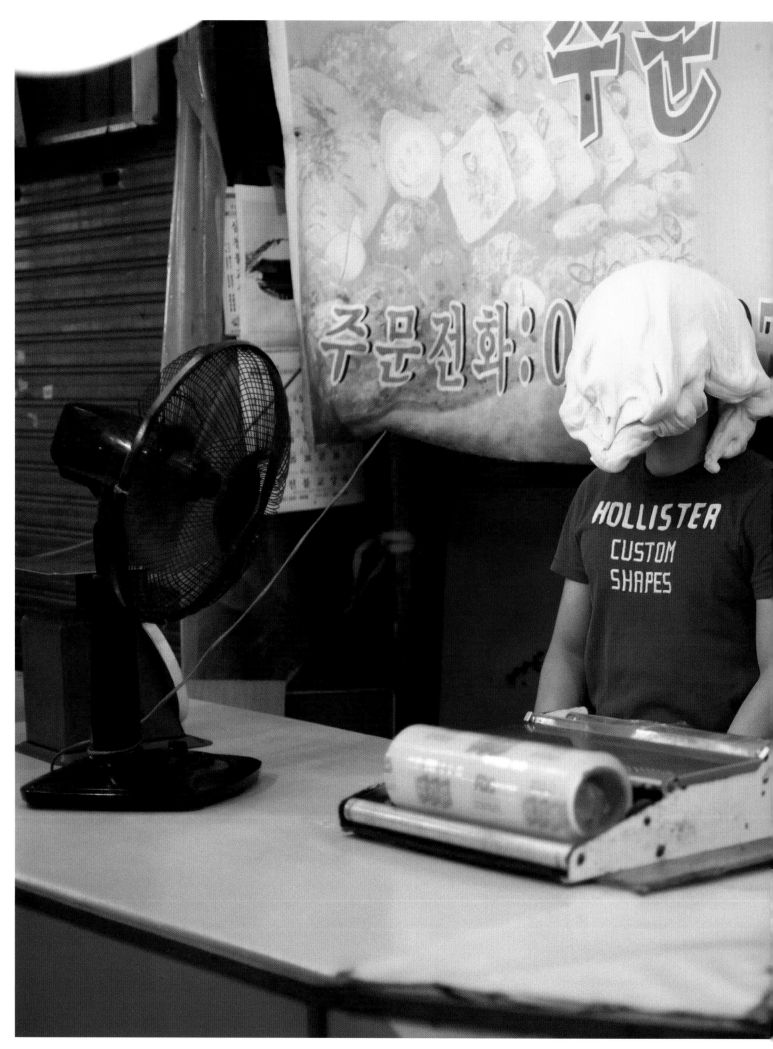

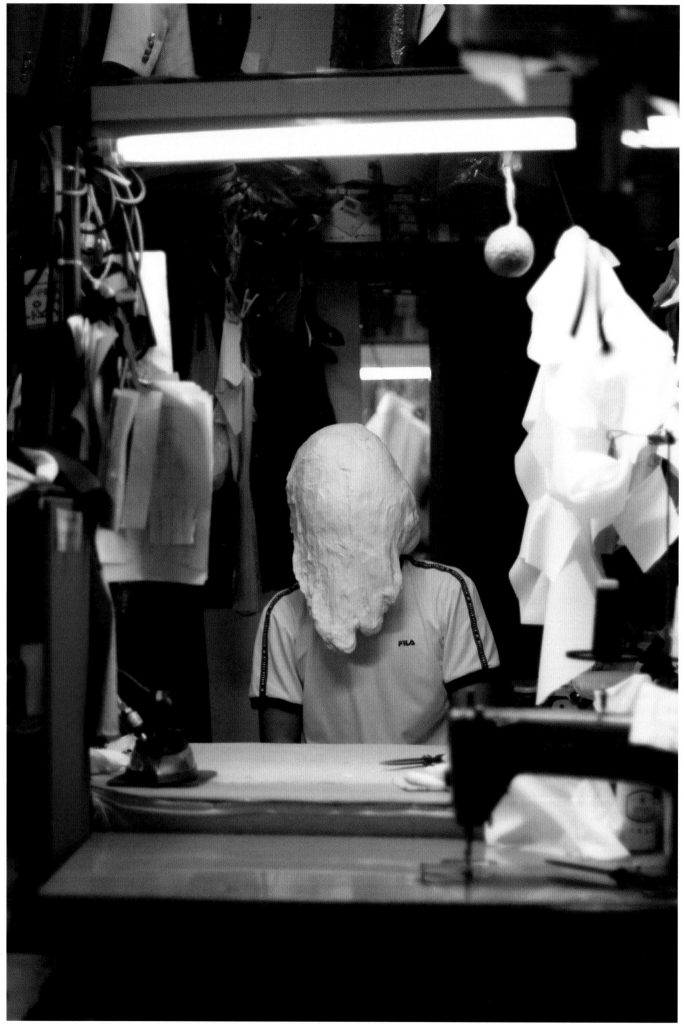

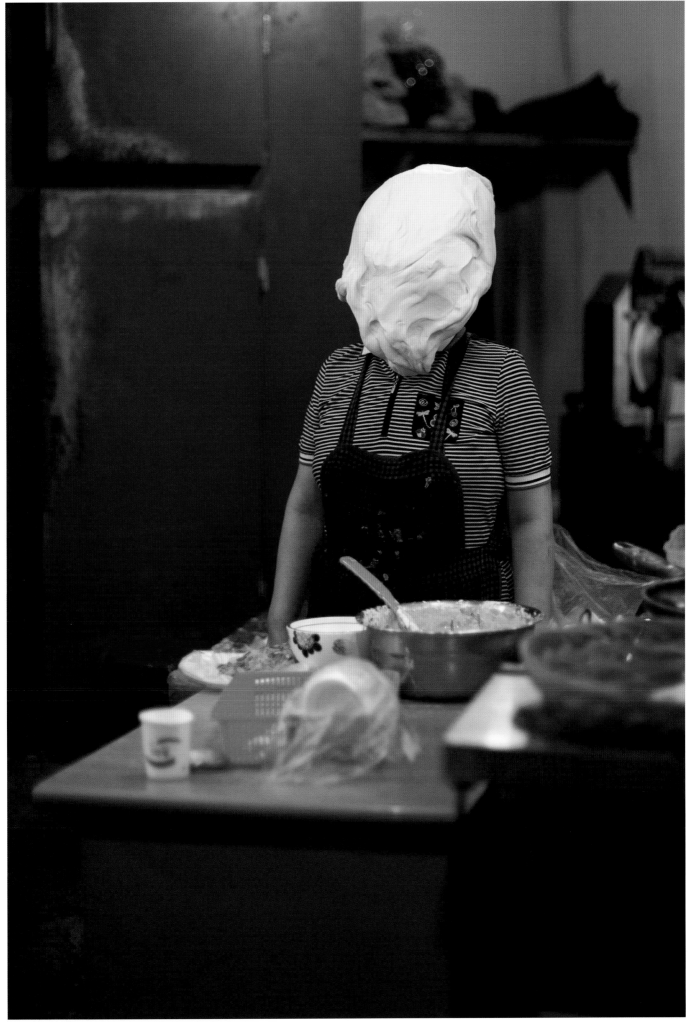

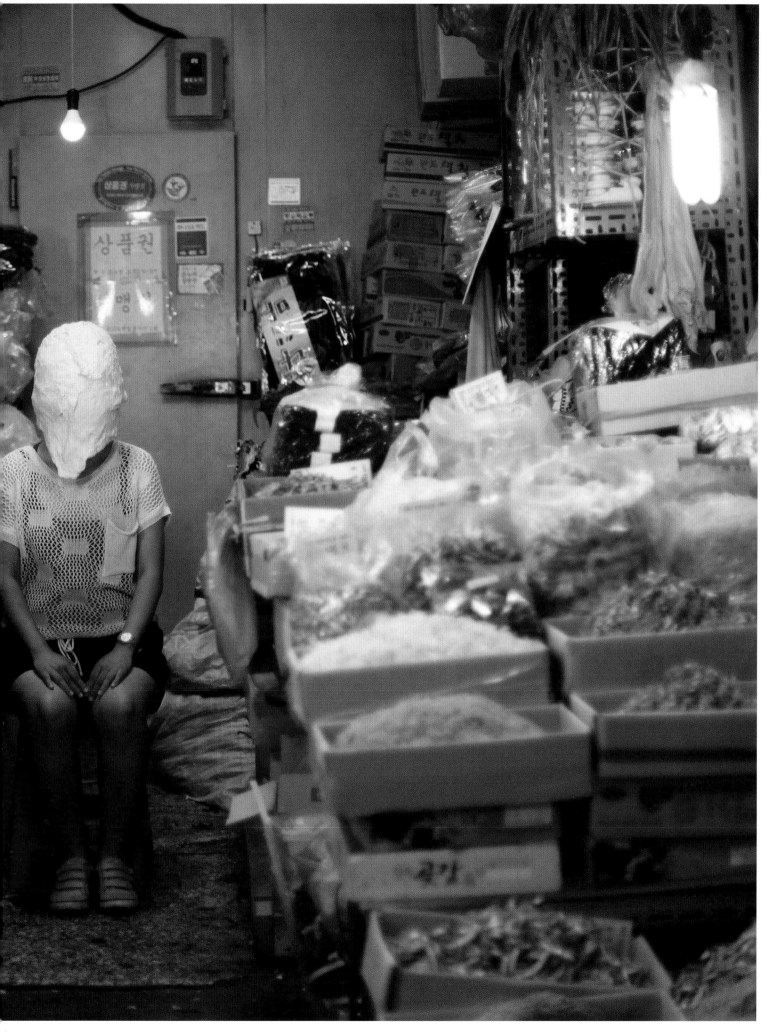

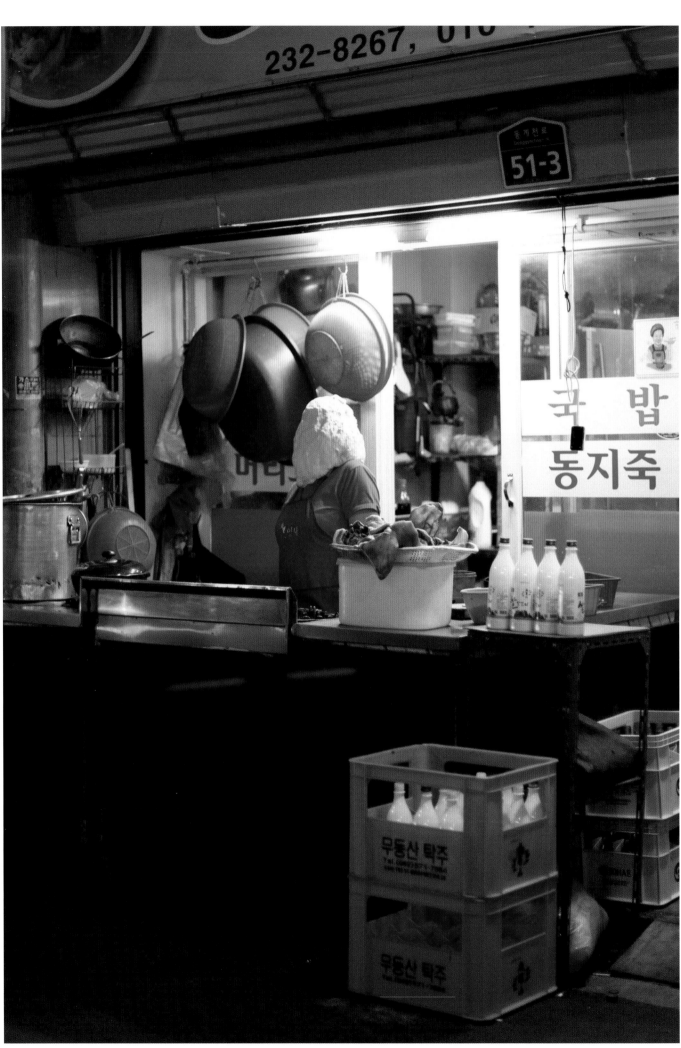

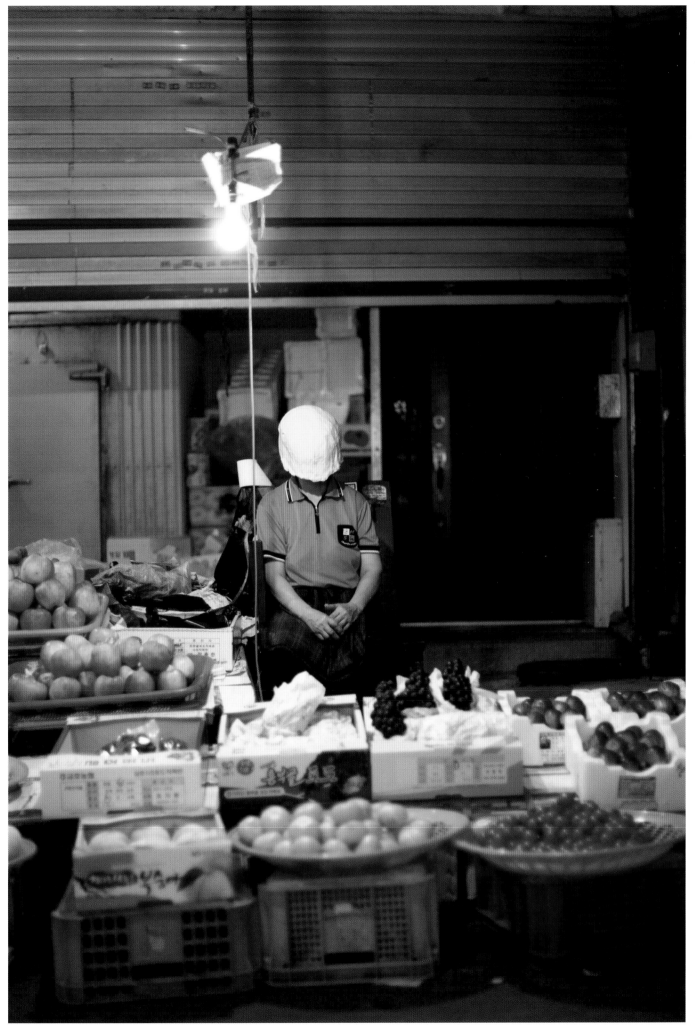

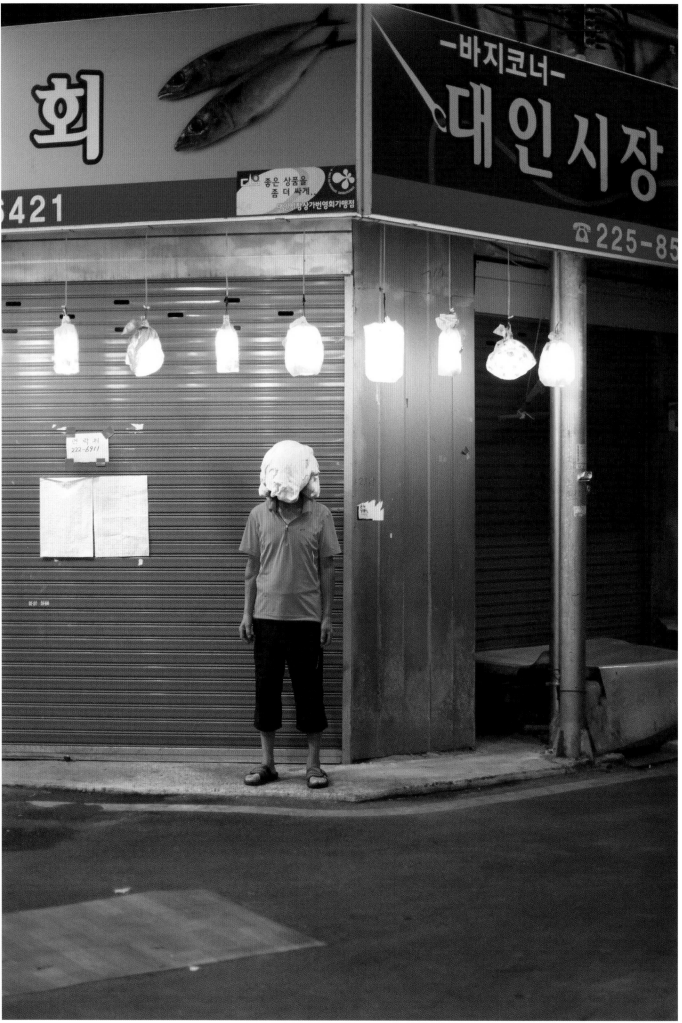

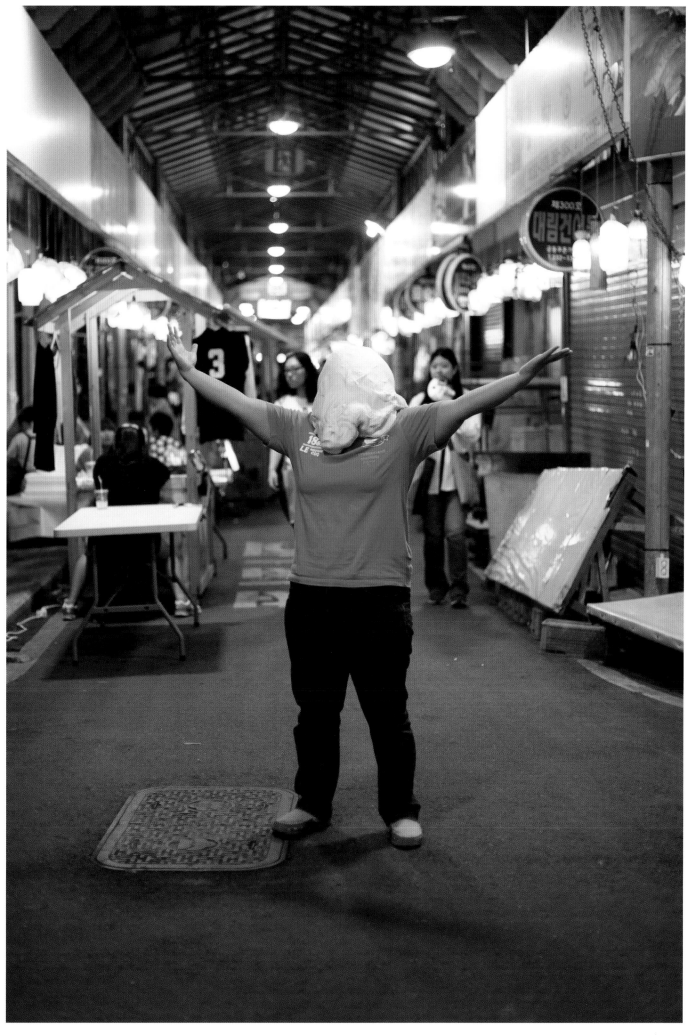

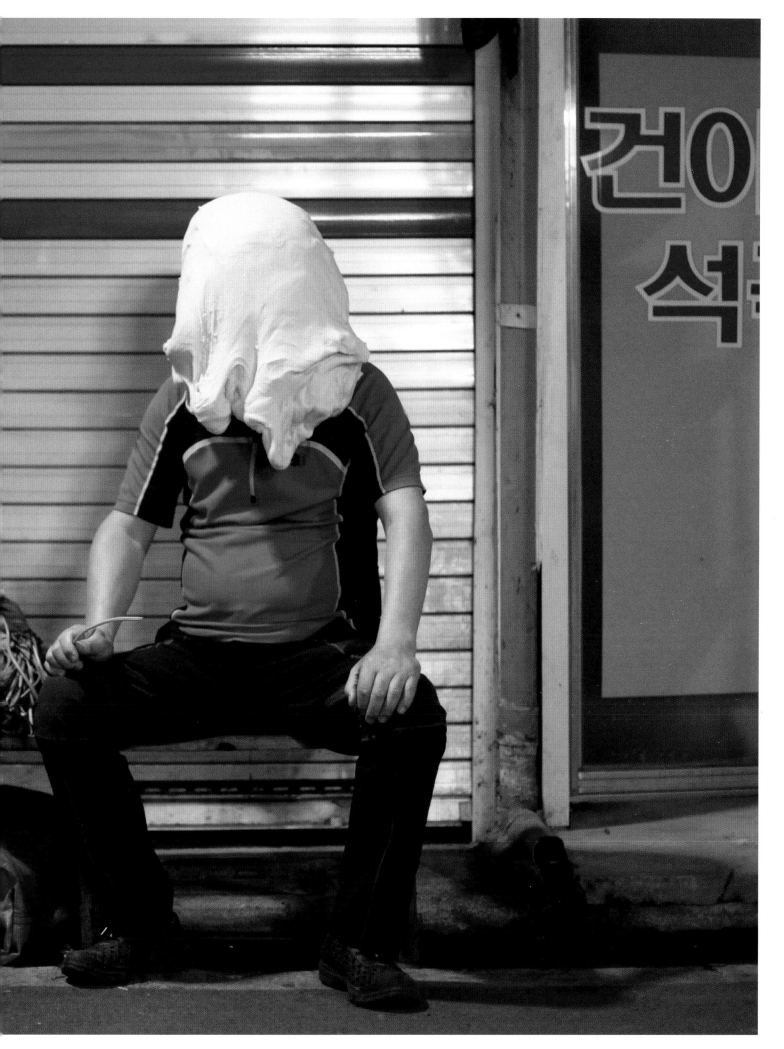

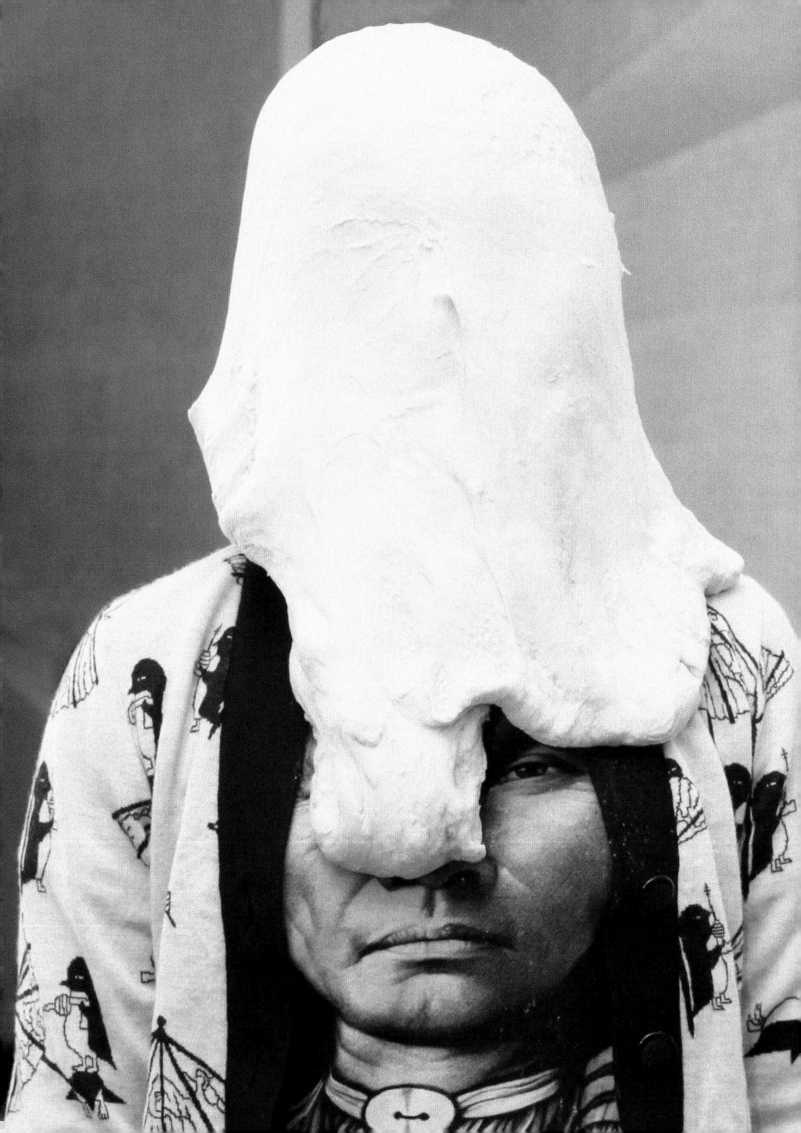

KIASMA MUSEUM FOR CONTEMPORARY ART, HELSINKI

YEAR **2012**
IMAGES **166**

PERFORMED PORTRAITS

The portrait is a genre that has evolved in countless directions, taking on myriad forms in contemporary art. The staggering diversity of current portraiture reflects both the wide array of creative channels available to today's artists, as well as a new-found understanding of human identity as an unstable category. How has the portrait changed with the advent of photography, the moving image, conceptual art and performance? Is it even valid these days to make a distinction between portraiture and other genres of contemporary art?

PIRKKO SIITARI
INDEPENDENT CURATOR AND FORMER DIRECTOR,
KIASMA MUSEUM OF CONTEMPORARY ART

The traditional function of portraits was to depict a recognizable subject and thus to declare and assert that subject's identity and social standing. The portraitist sought not only to capture a faithful likeness, but also some ineffable element, an intimation of the subject's deeper nature. In the postmodern era, however, identity is understood largely as a performative construct. Selfhood is no longer perceived as something inborn, essential and unchanging. It is instead recognized as something that is made and remade in words, actions and performative rituals.

Søren Dahlgaard's *Dough Portraits* fuse together established traditions and portraiture as performance. Each portrait comes about through an active exchange between the artist and model, with the artist playing the dual roles of director and documentarist. As the heavy lump of dough slowly oozes downwards, it forms a 'hood' or 'headpiece' that gradually swallows up the model's entire head. The dough trickles down each person's face in a slightly different way, providing them with a one-of-a-kind, highly sculptural new 'visage'.

The resulting images surprise us with their absurd humour. At first glimpse, they appear to have no counterpart in any existing genre. The artist nevertheless explicitly calls them 'portraits', inviting us to interpret them within the contextual framework of that specific form. When asked why he chose dough, he describes it as a living material that is familiar to everyone – and furthermore is effortless to mould.

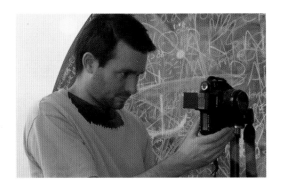 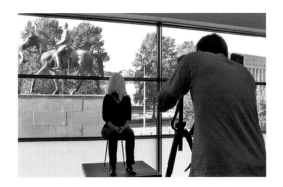

Wearing a hood of dough is a powerful multisensory experience, according to the comments of the models. The hood obscures their vision and muffles all sounds, enveloping them in a blanket of silence and darkness. The sitters are oblivious to our presence and reactions: they remain anonymous – they do not return our gaze. Similarly, we cannot see any feelings registered on their faces. Our attention is drawn elsewhere, to the hands and body, almost as if Dahlgaard were teaching us a new grammar of portraiture that is indifferent to any eye contact between the portraitist / viewer and the model. Instead, the encounter and exchange take place on a wholly different plane.

Dahlgaard's portraits thus destabilize the conventions of the return gaze, blocking us from seeing what is considered as the core element of any portrait: the face and specifically the eyes. These are thought to articulate the subject's inner essence, being the 'mirror of the soul' as the saying goes. The absence of these familiar coordinates foregrounds the meaningfulness of other elements in the *Dough Portraits*. We look instead to other cultural markers, such as clothing, body language and the positions of the arms and legs, while our focus remains squarely on the anonymous, living mask.

Dahlgaard subverts the traditional qualities of the portrait genre – figurativeness and recognizability – by concealing the face, as if denying us access to the model's inner being. In doing so, he creates a new performative and sculptural genre of

portraiture, a reinterpretation of identity – one that is funny, ironic and serious all at once.

Yet the *Dough Portraits* are much more than just portraits. They are documented performances that register emotions, actions, moments and corporeality. Under their dough hoods, the models become Other to themselves – a sculptural performance in dough, as if to suggest that selfhood and its representation is an ever-shifting process. The *Dough Portraits* are representations of postmodern identity itself.

Translation by Silja Kudel

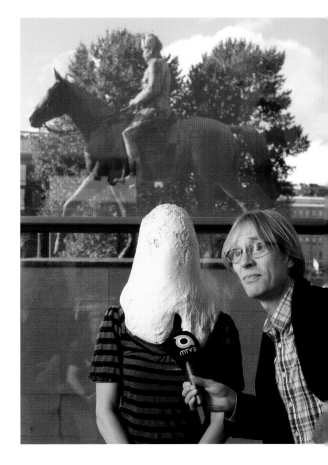

The photo session took place in two different locations inside KIASMA. Here, the backdrop is the statue just outside the museum of the famous Finnish military leader Marshal Carl Gustaf Mannerheim. On the following pages, the setting is the iconic architecture of the lobby designed by Steven Holl.

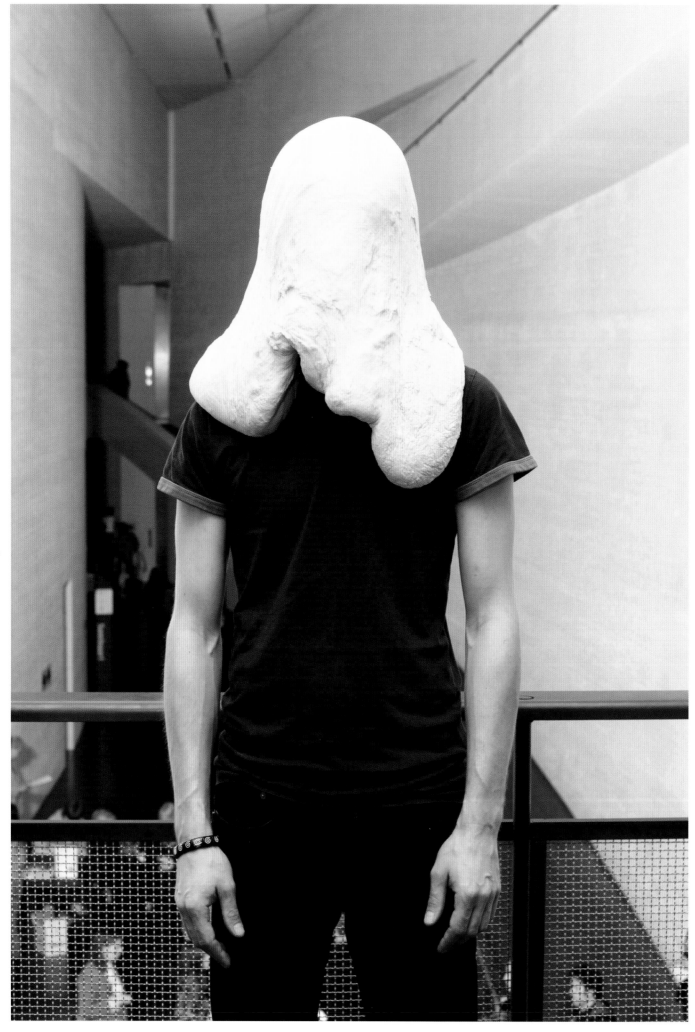

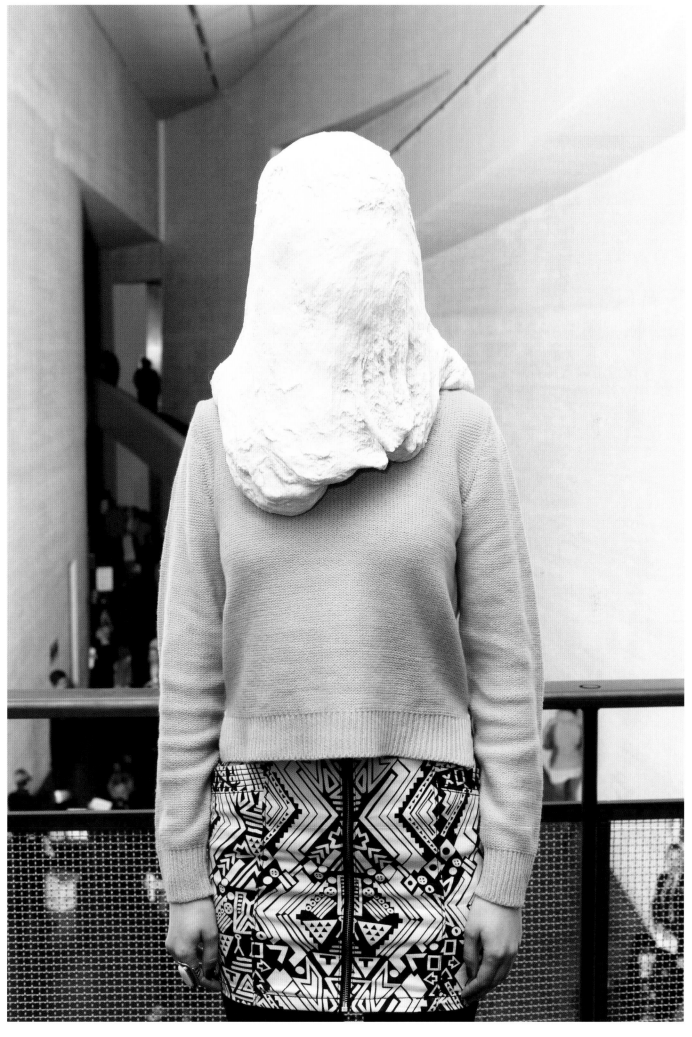

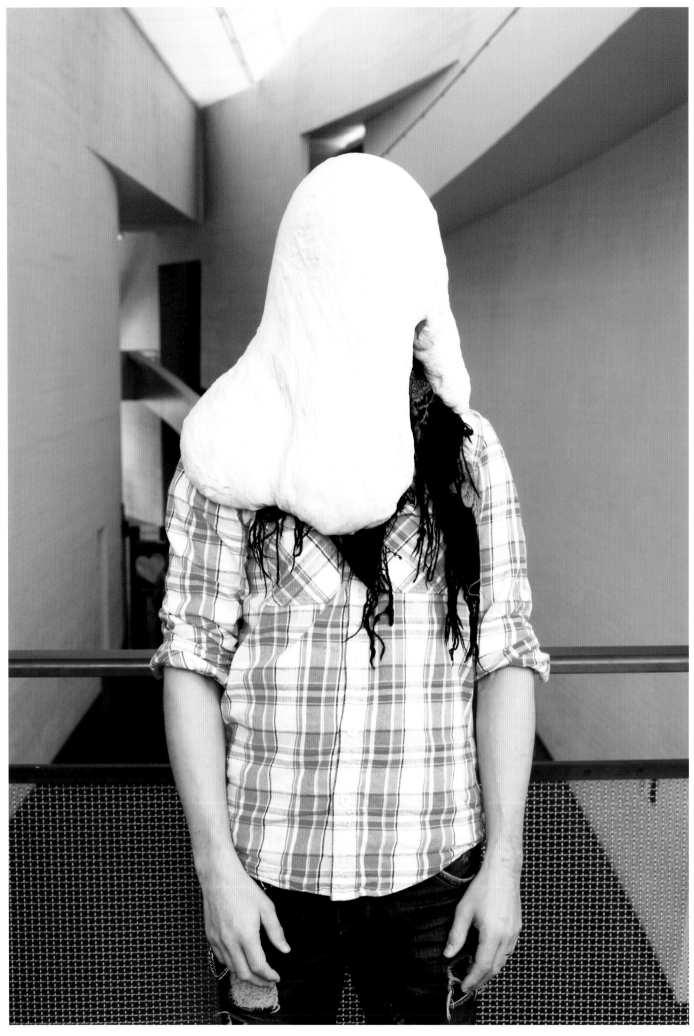

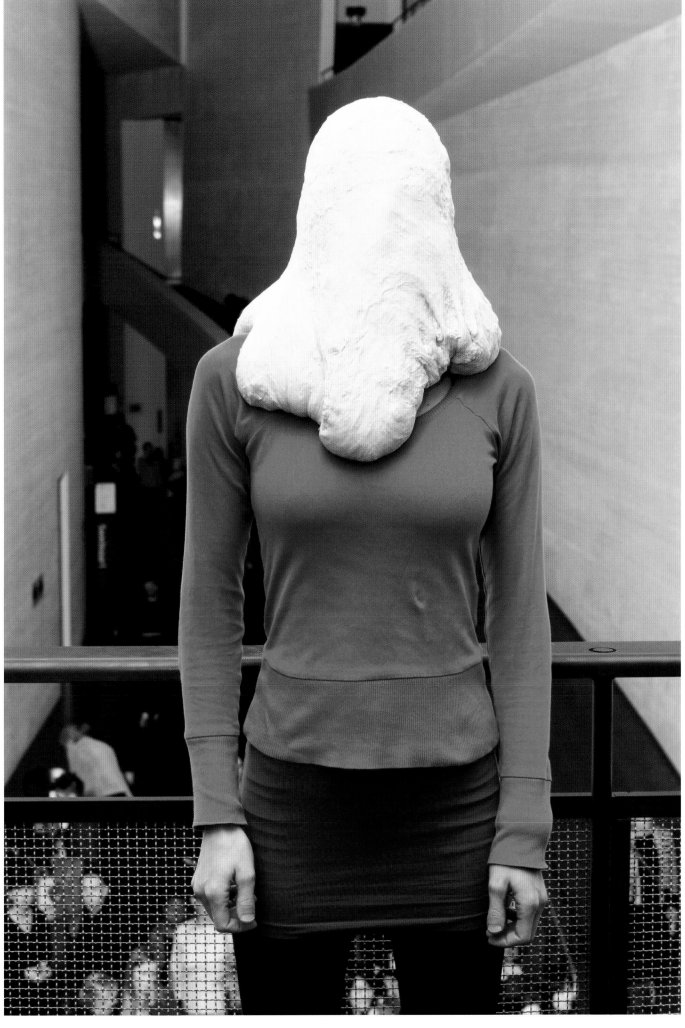

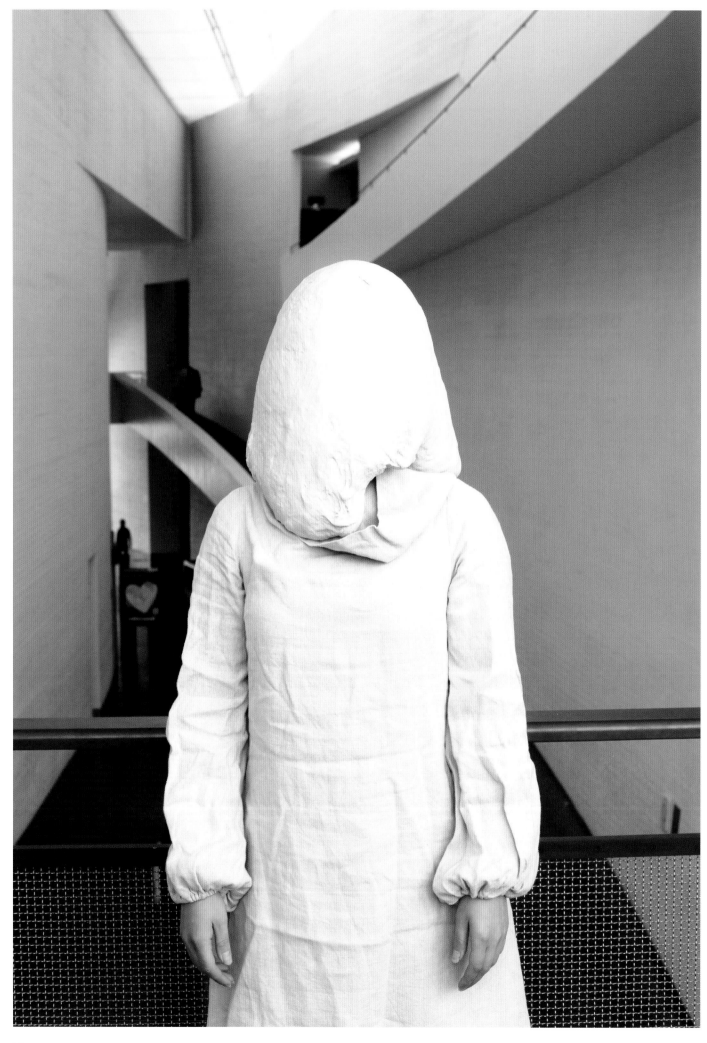

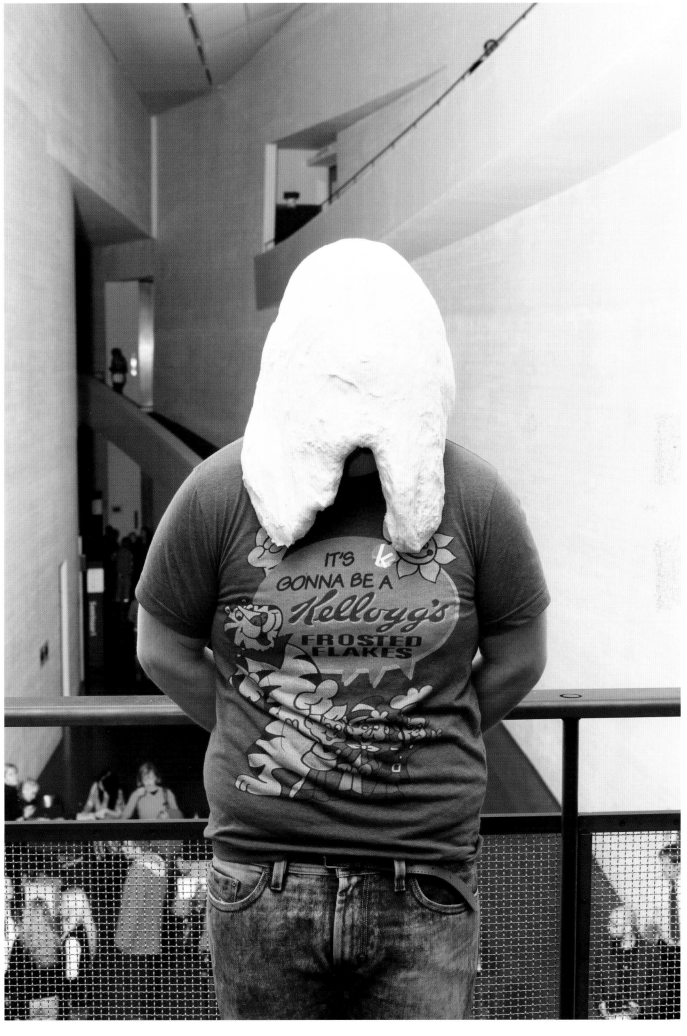

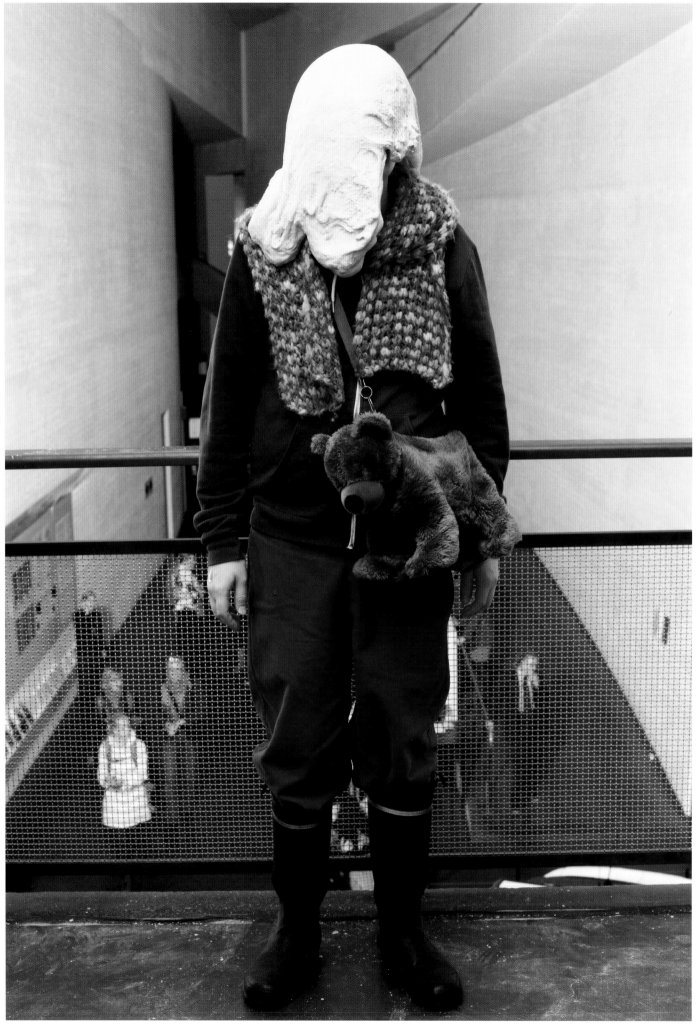

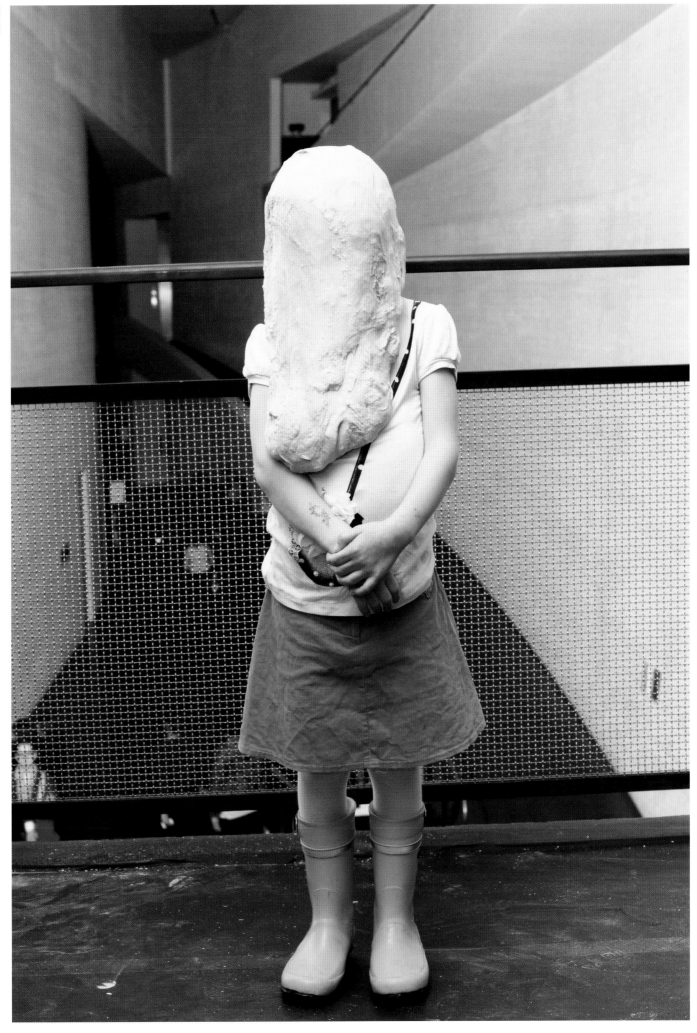

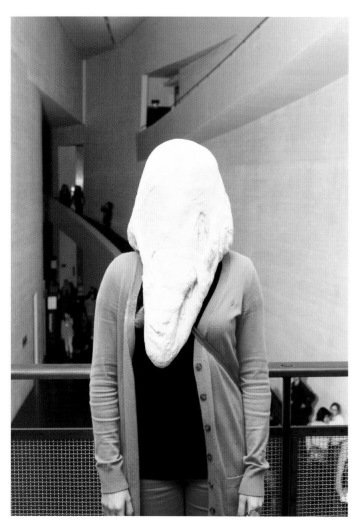
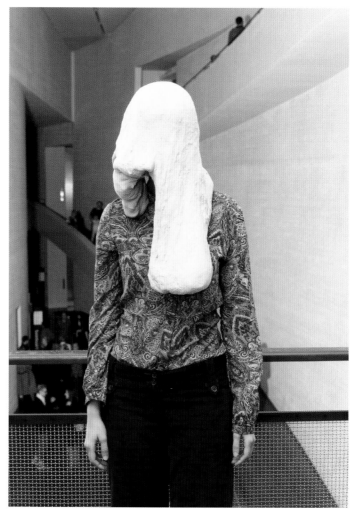
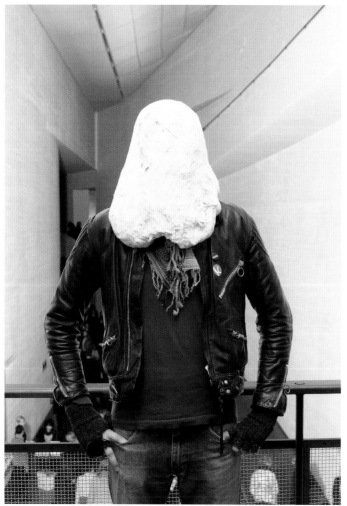
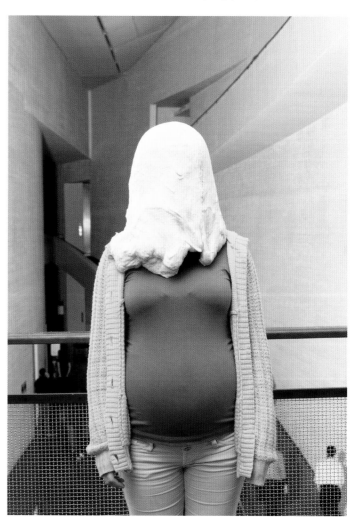

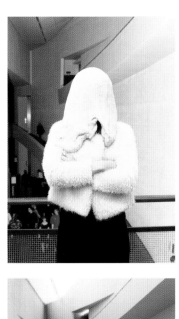 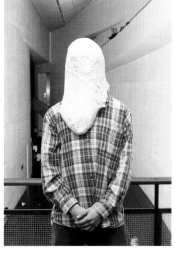 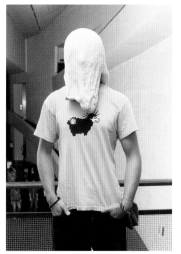 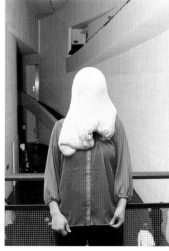

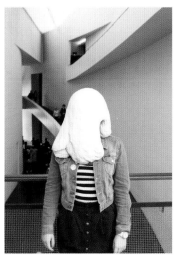 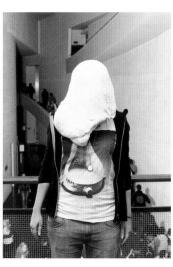 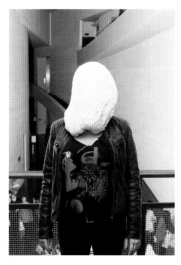 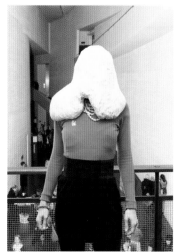

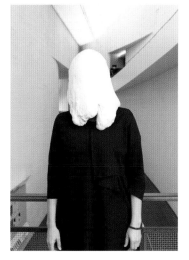 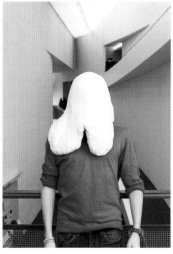 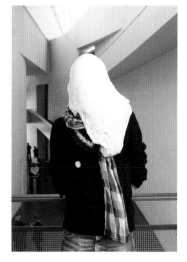 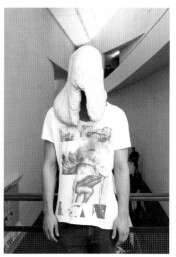

CLAE; CRISTOBAL; GRACE; MARIANNE
INKERI; CAROLIN; LINES; SUVI
SARI; ROBIN; TANA; ANTTI

OPPOSITE
MAIJA; CARME
TEEMU; MIRA

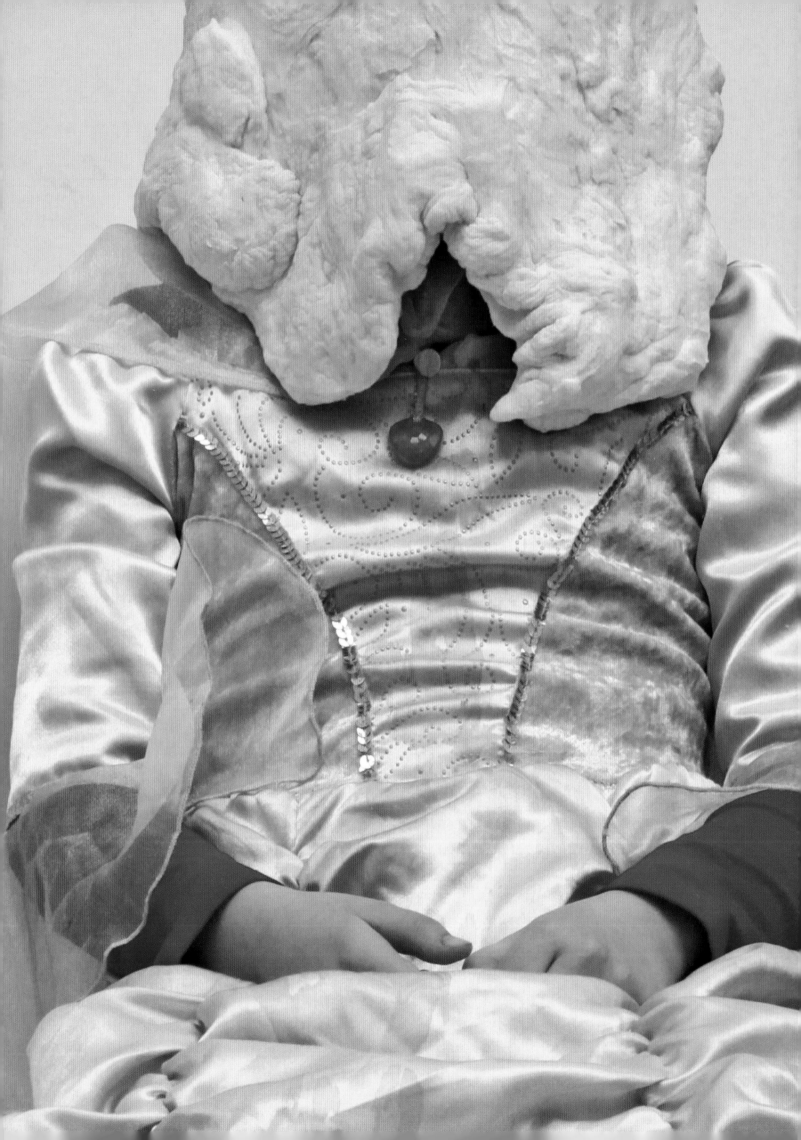

VENICE BIENNALE FOUNDATION

YEAR **2013**
IMAGES **164**

A CARNIVALESQUE MASQUERADE

The *Dough Portraits* came to Venice in February 2013 during that year's *Carnevale* season as part of the Venice Biennale's 4th International Kids' Carnival. Over the course of one weekend, dozens of children came to the Giardini dressed in a colourful array of fancy-dress outfits and party clothes. A succession of clowns, superheroes, astronauts, fairy princesses and furry monsters all came to be covered with dough and photographed. A few adults joined in, too, not just parents, but also the general director of the Venice Biennale. Even the president of the Biennale, Paolo Baratta, made an appearance – although he could not be persuaded to take part.

VALENTINA BORSATO
HEAD OF EDUCATION PROGRAMMES,
VENICE BIENNALE FOUNDATION

Held every year, the International Kids' Carnival is an important educational project of the Venice Biennale. Organized by the Biennale's education team, it sees different selected countries and institutions propose activities addressed to young people. It is designed to stimulate their creativity and experimentation through workshops, competitions, mask- and costume-making, to foster debate about their involvement in the world of art, and to encourage their personal participation and commitment. During the *Dough Portraits* event, all the children were invited to handle and work with the dough themselves and thus to discover its unique qualities as a material. It was clear that this workshop was an important way into Søren Dahlgaard's work.

For me, the project was all about exposing oneself to a wholly new and endearing experience. Covered in dough, one's body experiences a temporary blindness that is similar to the procedures undertaken when creating a facial cast, although Dahlgaard's masking process is faster and painless. An initial claustrophobic phase is followed by a momentary loss of control of one's body, and therefore of one's self. Perhaps this is the artist's challenge: to open oneself to a loss of one's self, and of one's beliefs, to let go of the robustness of one's ego, which slowly dissolves into a more liquid and malleable dimension, which is neither certain nor safe.

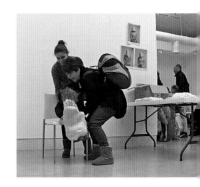

This process prompts various reflections about identity. In the light of the irony of a photograph that represents us without showing us, as we are partially covered and amusingly camouflaged, what emerges is an invitation not to take ourselves too seriously, opening up a space for a moment of lightness and relaxation that enables us to get away from the stress and continuous obligations imposed on us by our daily routines.

There is another way of thinking about what occurs. A centripetal movement draws participants towards the centre of an intimate experience, bringing one closer to the self's dynamics, which open the way to a different experiential quality of one's own skin and own boundaries. At the same time, there are centrifugal forces pushing one outwards to present one's portrait externally and expose oneself to the gaze of others, to a social dimension and therefore to judgment. What is evoked by the process is perhaps our vulnerability: we are not ourselves any more, or perhaps we are not ourselves yet. The material used for the work – dough – in its formlessness, in its ontological deprivation, waiting to be modified, to be cooked and to reach its final form, takes us back to ancestral time, as if the process inspiring the artist and taking place before us were a re-creation of humanity, a chance for each and every one of us to come back to existence, to redefine and re-create ourselves.

Offering this kind of experience in a context like the Kids' Carnival was very interesting, to say the least. Both young and old took part with enthusiasm, and their reactions were very different, based on every person's specific sensitivity and personality. The facial expressions as each one removed the several kilos of dough from their heads were quite a sight. Some were smiling, others were puzzled, and some were still craving for oxygen.

With the *Dough Portraits*, the artist was proposing an entirely personal reinterpretation of the notion of sculpture, and even of the concept of identity. But his 'conceptual' approach to sculpture became very intuitive for the kids through a practical experience: knead, touch, blend. Dough is a one-size-fits-all material to turn anyone into a sculpture, and everyone taking part valued the experience. Posture, hands, feet, colours of clothes, objects and not-the-usual faces are the fundamental elements of this humane sculpture. And the resulting portraits also made very amusing *Carnevale* souvenirs to take home!

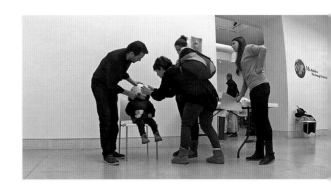

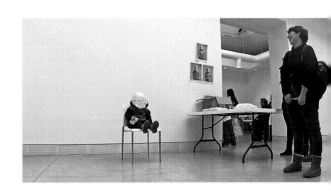

A three-year-old 'knight' struggles to keep the dough on his head while eating a snack, until the artist comes to the rescue.

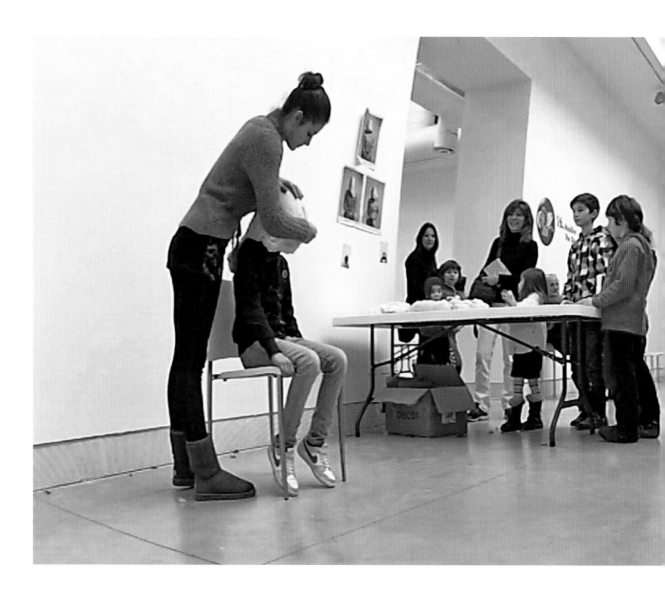

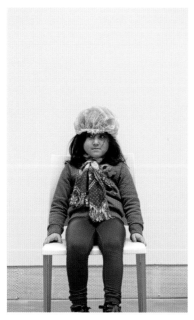

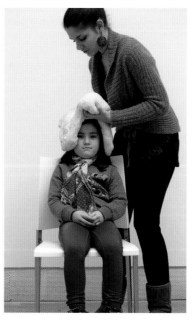

Parents and kids alike enjoyed the atmosphere of the photo session and dough workshops in the Biennale's famous Central Pavilion, the historic Padiglione Italia, in the Giardini – although one young sitter seemed rather nonplussed by the experience.

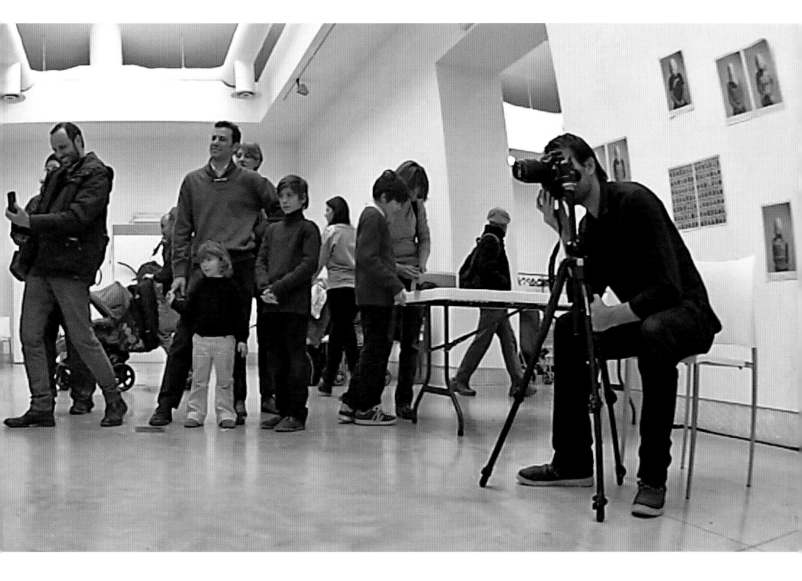

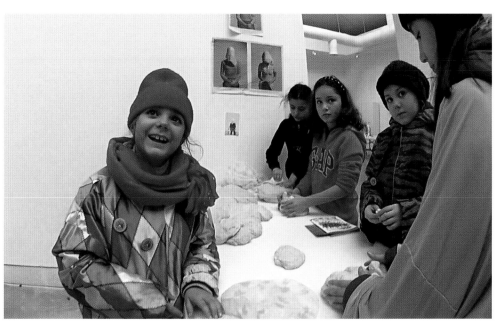

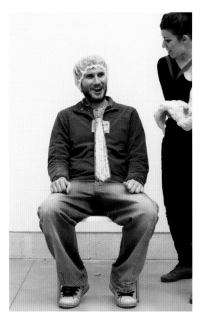
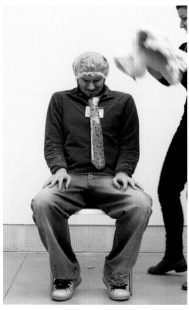
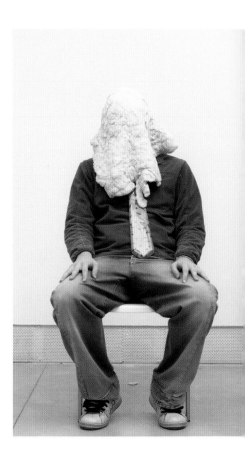

One of the volunteers took the plunge (above and right), while Andrea del Mercato, general director of the Venice Biennale, also joined in the fun (below), as the president of the Biennale, Paolo Baratta, watched on from the wings.

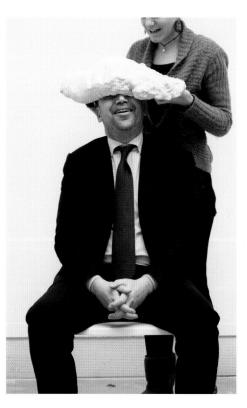
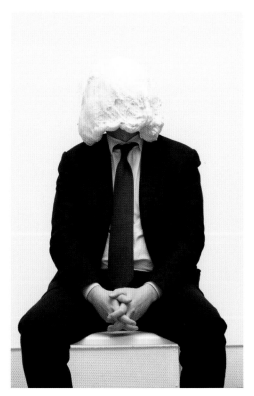

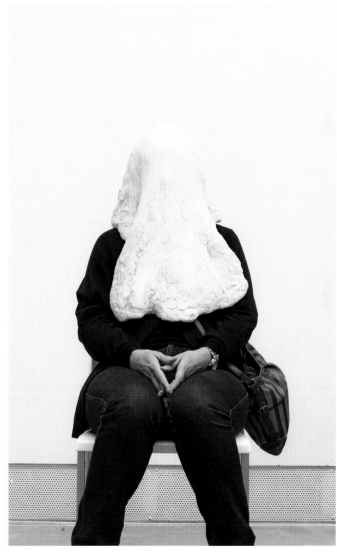

One brave *mamma* decided
it was high time that she, too, got
herself a new Carnival mask.

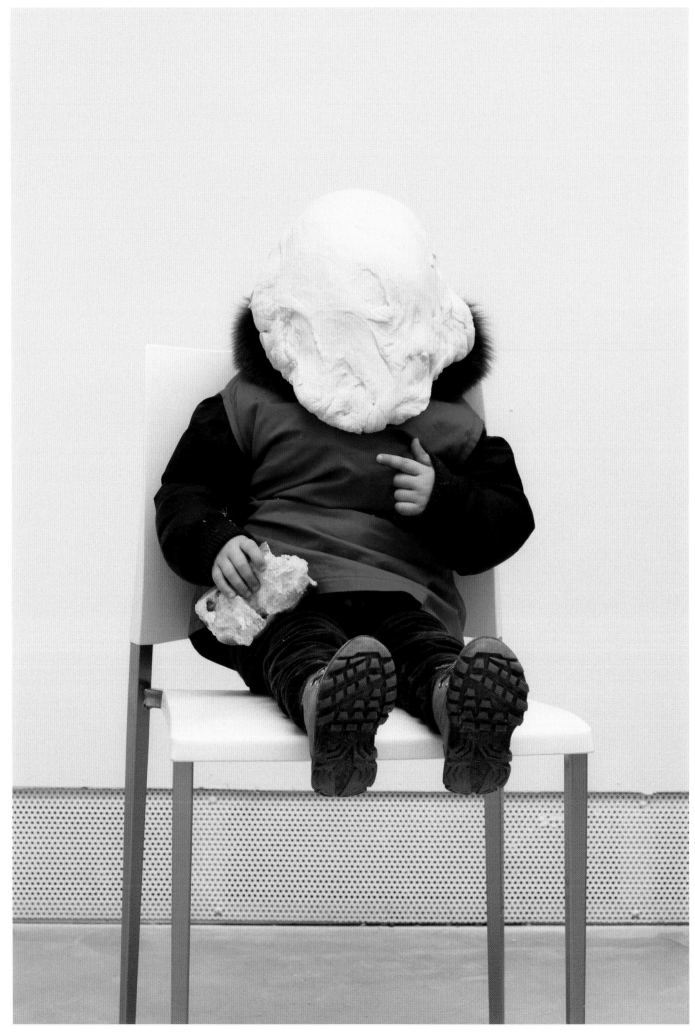

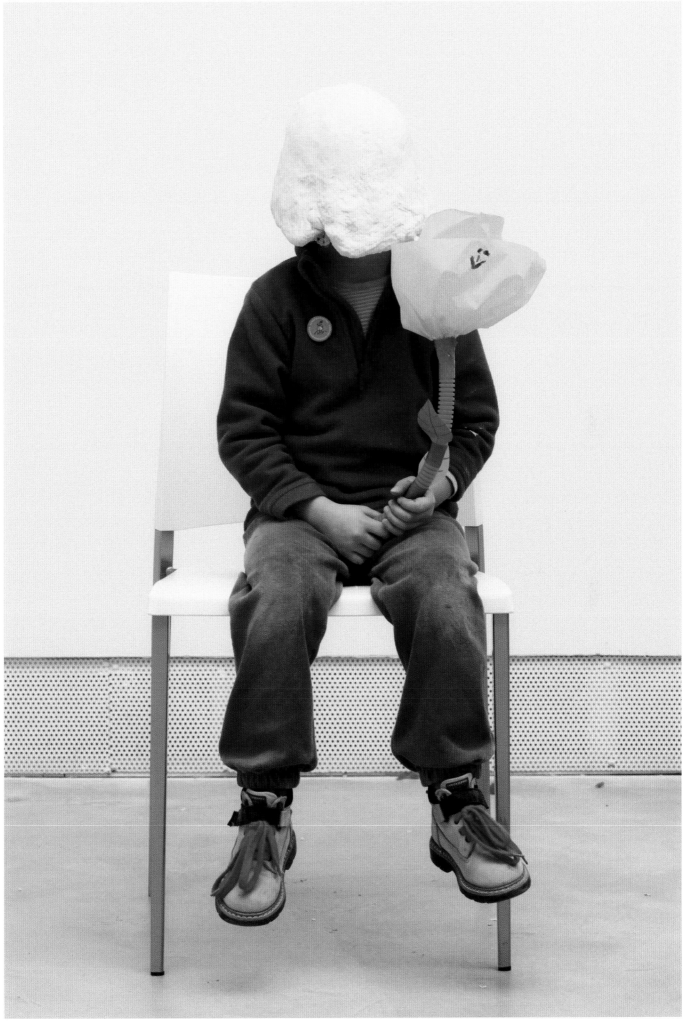

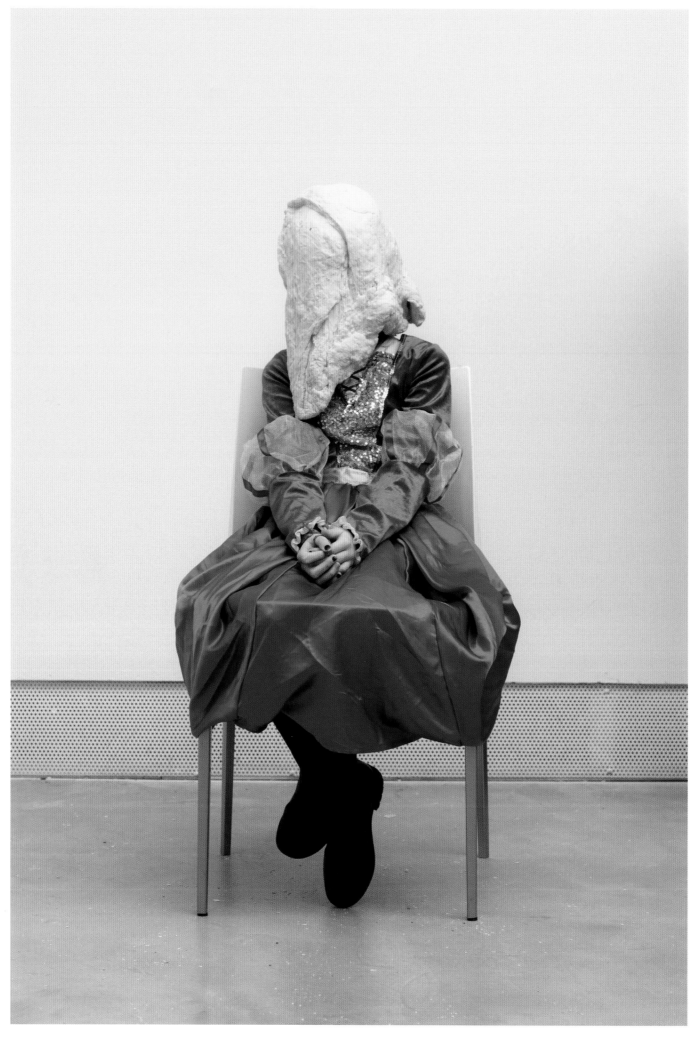

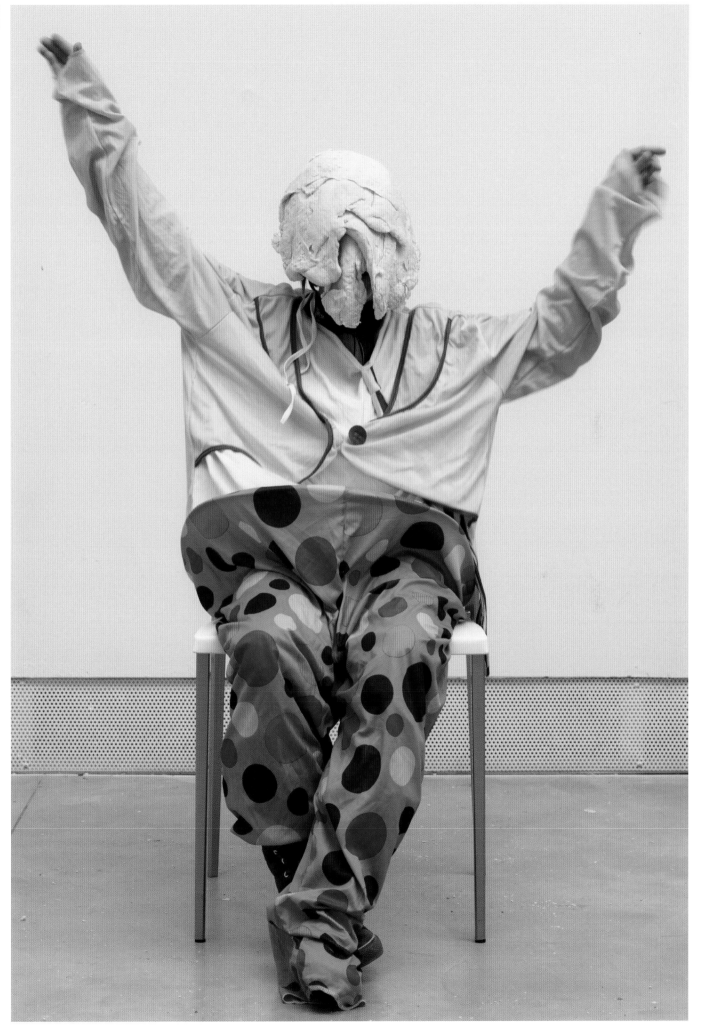

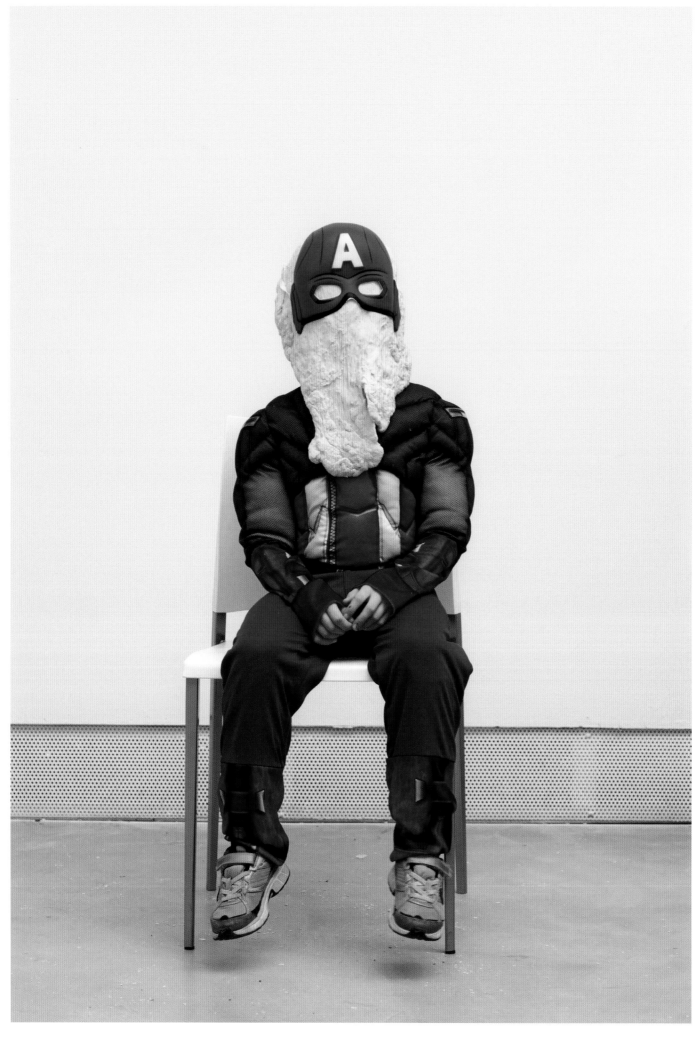

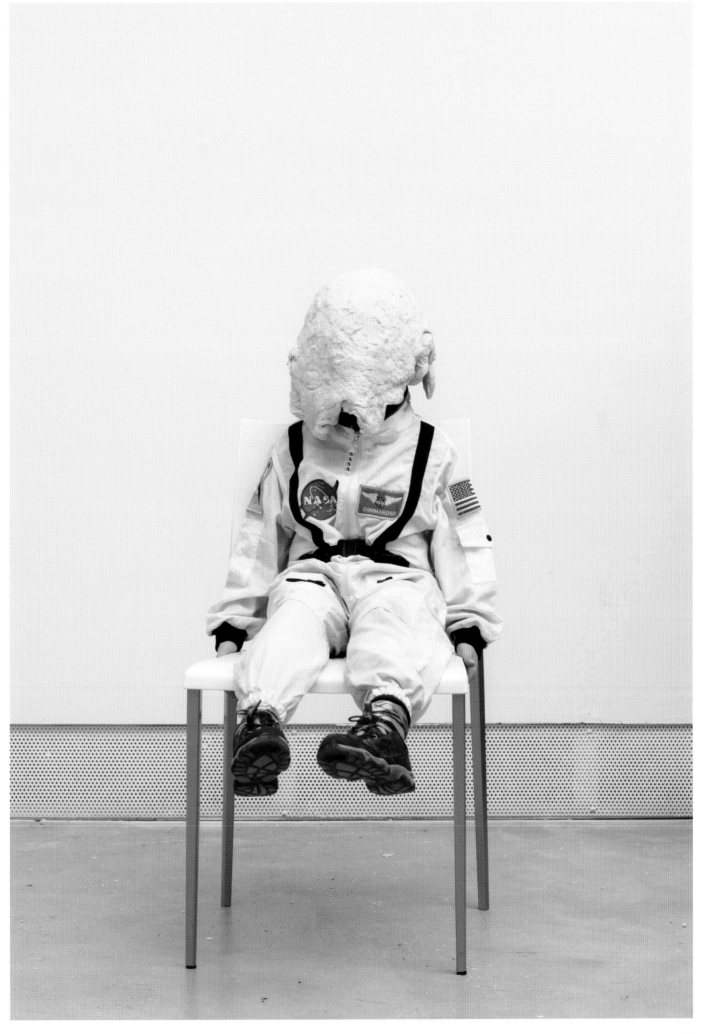

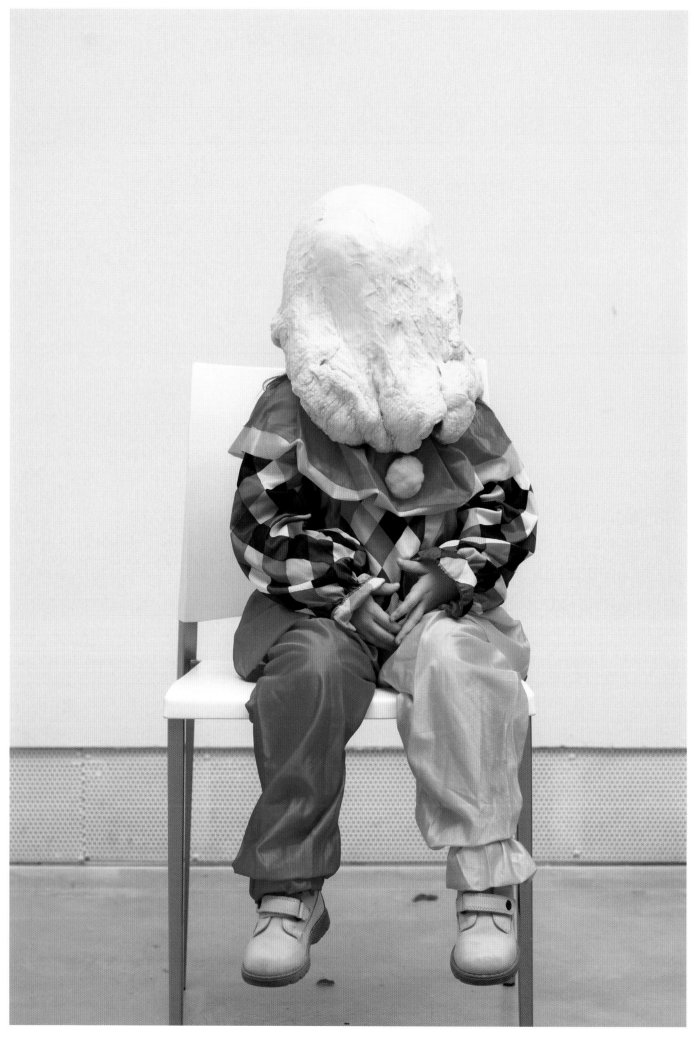

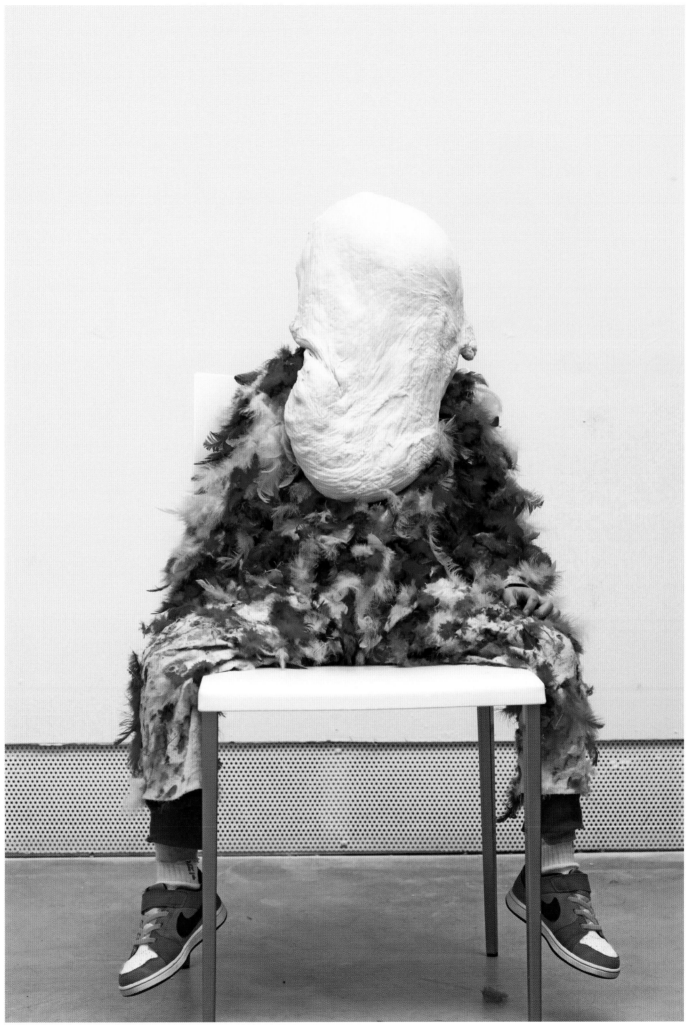

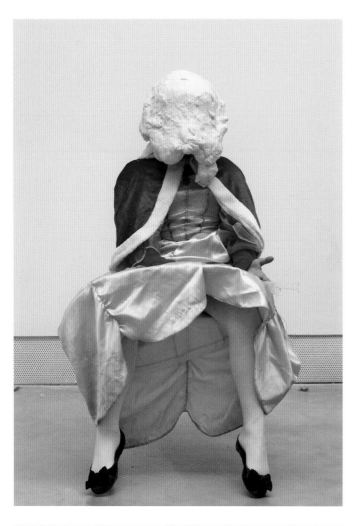
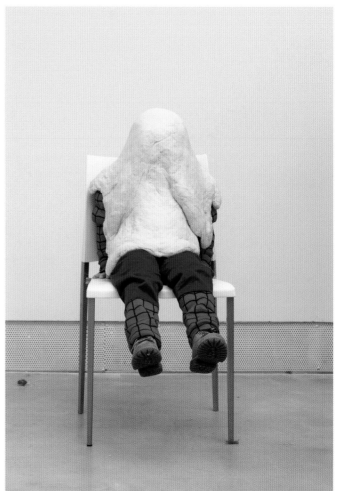

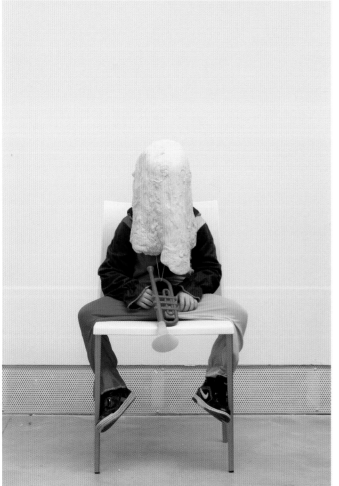
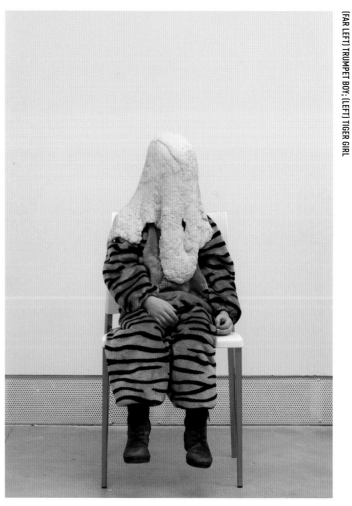

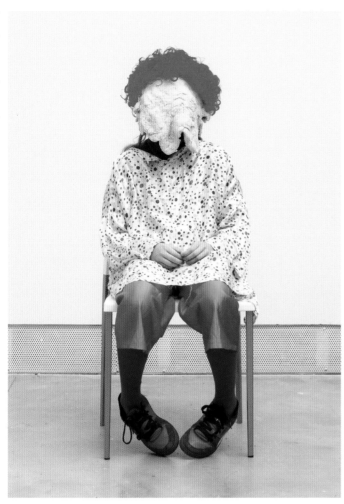

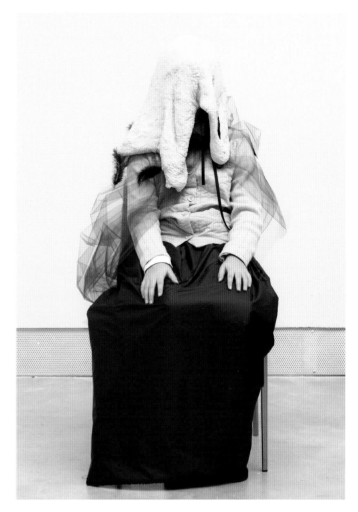

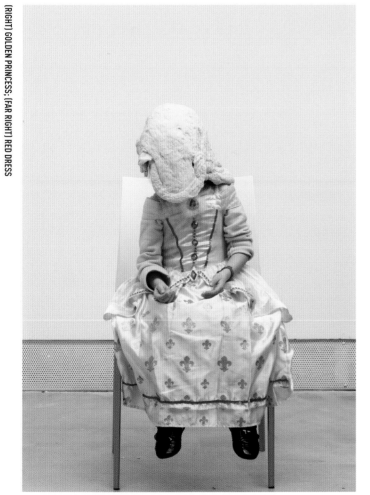

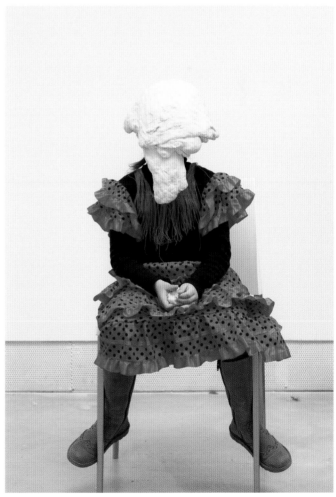

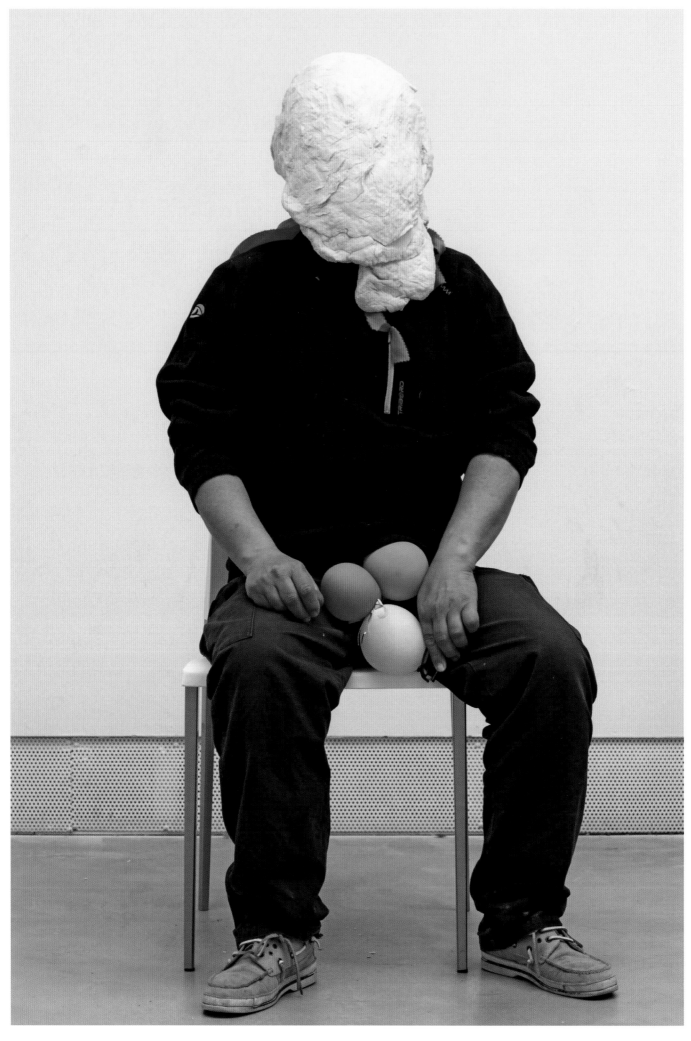

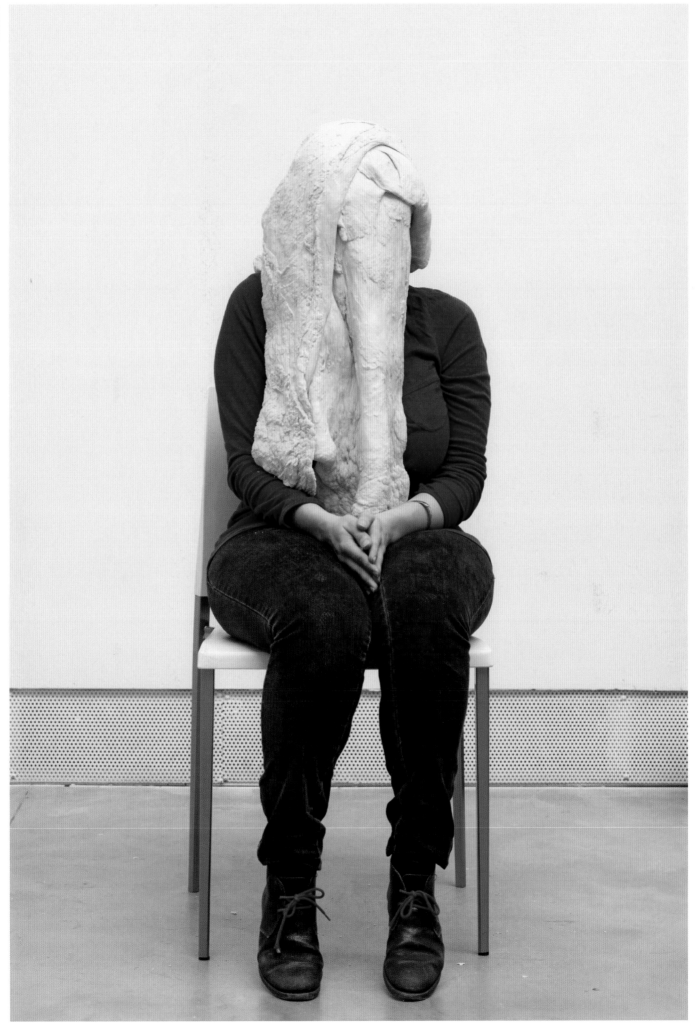

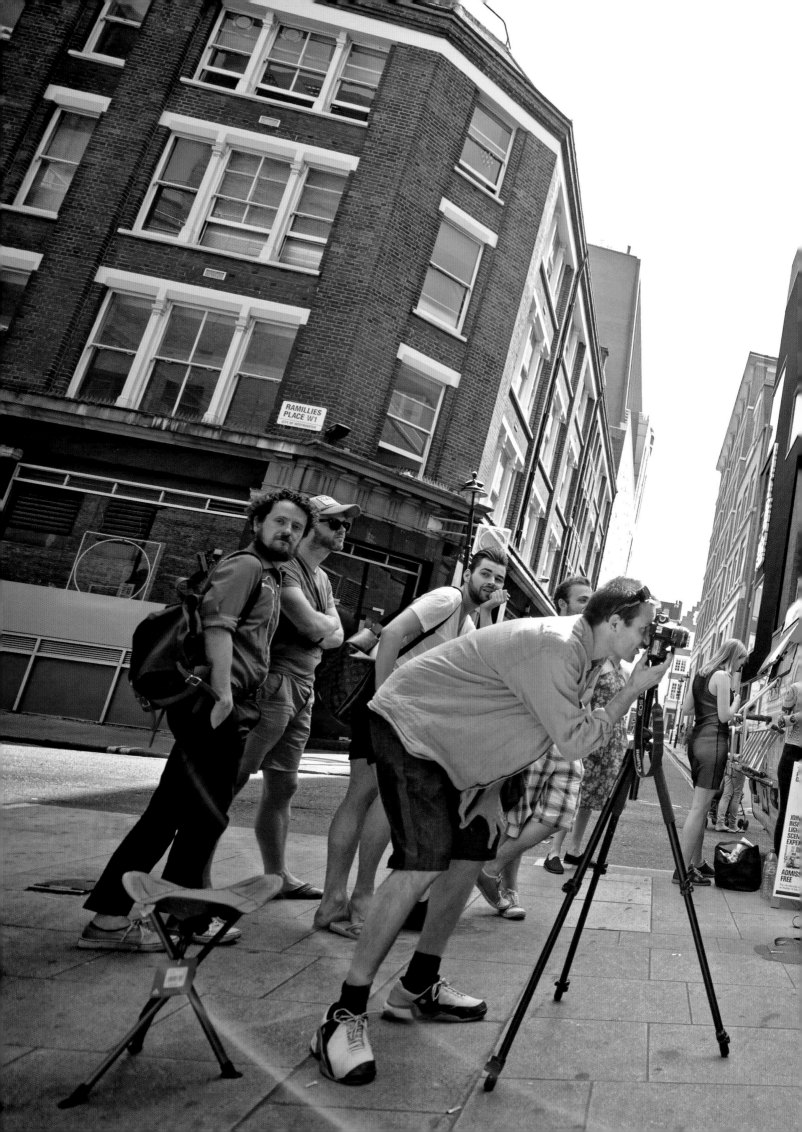

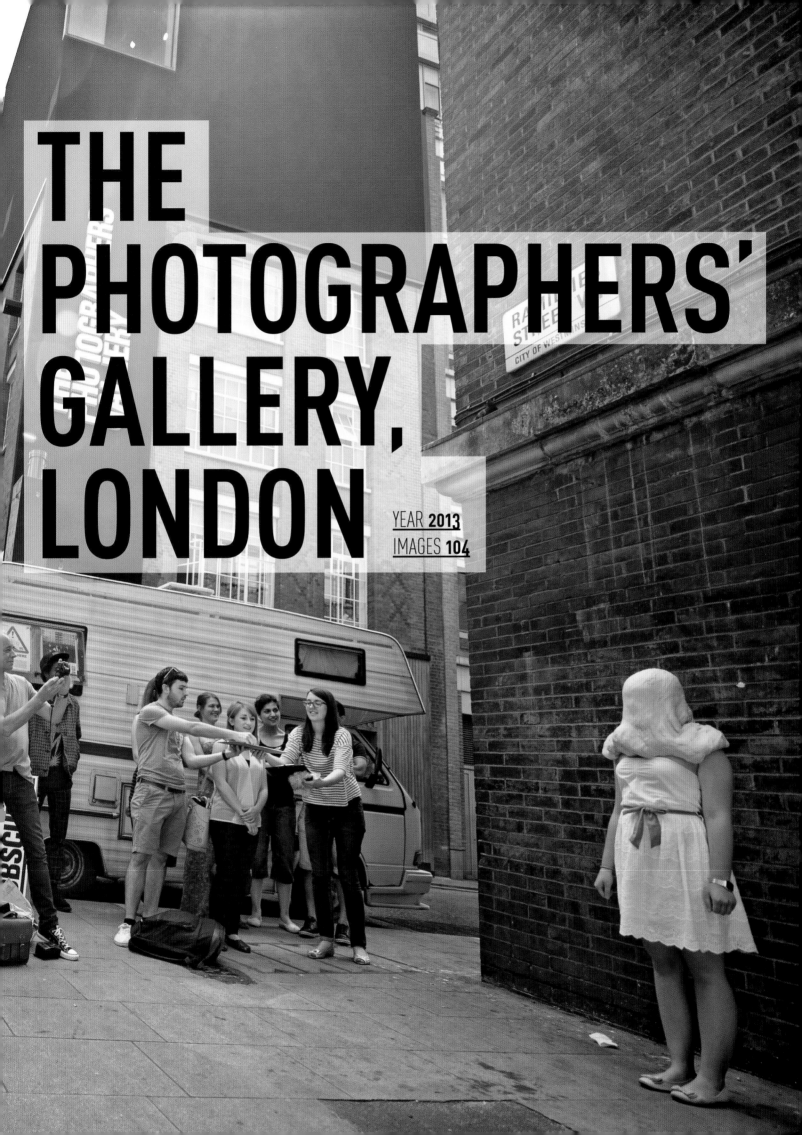

THE PHOTOGRAPHERS' GALLERY, LONDON

YEAR **2013**
IMAGES **104**

GIVE US THIS DAY OUR DAILY BREAD

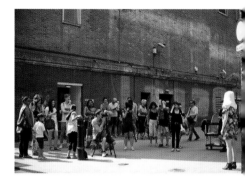

In the summer of 2013, I was charged with organizing an event as part of a weekend-long photo 'summer fayre' at The Photographers' Gallery. It was to have the hopeful task of animating the pedestrianized area outside the gallery, of providing a participatory photographic activity for our existing audiences, and of creating a provocation to draw in curious passers-by. I had taken part in an earlier *Dough Portraits* performance and had found the whole process, and my resulting portrait, both funny and disarming. The prospect of bringing the project to a wider London audience and of the spectacle it would create on the street was very appealing. With some good fortune, the artist's schedule allowed him to deliver his performance during the weekend of activity, and so we forged ahead with the planning.

KAREN MCQUAID
CURATOR, THE PHOTOGRAPHERS' GALLERY,
LONDON

In the early hours of the morning of the event, I found myself in a bakery collecting thirty kilograms of dough for the day's proceedings. The place had not yet opened for business, and so I was ushered into the humid inner chamber and sat on a plastic chair to wait. Watching my enormous leaven bundle being prepared was a strangely satisfying experience, heightened by the fact that as young teenager I went through a Cher obsession and the bakery scene from the film *Moonstruck* was deeply ingrained in my imagination. Nestled as I was in a family-run Jewish bakers set up in 1911 and serving traditional challah bread to a mixed east London population, my thoughts turned to bread's centrality across diverse geography and cultures, the fact that it is the stuff of the everyday and the norm. I could not help but applaud Dahlgaard's humble choice of dough as the key ingredient to his performance. The French dramatist Jean Anouilh famously declared that he liked reality, as it tasted like bread. I suppose he too would have approved.

Dahlgaard takes the beginnings of bread, the elemental magical mix that rises to provide the most common of foodstuffs, and places it at the centre of the *Dough Portraits*, a series that is part performance, part live sculpture-making, and part travelling photographic portrait studio. To participate is to allow a large lump of dough to sit on your head, covering the cavities through which you take in your aural and visual information – and indeed your oxygen – and wait until your photograph is taken. It is odd under there: it shares the muffled sounds and glowing light of being under water, but with more thickness. The guiding hands of assistants are present to help rearrange the flow and direct the choreography, but the sitter's own physical engagement with the dough is crucial. The

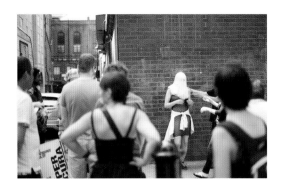

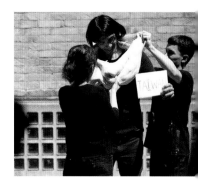

material is heavier than one anticipates, warmer and more potent too. Standing there as the photo is taken, wilfully allowing the soggy mixture to continue its slothful, gravity-propelled downward journey, one can but wait for the camera's click and try to decipher the instructions from under the heavy cloak.

This anticipatory pre-click stage seems to me key to the experience. Our senses, muted as they are, compute the moment at which the wait will become too much and the dough too heavy to maintain a unified form. As we have learned from watching those who have gone directly before us, the point at which the mask or screen will transform into a curtain to reveal our face is not what the photographer wants. The hope of pleasing him, the reward of a strong and strange portrait of ourselves, reduces our movement, increases our tolerance and obedience, as we stand, in public, exposed, self-conscious and with our senses deprived, willing the dough to form well, somehow enjoying the oddity of it all and trusting the man who controls the situation and ultimately our image.

There is something inherently rude about obscuring someone's face, removing their identifying features and rendering them anonymous for the most part. David King's collection of doctored or defaced Soviet-era photographs, amassed for the exhibition 'The Commissar Vanishes' and the book of the same name, is a chilling extreme of this rudeness. Erased either by the Soviet retoucher or by a private individual fearful of the repercussions of having photographic evidence of the victims of Stalin's murderous regime, these are faces obscured for the most brutal of reasons, often with black ink and by a vulgar hand. They are, of course, worlds darker than Dahlgaard's humorous

and participatory shots. Yet they share the use of a dense monochrome mass to obscure the face, which functions to trigger our desire to see what hides behind the occluded, to imagine what is beneath the formless features and shapes – the seduction of the erased detail, withheld from our visual access.

The playful nature and rudimentary method of masking off body parts in *Dough Portraits* perhaps better share traits with works such as Tatsumi Orimoto's *Bread Man* performance or the more recent *Eyes as Big as Plates* series by Karoline Hjorth and Riitta Ikonen, both of which present a mischievous bodily awkwardness and rely on trusting collaboration. In Dahlgaard's series, we try to look past the erasure of the face by attending more perceptively to what information we do have about the sitter – choice of clothing, posture, pose – to attempt to piece them together. When we widen our view from the individual portraits to the series as a whole, another wonderful transformation takes place. Cumulatively, the strange shapes morph into an odd collection of sculptures or busts, made not from marble or precious materials but from the ever-ubiquitous dough. They are not only a set of photographic portraits, a set of interactions and anticipations, but also a set of living sculptures. As Nicholas Cage declares in that deliciously dramatic scene from *Moonstruck*, 'What is life? They say bread is life.'

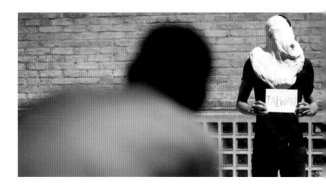

Londoners watch the photo shoot and line up to take part in the pedestrianized area between The Photographers' Gallery and a busy Oxford Street on a hot summer day.

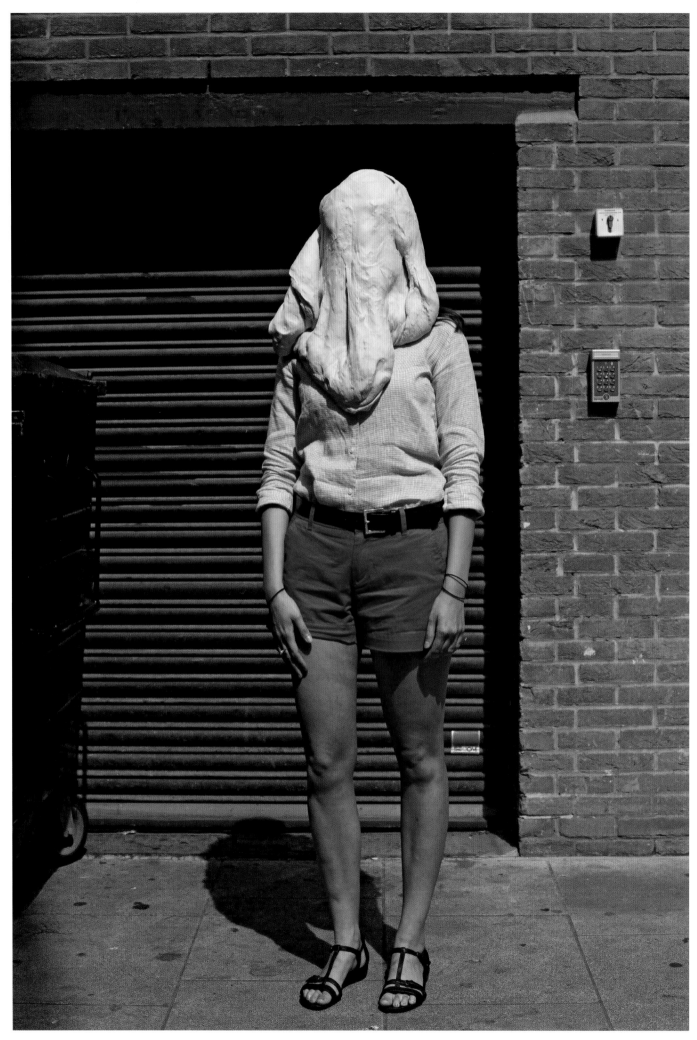

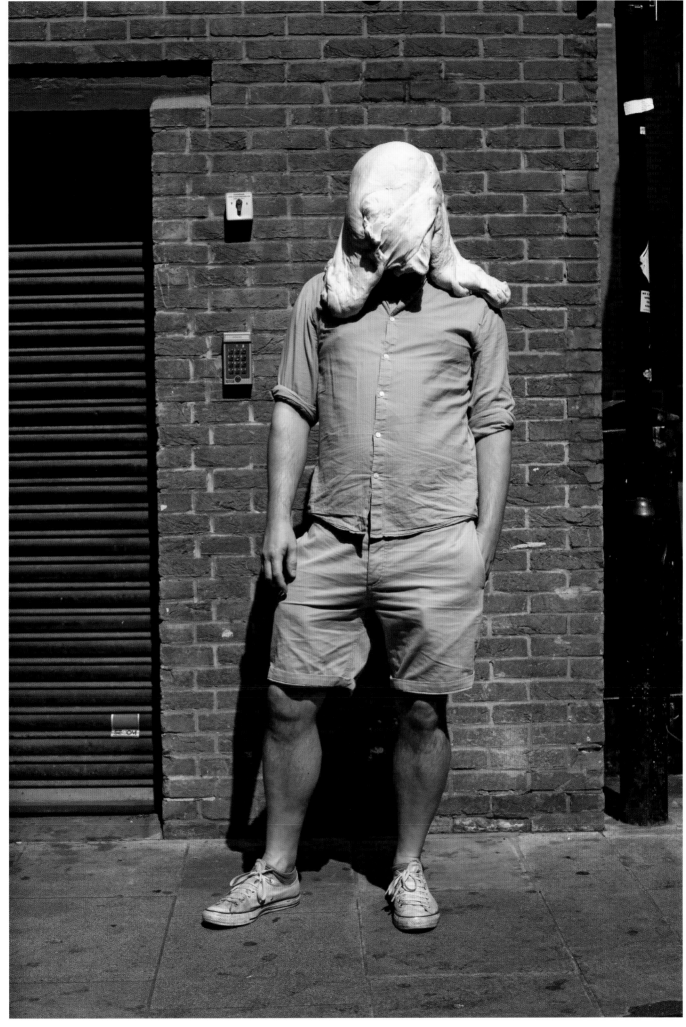

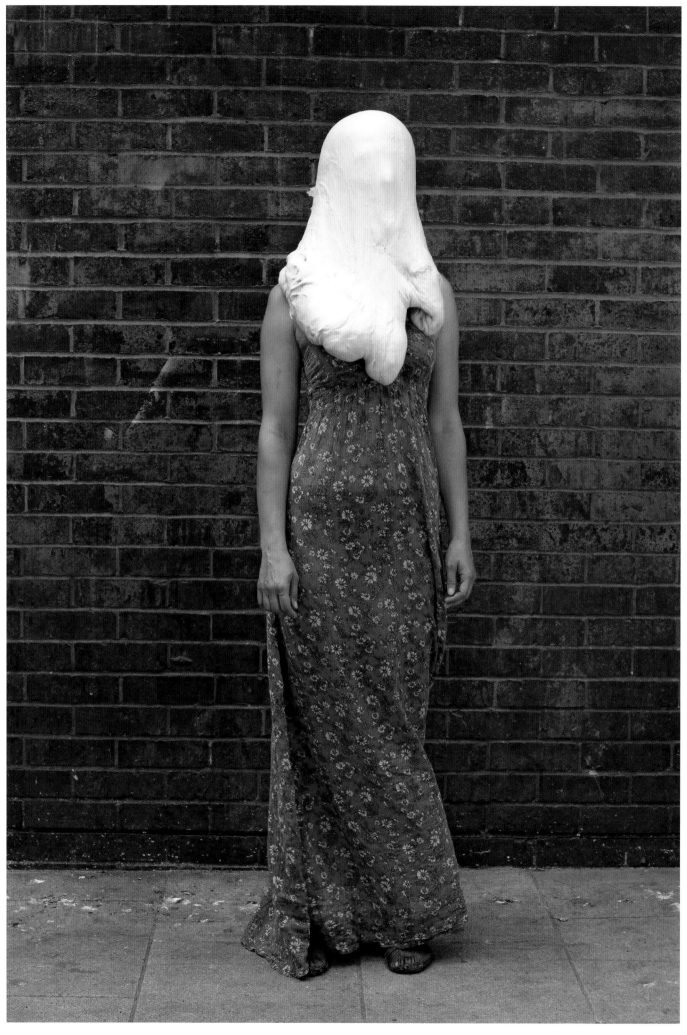

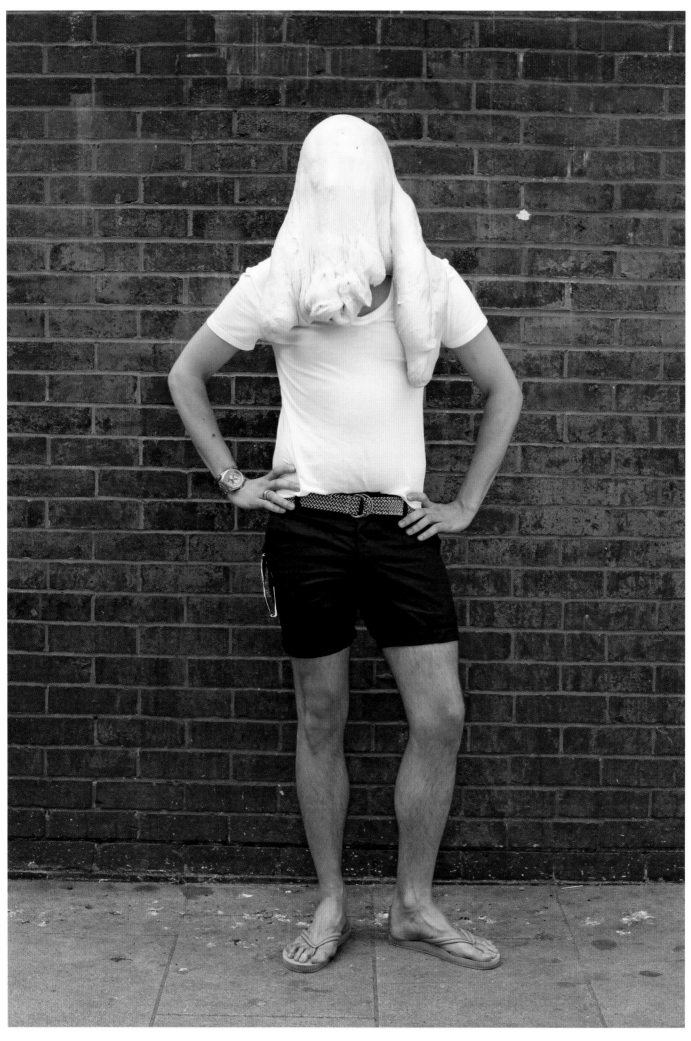

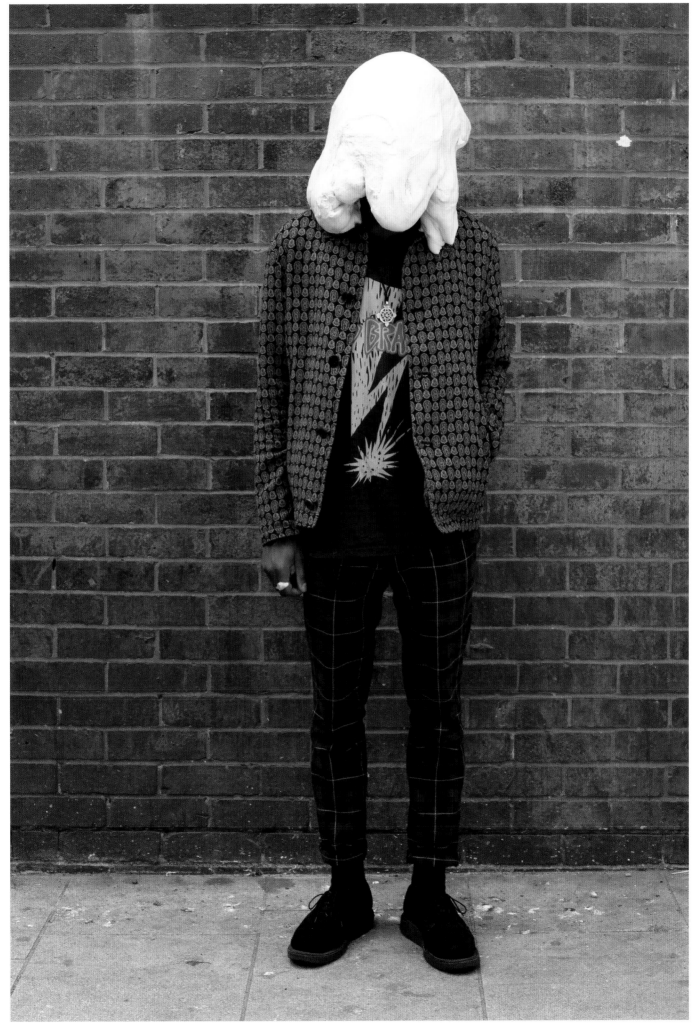

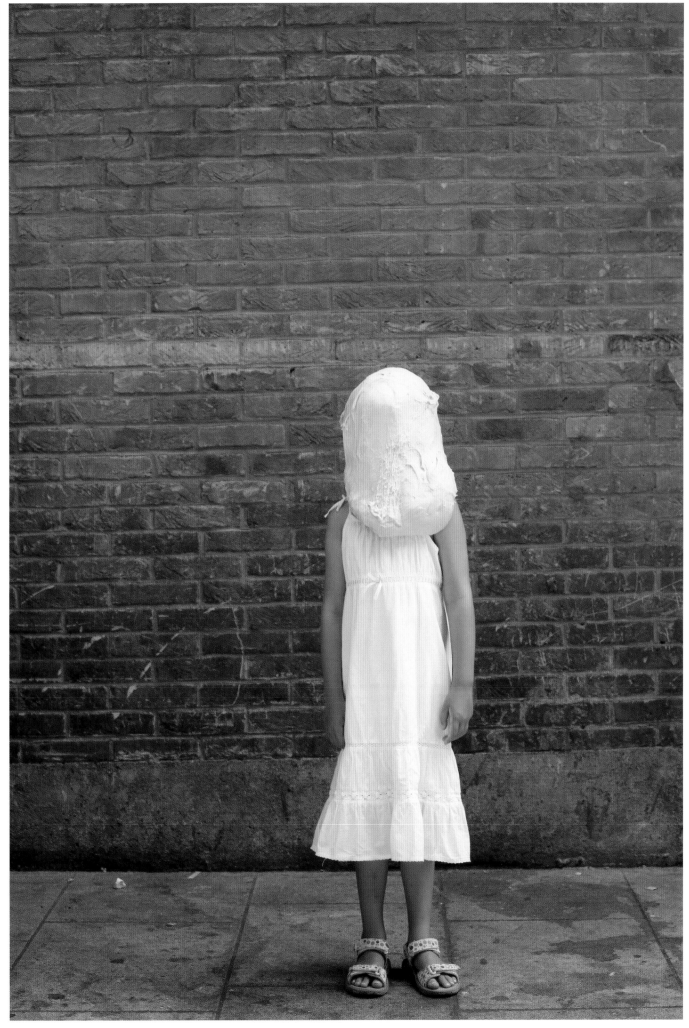

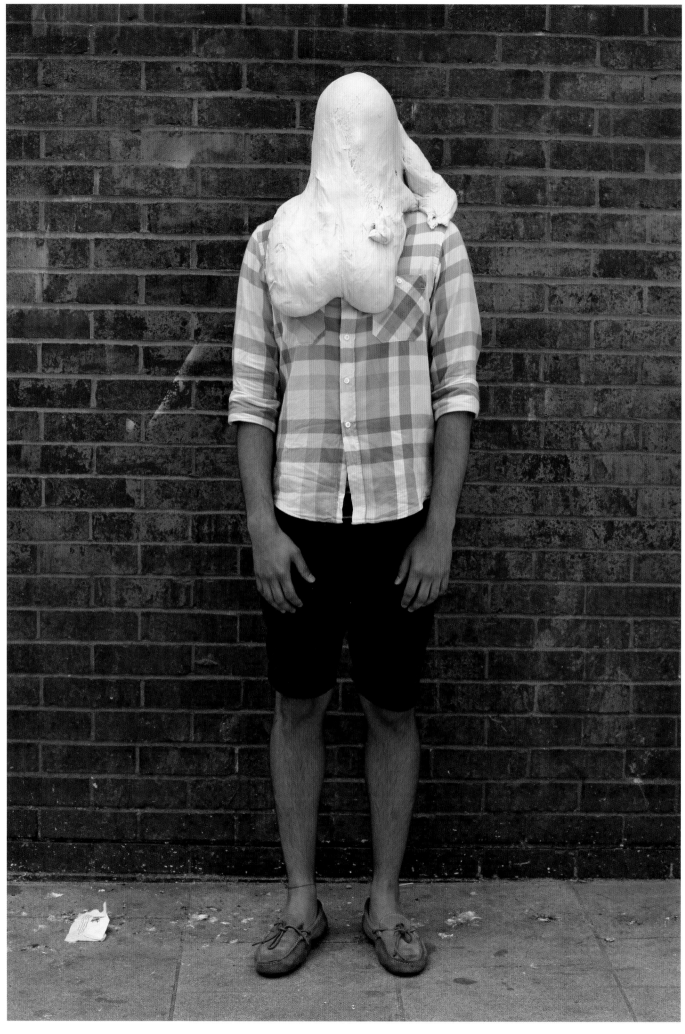

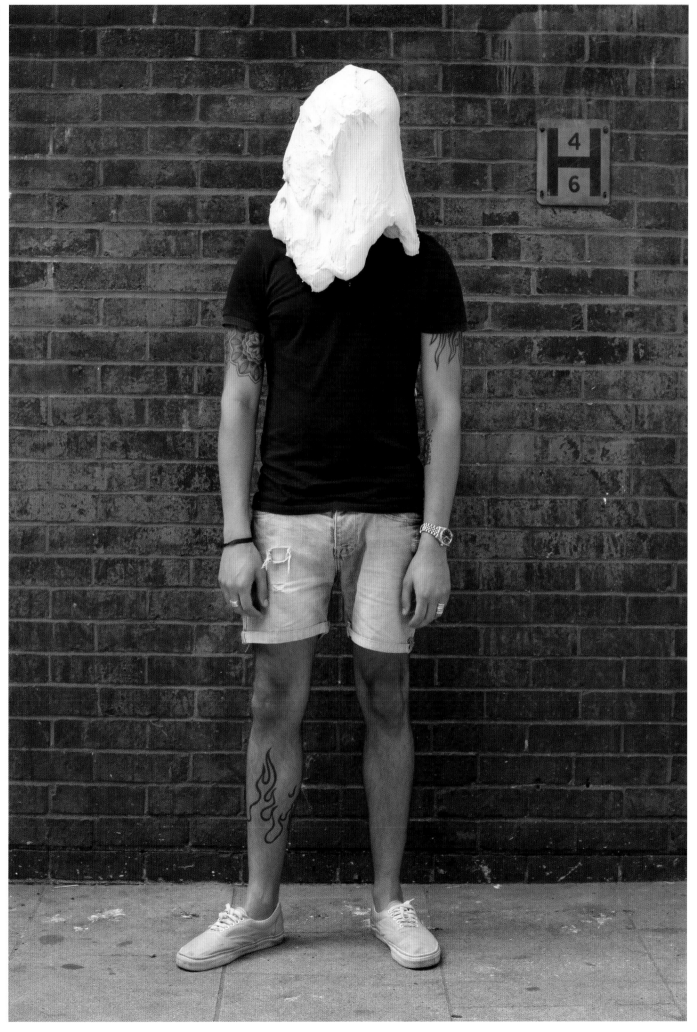

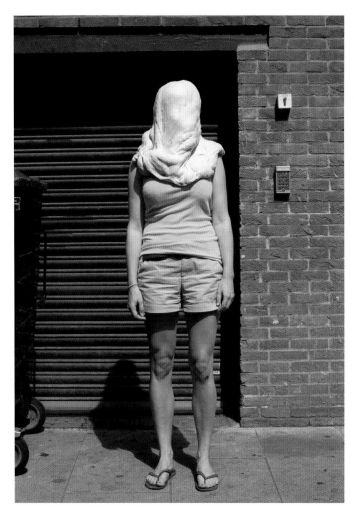

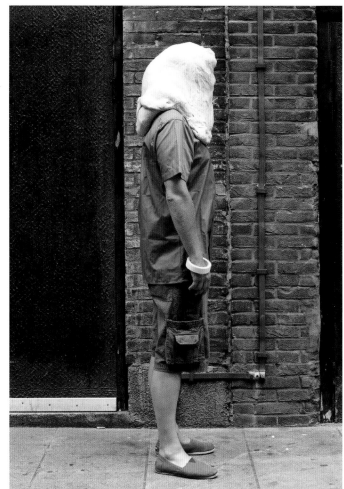

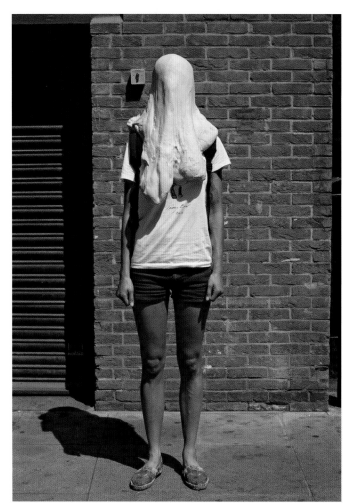

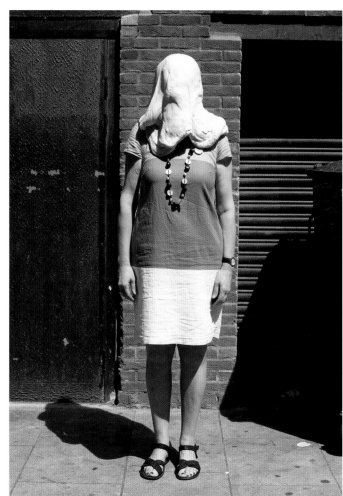

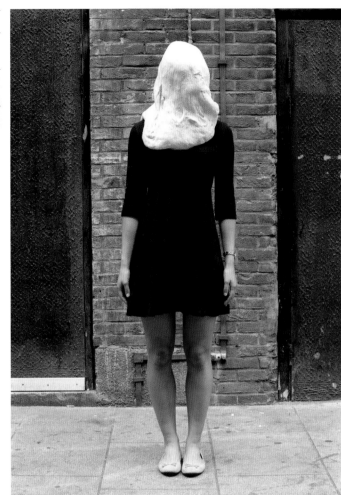
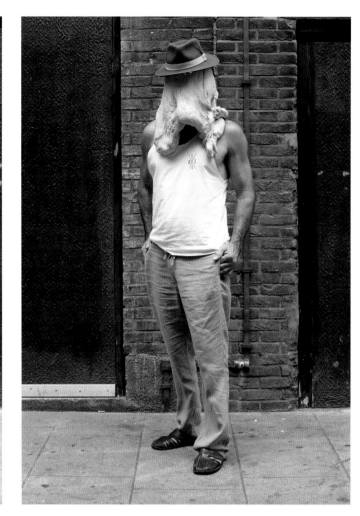

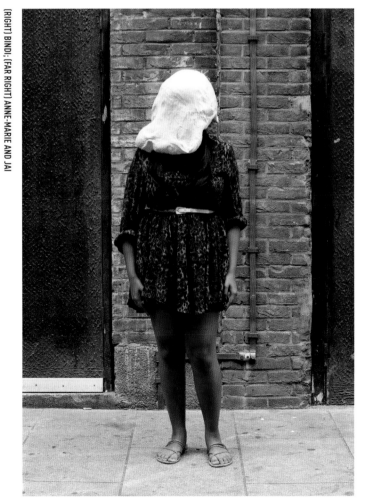
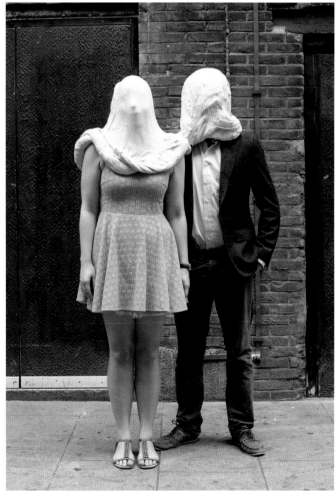

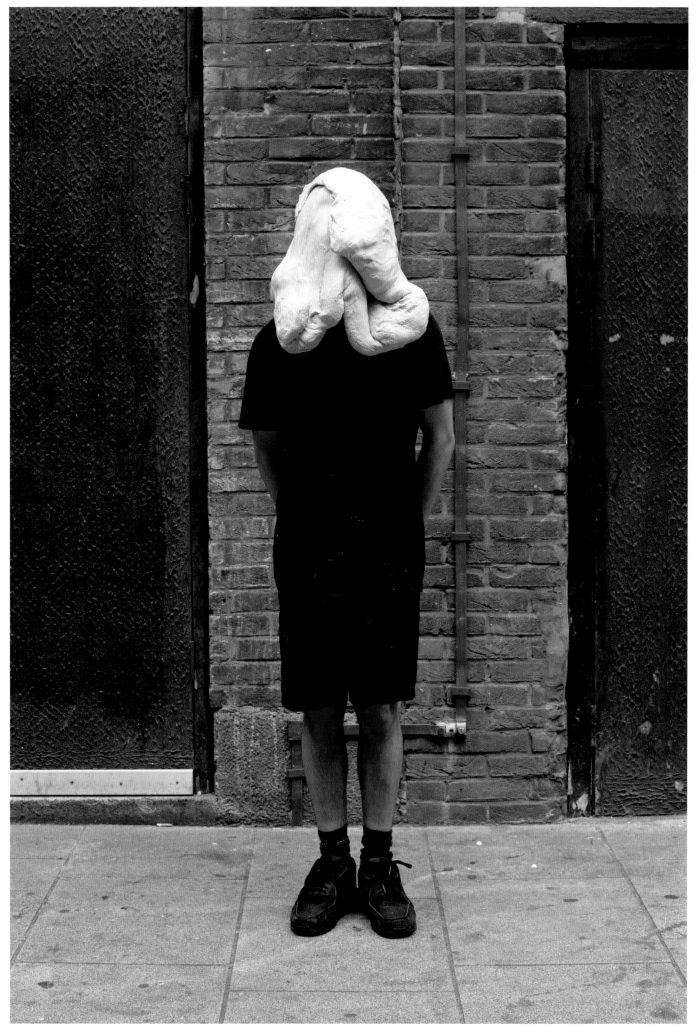

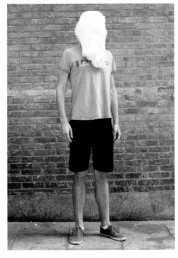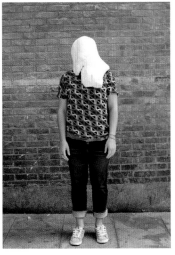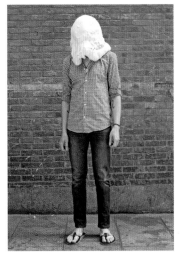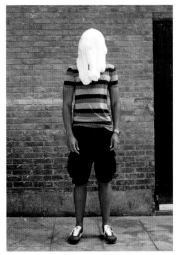
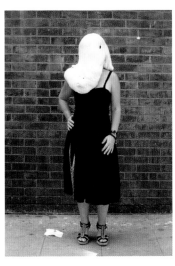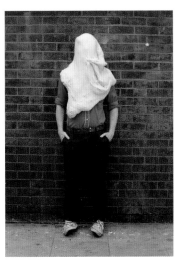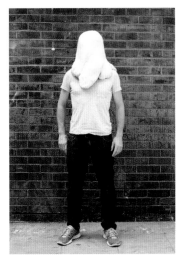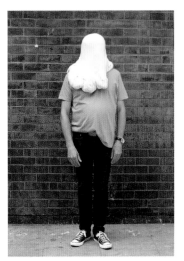
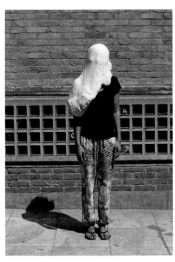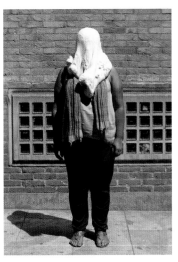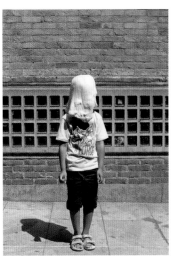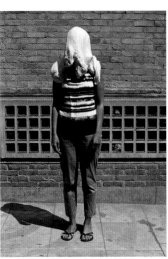

DAN; GINA; ALAN; ROBERT
CLAIRE; PAUL; ADAM; GREGORY
RANIYA; NASRIN; AKIF; LOUISE

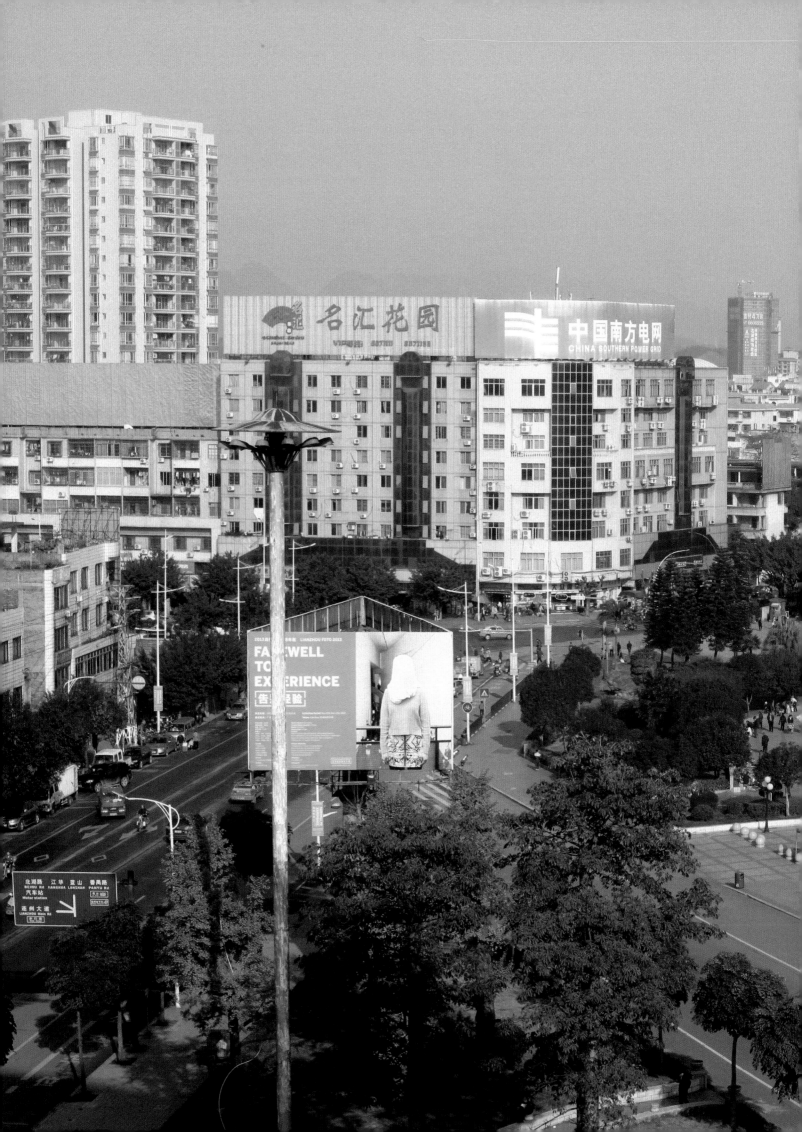

LIANZHOU INTERNATIONAL PHOTOGRAPHY FESTIVAL

YEAR **2013**
IMAGES **30**

I DO NOT NEED
TO SEE YOUR FACE

The *Dough Portraits* series was exhibited at the Lianzhou International Photography Festival in 2013. That year, the festival was focusing on contemporary photography in the Scandinavian region. And Søren Dahlgaard's project truly stood out among that group. With an unspeakable mystery, it firmly caught our attention.

<div align="right">

DUAN YUTING
CURATOR AND DIRECTOR,
LIANZHOU INTERNATIONAL PHOTOGRAPHY FESTIVAL

</div>

When I first met Søren, he seemed rather wild. And yet he had chosen dough, a rather soft, gentle material with many spiritual and philosophical associations, with which to have a very unique and personal dialogue with the world. The creative process to which he submits himself is interactive and multidirectional, such that he cannot complete the work independently. 'His' material is in fact shaped by all kinds of people of different races, identities and ages coming from various regions and wearing a wide range of dress. The moment they place the dough onto their heads and their faces disappear, it turns into sculpture, one with a bizarre content and more than a hint of humour. Of course, the participants act voluntarily, concealing themselves willingly under the guidance of Dahlgaard. The decisions of both artist and participant constitute the work.

While the *Dough Portraits* follow many conventions of regular portrait photography, and even those of portrait painting, they break with tradition in one obvious yet fundamental way. Unlike these other forms of portraiture, in which the facial expression of the subject is always to be highlighted, the *Dough Portraits* remain distinctly faceless. As such, these are images packed with uncertain elements that are difficult to describe. Some people might therefore find these 'portraits'

confusing to look at, but with a little extra attention to the subject's body and appearance, our imagination helps us to unveil their identity and destiny. We might ask ourselves then, 'Does it really matter if I can see your face?'

Lianzhou International Photography Festival takes place in a remote town in southern China that is surrounded by mountains. People here lead a simple, traditional life. And yet when Dahlgaard started shooting, the locals participated in the creation of the work with great curiosity and enthusiasm. Apart from some who found the dough a little heavy and suffocating, most of them found it funny to see themselves in the photograph, and were proud of being part of a real work of art. Søren was very much welcomed by the local residents, visitors to the festival and the media, both at the exhibition and in the public and private spaces where the photo shoots took place. He showed them that art and photography could be easy and fun.

The material characteristics of dough are that it is solid yet soft, flexible, sticky and easily stretchable. As such, it gives endless possibilities to how a face can be transformed and thereby an identity constructed. Much of the humour in these works comes from the absurd combination

of this commonplace element used in an uncommon way with the subject's rather formal pose. However, beneath the amusing visual aspect of the work, we can find a sarcastic and almost sadistic opposition to the way people are often judged by their appearances in our society. This act of covering oneself with dough in order to be depicted – concealing oneself to reveal a truth – thus goes against the grain, in more ways than one.

The various locations for the *Dough Portraits* sessions in Lianzhou included busy city squares and residential streets, private rooftops and communal gardens, and even a hair salon.

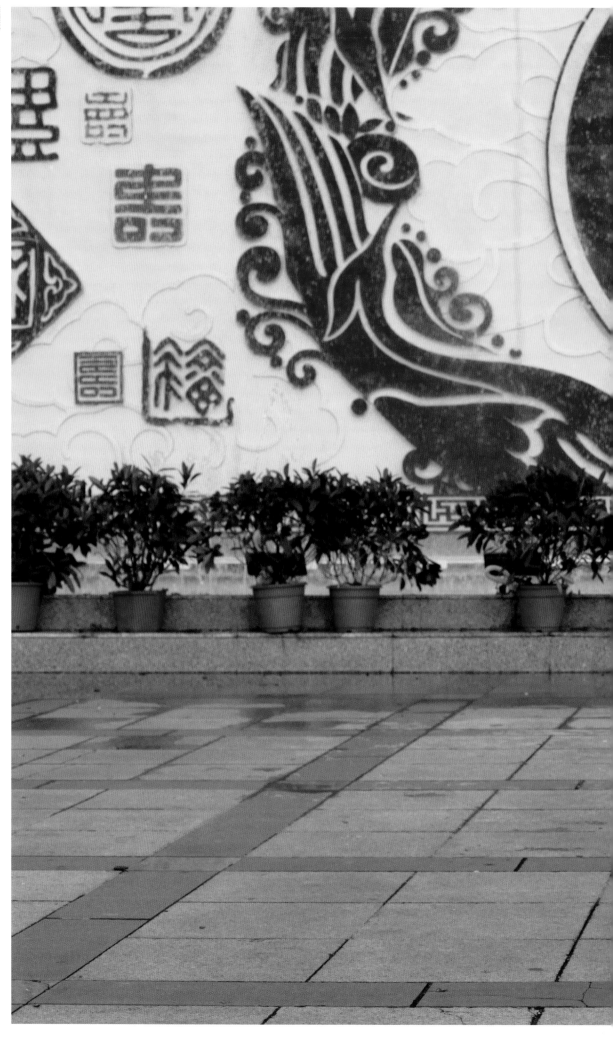

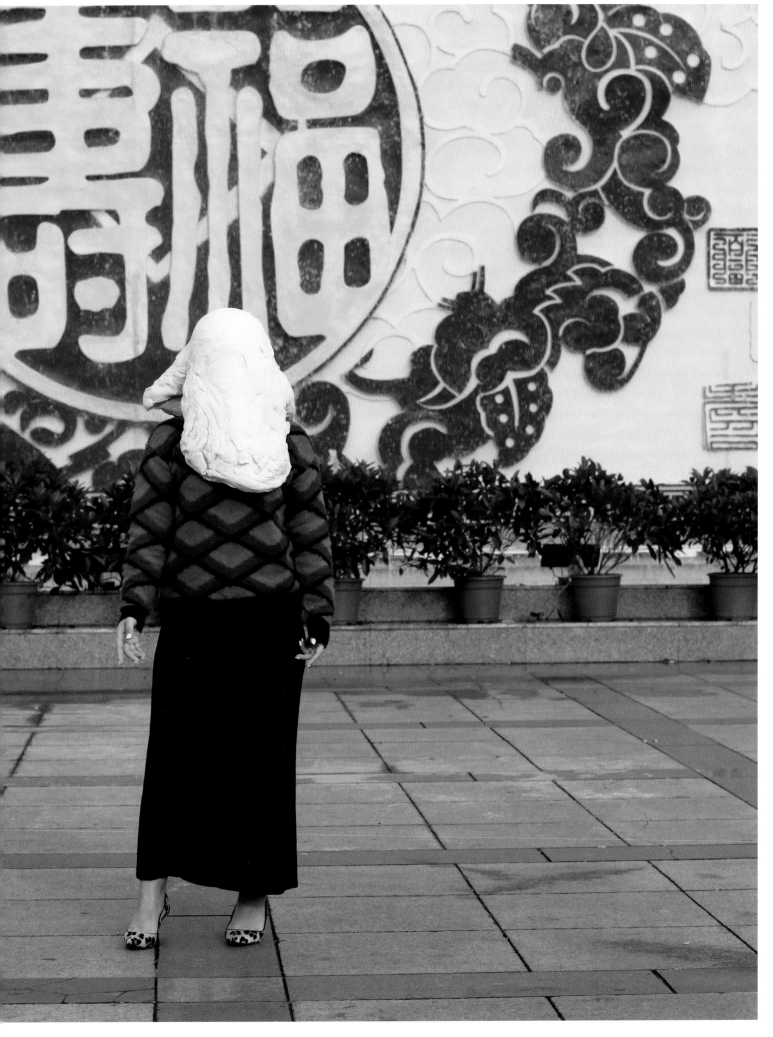

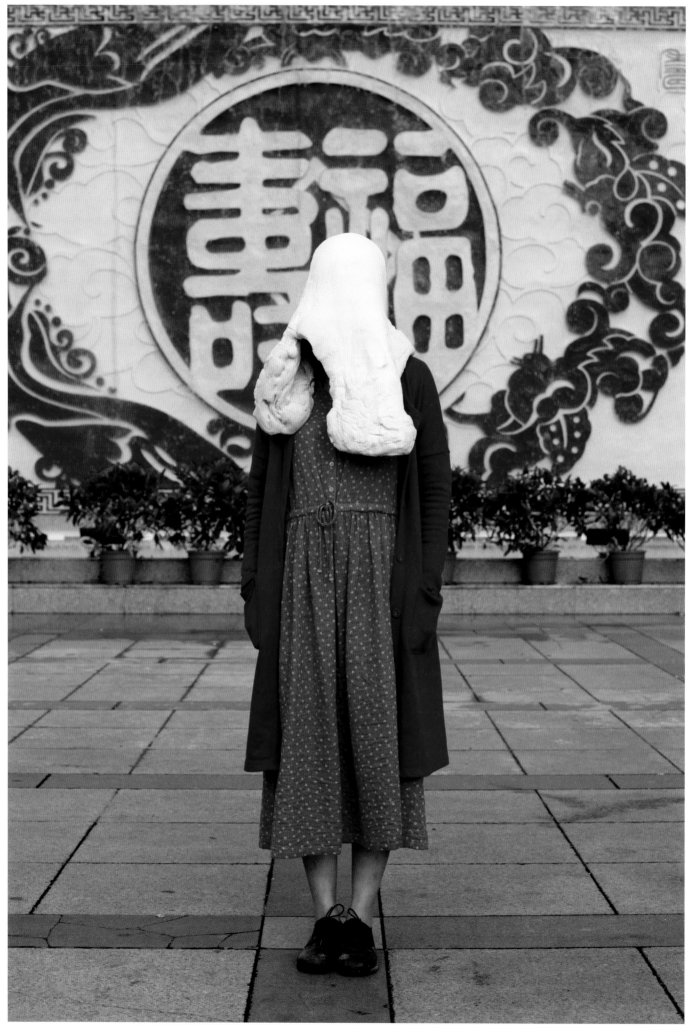

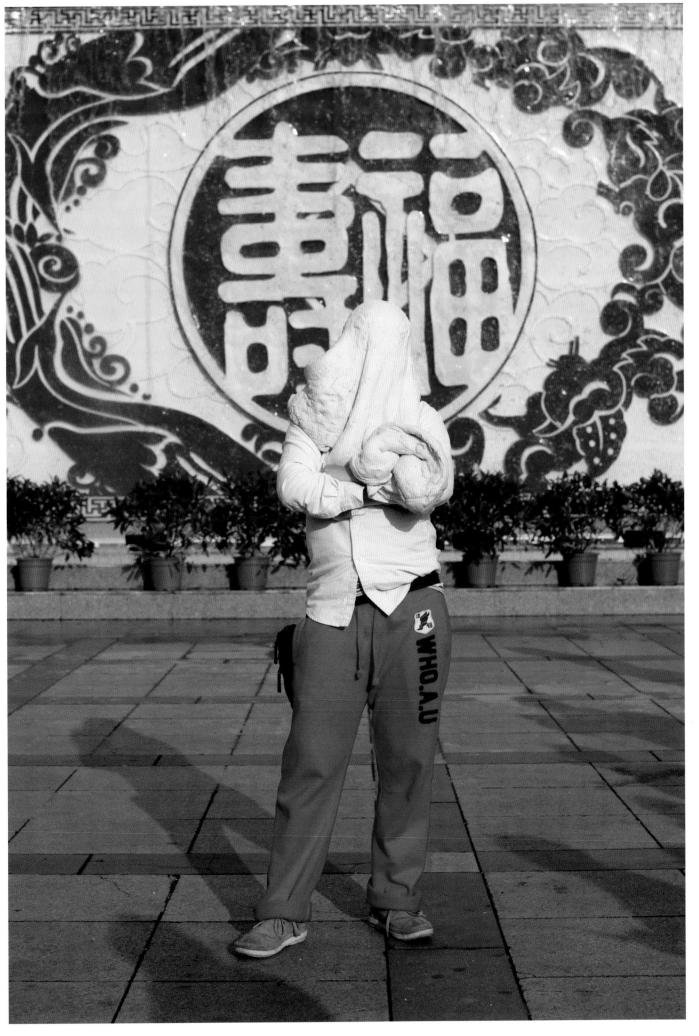

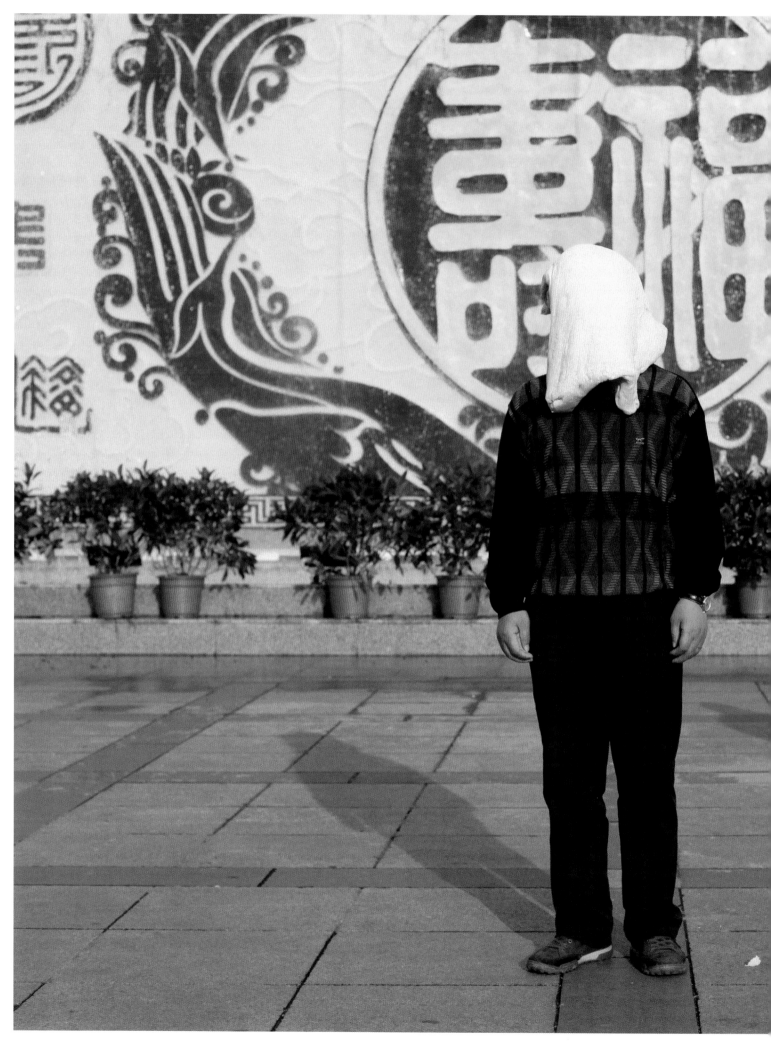

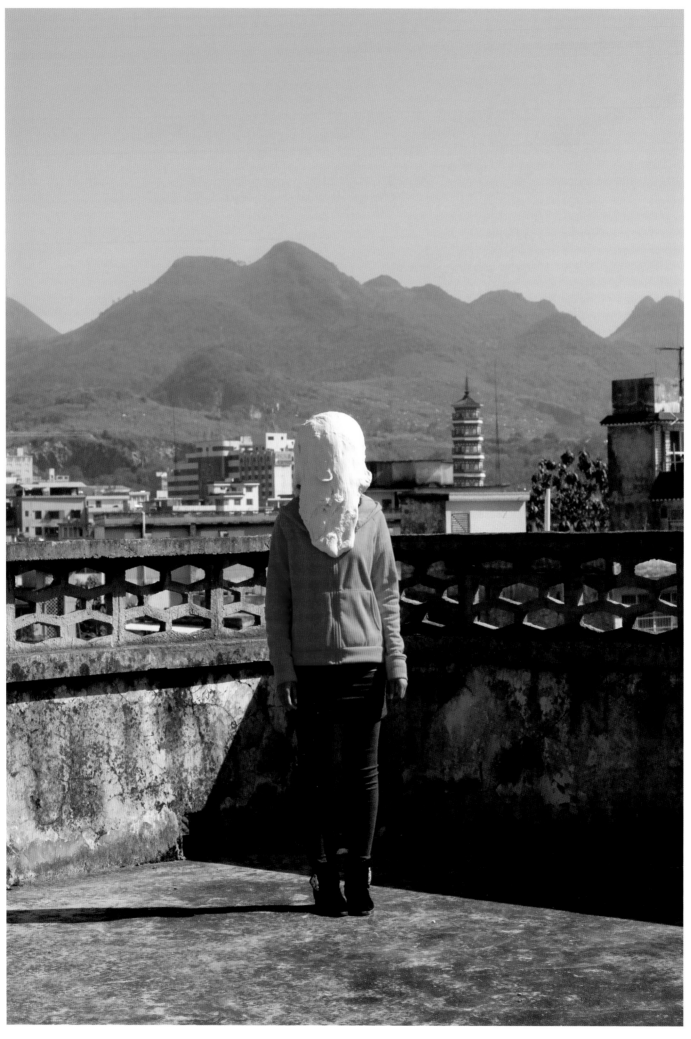

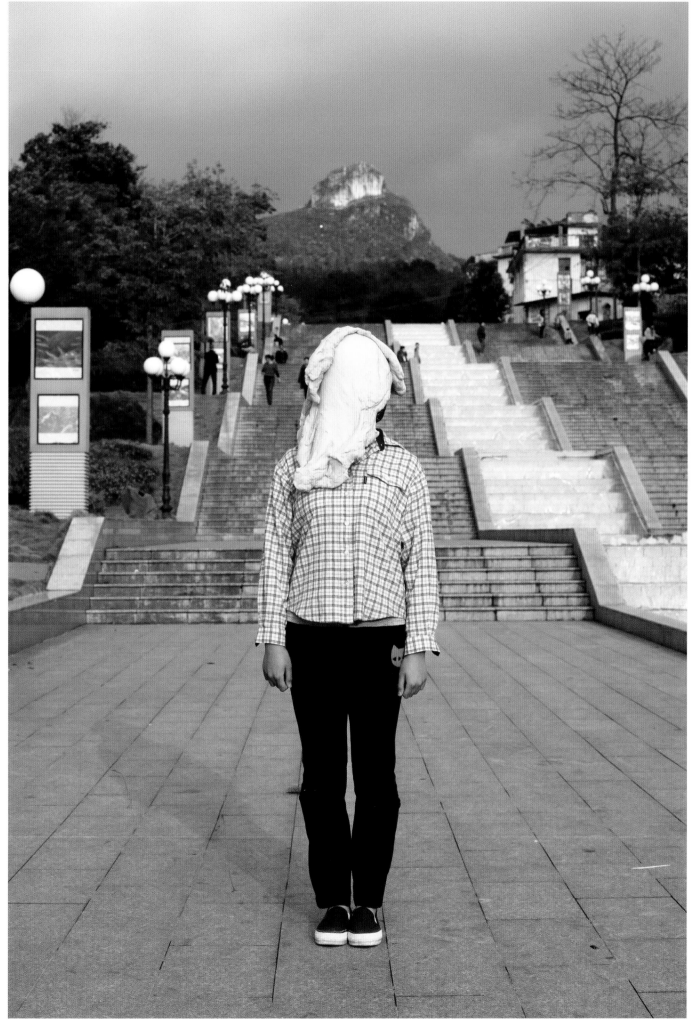

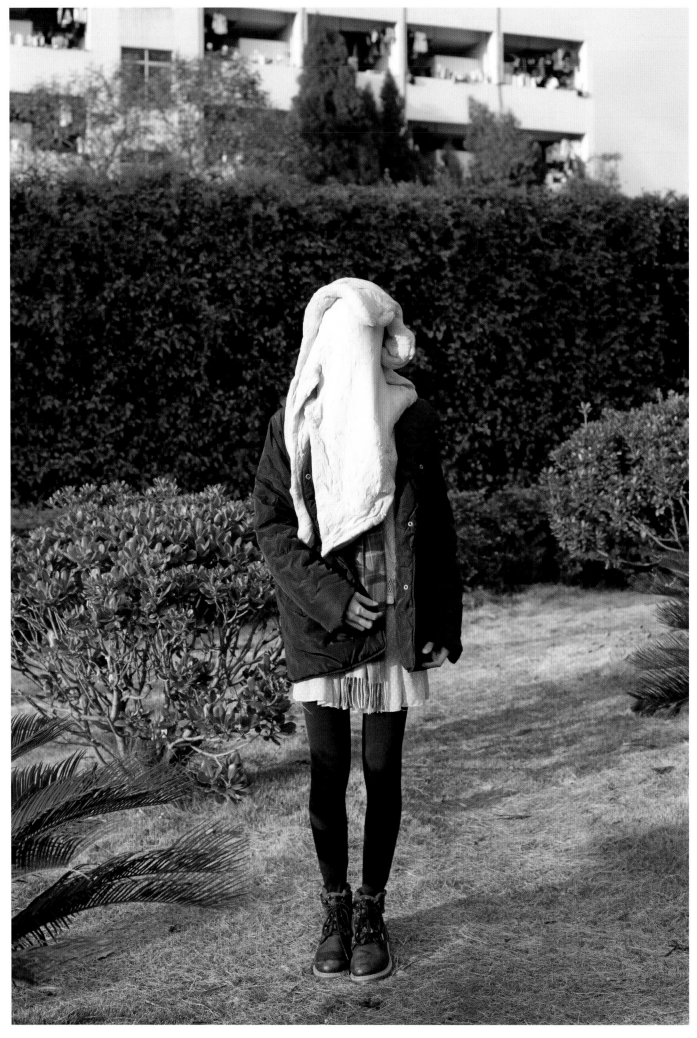

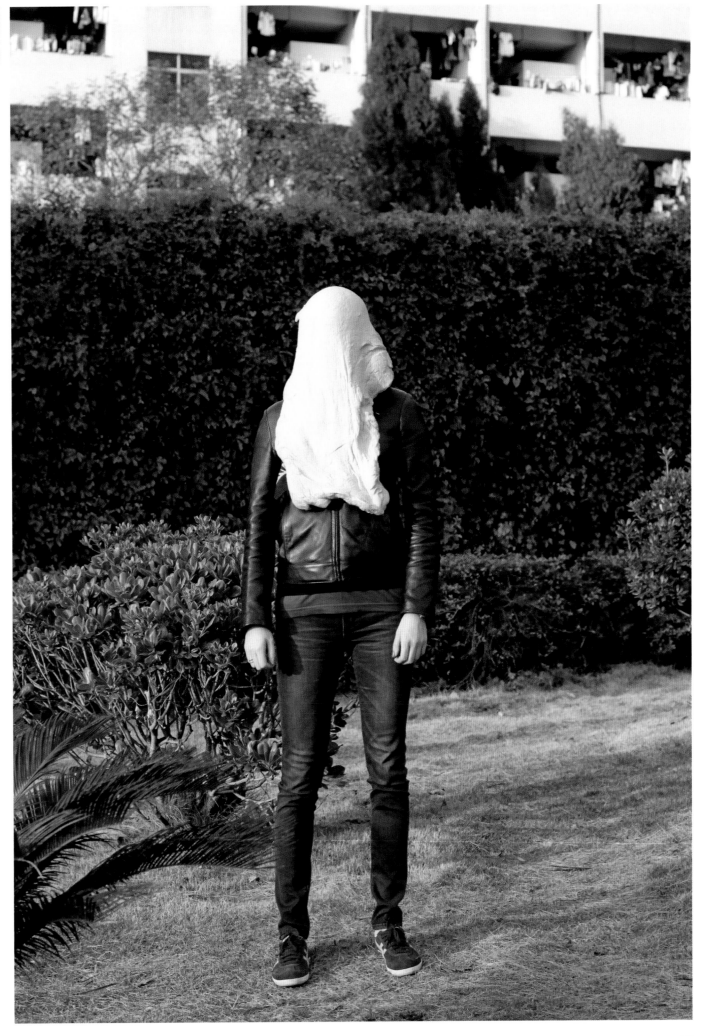

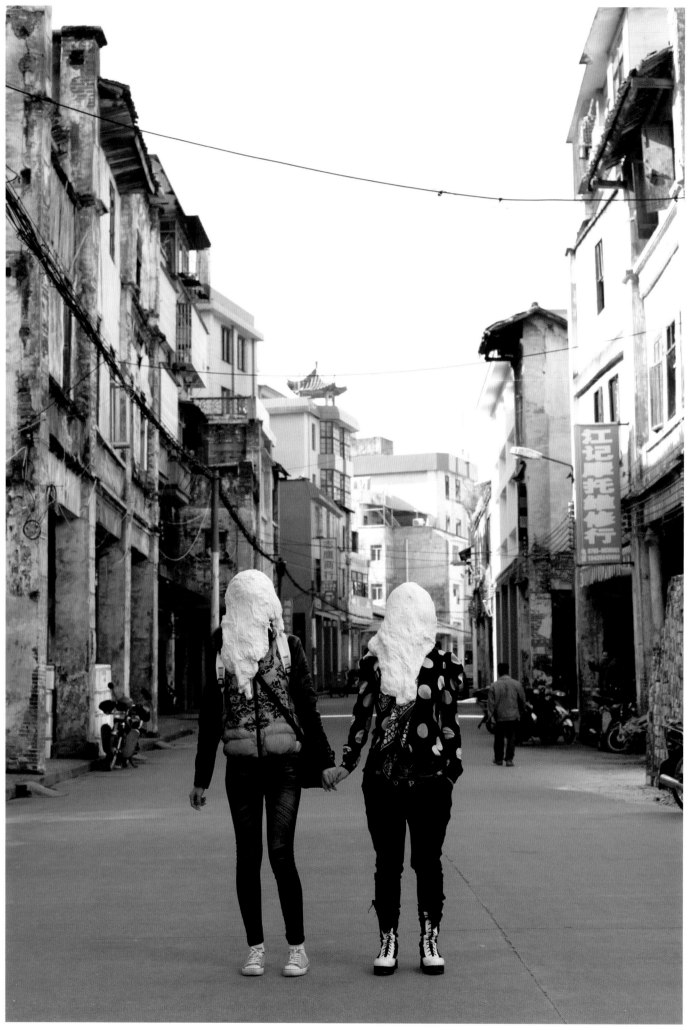

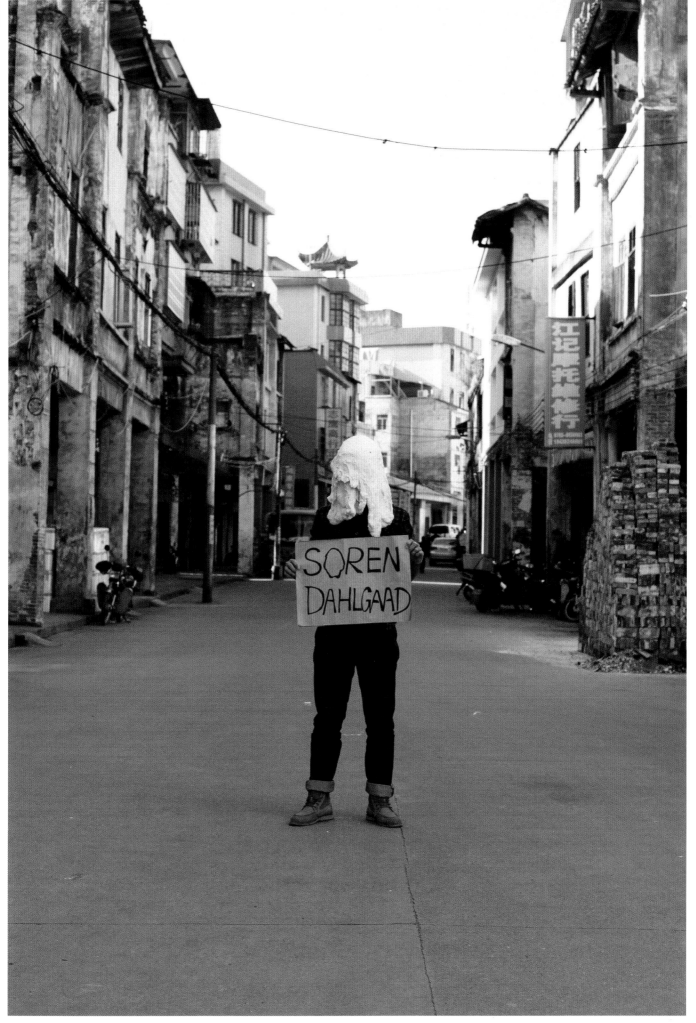

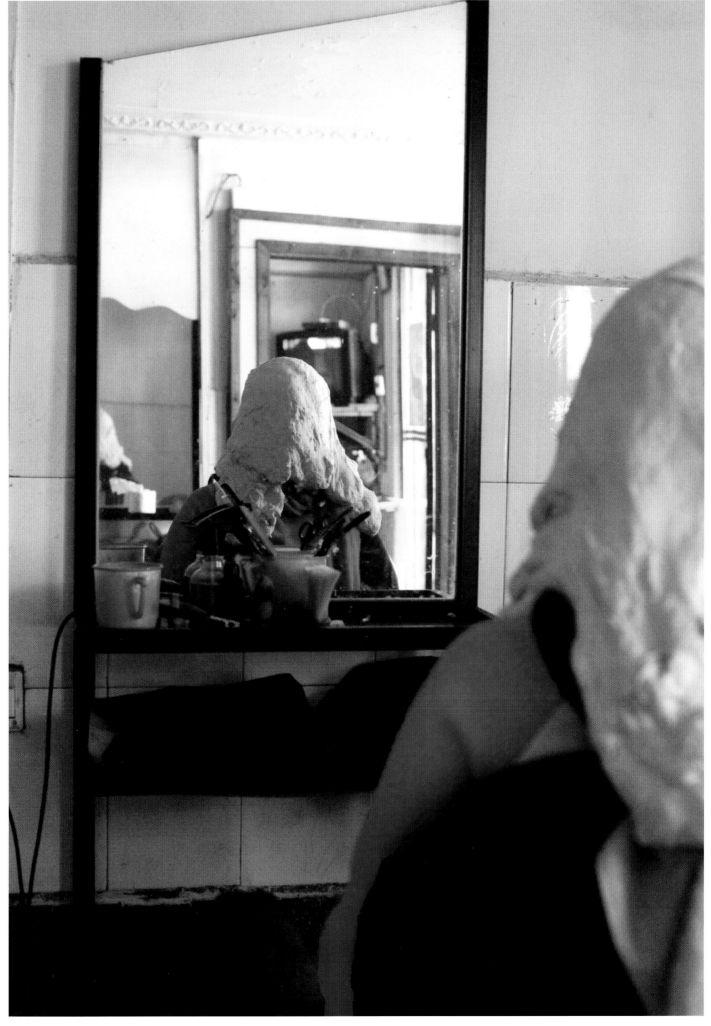

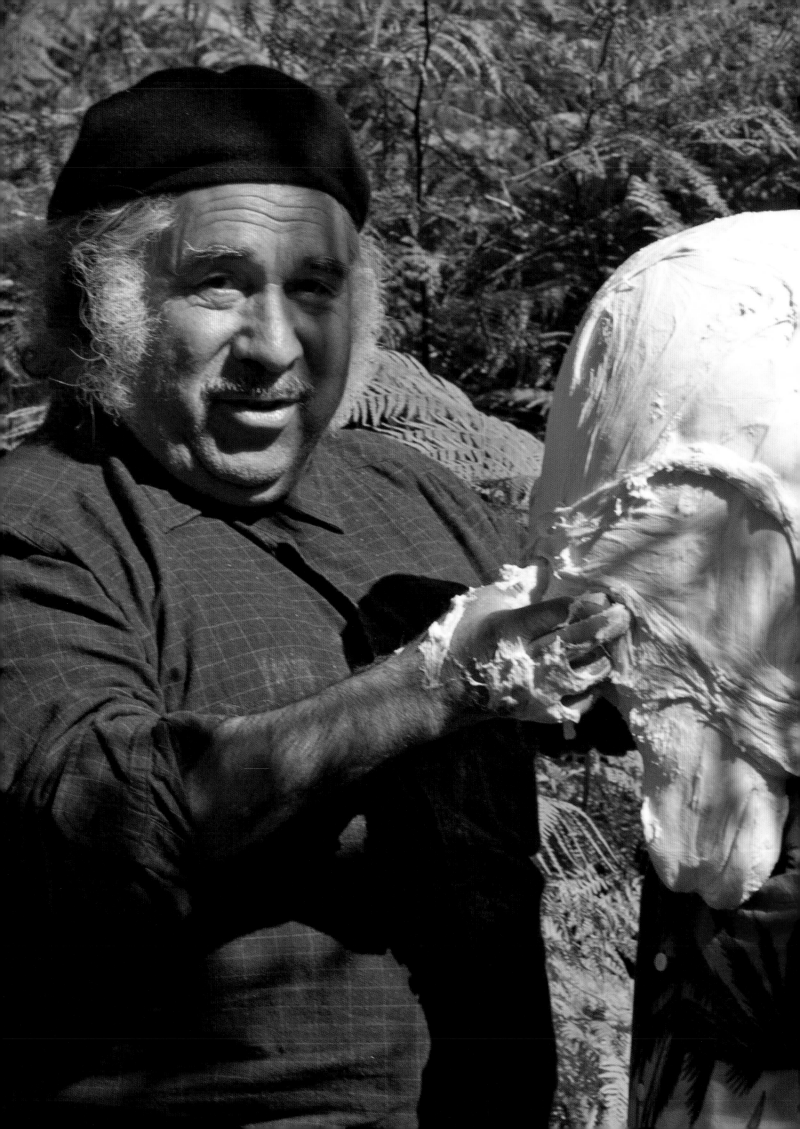

TARRAWARRA BIENNIAL, AUSTRALIA

YEAR **2014**
IMAGES **74**

BREAKING BREAD
WITH THE LOCALS

'Tis true my form is something odd,
But blaming me is blaming God;
Could I create myself anew
I would not fail in pleasing you.
If I could reach from pole to pole
Or grasp the ocean with a span,
I would be measured by the soul;
The mind's the standard of the man.'

Joseph Merrick, The Elephant Man

DJON MUNDINE AND NATALIE KING
CO-CURATORS, TARRAWARRA BIENNIAL 2014

In English, the word 'companion' came to mean someone with whom you 'broke bread' and shared a meal. Wheat bread was the main food in Europe until the late 1800s, and breakfast was often a small loaf. As such, bread was the stuff of life. In Australia, Aboriginal people processed the fruit of the cycad palm to remove toxins and then ground the seeds to flour as the main ingredient for baking bread, providing food for participants of large ceremonial gatherings. These loaves were gluten- and salt-free, but could cause cancer if the toxins present in the seeds had not been sufficiently leached. When processed wheat bread was introduced with the arrival of Europeans, it would cause more health problems for the indigenous people because of its salt content and other ingredients that were difficult to digest. The stuff of life has a darker side too.

In Jonathan Swift's 1726 satire on society, *Gulliver's Travels*, the writer reveals the illogical nature of human morality, and in the land of the giants, he exposes the grotesque ugly form of the human body under close scrutiny. If the face is the window to the soul, a picture of the mind and an image of one's heart, Søren Dahlgaard's portraits similarly depict a common face of bland plainness, if not ugliness. Like the deformities of Joseph Merrick, made famous as The Elephant Man, Dahlgaard's lumpy facial extrusions become dysmorphic; a reverse cast that is nonsensical. Draped in a lump of dough, the sitters enact faceless, sculptural portraits that are preposterous, partly improvisational and ephemeral. Dough is malleable and impermanent, making it perfect not only for Dahlgaard's obliterated self-images, but also for expressing the seeming impossibility of portraiture in the twenty-first century, given its weighty history.

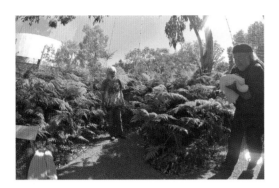
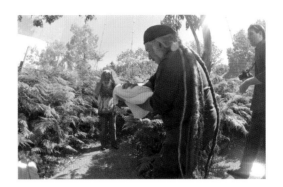

The placing of a mass of dough on the face is similar to the casting of 'death masks', a practice by physical anthropologists looking for characteristics in faces to prove their racist readings of 'primitive' and 'criminal' types in their dealings of Aboriginal people. Here dough cloaks character, class, station, the famous and common, friends and strangers, people posed in casual clothes and arranged at rest in various common places. Who am I? What is my character?

Taking a line from Grace Jones's 1981 song 'Art Groupie' – 'Love me in a picture / Kiss me in a cast / Touch me in a sculpture / Whisper in my mask' – the TarraWarra Biennial in 2014 had the title 'Whisper in My Mask'. It explored masking, secrets and hidden narratives as psychological states. The mask in its multifarious forms and functions can both reveal and conceal personas: it can protect, beautify, frighten or pacify, universalize or eternalize, intensifying and amplifying expression. We invited a number of Aboriginal and non-Aboriginal artists whose works explore different aspects of masking and elicit an emotional and sensory response.

Wherever possible, Dahlgaard involves locals in his iterative and evolving projects, thereby engaging with the nuances and particularities of place. For the TarraWarra Biennial, he arranged a weekend event in which members of the local town of Healesville on the outskirts of Melbourne could come and have their portraits taken within the grounds of the TarraWarra Museum of Art. Advertising in the local newspaper, he was able to mobilize and interest the community in his participatory and situational event. Families, couples, individuals and girls from

the Worowa Aboriginal College became part of the experiment. Further images were taken in the garden of Bunjilaka Aboriginal Culture Centre at the Melbourne Museum.

Renowned Aboriginal actor, activist, musician and elder Jack Charles became the subject of a billboard-size portrait stuck to the walls of the TarraWarra Museum as a way of addressing the local history of Aboriginal dispossession. Charles's great-great-grandfather had been at Coranderrk, a mission on the edge of Healesville. It was a self-sustaining, determined and vibrant Aboriginal community based on a revitalized farming life. When the government moved to close down the community in 1881, a fight for justice ensued with the Aboriginal Protection Board. During the Coranderrk Festival, established in 2013 to celebrate the strength and resilience of the original Coranderrk community, Dahlgaard had been introduced to the Aboriginal singer Bobbie Bununggurr, visiting from Ramingining on the Arafura Swamp. He became the subject of another dough portrait.

Dahlgaard elides and conflates age, race, gender and class in his bizarre faceless portraits, rendering everyone the same under the equalizing effect of the dough. Comedy, caricature, distortion, exaggeration, send-up, skit and cartoon can all be seen as systems or rituals of masking and unmasking. We are reminded here of Hans Christian Andersen's Danish fable 'The Emperor's New Clothes': a tale of deceit, disguise and invisibility. Dahlgaard deploys masking in a comic and exaggerated gesture of obliteration – a sculptural cast that fuses portraiture, photography and performance that is completely absurd, transformational and just plain fun.

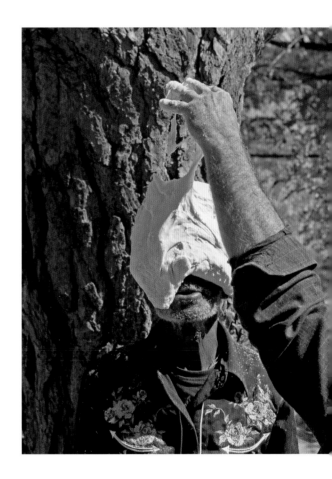

The artist's youngest son Olau looks apprehensive as he waits for the dough at the TarraWarra Museum of Art (opposite). Meanwhile, Djon Mundine brings in the dough for Jack Charles's portrait at the Bunjilaka Aboriginal Culture Centre (top), and then gets his hands sticky as he puts the dough on the head of Bobbie Bununggurr (above).

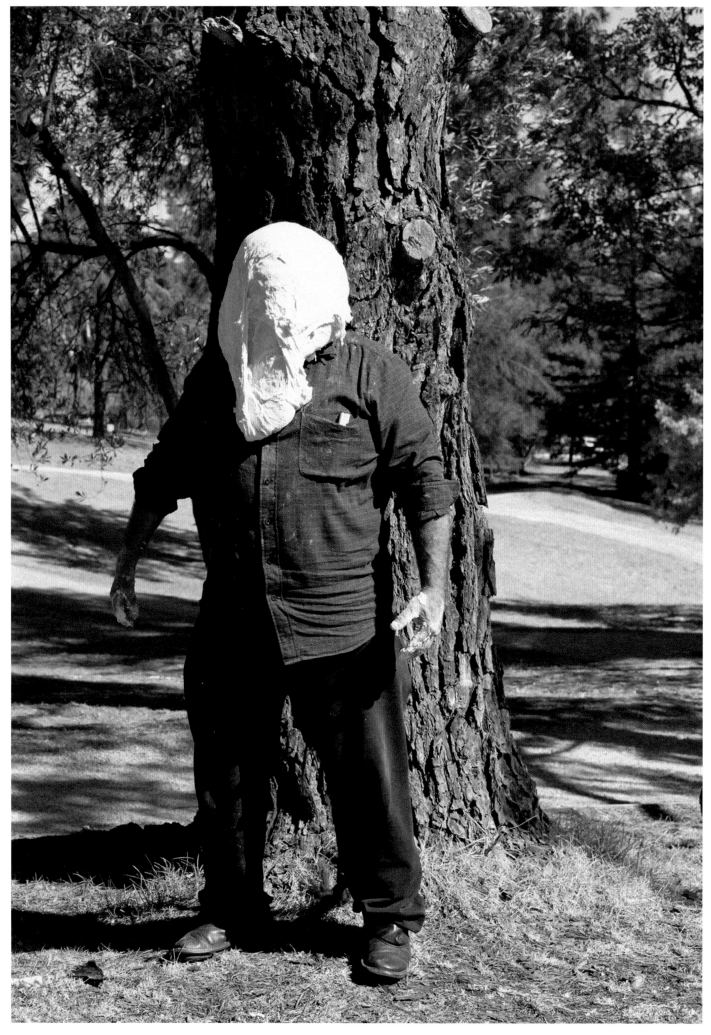

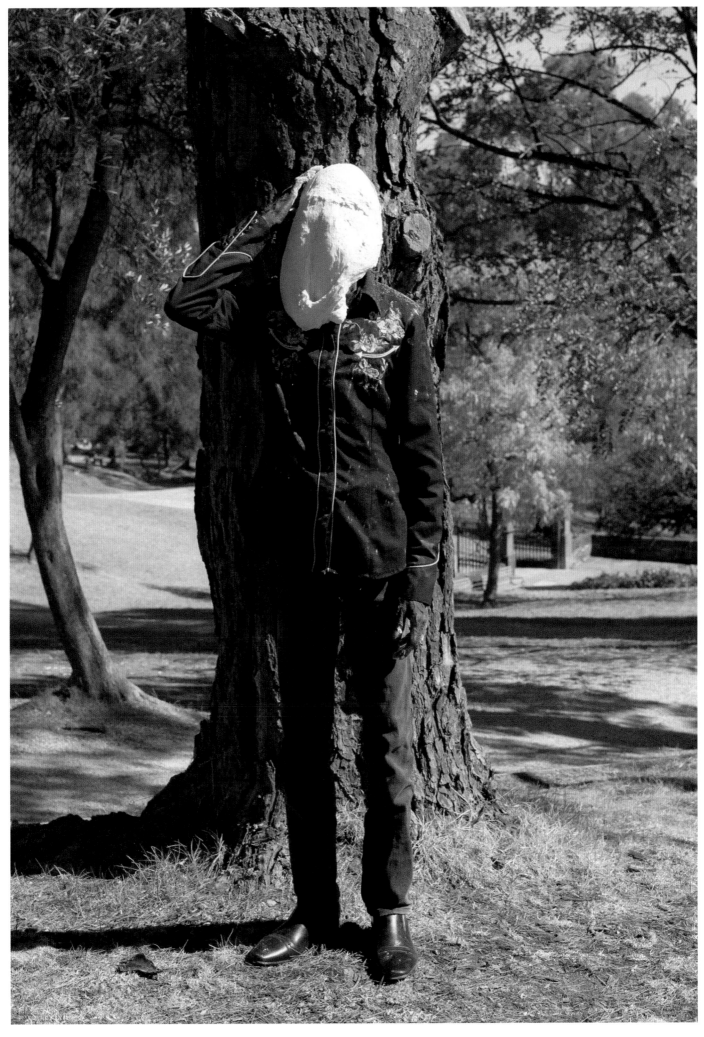

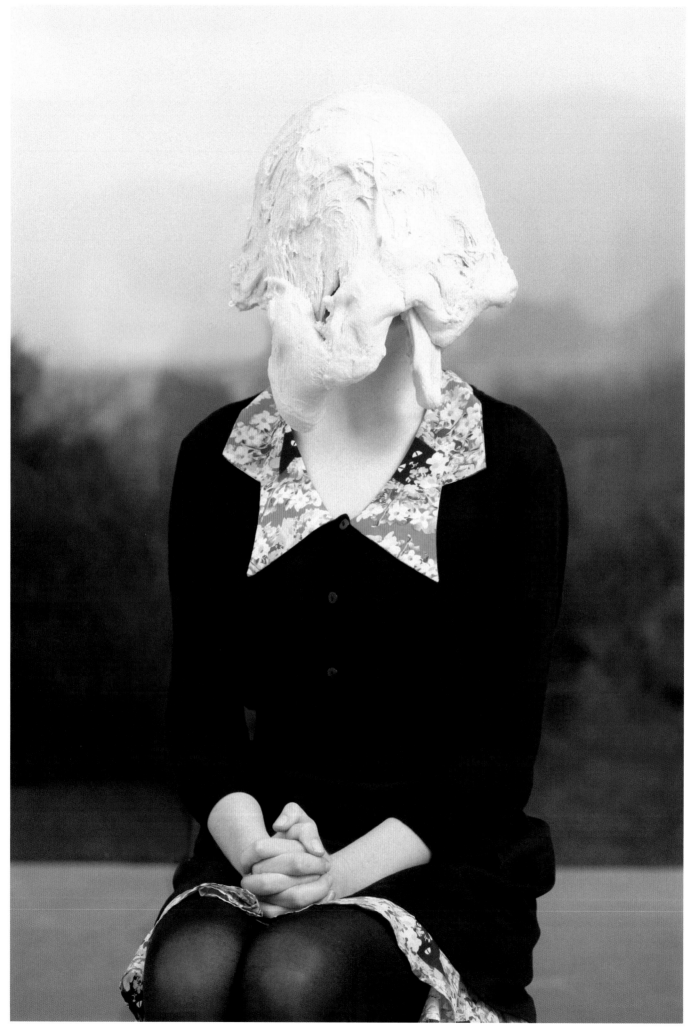

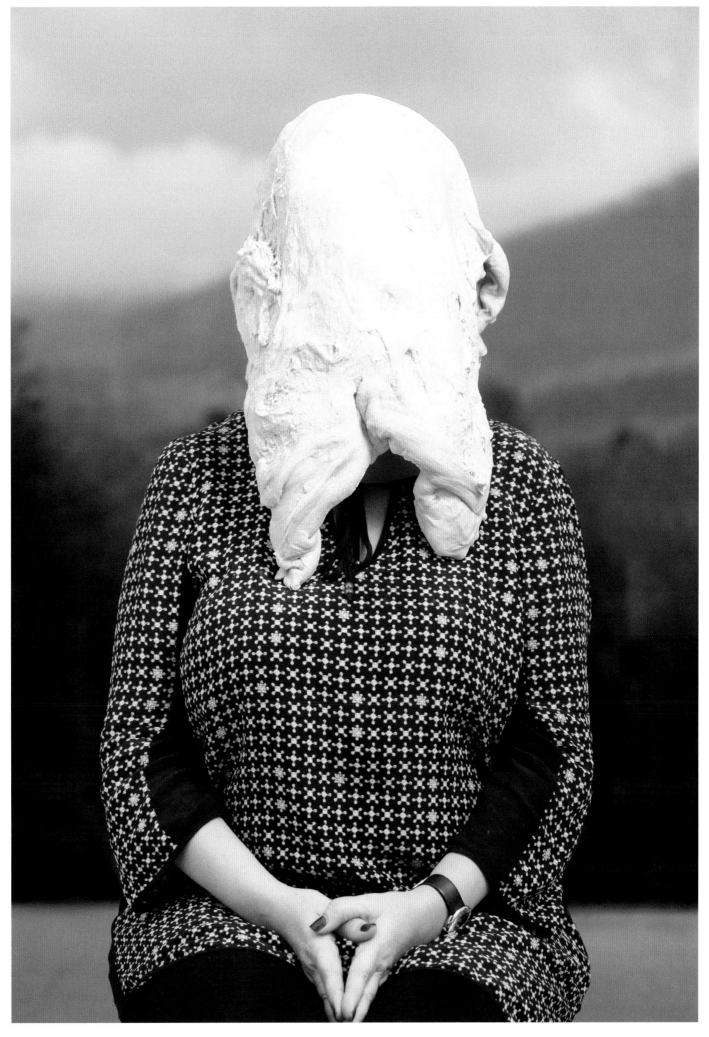

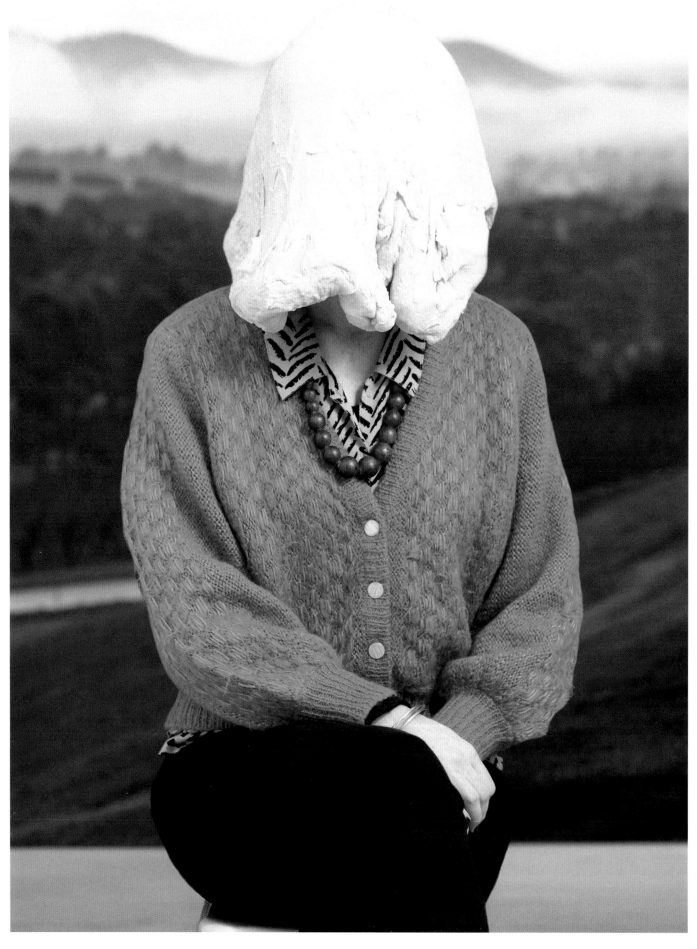

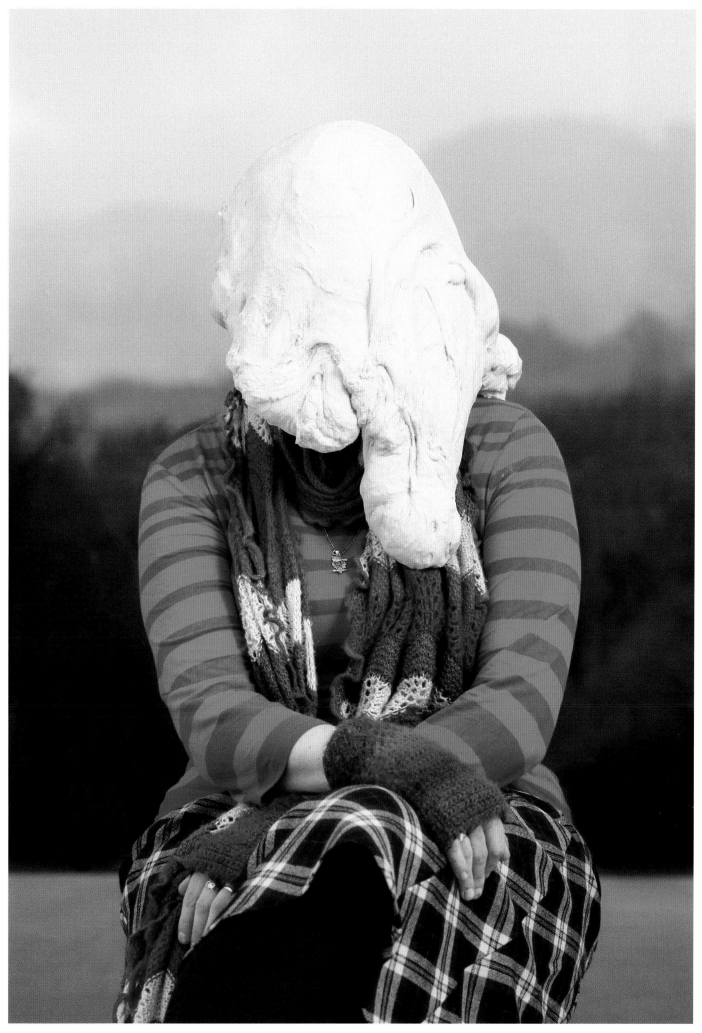

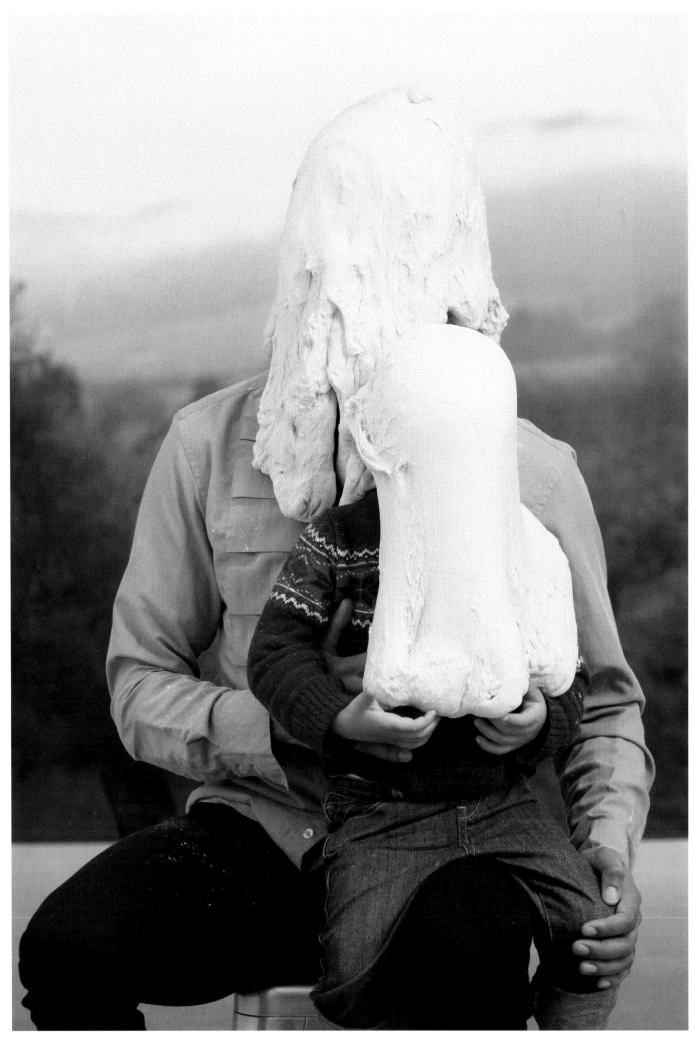

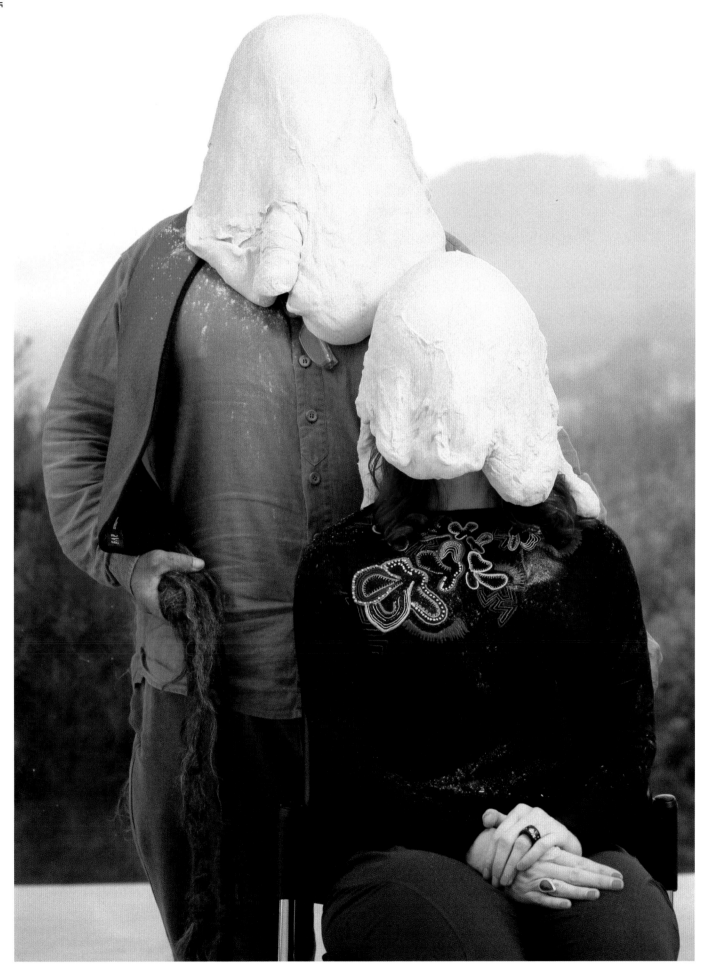

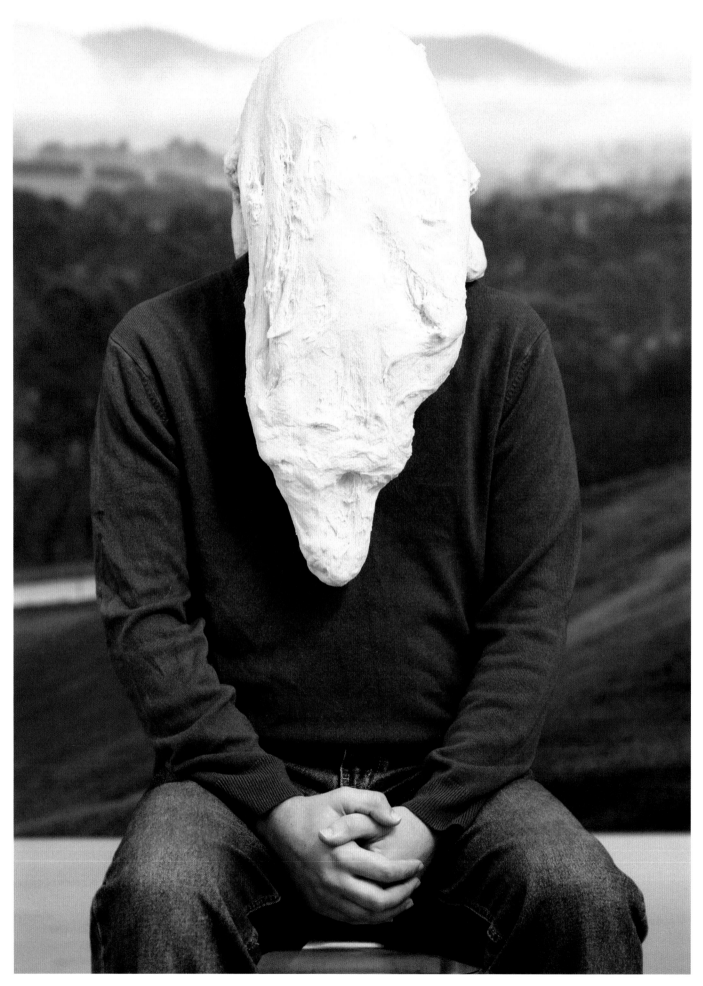

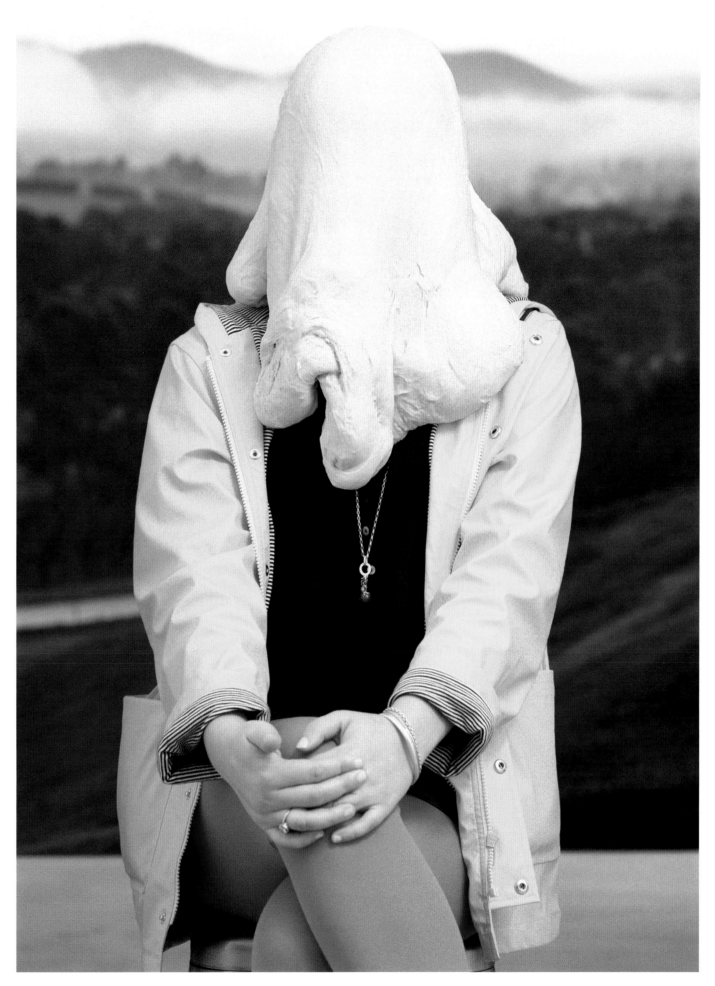

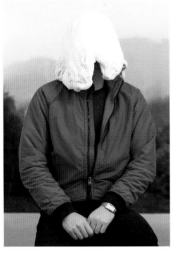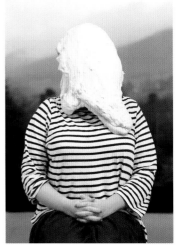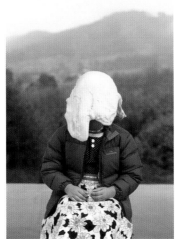

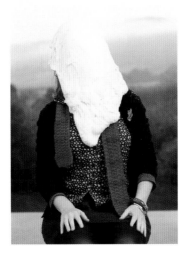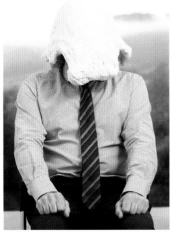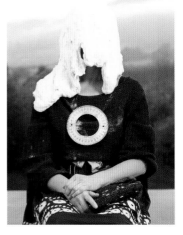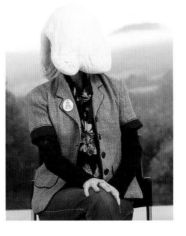

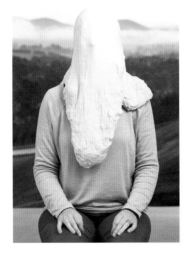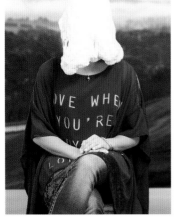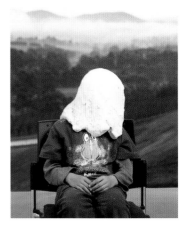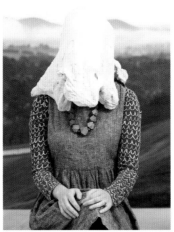

ELIZABETH; LUKE; AMANDA; AARIKA
MONICA; TONY; DAWN; SKYE
ALI; ASHA; OLAU; TESSA

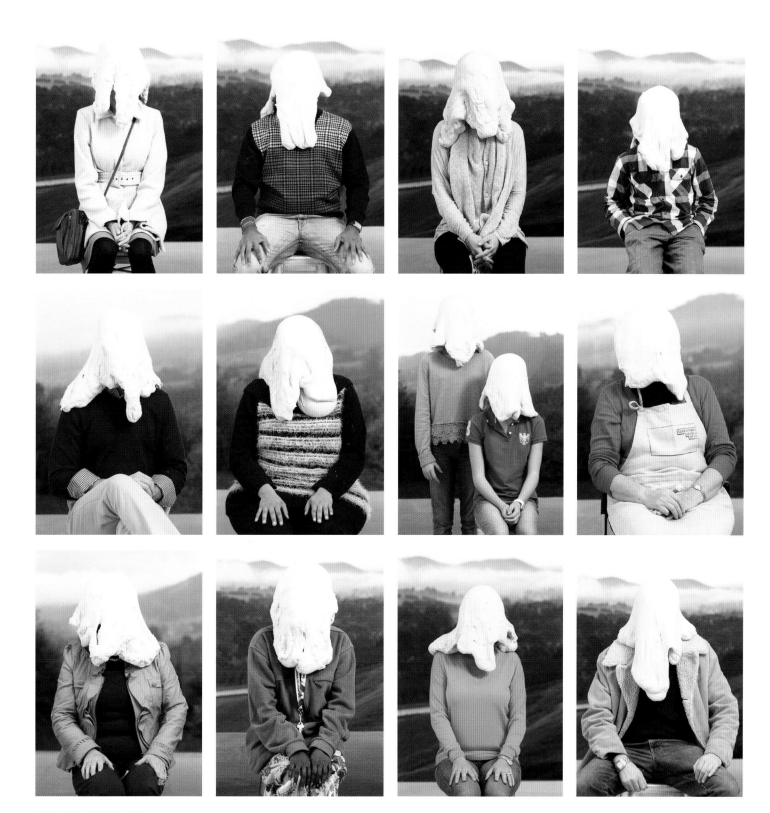

SARAH; KONER; AURELLIA; JULES
CHRISTOPHER; RASNMI; PIPER AND SUMMER; DENISE
HELEN; FRANCES; MELISSA; ANTOINE

PROCESS AND POSE

Three fragments concerning the participatory
aspect of the *Dough Portraits*

———————

RAIMAR STANGE
CRITIC AND CURATOR, BERLIN

I. Open works

Umberto Eco's *The Open Work* from 1962 remains
to this day a pioneering theorization of interactive
and partipicatory art. Eco defines the 'open work'
by redefining the role of the heretofore 'passive'
spectator who 'collaborates ... in making the
composition'. Participation is the artist's well-
calculated working method: 'In other words, the
author offers the interpreter, the performer, the
addressee a work to be completed. He does not
know the exact fashion in which his work will be
concluded, but he is aware that once completed,
the work in question will still be his own. It will
not be a different work; and, at the end of the
interpretative dialogue, a form that is his form
will have been organized, even though it may
have been assembled by an outside party in a
particular way that he could not have foreseen.'
Three aspects are crucial in this regard: first, the
addressee – the interpreter – becomes somebody
who 'organizes form'; second, this organizing
effort is unpredictable; and third, the process of
opening up the work's production does not really
modify the status quo of authorship: the artist
remains the boss, it is still 'his work'. The latter
remains the case precisely because it is he who
endows the work with a selection of 'organic
complements which they [the viewer/participant]

graft into [its] structural vitality', and thus composes the work in a unique manner. Hence, 'open works' are anything but 'conglomerations of random components', and it is precisely for this reason that the term 'author', designating the person responsible for the work's formal conceptualization, still makes sense.

Now, in his essay 'The Emancipated Spectator' (2008), Jacques Rancière opposes Eco's idea of a reformed performance practice by turning his passive spectator into an active participant in the aesthetic event; that is to say, by turning every performance into an 'open work'. Through his notion of so-called 'participation', he criticizes that it (participation) disregards the fact that mere viewing is *already* active reception. Rancière writes: 'We do not have to transform spectators into actors.... We have to recognize ... the activity peculiar to the spectator.' Hence, Rancière fundamentally contradicts Eco's insight. According to him, the addressee does not participate in the concrete making of the work; he is allowed only to interpret and, in doing so, to construct his 'own poem'. But such a socially conservative attitude not only condemns the addressee again to high-priced spectatorship, disenfranchised from aesthetic action, but also turns artistic work once more into an effort that is expected to deliver finished and conclusively organized constellations on demand. Søren Dahlgaard, however, does not play along.

II. Pie battle?

In Dahlgaard's video *Hexagonal Cyclops* (2000), we see a man in a white protective suit and shield (also in white), standing within a six-windowed panopticon. From these windows, the man is pelted with lumps of dough, which he attempts, not always successfully, to dodge. In this minimalist-actionist 'turbo-pie-battle', one finds not only a moment of (slapstick-like) humour, which is typical for Dahlgaard, but also that of an interactive dialogue. After all, the man participates in the 'making of the work' in so far as he codetermines its choreography through his swerving movements. How he might duck Dahlgaard could very well guess, yet exactly how

the man will move he could not know. However, with the concept and the architectonics of the work, the artist has determined in advance the rules and conditions (the 'organic complements which [are grafted] into the structural vitality' [Eco]) of his performance.

Dahlgaard's *Dough Portraits* also make use of dough as essential material. As in *Hexagonal Cyclops*, these portraits, with their well-calibrated tension between humiliation and fun, are a little reminiscent of pie-battles as we know them from silent film comedies. In this series, however, people enter into the aesthetic play and not only react to a predefined set of rules, but also productively codetermine how the final work will look; which is to say, they may make decisions that are not merely negative (avoidant) in nature. In the Maldives in July 2009, it looked like this: ninety-nine people participated in Dahlgaard's project: schoolchildren, fishermen, a posh lady. First, each one chose a lump of ten kilos of dough to model according to their own conception of a mask, within constraints imposed by the unstable material's internal dynamics. In the process, the actors began to talk with each other, joking and helping one another: 'teamwork' almost occurred in this participatory performance. Eventually, each participant put on his or her white mask, presenting themselves to the photographer, who through an act of documentation brought the work to a conclusion. It is only now that the moment of activity emerges that Rancière wrongly claims as the only relevant outcome: the viewing of the work. By concealing the face, the mask functions as anti-portrait. It prevents the portrait that appears in any passport photo. The addressee must, of necessity, start looking for other hints. In which pose does the person portrayed present her- or himself? What clothes does she or he wear? and so on. It is then that the addressee begins to imagine his 'own poem' (Rancière). The *Dough Portraits* prove themselves to be participatory projects that, in the sense meant fully by Eco, allow actors to concretely collaborate in the work's production. Moreover, it is a work that incites the recipient's eminently active interpretation.

III. Pose or process?

To conclude by briefly mentioning another precursor of the *Dough Portraits*, namely Dahlgaard's video *12 Second Sculpture* (2006), the title of which alludes to Austrian artist Erwin Wurm's *One Minute Sculptures* (1997–ongoing). With these 'do-it-yourself sculptures', as critic Paulo Herkenhoff describes them, Wurm offers a manual for various actions to be executed by others. For instance, a woman lies on an orange with extended arms and legs for, as the title of this performative sculpture announces, a minute's duration. Dahlgaard's *12 Second Sculpture* documents a thirty-kilogram lump of dough 'sitting' on a white chair before slowly but surely sliding damply to the floor.

Now, the significant difference between Wurm's concept of *One Minute Sculptures* and Dahlgaard's aesthetic of *Dough Portraits* is mainly this: Wurm deploys man, his participant, in a more or less authoritarian manner, dictating exactly what they should do. His participants are, so to speak, human material with which the artist can operate according to his ideas and desire. Here, the one-minute pose is the key, not the process that constitutes it. As early as 1980, Roland Barthes famously wrote on posing in his book *Camera Lucida*: 'I constitute myself in the process of "posing". I instantaneously make another body for myself, I transform myself in advance into an image.' Thanks to this 'in advance' of the pose in his works, Wurm is able to anticipate exactly the form that his sculptures will take. In Dahlgaard's work, however, the quality lies not least in the fact that those portrayed, as outlined above, make their own decisions. Hence, the visual results of such a processual collaboration are not wholly predictable for the artist. To formulate it emphatically, one could say that in Dahlgaard's work the performer remains a human being and does not deteriorate into a valuable art commodity (even though in English 'dough' also means 'money'). For that, the photographs are anyway too 'silly' and, to paraphrase Mikhail Bakhtin, deride the value-generating ideology of high art.

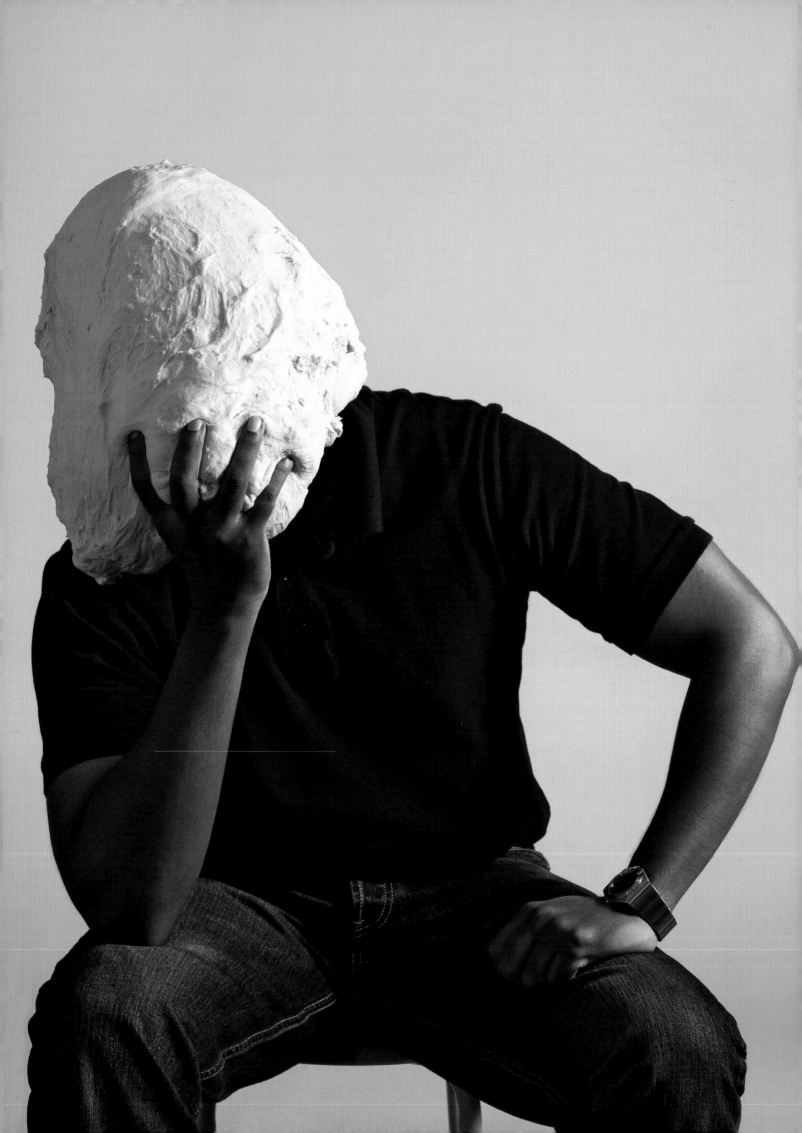

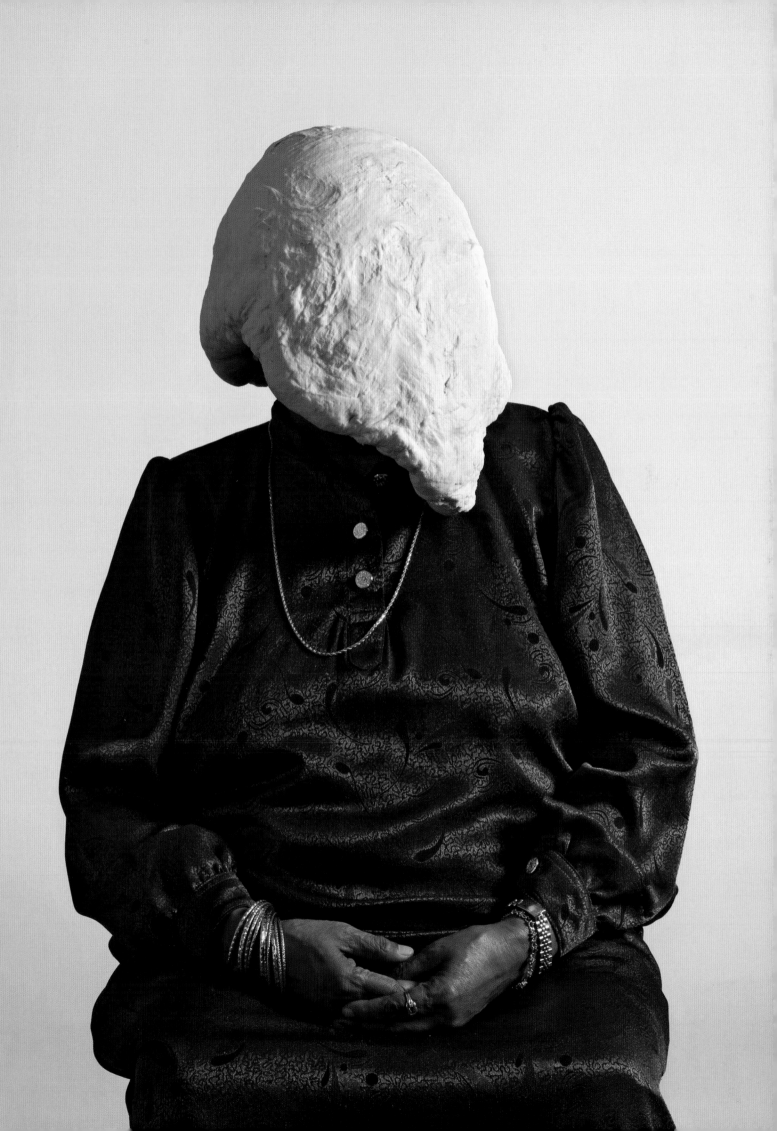

MIXING DISCIPLINES

'Humour creates both distance and intimacy: you get closer by smiling and gain perspective through laughing.'

Dan Perjovschi, artist

SØREN DAHLGAARD
THE ARTIST

In search of a medium with no previous history in art, I began using dough as a sculptural material in the summer of 1997, shortly before I moved to London to start at the Slade School of Art. My early video and staged-photo series *Circular Alteration* featured fifty lumps of dough, each of around ten kilograms, placed on a large platform. It was a strange kind of dough field situated in a psychedelic, sci-fi scenario inspired by Stanley Kubrick's *2001: A Space Odyssey* in which the lumps started to breathe and jump around, while scientists tried to work out what was going on. The next video and photo work that I made with dough was *Elliptic Touchdown* in 1999, followed by *Hexagonal Cyclops* from 2000 and *Challenging Dough* in 2005. A common element in all of these pieces, apart from the principal material being lots of dough, was the number of artistic disciplines they fused in a single work. Mixing video, staged photography and sculpture, as well as durational processes and play, resulted in a time-based performing sculptural narrative that built on an aesthetic derived from a diverse range of influences, including land art, the work of Matthew Barney, Paul McCarthy and Roman Signer, and my own Danish suburban background.

Similarly, the *Dough Portraits* series merges photography, sculpture, performance, participatory art and collaboration into a playful hybrid. While I initiate and direct every event, the collaborative encounter with each participant is a fundamental element. We create the portrait together. I explain and arrange the set-up and frame the shot, but the subject chooses their own lump of dough, kneads and shapes it as they wish, and then places it on their head. What is striking is that each lump has a different shape and expression. That is just one of the characteristics of dough as a sculptural material, and one reason why I believe that it has such an untapped artistic potential.

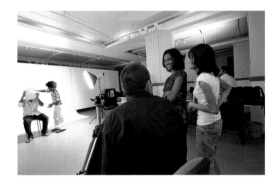
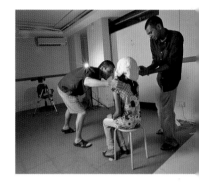

Some of dough's textural qualities are rather similar to those of materials historically employed in the plastic arts, particularly clay and plaster, but it is really an absurd material in terms of classical forms of sculpture. Traditional materials – wood, marble, stone and bronze, for example – can last for hundreds of years, while dough is good only for a few hours. But this conventional idea of sculpture is just my starting point. What I am trying to do is take a conceptual approach to the medium. Dough for me is merely a prop in the staged video or photo scene; and when I stage this scene, there is always a narrative. While dough may be the sculptural material, it is the participants themselves who perform and transform into the sculpture for the duration of the shot. Photography and video are the media by which I make a lasting artwork that endures beyond the performance.

The *Dough Portraits* events succeed in breaking down the barriers between the artwork and the spectator, which are present in the normal museum art-viewing experience. The humour and playfulness of the occasion are key in achieving this. The groundbreaking avant-garde Japanese art group Gutai, active in the 1950s, had a similar aim when they developed events and exhibitions and staged them in unexpected locations such as parks and on a rooftop. They were always driven to create something new and original, and often with hilarious results. That is true of the *Dough Portraits* too, as the stills and photos of the sessions in this book demonstrate. But does containing slapstick humour mean that we have to consider a work to be low art? Does high art always have to be serious (that is, humourless)?

In fact, the *Dough Portraits* series, as ludicrous as it may appear, is closely connected to the long history of grand and serious portraiture.

In the old days, artists were commissioned to paint and sculpt portraits of the rich and powerful: kings and queens, popes and princes, mercenaries and merchants. The *Dough Portraits* relate to this tradition, as well as to the more recent medium of portrait photography, which continued many of painted portraiture's conventions, while introducing new ones of its own. While few of us have ever been painted or sculpted, everyone must have been photographed at some stage of life. We have all posed for school photos or had our image taken for a passport or identity card, so the experience of sitting in front of a camera for a portrait is familiar to us all.

Dough, too, is common in all cultures around the world, except for nomadic peoples. Nearly everyone eats some kind of dough each day, in the form of bread, cake, noodles, pasta, naan, croissants, biscuits, doughnuts, etc. When these two familiar concepts, the portrait and a lump of dough, are brought together – as in a big mixing bowl, perhaps – they change into something new. The stuff on people's faces is not dough any more – it has become part of their new identity. That is the foundation of my entire art project: to turn familiar objects into something strange, and to tell new stories by doing so. By introducing a non-art material like dough into established genres such as sculpture, photography, video, painting, performance and documentary, and by creating a new set of rules for how to use it, the existing artistic categories break up, and these disciplines are thereby transformed into a new interdisciplinary hybrid.

Many of my projects start off as a reaction to an established way of doing something. I ask simple questions about making art. Why do so many artists paint? Why do they use paintbrushes? Why do most artists work in a studio? And why alone?

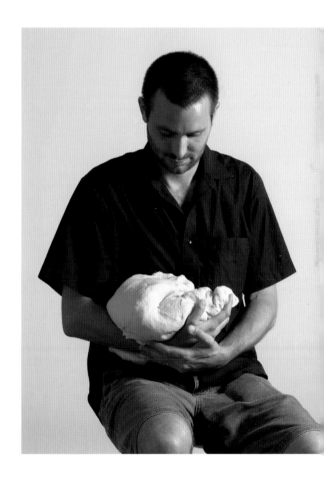

Mixing the dough and preparing for the first Maldives *Dough Portraits* event in 2009 (top row). Meanwhile, the artist takes a break from the shoot to sit down and explain art to the dough (above).

Why is the painting process often hidden? Is it secret? Why? What is skill? What is a masterful technique? What makes a masterpiece? How do you make a masterpiece? Who decides what a masterpiece is? How? Based on what? How do you reinvent an established direction in art?

And I ask simple questions about life, too. Why do we live the way we do? Why do many men wear a tie to work? Why do people watch television for three hours a day on average in the Westernized world? Why do most people act the same way every day? Why do we buy, think and do the same things over and over? Is it possible to rethink the way our lives are designed so we can address the problems that our current systems are causing? How can you take charge and change the way you live and do everyday things?

And my practice is often driven by a desire to build on a certain genre of art by rethinking and transforming it. This has included landscape painting, portrait painting, portrait photography, the concept of the white cube, the methods and tools of art-making, the idea of the original artwork, and the very notion of the artist itself. I digest, question and challenge sets of clichés by using narrative and new methods of making art inspired by other fields (such as sport) or a new mix of known methods from a range of practices. My thinking is often provoked by well-known and celebrated artworks, especially those that are held to be important in some way. I want to challenge their position and question their claim to significance. By transforming the original framework or method adopted by the artist in question – the starting point of the work – I try to create a fresh and relevant expression for the current time and context. The overall philosophical point of my work is to reflect on existential issues by doing something new with an already known concept.

Dough Portraits was no exception. The work is developed from fundamentally simple questions. Can we see in a different way? Can a faceless portrait still be a portrait and relate to the classic art portrait? Can the creation of the artwork include and activate the audience to create a hands-on experience? According to the phenomenologist Maurice Merleau-Ponty, your body remembers experiences in the bodily memory, where they become habits. Merleau-Ponty's concept of phenomenology has influenced Olafur Eliasson's work about seeing yourself sensing. In the *Dough Portraits* events, you see other people sensing, and when you participate, your sensory experience of the dough happens through smell and touch, through feeling with your fingers and skin the temperature, texture and weight of the dough. This physical experience embeds into the memory in a deep way.

The *Dough Portraits* seek to challenge the conventions of established ways of working with art, and to position this process as an essential form of expression. As such, they belong within an artistic line of discourse that is born out of a desire to stimulate a multilayered philosophical discussion about life, society and community. But I hope also that by being something new and different – something that involves the public and is about identity – the series is something that everyone can relate to.

It certainly draws many people to it. So far, I have taken more than two thousand portraits in fourteen countries on five different continents over a period of seven years. In that time, I have had quite a number of strange experiences with dough, as perhaps you can imagine.

One of the most absurd situations was during a photo session one sunny Sunday afternoon in a garden outside the capital city of Brazil, Brasília. The entire family of the director of the ECCO Contemporary Culture Center, Karla Osório Netto, had gathered for lunch and were then lining up to make a dough portrait. The garden was quite large and it was a beautiful setting for the shoot. All of a sudden, while Karla's brother-in-law was posing with the dough on his head, a flock of about ten llamas emerged from the trees. They were very curious to see what was going on and came right over to the dough head and started to nibble on it. I was a little shocked and a bit worried about all these excited creatures running all over the place, while trying to focus on the task at hand and photograph. Then one baby llama started to breastfeed on its mother right next to the posing model. Everyone was laughing, the dough was falling down, and suddenly the large family dog came running over and was very excited to join in and eat the dough. I was in hysterics, while trying to document this bizarre scene, wondering if the llamas might start spitting over everything at any moment.

Another time, I was transporting five hundred kilograms of dough from the bakery in the back of the car. I was stuck in traffic for longer than expected, and while sitting in a jam, I turned around to check on it. Because of all the yeast that had been put in it, the dough had risen to the ceiling of the car and was coming through the metal grille between the back and the driver's seat and touching the windows all around the inside. The people in the car next to me were looking over – it must have been quite a strange sight. Instead of worrying too much about the dough being out of control, I just thought what a fun day at work I was having.

In 2014, I did a dough portrait workshop with a sixth-grade class in Melbourne. The kids were so excited it was like a riot, first when they were mixing the dough in the art room and then outside when we were making the portraits. They threw the dough around the room, shouted and ran around the yard completely out of control. They had a good time and we got some great images, but I was exhausted after this situation, which was very different from the rather quiet and well-behaved museum or gallery setting.

One of the most satisfying episodes was in Maldives, where my wife Amani comes from. I have done two *Dough Portraits* events there to date. The first took place at the National Art Gallery in 2009. We made ninety-nine portraits in the gallery against a neutral white background. There were so many great images: of children wearing school uniform, a surfer, a traditional drummer, a man in a sarong, business people wearing shirts and ties. But my favourite is the photo of Moomina, my wife's aunt, wearing a beautiful purple silk dress and lots of gold jewellery. The day before, she had been wearing the same dress at her daughter's wedding party, and I asked her to wear it to the photo session the following day. The image is extraordinary (see page 249) and speaks for itself.

Not all the events ended so happily though. In 2009, the Shoshana Wayne Gallery in Santa Monica, Los Angeles, invited me to do some dough portraits in its space. The idea was to photograph a mix of people from Hollywood and around Los Angeles, including a number of celebrities and well-known artists whom the gallery knew and could invite. Chris Burden and Mike Kelley got a phone call and were up for it, but Ed Ruscha had to turn down the offer due to his weak neck at the time. William Shatner of *Star Trek* fame was also ready to do it, and there were several other celebrated actors who were happy to participate. Hiding famous faces behind the dough would have created a new and interesting layer in the project. Unfortunately, the gallery decided to postpone the event and exhibition, so I only got to do a test shoot with seven people in the space. But this idea could still be interesting to realize. Chris Burden later emailed me and said, 'I think your art is very provocative, and I enjoy the sly humor that infuses it.' His encouragement almost made up for the show that never was.

Despite the disappointment of Los Angeles, I have been very lucky to be able to take the *Dough Portraits* to so many countries, all thanks to a lot of helpful and dedicated people who wanted to make it happen in their neighbourhood, gallery, festival or wherever. There have been many special moments along the journey of this seven-year-long project – and I am sure that there will be many more to come.

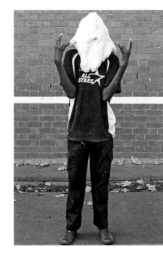
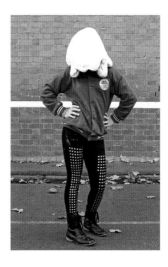
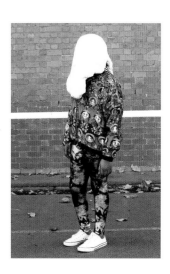

Three of the sixth-grade kids from the Melbourne school pose with attitude for the camera (right). The artist's eldest son Eskil, here aged nine, was somewhat better behaved for his portrait at the National Art Gallery of Maldives in 2009 (below left), as was Shoshana Blank for the Los Angeles test shoot in the same year (below right).

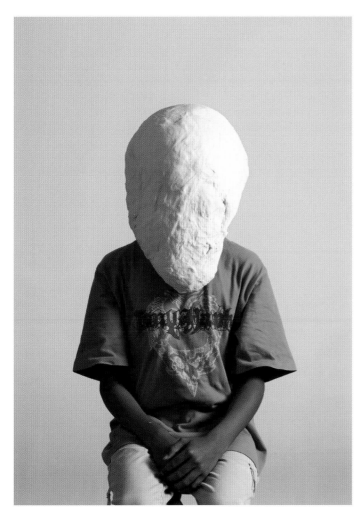
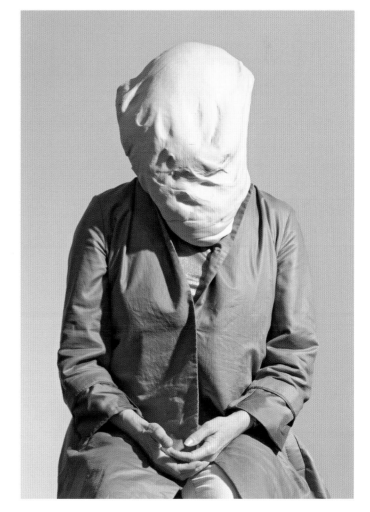

Picture captions

Acknowledgments

My huge thanks go to the following people and organizations for the contributions they have made to this project over the years.

Australia Natalie King; Djon Mundine; Jack Charles; Joy Elder; Victoria Lynn; Anthony Fitzpatrick and all the staff of the TarraWarra Museum of Art; Deb Kunda and Gertrude Contemporary; Sonny Kirik and A Treat of France bakery, Carlton North.
Brazil Karla Osoría Netto, and all the staff at ECCO Contemporary Culture Center, Brasília; the Danish ambassador, Svend Roed; Nielsen and Anne-Marie Overbye; Wagner Barja; National Art Gallery, Brasília.
Canada Barrie Mowatt and all the staff of the Vancouver Biennale.
China Beate Cegielska; Duan Yuting and the team at Lianzhou International Photography Festival.
Denmark Judi Lund Finderup; Tine Nygaard; Henrik Holm and all the assistants at the National Gallery of Denmark; Mikkel Tjellesen; Bjørn Bertheusen; Sam Jedig, Stalke Galleri; Helle Berhndt; Barbara Læssøe Stephensen; Danish Broadcasting Association; Mads Brügger; Svante Lindeburg; Niels Frid-Nielsen; Pernille Rasmussen; Tytter Mann Lab+; Suzanne Russell; Torben Zenth, Kopenhagen.dk, Kunsten.nu; Ingrid Fischer Jonge; Jens Friis; Beate Cegielska, Galleri Image; Rune Gade; Patricia and Thomas Asbæk; Liselotte Haejin Birkmose, Asbæk Galleri; Camila Rohde; Morten Poulsen, Gallery Poulsen; Kent Wolfsen, Galerie Wolfsen; Allan Hjorth, Gallery Hjorth; Christine Buhl Andersen, KØS – Museum for Art Public Space; Randers Art Museum; Esbjerg Art Museum; Helene Nyborg; Contemporary Art Center Viborg; Aukje Lepoutre Ravn; Claus Due Designbolaget; Else Marie Bukdahl; Jakob Fibiger; Jan Bilgrav; Sara Lysgaard; Karin Michelsen; Magnus Wallin.
Finland Pirkko Siitari; Patrik Nyberg; Arja Miller and all the staff at KIASMA Museum for Contemporary Art, Helsinki.
Hong Kong Gim Gwang-cheol, Mok Augustine and the Jockey Club Creative Arts Centre.
Israel Meir Tati; Udi Edelman; Ran Kasmy-Ilan; Eyal Danon; Israeli Center for Digital Art, Holon.
Italy Manuela Lucadazio; Paolo Baratta; Valentina Borsato; Andrea del Marcato; Marta Plevani; Micol Saleri; Paolo Rosso, Microclima; Giorgia Fincato; Isabella Falbo; and all the staff at the Venice Biennale Foundation.
Kosovo Rafet and Lena Jonuzi, Ku(rz)nsthalle, Graz; Bella Angora.
Maldives Moomina Haleem; Amani Naseem; Miyan, Aya and Ranya Naseem; the Hikifinis; Hassa; Filza; Mamduh; Waka; Samra Saleem; Disco Saleem; Naeem and all the staff at the National Art Gallery.
Poland Arti Grabowski; Fabio Cavallucci; and the staff of the Centre for Contemporary Art Ujazdowski Castle, Warsaw.
South Korea Gim Gwang-cheol and the staff of the Gwangju International Media Arts Festival and Gwangju Biennale.
UK Karen McQuaid, Brett Rogers and all the staff of The Photographers' Gallery; Clare Mander, Andipa Gallery; Simon Williams.

The Danish Arts Council for supporting several of the trips and the first *Dough Portraits* publication with the National Gallery Denmark in 2008 and production of work for the KIASMA collection. The Danish Arts Council international coordination and the Danish embassies for supporting the project in Brazil, Canada, Finland, Kosovo and the United Kingdom.

Mette Flink of FLINK for her huge commitment to the design of the publication. Andrew Brown of Art / Books for publishing the book and for his skilled design and sharp editorial mind.

Enormous thanks to Moomina Haleem of Kaimoo Travels, Maldives, for her generous support of the publication.

Last, but not least, my mom Karen Lybye, who, even though she says she feels slightly embarrassed about how silly the *Dough Portraits* are, loves me nonetheless.

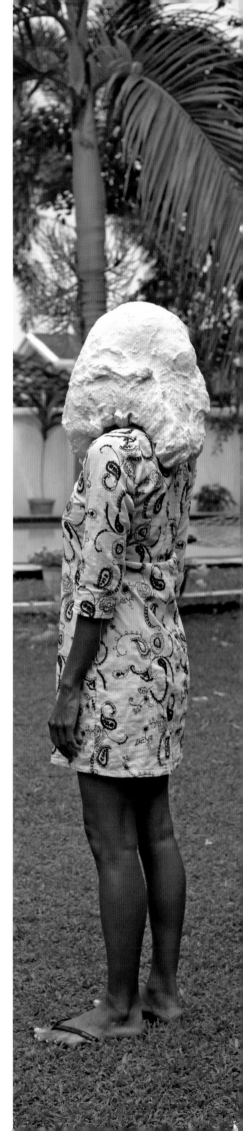